Notre-Dame of Amiens

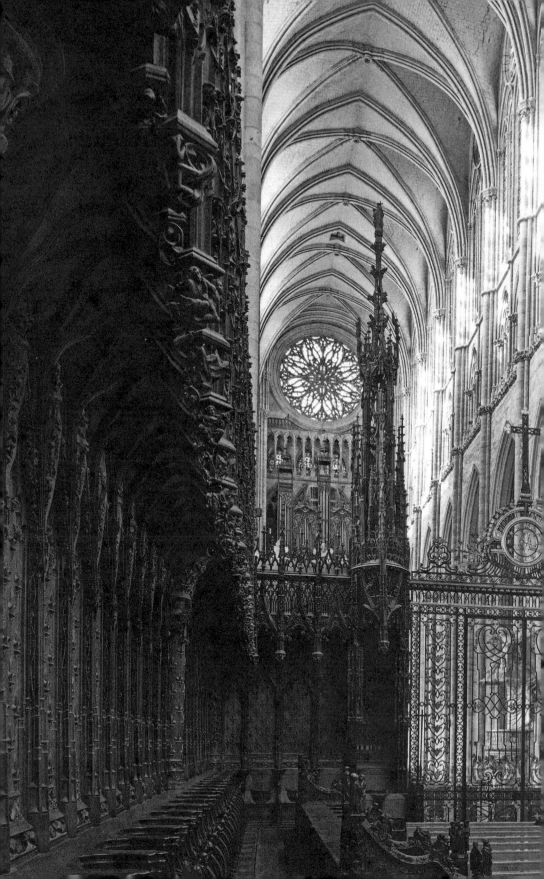

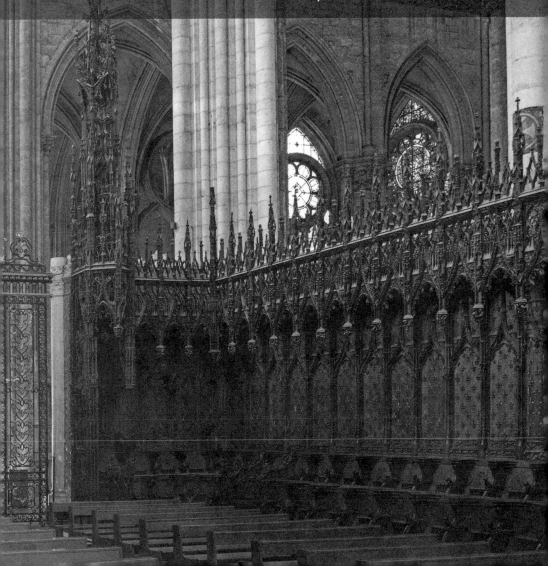

Notre-Dame of Amiens

LIFE OF THE GOTHIC CATHEDRAL

Stephen Murray

Columbia University Press New York

Columbia University Press
Publishers Since 1893
New York Chichester, West Sussex
cup.columbia.edu

All photographs are by the author unless otherwise indicated

Library of Congress Cataloging-in-Publication Data
Names: Murray, Stephen, author.
Title: Notre-Dame of Amiens : life of the Gothic cathedral / Stephen Murray.
Description: New York : Columbia University Press, [2020] |
Includes bibliographical references and index.
Identifiers: LCCN 2019056078 (print) | LCCN 2019056079 (ebook) | ISBN 9780231195768 (cloth) |
ISBN 9780231551472 (ebook)
Subjects: LCSH: Cathédrale d'Amiens. | Architecture, Gothic—France—Amiens. | Architecture and
society—France—Amiens—History. | Amiens (France)—Buildings, structures, etc.
Classification: LCC NA5551.A45 M873 2020 (print) | LCC NA5551.A45 (ebook) | DDC
720.944/2625—dc23
LC record available at https://lccn.loc.gov/2019056078
LC ebook record available at https://lccn.loc.gov/2019056079

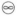

Columbia University Press books are printed on permanent and durable acid-free paper.
Printed in the United States of America

Cover design: Milenda Nan Ok Lee

Cover credit: Upper chevet, hemicycle, seen from the east: the work of Master Mason Renaud
de Cormont, c. 1260 –1270. Stephen Murray, photographer.

All men naturally desire knowledge. . . . Wherefore God, who so loves man that He wants to provide for his every need, has given him a particular faculty of mind called Memory. This Memory has two doors: Sight and Hearing. And to each of these two doors a pathway leads, namely Depiction and Description. Depiction serves the eye and Description serves the ear. . . . Memory . . . renders the past as if it were present.

<div align="right">

RICHARD DE FOURNIVAL, CHANCELLOR OF
AMIENS CATHEDRAL, C. 1250

</div>

The Mother of God, Saint Mary of Amiens, is your lady of all ladies. She is the lady of the world, she is the queen of the glorious heavens, she is the treasure of sinners, she is the savior of souls, she is the spouse of our Lord, she is the mother of Jesus Christ, she is the temple of the Holy Spirit.

WORDS OF AN ANONYMOUS PREACHER, C. 1270

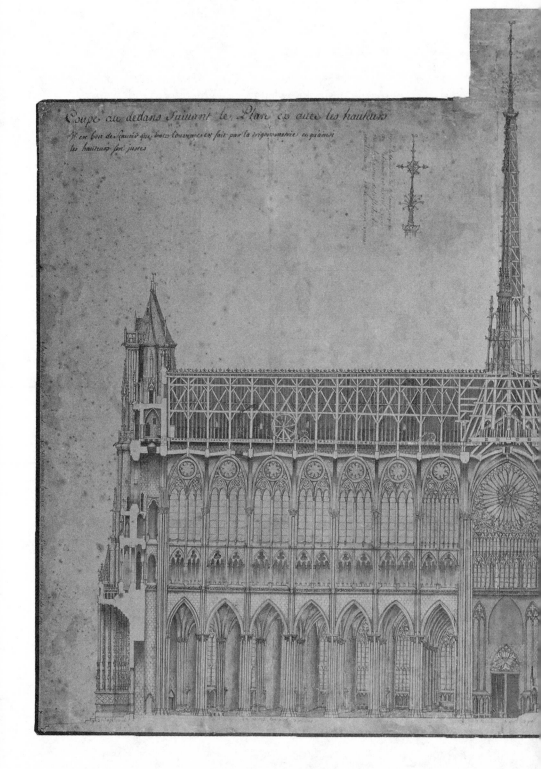

Coupe au dedans suivant le Plan ou sont les hauteurs

Il est bon de scavoir que toutes Louanges est fait par la trigonometrie ou prises les hauteurs sont justes

Plan Saint Marc, Longitudinal Section. Collections du Musée de Picardie, Amiens, Anonyme, France, vers 1727, Coupe longitudinale de la Cathédrale d'Amiens, plume sur papier, collection du Musée de Picardie, Amiens, no inv. : M.P.2072-32, , photo Ludovic Leleu/Musée de Picardie.

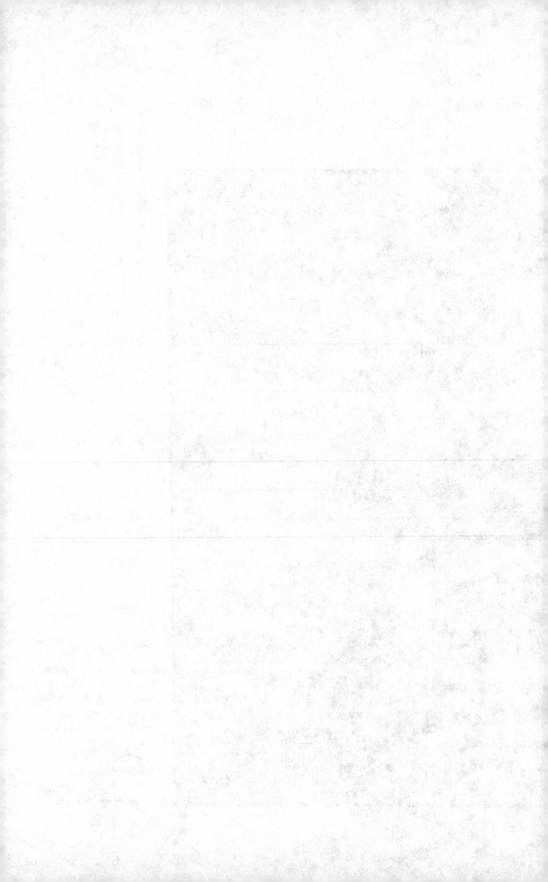

Contents

Acknowledgments

AS I LOOK BACK at a half-century of engagement with Amiens, my feelings of gratitude and admiration are obviously directed principally toward the cathedral of Notre-Dame herself, whose beauty and perfection never fail to inspire, yet whose very imperfections encourage us to tease out the stories of builders and users.

And then, I want to remember the many people with whom I learned to look at the cathedral, starting with my teacher, Peter Kidson, and the participants in a memorable Easter field trip in snowy weather organized by the Courtauld Institute in 1969. My first serious archaeological work at Amiens began in 1978 when, accompanied by my family, I began to prepare measured drawings in order to make comparisons with Beauvais Cathedral, the subject of my 1989 book. Thanks to Grainne, Pippa, and Finnian for their patience, support and inspiration.

In 1987–88 I was able to spend months engaged in intense archaeological and archive work in Amiens: thanks to the Guggenheim Foundation; to Jean-Yves Le Corre, conservator at the Direction régionale des affaires culturelles; and to James Addiss, with whom I measured out the cathedral plan.

Through the 1990s I continued to return to the cathedral, often in the company of my National Endowment for the Humanities summer seminar participants whose curiosity and enthusiasm were contagious. In 1993, under the tenure of grants from the NEH and the Andrew Mellon Foundation, I established the Media Center for Art History at Columbia University with the objective of exploiting the new digital media in the teaching of the Columbia Core Curriculum, where Amiens Cathedral represents the

thousand years of artistic production of the Middle Ages. I am grateful to all those who helped launch this enterprise, particularly to Maurice Luker and Vice Provost Michael Crow. Our digital *Amiens Project* was featured in the Seventieth Columbia University Lecture (1995) and attracted the attention of Xavier Bailly, director of patrimony at Amiens, who in 1998 graciously awarded me honorary citizenship. I also want to thank Didier Groux and Christopher Weeks, who allowed me access to their important work of restoration on the portals in the 1990s, and to Maurice Duvanel, who introduced me to the community of the *compagnons de devoir*.

Having spent a decade engaged in digital mapping of Romanesque and Gothic churches, I found myself drawn back to Amiens in 2014 with a new project leading to the website and this book. For the website work I am infinitely grateful to Emogene Cataldo, Tori Schmitt, Stefaan van Liefferinge, Tim Trombley, Gabriel Rodriguez, and Myles Zhang. Susan Boynton, Frédéric Billiet, and Benjamin Bagby worked with me to add the musical dimension to the project. Lisa and Bernard Selz have taken a keen interest in my work and graciously joined me in a memorable visit to the Amiens choir stalls in 2015.

In this last phase of work in Amiens I have been helped by innumerable colleagues and friends: Professors Étienne Hamon and El Mustapha Mouaddib; Emeline Lefèbvre, Thierry Sanchez, and the team of cathedral guides; Christian Sutcliffe; Louis Mouton; Nicolas Asseray; Aurélien André, keeper of the diocesan archives; Don Edouard Courlet de Vregille, rector of the cathedral, as well as the ever-welcoming team at Le Prieuré, which provided delightful accommodation. I have relied throughout upon the unfailing support and advice of Rory O'Neill, Robert Harrist, Michael Davis, Robert Bork, Matthew Reeve, Annie Mouton-James and Adeline Ducasse. And I want to thank the director and editors of Columbia University Press, who have been generous with their guidance and support.

I am deeply grateful to the University of Picardy, Jules Verne, and to President Mohammed Benlahsen, for the award of an honorary doctorate in December 2019—the culmination of my professional career—and to my colleague and friend Arnaud Timbert for his sponsorship.

May I offer this, my final book, to the people of Amiens?

Aux Amiénois!

Notre-Dame of Amiens

Prologue

S TUDENTS AND LOVERS of the great French Gothic cathedrals—
Laon, Notre-Dame of Paris, Soissons, Chartres, Bourges, Reims,
Beauvais, and Amiens—have, for centuries, asked themselves: Which
is the most beautiful of them all? For many, that distinction goes to Amiens.
But how should we tell the story of this overwhelming masterpiece that
appears to link human creativity with the Divine? How can we hope to
create a written structure to match the cathedral? Our book must recount
the stories of a long-vanished past—while at the same time embracing the
continuing physical presence of the cathedral in our own time and space,
still inviting us to approach, to enter, and to marvel.

These are issues that I have reflected upon endlessly in the more than
thirty years I spent teaching the Columbia University Core Curriculum,
"Art Humanities," where Amiens Cathedral represents the artistic produc-
tion of the thousand-year western European "Middle Ages." As those who
are familiar with Columbia will know, that course is taught not within the
linear structure of the academic lecture, but with the so-called Socratic
method, here understood as a dialectical means of imparting and cultivat-
ing knowledge, creative vision, and critical thought through the dialogue of
question and answer. Lying at the very heart of the enterprise is the business
of translating visual perceptions of the work of art into verbal rhetoric, or
ekphrasis. This process is triggered by the not-so-simple questions, "What
can we see here . . . ? And what can*not* be seen . . . ?" Multiple responses
will result, and fruitful disagreements will be rehearsed. It is through such
debate and disagreement that an individual may develop the ability to reach

a coherent personal narrative—one where the affect and the meaning of the work of art may be understood by the viewer and narrated to an audience.

But there is another dimension to the Socratic method. Plato invoked Socrates as one who taught us about the way an inanimate object can appear to speak to us though the agency of an *interlocutor*—one who stands in front of the object and points and talks. The relationship has been compared with that of a ventriloquist making a puppet appear to speak.[1] However, when the viewer narrates the work of art to an audience, I would suggest that rather than making the inanimate object speak, the reverse is true: the interlocutor has been induced by that work of art—in this case, the cathedral—to articulate thoughts and words that would not otherwise have come to mind.

Socratic method, then, might be understood not just as the dialectical process of learning to look through question and answer, but also as the magic that is possible when an inspired (or, at least, a well-informed) interlocutor is led by the work of art to articulate rhetorical responses that might be both original and eloquent. In the pages of my book I want to encourage the user to engage in close looking and inspired describing. By embracing both kinds of Socratic method I hope to extend the appeal of this book beyond the classroom to a much wider audience of medievalists and cathedral lovers.

In addition to these concerns, I have, for more than thirty years, sought to engage the new media in the grand enterprise of animating the work of art in the classroom. Particularly exciting is the *immediacy* of the high-resolution, zoomable image and panorama on the screen. And I have enjoyed stringing images in sequences and adding words to prompt the interlocutor to tell multiple stories. Also, the ability to capture the *sounds* of the cathedral is something that cannot be achieved in the pages of a book. I would therefore like to encourage readers to navigate to the website designed to accompany this book and to move through cathedral spaces in virtual reality: www. learn.columbia.edu/amiens.[2]

In chapter 1, "Visiting the Cathedral," inspired by John Ruskin's *Bible of Amiens*, we will approach, enter, and move through the spaces of the cathedral.[3] As interlocutor, Ruskin both engages and irritates as he inspires and informs his imaginary companions about the visible present and the vanished past—the architectural forms and monuments of the existing edifice

Socratic Method

in relation to the context of the cathedral in the medieval city of Amiens. Ruskin was very aware of the fact that we can only fully experience the cathedral through our own passage through space. He also recognized the limited time and attention span of his audience. If on a sunny day you have sufficient time, he advises, you should climb the high ground to the northwest of the city to enjoy the distant view of the cathedral from the Citadel (figs. 0.1–2). Since entering through the west portals and down the length of the nave was not Ruskin's favorite passage into the cathedral (fig. 0.3), he recommends that if you find yourself pressed for time and the day is rainy, you should enter directly through the south transept portal where you will be precipitated dramatically into the heart of the cathedral (fig. 0.4). Ruskin was also very conscious of the vital link between rhetorical eloquence and visual appreciation. In his most beautiful passage he recommends that we focus upon the choir, especially the magnificent Late Gothic choir stalls (fig. 0.5):

> Sweet and young-grained wood it is, trained and chosen for such work, sound now as four hundred years since. Under the carver's hand it seems to cut like clay, to fold like silk, to grow like living branches, to leap like living flame. Canopy crowning canopy, pinnacle piercing pinnacle—it shoots and wreaths itself into an enchanted glade, inextricable, imperishable, fuller of leafage than any forest, and fuller of story than any book.[4]

With such passages of eloquence to urge them forward through the spaces of the cathedral, visitors will come away with eyes opened to the marvelous and the miraculous.

Inspired by Ruskin, I want to assume the role of interlocutor in these pages. In chapter 1, I will provide an introduction to the vanished past as well as a commentary on the visible present. In approaching and visiting the cathedral, you, the reader, may familiarize yourself with the forms and spaces of the great monument using the images printed on the page, coupled with online images, panoramas, and animations on the accompanying website. The architectural forms of the cathedral draw us forward compulsively in a passage sometimes understood as a *ductus* (from Latin *ducere*, to lead).[5]

On the website, that forward passage is simulated with carefully composed sequences of high-resolution images.

your experience changes depending on the environment

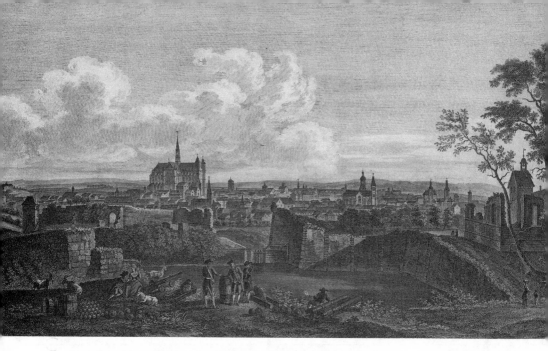

FIGURE 0.1 View of Amiens from the walls of the Citadel: drawn by Basire, engraved by Duparc, c. 1780 (Archives départementales de la Somme). See also color plate.

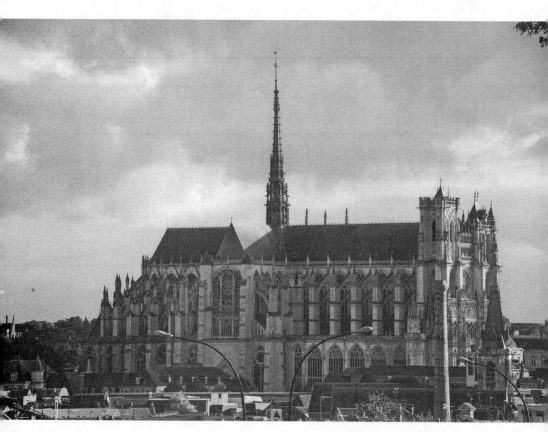

FIGURE 0.2 The cathedral seen from the same spot today. See also color plate.

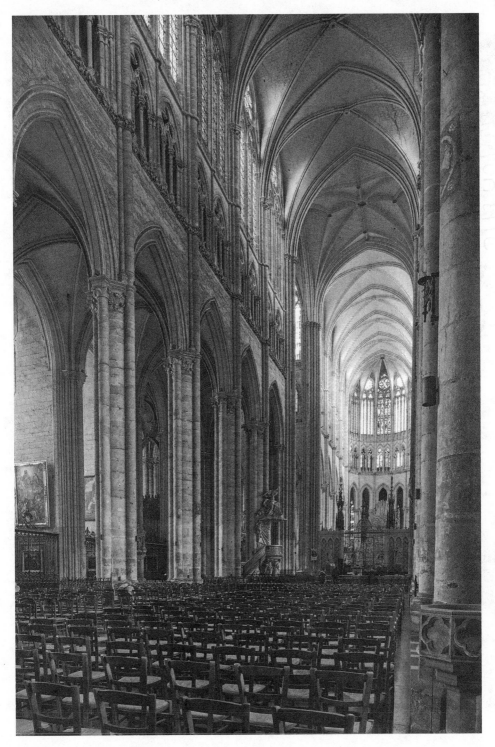

FIGURE 0.3 View down the length of the nave. See also color plate.

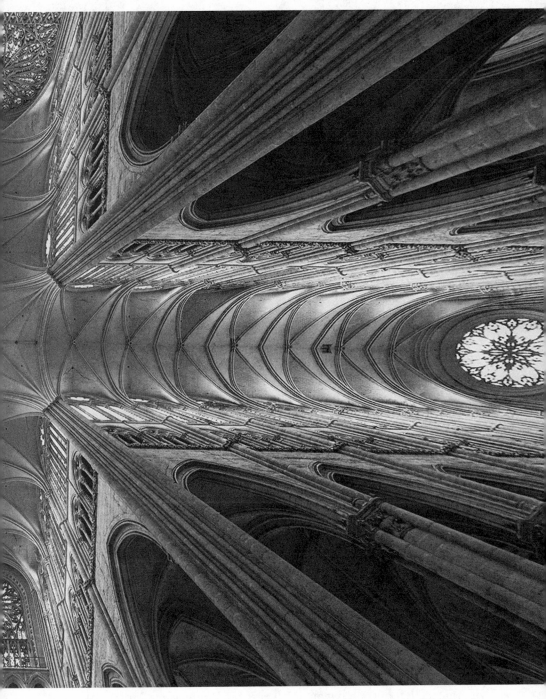

FIGURE 0.4 Spatial envelope of the cathedral: we are in the middle: *in medio ecclesiae*.See also color plate.

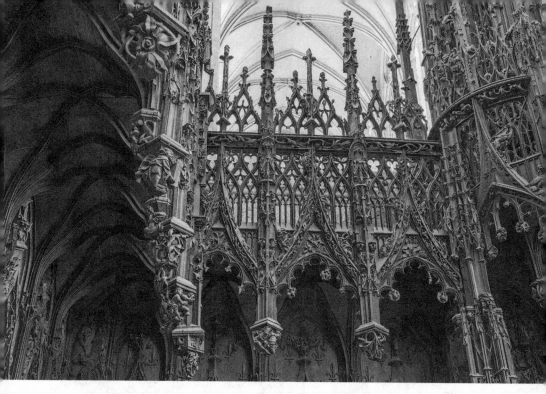

FIGURE 0.5 Choir interior: choir stalls

The unscrambling of the multiple messages embedded in the figural pro-grams of the four great portals leads us to another level of understanding. In chapter 2, "The Portals," I will provide an introduction to the extraordi-nary program of figurative sculpture in the west façade and south transept portals. The program for the west portals was certainly devised by members of the clergy, but the message was aimed at laypeople. This is made par-ticularly clear in the words of a contemporary preacher who, in a sermon delivered in the immediate proximity of the cathedral close to the time of construction, offers a most attractive deal to members of his congregation through three avenues of salvation matching the three great portals of the western frontispiece.[6] You can be absolutely certain of the Last Judgment, and the outcome may be awful, the preacher declares, but you have three powerful mechanisms working on your behalf. It lies within your power to change your life through good works and imitation of the apostles (central portal); the church is also there for you with its saints, its miracles, and its sacraments (left portal); but above all else, the Virgin Mary, Mother of God, Sainte Marie d'Amiens is there for you (in the right portal) with the power

to break that dreadful contract with death resulting from the original sin of Adam and Eve.

Passing through cathedral spaces, we will encounter many signs of the presences, now vanished, of our medieval predecessors: clergy, artisans, and laypeople. We will seek to animate those presences in chapter 3, "Clergy, Artisans, and Laypeople: Makers and Users." First, we meet the cathedral clergy. The principal responsibility of the clergy, after the performance of the sacraments, was the repetitive daily routine of the Divine Office: chanting the psalms. This activity was enlivened through the celebration of the great cyclical feasts of the Christian year, as well as the anniversaries of the saints, saintly bishops/clergy, and benefactors associated with the cathedral. The sounds of their voices and the passage of their processions have long since vanished, as has much of the liturgical furniture that facilitated their mission, yet members of the medieval clergy are still palpably present in the form of a remarkable sequence of episcopal tomb monuments, which will provide an introduction to the presence of the bishops in the life and space of the cathedral. Unfortunately, the medieval throne of the bishop (*cathedra*) is gone—but we still have the magnificent early sixteenth-century choir stalls that provided a fabulous stage set for the liturgical life of the cathedral (fig. 0.5).

Next, we will encounter the artisans: the masons who built the cathedral, the carpenters who facilitated the work of the masons and erected the magnificent roof and steeple, the sculptors (*tailleurs d'images*) who created the portals, the glaziers who installed the stained glass windows. By the later Middle Ages, ample documentation allows us to understand the role of these artisans, mostly local people, responsible for the production of the thousands of images that populate the Late Gothic choir stalls, shrines, and screens. They worked within the world of a cathedral created by legendary predecessors whom they knew by name: Robert de Luzarches, the founding master mason, together with his companion Thomas de Cormont, and Thomas's son, Renaud, whose presence was recorded in the great labyrinth set in the pavement of the nave (fig. 1.40). The labyrinth served as a reminder that these original creators of the cathedral belonged to the mythical world of Daedalus, builder of the labyrinth on the island of Crete, maker of wonderful things, and the first man to fly. The world of the artisans is found not just in the great labyrinth but also in the architectural

forms and spaces, as well as the figurative programs of the cathedral itself: a Gothic world of breathtaking, gravity-defying transformations leading us to the experience of the miraculous and the sublime.

Master Robert de Luzarches probably did not grow up in Amiens: he brought to the construction project his working knowledge of earlier Gothic cathedrals like those of nearby Laon and Soissons; he was probably also acquainted with some of the great Cistercian churches favored by the kings of France. His plan linked the worlds of the laypeople and the clergy within the spaces of the new cathedral, coming to a crescendo in the middle of the church, *in medio ecclesiae*, where the enlarged bays around the central crossing create a unique space for the dramatic projection of the liturgy beyond the enclosed choir into the world of the laypeople (fig. 0.4). Amiens Cathedral was conceived around this space, with the lengths of the transept arms, nave, and choir plotted by dynamic geometry generated from a great central square. It was also *constructed* from the center outward with aboveground work starting in the south transept and south nave aisle: we will follow the construction campaigns and the role of the three initial master masons.

Modern visitors, as they approach, enter, and move through the cathedral, mimic the movements of medieval laypeople. Whereas we may be drawn forward by our visual curiosity and craving for aesthetic experience, our medieval predecessors might pursue the cult of saints, invoke the intervention of the Virgin Mary, attend offices in one of the chapels, or participate in the great feasts of the Christian year. The engagement of laypeople in the medieval world of the cathedral varied enormously according to social standing. Ordinary folk might be terrified by the prospect of Last Judgment depicted in the central west portal, seduced by the salvific power of the Virgin Mary, or entranced by the dramatic relic processions (sometimes including spectacles like the animated dragons known as *papoires*). Wealthier members of the city population who rejoiced in the title of *marchand* (merchant) might associate themselves with the life of the clergy through participation in the activities of one of the lay confraternities—especially the *Puy Notre-Dame*. Laypeople might donate a window to the cathedral, or even want to be buried in one of the lateral chapels added to the nave during the late thirteenth and fourteenth centuries. The two worlds—that of the clergy and that of the laypeople of Amiens—might also come into conflict. While Amiens was spared the violent manifestations that accompanied the construction of the

nearby cathedrals of Laon, Reims, and Beauvais, the intense fundraising necessitated by cathedral construction may have provoked anticlerical incidents, and in 1258 members of the bourgeois were accused of having set the cathedral on fire.

In chapters 4 and 5, "Telling the Story of the Great Enterprise" parts I (1220–c. 1300) and II (c. 1300–1530), I tell the exciting story of the construction and embellishment of the Gothic cathedral, extended over a period of three centuries. We begin with members of the clergy returning from the great 1215 Lateran Council in Rome, their thoughts full of liturgical and pastoral reform, and their memories charged with the sights they had seen in Italy. Hopes of initiating such reforms were dashed by the destruction of the old cathedral in a fire that was said to have taken place in 1218.[7] Beginning in 1220, a visionary master mason, Robert de Luzarches, quickly laid out the foundations and lower walls of the new cathedral with an innovative scheme through which the spatial regularity of the nave (square and double square bays) was dramatically transformed with expanded spaces at the central crossing where the transept intersects the body of the building. Master Robert worked with Thomas de Cormont who, in the second and third decades of work, completed the upper nave—taller than that of any existing cathedral—and started the lower choir. In the 1250s and 1260s, Thomas's son Renaud then built the upper choir and introduced many innovations, some of them structurally unsound; he also installed the pavement in 1288. The first part of our story ends with the clergy triumphantly taking their places in the new choir in the years around 1270, accompanied by glittering liturgical celebrations. Fittingly, the cathedral was finally crowned with a splendidly innovative new roof and central steeple in the decades around 1300.

However, all was not well. In their rush to take their seats in the new choir, the clergy had left critical parts of the cathedral unfinished and were still lacking facilities (cemetery, chapter house) considered essential to their mission. Economic and political circumstances changed sharply: the fourteenth century was hardly propitious for building, and the clergy struggled to continue the work of adding lateral chapels to the nave in order to better accommodate elite burials. Then disaster struck. In the dramatic last episode in the life of the Gothic cathedral, the enlarged central bays began to fail as the main crossing piers, burdened with the weight of the great central

steeple, buckled inward at arcade level and outward in their upper parts. Although this deformation was arrested through the installation (c. 1497–c. 1500) of iron chains running the length of both sides of the nave, transept arms, and choir—eight chains in all—the structural security of the cathedral was still not assured. Soon afterward it was necessary to rebuild the choir flyers, badly conceived by Renaud de Cormont. Finally, in 1528, a lightning strike sent the old steeple over the crossing crashing down in flames.

Considered in broad historical terms, this three-hundred-year *Life* begins with the triumph of Catholicism (the Fourth Lateran Council [1215]; the suppression of heresy through the Albigensian Crusade [1209–1229]) and the definitive formation of the geographical contours of France (the Battle of Bouvines, fought close to Amiens [1214]). It ends with challenges to the status of the clergy, the validity of the sacraments, and the cult of saints; in other words, with the Protestant Reformation. Some of the last projects in the life of this Gothic cathedral may be seen in terms of defiance: the great golden steeple—the *grand clocher doré* carrying relics of the Passion and the saints high above the Picard plain—was completed just as the preaching of Martin Luther, with its admonitions against the veneration of relics, was making its impact felt.

Whereas the modern visitor can appreciate the transformative architectural power of the cathedral and can come a long way in unscrambling the message encoded in its figurative programs, the understanding of liturgical practice may remain more elusive. Yet the material forms of the cathedral were but husk containing this essential germ. The Gothic cathedral was animated through the daily liturgical practice of the clergy, which transformed the material cathedral and city into Celestial Jerusalem and elevated the clergy to the ranks of the angels in their incessant praise of God. In chapter 6, "Liturgical Performance: Angels in the Architecture," we will look at how such a transformative miracle was achieved through the minute orchestration of the movements, vestments, words, and musical production of the clergy in the choir. For this, we will draw upon two principal written sources. The first is the great choir book or *Ordinaire de l'église Notre-Dame, Cathédrale d'Amiens* (hereinafter referred to as the *Ordinary*), compiled in 1291, that lays out liturgical procedures for the newly completed Gothic choir. The second is the *Essay d'un Cérémonial pour l'église d'Amiens*, compiled by Canon François Villeman in the early

eighteenth century. Villeman witnessed and recorded the suppression of many of the more engaging paraliturgical practices of the late Middle Ages. And then, we have a third source—the cathedral itself. Our passage through the cathedral will reveal the architectural genius of the design of the sanctuary, with its unifying center point determining the location of the principal altar and relic tribune, and where the radiating geometry of the hemicycle comes together in a single point marked by the image of Christ in the central keystone. We will document some of the spectacular processions that took the clergy and the relics of the saints far beyond the confines of the cathedral through the streets of the city.

A good story should have a beginning, a middle, and an end. In one sense, we can identify the year 1530 as the "end" of the "Gothic" chapter in the life of the cathedral: it marks the death of the last great building dean, Adrien de Hénencourt. As the sixteenth century progressed, the cathedral certainly entered a new phase when the old forms and practices were increasingly an embarrassment to the clergy, reaching a crescendo in the mid-eighteenth century with the systematic destruction of tombs, shrines, screens, stained glass, and devotional images considered visually unacceptable, as well as the suppression of many of the paraliturgical practices and processions that had helped cement the affection and allegiance of the laypeople. This second phase, lasting around two hundred and fifty years, was violently terminated by the French Revolution and the disestablishment of the Church.

And then, of course, our great cathedral has enjoyed a third chapter in its life, from the Revolution to the present time, when it has become a powerful magnet attracting many thousands of international visitors each year. Exterior surfaces, recently cleaned and restored, glisten like new, and on summer nights the west façade is animated through the play of light and brilliant colors projected onto the sculpture of the portals. This dazzling display allows modern visitors, if they like, to persuade themselves that they are seeing the painted cathedral as it once was.

This great anniversary year, 2020, obviously invites us to remember and to celebrate the entire eight-hundred-year life of Notre-Dame of Amiens.[8] Our agenda in the following pages, however, is a more limited one: to focus upon the *Gothic* chapter in the cathedral's long life, beginning with the experience of the visit.

Visiting the Cathedral | I

I N THE PROLOGUE I invoked John Ruskin as inspiration in the rhetor-
ical construction of a visit to the cathedral. Does this mean that such a
visit, led by a guide or interlocutor, is essentially a modern phenomenon?
Inherent in the modern visit is the idea that we are driven principally by our
curiosity and aesthetic craving, and that we come and go—in contrast to
the builders and the clergy whose engagement with more profound issues
led them to spend their entire lives in and around the cathedral.

However, I want to trace the role of the interlocutor—the person who
points and talks and guides—back to the period of the construction of the
Gothic cathedral. The difference between a pilgrim and a tourist might
actually have been less distinct than we would think, and the cathedral was
probably already in the Middle Ages the target of something akin to mod-
ern tourism.[1] Conrad Rudolph has recently provided a most convincing
survey of a wide range of documentation of the "show-and-tell" business
medieval lay visitors might encounter on arriving at a major monument.[2]

Perhaps the most striking example of the guided tour at a time not far
removed from the life of the medieval cathedral is provided by Jean Pagès
(1655–1723), a self-described "merchant" of Amiens.[3] The author, like John
Ruskin, wants to first take you up to the top of the city rampart and have you
admire the cruciform shape of the cathedral in relation to the surrounding
city. He brings you to the square (*parvis*) in front of the portals, reminding you
that the word *parvis* is derived from *Paradisus*. He points to the little shops
where you can buy tourist souvenirs, and provides information about the por-
tals and towers. He attempts to locate the phenomenon of "Gothic" within a

wider framework of architectural history and provides a concise description of the cathedral and a short history of construction. Pagès, as interlocutor, organizes our passage through interior spaces mostly around pictures and shrines. He is aware of the images (now mostly lost) of local professional groups in the stained glass windows.[4] He provides specific information about the forms that we consider Gothic.[5] He does not fail to point out the astonishing architectural space encountered in the center of the cathedral, the crossing: *The architecture of this part of the building of our august temple is so beautiful, so surprising that unless you yourself had not come here to admire I can only give you a weak impression, despite all my zeal for the beauty of this superb edifice.*[6] I will make the case that it was in this very part of the cathedral, *in medio ecclesiae*, that laypeople and clergy came together, united through liturgical and devotional activities. Indeed, Pagès's own appreciation of the spaces of the cathedral included the lively acoustics and the sense of the sublime.[7] Above all, he considered that architectural form, space, light, and song all contribute to the unifying force of the cathedral—which was sufficient to bind together the worlds of the laypeople and clergy.[8]

The following pages, then, have been written in the conviction that that the role of guide and interlocutor is *not* a modern imposition, but that it extends back into the life of the Gothic cathedral. The framework of the visit, moreover, provides a vital means of comprehension. Let us approach, then, and enter, responding not only to what we can see, but also to the need to understand what can*not* be seen: the material and human circumstances of the vanished ages that left us the great cathedral as a representation—or physical embodiment—of the past. *Où sont les neiges d'antan?*[9]

a) Approaching the Cathedral: The Vanished Past

Let us start our visit with what appears to be a simple question: Why Amiens, of all places? Why should this most beautiful cathedral have been built on this particular spot? How, when, and why did Amiens become a city? For that matter, how does any city—Rome, Constantinople, Paris, New York—find its destiny? We should not underestimate the role of myth and storytelling: think of Virgil's story of Aeneas, led forward by destiny to found Rome—*Italiam non sponte sequor.* And what about Paris, city of saints, with its Denis, Geneviève, and Marcellus?

i) Roman Amiens: Samarobriva

Amiens is located on the Somme River to the north of Paris, on the flat Picard plain where the underlying chalk is overlaid with alluvial deposits of considerable fertility.[10] Because the soil is relatively easy to work, the surrounding area was settled early: Saint-Acheul, just to the east of Amiens, achieved fame through the discovery in the 1830s of early Paleolithic stone tools manufactured by *Homo erectus* some 450,000 years ago. The site that was to become Amiens was attractive to early settlers on account of an elevated gravel terrace, rising almost one hundred feet above the flood plain of the Somme, a major navigable river (fig. 1.1).

The presence of a great city and cathedral conveys the appearance of inevitability, almost as if intended by fate or by divine providence. Yet the first occurrence of the name *Samarobriva* ("Passage over the Somme") in written sources involved circumstances that were distinctly accidental.[11] In book 5, chapter 24 of his *Gallic Wars*, Caesar recounts that as he returned

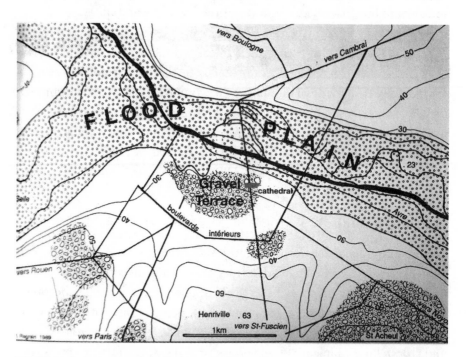

FIGURE 1.1 Amiens: physical site (*Amiens*, ed. Christine Bonneton). The river Somme, flowing from right to left, is flanked by numerous lesser channels of the flood plain. The site of the cathedral is marked on the east side of a gravel terrace at an elevation above the flood plain.

from his near-disastrous second expedition to Britain in 54 BC, during which a violent storm had destroyed much of his fleet, he pulled his boats out of the water while rowing up the Somme and summoned an assembly of the Gauls at Samarobriva, where he spent the winter. The Gallic people of the region were known to the Romans as the Ambiani—some scholars have suggested derivation from the Latin term *ambo*, meaning "both," since the group had settled both sides of the Somme. However, intense archaeological investigations conducted over several decades have uncovered no traces of a Celtic fortified city or *oppidum*: the first signs of Roman presence at the site that was to become Amiens only come half a century after Julius Caesar's visit. Is it possible that the location Caesar called "Passage over the Somme" was *not*, in fact, the site that later became Amiens?[12] Certain, however, is that the great Roman city established here in the last decades BC occupied a key site at the intersection of the Via Agrippa, the road linking the city of Lyon and southern Gaul to the English Channel, and the navigable river that provided a principal route to Britain; and that this city, which became known as Samarobriva, served as a key administrative and military center used in the Roman conquest of Britain and Germany, and in defense against the invasions of Franks and other Goths.

Archaeology has revealed the existence of three principal phases in the disposition of space in the Roman city. The earliest Roman settlement was located close to the Somme and the parallel Avre River, elevated above the flood plain on the gravel terrace. The settlers established a gridded street system made up of rectangular islands (*insulae*), each measuring 320 by 385 feet.[13] The early city had a military purpose and character. In a second phase in the mid-to-later first century, this initial plan was extended to the south with new areas laid out around a gridded system of streets made up of squares measuring 550 feet on each side.[14] The civilian population rapidly increased: at its height the city stretched out over 130 hectares and had a population of as many as 15,000. Samarobriva, with its great forum and amphitheater big enough to accommodate the entire city population (fig. 1.2), was one of the largest provincial Roman cities of the north, twice the size of Lutetia, which later became Paris. The third phase came with the period of Germanic incursions beginning in the third century: the city lost at least half its population and shrank behind a defensive wall, built circa 300 AD, to an area of around 20 hectares (fig. 1.3). The amphitheater was

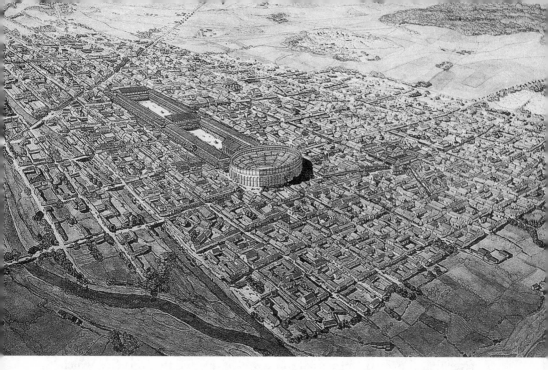

FIGURE 1.2 Roman Amiens: Samarobriva (jeanclaudegolvin.com). Cutting across the city grid is the great road, the *Via Agrippa*.

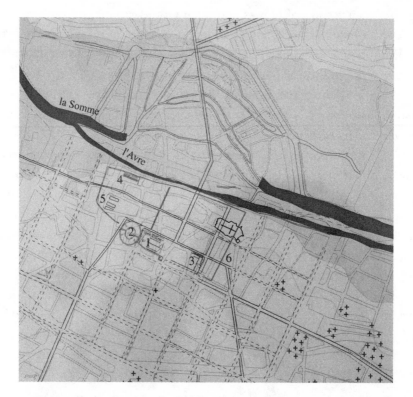

FIGURE 1.3 The late Roman wall c. 300 (*La marque de Rome. Samarobriva [Amiens]*). 1: forum, 2: amphitheater, 3: sword manufacturing, 4–5: storehouses, 6: St Martin's gate, 7: necropolis of S-Acheul. See also color plate.

transformed into a fortress. The name of the city changed from Samaro-briva to *civitas Ambianensium*—which eventually gives us "Amiens."

What impact did the early history of the city have upon the site and form of the Gothic cathedral? First, we might note that the ability to control space through a range of surveying instruments, perfected by the Romans in the grid systems applied to plot rural landscapes and cities like Samarobriva, was not entirely lost to subsequent generations: it was sustained through the Middle Ages by land surveyors known as *agrimensores*.[15] The rigorous control of space and form characteristic of the great church architecture of the Middle Ages—especially that known as Gothic—is an expression of this continuing tradition: the plan of the cathedral embodies systematic square schematism similar to the plotting of the Roman city. The cathedral, moreover, was aligned (albeit not in perfect orientation) with the Roman street grid, and the same unit of measurement was employed. Second, as Christianity was established in the city, probably by the end of the third century, the site assigned by the Roman authorities for the principal church and bishop's residence was the most elevated area of the walled city, the northeast corner. As in many other Roman cities, the episcopal group was located on the edge, close to the city wall adjacent to the bishop's residence, while the memorial shrine commemorating the mission and martyrdom of the legendary saints lay outside the walls, in the necropolis of Saint-Acheul to the east. In this way, the topography of power within city space was established, with ecclesiastical presence to the east and secular authority to the west: much the same as on the Île de la Cité of Paris (Roman *Lutetia Parisiorum*).

ii) Storytelling and the Quest for Christian Roots: Miraculous Transformations

The circumstances of the establishment of Christianity in Amiens and the surrounding area between the second and fourth centuries remain obscure—we will review the scant archaeological and written evidence in chapter 3. What is certain is that between the eighth and twelfth centuries members of the local clergy, longing to reinforce their relationship with Christian roots, undertook a great storytelling enterprise with the objective of providing substance to the mythic figures of the evangelists: Quentin,

Fuscien (Fuscian), Gentien (Gentian), Victoric (Victoricus), and, above all, Firmin the Martyr who, it was believed, brought the new religion to the area in the late third century.[16] The story of Firmin's martyrdom echoes that of many another evangelist: coming to the city from afar (in Firmin's case, from Pamplona in northern Spain) and beginning to preach and baptize, he was enthusiastically welcomed by the population. However, his popularity aroused the envy of Rictius Varus, a governor (*vicarius*) in Roman Gaul at the end of the third century during the time of Emperor Diocletian's persecution of Christians. Firmin was imprisoned and decapitated; his body, retrieved by Faustinian (Faustinanus), one of his followers, was said to have been buried in the necropolis known as Abladana, now Saint-Acheul, a mile east of Amiens.[17] The site of the saint's tomb was then lost in the confusion of the Germanic invasions and the destruction of the suburbs. Miraculously rediscovered in the seventh century by Bishop Sauve (Salvius), the relics of Firmin the Martyr, together with saints Firmin the Confessor,[18] Ache, and Acheul, were brought back into the safety of the city walls and deposited in the episcopal church. This, or so the story goes, was the beginning of what we know as Amiens Cathedral.

The story of the miracles that attended the discovery (*invention*) of the lost body of the saint became established at the very core of the mythic identity of the cathedral and city of—these miracles, vividly depicted in painted sculpture and displayed conspicuously in the Gothic cathedral, retell the story of the saints using the "virtual reality" equivalent of the time. There were three principal episodes in the miraculous sequence of events. First, the place of the tomb was revealed to Bishop Sauve by a ray of light (figs 1.4; 5.10–11).[19] Second, the intense cold of a winter's day (January 13) was transformed into springlike weather: trees leafed out, flowers bloomed, and a sweet odor percolated through the entire diocese, leading the residents of neighboring towns to assemble and participate in the miracle. Exuberant foliage as a sign of transformation was incorporated in numerous ways throughout the Gothic cathedral, most notably in the great foliate garland (unique of its kind) at the base of the triforium. Third, the procession, accompanied by miracles of a kind never seen before or since, turned into a kind of Triumphal Entry of Christ into Jerusalem (fig. 1.5). To the southeast of the cathedral, at the old Roman gate known in the Middle Ages as the "Arched Gate" (French: Porte de l'Arquet), stood a tower known

Saint Firmin brought springtime in January to stunt Amiens

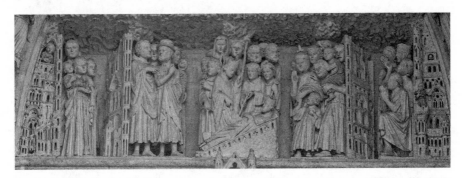

FIGURE 1.4 Invention of the relics of Saint Firmin: north-west portal. City folk emerge from nearby Thérouanne, Cambrai, Noyon and Beauvais in order to participate in the miracle.

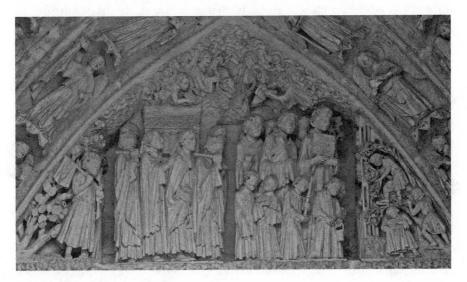

FIGURE 1.5 Translation of the relics of Saint Firmin: north-west portal

as the Jerusalem Tower, no doubt in memory of the miraculous procession. The Jerusalem Tower featured importantly in the paraliturgical events of the annual Palm Sunday procession, which returned to the cathedral by means of this gate and engaged in antiphonal singing at the tower.

Fabulous though the Saint Firmin story sounds, it might embody some real historical elements. By the fifth century many churches were seeking to bolster their authority by reconstructing their physical relationship with legendary founders: local saints, bishops, and martyrs. King Dagobert's

(623–639) generosity toward the abbey of Saint-Denis had provided a vivid demonstration of the benefits to be gained from the physical presence of the saints' bodies within the space of the church choir.[20] It is possible that this realization generated enthusiastic relic prospecting in the necropolises that surrounded Amiens, especially the one to the east at Saint-Acheul ("Abladana") where the diggers were sure to find a rich array of early Christian sarcophagi.[21] We may speculate that they found what they were looking for, discovering a sarcophagus with the name Firminus—possibly even including the title of bishop (*episcopus*). They may also have found the names of the other key players in the Firmin story engraved upon the sarcophagi—these would be members of the earliest Christian community in Amiens who had chosen to be buried *ad sanctos*, at the tombs of the legendary saints.[22] Then a multitude of the faithful would have brought the remains back to Amiens, with the clergy retrospectively devising the story of the seventh-century Bishop Sauve and his divine illumination.

Worth underscoring is the importance that our stories have placed upon the enthusiastic participation of the laypeople of the city and the surrounding area. The transfer of the relics of the saints into the principal church of the city of Amiens expressed the desire of the clergy to harness and control the powerful force of popular enthusiasm for miracle stories and burial *ad sanctos*.

Whereas the story of Saint Firmin was adopted and repeated with great enthusiasm through the iconography and liturgy of the cathedral and the figure of Firmin embraced as the patron of the city, the memory of a much greater saint with local connections was curiously neglected in cathedral iconography. In the early Middle Ages the cult of Saint Martin enjoyed unrivaled success—and the principal miracle associated with him had actually taken place in Amiens, at the eastern gate in the Roman wall located to the southeast of the cathedral.[23] Sulpicius Severus (c. 363–c. 452, *Life of Saint Martin*, chapter 3) tells the story of how Martin (d. 397), soon to become a Roman cavalry officer, encountered a scantily clad beggar outside the Amiens city gate on a bitterly cold winter's day and divided his cloak in order to clothe him.[24] That night Jesus appeared to Martin in a dream, saying to his angels, "Martin is still only a catechumen [a Christian novice], but he has clothed me with this garment."[25] Martin of Tours, probably baptized in Amiens, went on to mega-saint status in early medieval France;

it is therefore odd that he found so little place in the mythology and iconography of the cathedral. Instead, his cult was fostered by the nearby church of Saint-Martin-aux-Jumeaux, which claimed to occupy the site where the miracle took place.[26]

iii) Medieval Transformations

The stories of the saints project intense yearnings: for a lost past, for physical contact with the saints, for miraculous transformations, for Christian unity.[27] It is not fanciful to suggest that the rapid and radical changes experienced in Amiens between the eleventh and early thirteenth centuries—while not quite corresponding to those very desires, and hardly miraculous—were nevertheless astonishingly transformative. In reviewing these changes, we will set the stage for the construction of this Gothic cathedral.

DEMOGRAPHIC RECOVERY

It is impossible to determine exactly when the long demographic decline that had begun with the late Roman Empire reversed itself and populations in northern Europe began to increase. Historians have suggested that Picardy, to the northeast of Paris, saw population increases beginning perhaps as early as the tenth century, thanks partly to the highly fertile and easily worked alluvial soil.[28] The availability of silver coinage retrieved from Viking hoards may have allowed the population to purchase iron to improve their vital tools: saws, scythes, chisels, iron-trimmed plows, and water mills. The demographic boom brought additional population to cities like Amiens, and made possible the proliferation of numerous prosperous villages. It is thought that by the thirteenth century the population of Amiens numbered between fifteen and twenty thousand citizens in a province of around one million. The growth of the city was fostered by similar circumstances that had led to its first establishment: navigation on the Somme River, as well as local production, both agrarian and industrial, including metallurgy.[29] Amiens became a major production and distribution center for woad, an essential blue dye widely used in fabric production and heavily exported, especially to Flanders and England.[30] The woad traffickers established themselves as the most powerful merchant group in Amiens,

eventually playing an important role in the emergence of the commune and in the life of the cathedral. In addition to the growing wealth of city folk, we must not forget the role of the *rustici*, or countryfolk, in the large prosperous villages of the immediately surrounding region. These were agrarian producers engaged in the early capitalistic cash economy, and they appear to have had a keen sense of the value of their products and the profits to be made.[31] In a fundraising sermon preached to the rustici of Amiens around 1260, the preacher appealed above all to their sense of a good bargain.[32] Interestingly, the earliest financial accounts for the construction of Troyes Cathedral in the 1290s indicate that contributions from the faithful of the diocese formed the largest single item in the receipts of the fabric fund.[33] It was in this buoyant, technologically innovative society that the architectural mode that we call Gothic first appeared and flourished.

TEXTILE PRODUCTION: THE LOOM AND THE WATER MILL

The introduction of the horizontal loom in western Europe by the twelfth century revolutionized textile production.[34] This loom was mechanized with foot pedals, allowing the longitudinal warp threads to be raised in alternating rhythm by means of a heddle bar so that the weaver could pass the pick carrying the cross thread, or weft, through the divided strands. Amiens formed part of the cluster of textile-producing cities extending to the north through Flanders. Our city was particularly favored by the ease with which raw wool from England could be transported by water up the Somme, or overland from the nearby Channel port of Boulogne-sur-Mer. By the eleventh and twelfth centuries, increasing numbers of mills powered by the canalized waters of the Somme were constructed to the north of the city beyond the Roman wall. With the application of industrial techniques—and the development of a professional urban class of specialized textile workers (wool sorters, beaters, combers, carders, warp and weft spinners, weavers, fullers, and dyers)—the quality and quantity of locally produced woolen cloth (known as *mensa* or *miensa*) improved greatly; and by the twelfth century it was making its way to markets in Italy.[35] It has been suggested that the same mentality that lies behind the increasingly mechanized production of woolen cloth was applied to the rationalized production of stones, facilitating rapid construction of the Gothic cathedral.[36]

THE COMMUNE: FORMATION OF URBAN IDENTITY; CONTROL OF URBAN SPACE

Growing numbers of city dwellers or bourgeois who were engaged in industrial or commercial activities, the relative absence of external threats, and royal interest in binding townsfolk in allegiance to the crown to offset the power of local *seigneurs*—these are the circumstances that led to the formation of communes in the north in the decades around 1100.[37] The communal movement was driven by the desire of the bourgeois for some level of control over urban jurisdiction: by substituting elected magistrates for appointed ones, they weakened the restrictive power of the local secular seigneur. The establishment of a commune has sometimes been described as a "feudal mutation"—instead of swearing allegiance to a local lord, citizens now under the protection of the king of France, as distant suzerain, would swear an oath of mutual defense, taking responsibility for low justice in the city and for making an annual payment (*taille*) that could be used for purposes of defense. Such aspirations were often opposed by the established secular authorities: in early twelfth-century Amiens, Count Enguerrand I de Coucy was supported both by his castle keeper or *châtelain*, Adam—who held the castle that had been built on the foundations of the old amphitheater to the southwest of the city—and by his own son, Thomas de Marle, Lord of Coucy, infamous for his gratuitous acts of cruelty.[38] The bourgeois were, on the other hand, supported by Bishop Geoffroy d'Amiens, along with his secular representative or *vidame*, Guermond de Picquigny; and by King Louis VI.[39] In the violent conflict that ensued (1113–14), the count at first gained the upper hand and his son laid waste to the rural possessions of the bishop. In 1115, on Palm Sunday, the king arrived in Amiens with a contingent of troops, only to be driven back initially. After two years of siege, the castle finally fell and was entirely demolished. Count Enguerrand I died soon afterward and the new countess, Adèle de Vermandois, recognized the commune in a charter that no longer survives.[40] With the lack of male heirs, King Philip II (Philip Augustus) was able to displace the husband of the last countess: the county then reverted to the crown in perpetual union (1190).

In this way, the western parts of the city that had previously been controlled by the count and his castle keeper fell under the control of the

commune, whose authority—confirmed in a royal charter of 1185—was expressed by the presence of a great tower or *beffroi*.[41] The commune was governed by a mayor and twenty-four aldermen (*échevins*): in its early years these positions were generally held by members of a limited number of patrician urban families who had held office either under the bishop or under the count (the families of de Coquerel, de Croy, de La Croix, de Saint-Fuscien, du Gard, Le Moine, Le Monnier, Le Roux, Le Sec, and Le Tonloyer).[42] The power structure of this old urban elite was challenged in the decades around 1200, as new families who had made their wealth from industrial production and marketing, especially woad and textiles, began to find representation among the aldermen and in the cathedral chapter. Twenty-four corporations, known by their insignia as *bannières*, each elected a representative who would participate in the election of a new mayor each year. These corporations were dominated by the woad merchants and tavern keepers. Food production had six bannières, textile production five, and leather and fur four, while metallurgy (blacksmithing) and the building industry had only three.

While the commune was seated in the west of the city, the clergy dominated the east. The cathedral chapter held the area of the cloister and the cathedral itself, together with its immediate surroundings: as we have seen, it also possessed lucrative rights in the northern industrial sector (fig. 1.6). The bishop controlled both a small pocket of land to the north of the cathedral extending up to and just beyond the Somme, as well as the eastern suburb known as le Riquebourg. Episcopal estates, however, extended far into the countryside to the southeast of Amiens—much of the wealth for cathedral construction came from outside the city.

Both clergy and citizens benefited from the rapid development of the area north of the old Roman city where the waters of the Somme, diverted into numerous fast-moving channels, drove the mills that powered the mechanized production of woolen textiles. The chapter, as lord of the waterways (*seigneur des eaux*), exercised control over the system of canals and possessed twelve mills conferred by Bishop Guy de Ponthieu. Twelfth-century development of quays to exploit navigation on the Somme generally involved agreements between members of the bourgeois elite and the chapter. In the 1180s and 1190s, during the struggle between Philip Augustus and his

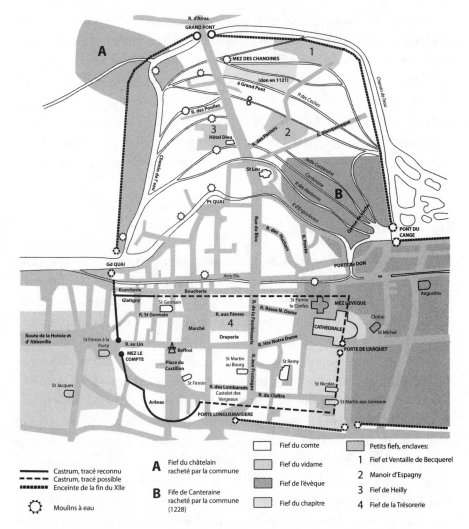

FIGURE 1.6 Distribution of power in the medieval city (from Massiet du Biest, reworked by Emogene Cataldo). The small circles indicate water mills. See also color plate.

Plantagenet rivals, this northern suburb of Saint-Leu was enclosed in a new wall extending far beyond the old Roman fortifications. The new wall was protected on its east side by the great northern loop (*chemin de l'eau*) of the Somme, involving a substantial reworking of the river channel with dredging and newly consolidated banks, presumably involving the participation of the chapter.

The historical significance of the decades leading up to and directly following the year 1200 was enormous for the people of Amiens. Under the old regime, their dependence on the two principal seigneurs of the city—bishop and count—was expressed in the payment of a *cens*, or feudal due. While the bishop continued to receive an annual payment of four deniers known as the Respite of Saint Firmin, payments to the count obviously ceased, and it appears that by the early thirteenth century those payments were being received by the commune, which was taking an increasingly powerful role in the internal affairs of the city.[43]

THE FORMATION OF FRANCE

Demographic boom, industrial revolution, communal emancipation, and emerging urban institutional identity—transformative indeed! But even more dramatic in the decades preceding the start of construction of the Gothic cathedral was the definitive emergence of the geographic and cultural entity that we call France.

With the marriage of King Philip Augustus and Isabella of Hainault in 1180, the area surrounding and to the north of Amiens—the Artois—passed to the king as dowry, confirmed in subsequent treaties.[44] On the death of Isabella, King Philip Augustus married a second time: to Ingeborg of Denmark. The wedding took place in the cathedral of Amiens on August 15, 1193: this earlier church had been rebuilt in the mid-twelfth century, but was to burn at a date generally said to be 1218, making way for the present cathedral. The acquisition of this critical province to the northeast of Paris was the first of a series of dramatic extensions of the royal domain under direct Capetian control.[45]

The emergence of France as a nation unified under a Catholic monarch takes on the air of inevitability, but in the last decades of the twelfth century the triumph of King Philip Augustus, the Capetian monarch, over his Plantagenet rivals was far from certain—and there were also dangers from the German Empire, from resurgent Islam in Spain, and from disaffected magnates like the counts of Champagne and Toulouse.[46] Events turned in a remarkable way in 1204, however, with the fall of Château Gaillard—the key castle built by King Richard of England to defend lower Normandy—and the subsequent capitulation of Rouen and French conquest of Normandy.

A second event in 1204 marked a critical point in the life of the cathedral. In this year crusaders dominated by Frankish forces seized Constantinople, and Amiens Cathedral was the recipient of one of the notable relics pillaged from that city—the head of John the Baptist. On December 17, Walon de Sarton, canon of the nearby collegiate church of Picquigny, and relative of members of the cathedral chapter, presented the precious relic to Richard de Gerberoy, bishop of Amiens—it became the center of a flourishing pilgrimage cult.[47]

The decisive military victory of the French over their rivals, the English and Germans, took place in 1214 just to the northeast of Amiens in the Battle of Bouvines, near Lille.[48] French urban militias belonging to northern cities played a crucial role in the battle, and Amiens received its rewards after the victory, which was celebrated in a triumphal procession from the battlefield to Paris.

After this stunning victory, Philip Augustus moved to invade England— the expedition of 1215–16 was led by Prince Louis, Philip's son by Isabella of Hainault.[49] Because of its location controlling river navigation to the English Channel, Amiens must have played an important role in staging the invasion: the port of Boulogne was one of several points of embarkation for the French fleet, which numbered more than 800 vessels. The people of Amiens might remember Prince Louis's local roots (his mother was from the area directly to the north). It is significant that the writers of the inscription in the commemorative plaque at the center of the labyrinth associated "their" king Louis VIII with the start of work in 1220—despite the fact that young Louis, the future Louis VIII of France, did not succeed his father Philip Augustus until 1223.

Would medieval people have drawn a connection between the emergence of Amiens as the most important center of royal power in the north and the construction of the Gothic cathedral? Dieter Kimpel and Robert Suckale have remarked on the coincidence in time and space of the territorial unity we call France with the spread of relatively similar Gothic cathedrals and abbey churches, suggesting that architectural production might have been a tool of the monarch in the construction of the consolidated territory of a nation.[50] It is hard to find clear documentation for royal sponsorship of cathedral construction, yet the presence of the king is certainly embodied most emphatically in the forms and spaces of Amiens Cathedral, where a

prominent gallery of kings was placed upon the western frontispiece, matching that of Notre-Dame of Paris; where the canons' stalls featured a magnificent seat for the king or his representative; and where images of kings proliferated both in the stained glass and in sculptural representations.[51]

iv) Monument and Contexts

Gothic architecture has been seen as the expression of a variety of forces or movements, both positive and negative: the unifying power of the Capetian monarchy, the growth and institutional transformation of cities, the presence of new urban professional classes, the rationalization of production that lay behind the booming textile industry, the power and wealth of the clergy, growing cultural unity. It has also been seen as a sign of the clergy's potentially oppressive control of the means of production and circulation of goods—especially agrarian production and river navigation. It has been claimed (by Robert Lopez) that the massive economic effort of cathedral construction might cripple a city like Beauvais or Amiens.[52] It is certainly true that such communes were running into acute fiscal problems by the middle decades of the thirteenth century, and that anticlerical incidents took place in and around Amiens—in 1258, for example, a fire broke out in the scaffolding in the upper choir, and members of the bourgeois were implicated in arson. Yet in Amiens the clergy had generally enjoyed, as far as we know, good relationships with the townsfolk, and the expenditure of massive amounts of cash inside city walls can only have helped provide employment; while the towering bulk of the cathedral, dominating the urban landscape, was surely a powerful stimulus for feelings of local pride and identity.[53]

We might also consider the role of the great cathedral in expressing or imposing Catholic unity at a time when that unity was challenged by groups of Christians who held radically different views on the role of the sacraments, the priesthood, and the Trinity. Among these groups were the Cathars, Bogomils, Albigensians, and Waldensians. Early work of construction at Amiens Cathedral coincided with the military campaigns known as the Albigensian Crusade and with the growing presence of various heretical groups in the burgeoning populations of textile-producing cities: followers of the Waldensian sect are documented in Strasbourg and Metz in the

twelfth century, and their preachers are known to have come as far north as nearby Reims and Liège.[54]

Rather than simply viewing the construction of Amiens Cathedral as a sign of consensus or oppression, we might instead consider the economic impact this enormous project had on the relations between clergy and townsfolk. In this context, there is another dimension, rarely considered: the need to ensure a reliable and continuing flow of cash to meet payroll could well have led the clergy to avoid conflicts and to liberalize relations with townsfolk and country rustici on episcopal rural estates. Indeed, in 1226, only six years after construction had begun on the cathedral at Amiens, the annual tax known as the Respite of Saint Firmin levied on members of the commune was reduced from four to three pence.[55] Shortly thereafter, in 1228, Bishop Geoffroy d'Eu—in return for an annual cash payment— ceded to the commune all episcopal claims to rights of justice in the rue de Nouvelle-Canteraine, a road situated to the southeast of the new industrial neighborhood of Saint-Leu.[56]

b) The Visible Present

i) Approaching the Cathedral

Having provided a sketch of vanished circumstances of the past that attended the construction of the Gothic cathedral of Amiens, it is time now to address what we can actually see today—the monument itself. [57] John Ruskin wanted to take us up the slope to the citadel, to the northwest of the city, in order to gain the best view (figs. 0.1–2). Jean Pagès wanted to start the visit atop the city rampart. Today, the 104-meter Tour Perret (constructed 1950–1952) offers a sweeping view over an urban landscape dominated, much as it was in the Middle Ages, by the cathedral (fig. 1.7). Looking down from our lofty perch, we can grasp the entirety of this colossal building, which almost appears as a fragile model of itself.[58] We see the southeastern end of the cathedral, which is formed of a long boatlike mass aligned roughly east-west and intersected by a crossarm or transept. The central spire marking the middle of the church carries the relics of the local saints high above the Picard plain (seen in the background). The cathedral's western towers, partly visible here, are modest in height relative to the body of the cathedral. The choir,

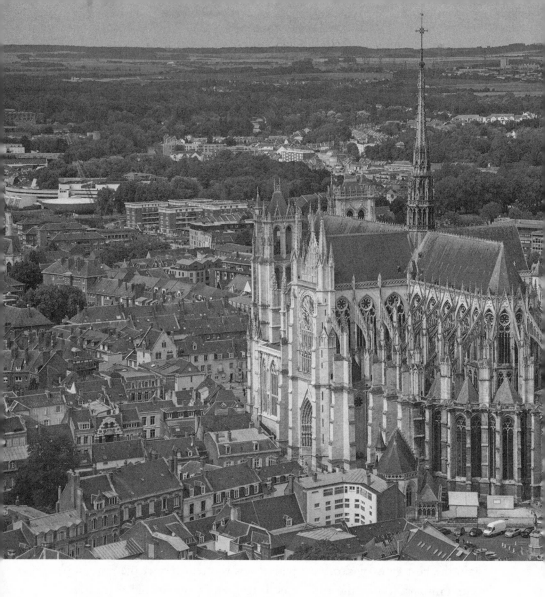

which projects toward us, terminates with a hemicycle ringed by a lower corridor, or ambulatory, opening onto a crown of seven radiating chapels. Whereas earlier cathedrals (Laon, Reims, Chartres) often have deeply projecting transept arms and multiple towers at the outer edges of the cruciform plan, Amiens Cathedral lacks transept towers, and its bulk looks streamlined in relation to these older cathedrals.[59] Before we descend from our vantage point in the Tour Perret, note the clump of trees to the right marking the garden of the former episcopal palace. The waters of the Somme, invisible here, run from right to left, out of sight just beyond the trees.

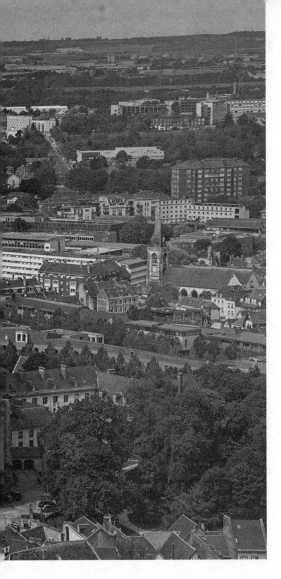

FIGURE 1.7 View from the *Tour Perret*, 104m high. The tip of the cathedral steeple is 112m. See also color plate.

John Ruskin would have been horrified at the Tour Perret—though he might have climbed that other tower dominating the urban landscape, the massive *Beffroi*, the expression of the identity and authority of the commune.[60] A photograph taken from the top of the Belfry in the middle decades of the nineteenth century represents the city and cathedral as Ruskin would have seen them (fig. 1.8). At our feet, we see the narrow and irregular streets of the city flanked by houses of three, four, or five stories. These houses range in date from the late medieval period to the eighteenth and nineteenth centuries; the cathedral, seen from the southwest, rises

high above the rooftops. Note the steepness of the cathedral's silhouette: along the south or right-side flank, we can appreciate the sheer verticality of the buttresses that rise to launch the (here invisible) flying buttresses. A line of chapels, added in the fourteenth century, projects out from the flank of the lower nave. The western frontispiece, facing toward us, is organized in three vertical slices, each with a deep, gabled portal: the middle portal opens into the central vessel of the nave, while the two lateral portals give on to the side aisles. The middle level is occupied by two horizontal galleries; the top of the central vessel is crowned by a rose window illuminating the upper nave, while the lateral segments rise into modest towers.

A second ascent into the Belfry a century and a half later reveals the extent of the calamities that struck Amiens in the twentieth century (fig. 1.9). Apart from the cathedral and the seventeenth-century bishop's palace to the north (left) side of the cathedral, almost nothing of the old city can be seen—the result of bombardments during the First World War, and a devastating conflagration in the Second.

Ruskin loved views of the cathedral as seen from the banks of the Somme—he was fascinated by the waterways of Amiens, "the Venice of France." Today, such unspoiled views are hard to find. Seen from downstream, the silhouette of the cathedral gets muddled with the Tour Perret, while from upstream our view is partly obstructed by a recently constructed tall apartment building, here hidden behind the trees (fig. 1.10).

It is from the north that the most satisfying distant views of the cathedral may be enjoyed—across what used to be the flood plain of the Somme (now the parc Saint-Pierre, fig. 1.11); or on the right bank of the Somme, the quai Belu in the quartier Saint-Leu (fig. 1.12). From this position the long mass of the cathedral looks like a boat with flying buttresses as oars. That mass is broken by the transept, and the north transept façade facing us

FIGURE 1.8 View from the *Beffroi*, c. 1850 (old slide from the Columbia University Department of Art History and Archaeology collection).

FIGURE 1.9 The same view, c. 2015

FIGURE 1.10 View of the cathedral from the bank of the river Somme, upstream. See also color plate.

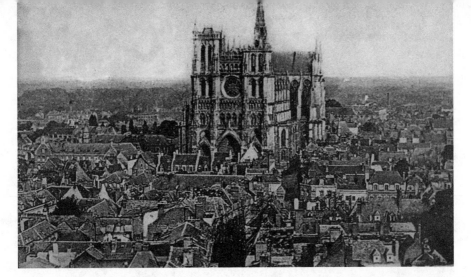

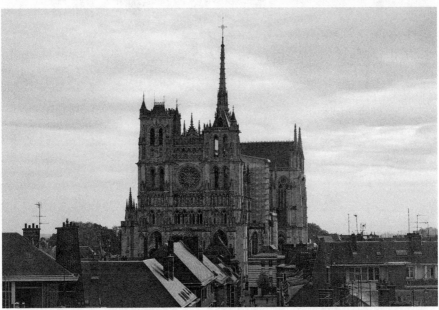

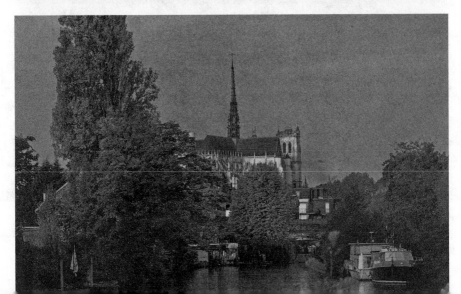

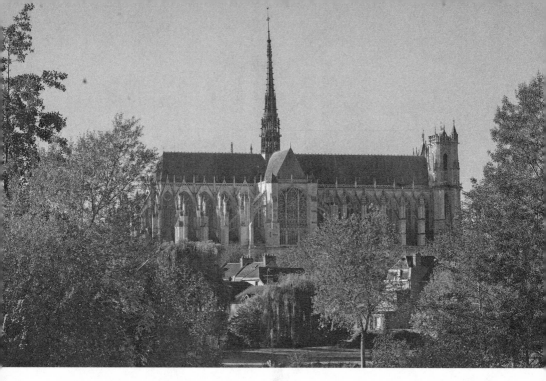

FIGURE 1.11 Cathedral from the north, Parc S-Pierre

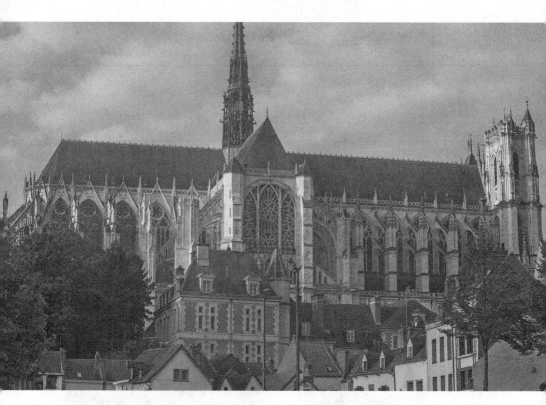

FIGURE 1.12 Cathedral from the north, *Quai Bélu*. The bishop's palace is the brick-and-stone structure in front of the north transept. The saw-toothed houses in front are of the type inhabited by medieval laypeople and artisans. See also color plate.

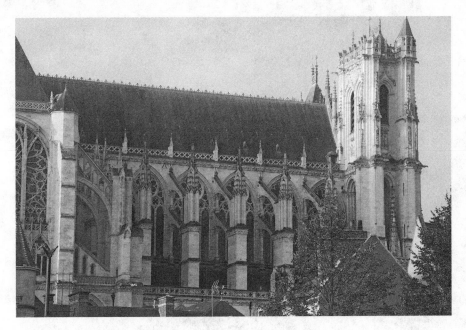

FIGURE 1.13 Upper nave from the north

is dominated by a huge rose window. The curious little buttresses within the window bear witness to chronic structural problems in this area: the builders felt it necessary to prop up the upper rim of the rose.[61] The transept gable is of wood rather than stone in order to eliminate excessive weight. At first sight, the transept appears to divide the length of the cathedral into two unequal parts: the nave to our right seems much longer than the choir to the left. We must remember, however, that from this distance we can see only the cathedral superstructure: the lower parts are hidden by the surrounding buildings and trees. If we consider the entire plan and include eastern ambulatory and chapels, the division between nave and choir comes at exactly the halfway point (fig. 1.19).

Now zoom in (using the website) and look more closely at the forms of the upper choir and nave. In what ways are they different? The upper wall of the nave (fig. 1.13) is capped by a horizontal balustrade, and the substantial double-rank flyers spring from massive rectangular uprights or *culées*. In the choir, on the other hand (fig. 1.14), the upper wall is broken by jagged gables and the flyers embody openwork panels or tracery—the same forms that were developed in order to support the

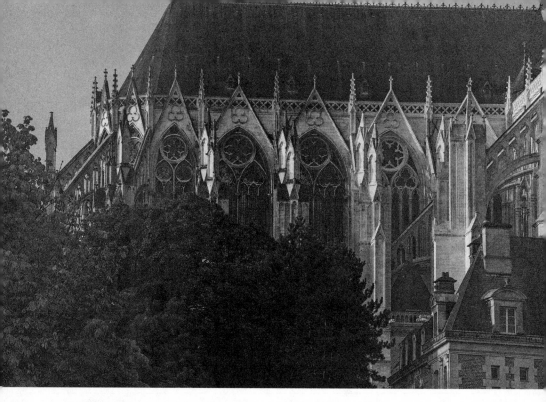

FIGURE 1.14 Upper choir from the north

stained glass of the great windows. The gables, pinnacles, and openwork flyers tend to fragment the exterior mass of the choir. What do these signs of change mean? Were the more elaborate forms of the choir intended to celebrate the presence of the clergy while laypeople were assigned a less exalted space in the nave? Or do these differences mark the passing of time and the hands of two different architects or master masons? These are questions that will confront us repeatedly as we approach and enter the cathedral. When in chapter 4 we come to consider the identity of the master masons and the contribution of each, we will see that the upper nave was probably the work of Thomas de Cormont in the 1230s, while the upper choir was certainly done by his son Renaud de Cormont in the 1250s and 1260s.

The corresponding view from the south side is less satisfying: we are blocked by nineteenth- and twentieth-century structures that have replaced the canons' houses of the cloister (fig 1.15). Again, we note the differences between nave and choir and the much more delicately articulated forms of

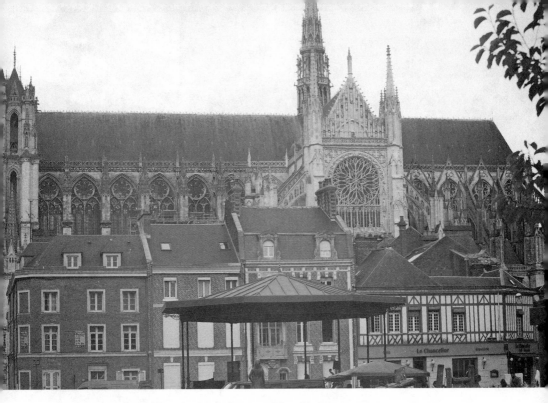

FIGURE 1.15 Cathedral from the south, the area of the old cloister

the upper south transept, which appears to belong to a much later date: chronic structural problems in this area led to repeated rebuilding and culminated in the installation of the rose window in the years around 1500. Particularly striking, from this viewpoint, is the limited height and very shallow east-west depth of the western towers.

Now let us circle the exterior flanks of the cathedral before finally making our entrance at the west portal. First, we take a position to the north of the nave (fig. 1.16)—a view that would have been impossible in the Middle Ages owing to the existence on the site of the now-demolished collegiate church of Saint-Firmin the Confessor. We see the continuous screen of chapels— six of them—along the lower flank of the nave (figs. 1.17–18), while above them the great rectangular buttress uprights ascend to support the flyers of the great windows that illuminate the upper nave—the *clerestory*. Here, the student might engage in some detective work, taking a clue from the form of the decorative stonework, or *tracery*, set in each window. How many different types of tracery pattern can you distinguish? The simplest pattern

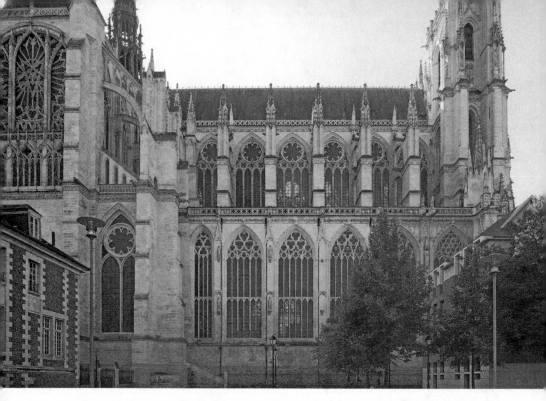

FIGURE 1.16 North flank of the nave and transept.

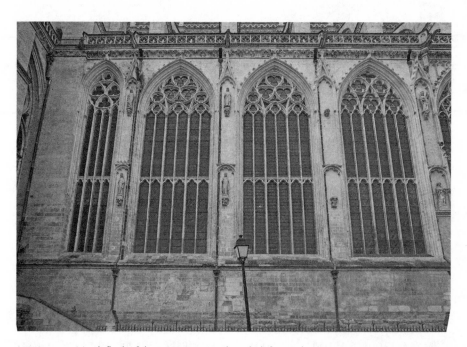

FIGURE 1.17 North flank of the nave, eastern chapels, left to right: Saint Agnes, Saint Louis, Saint Honoré, Saint Michael

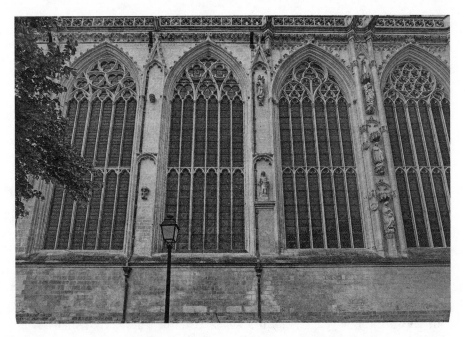

FIGURE 1.18 North flank of the nave, western chapels, left to right: Saint Honoré, Saint Michael, Saint John the Evangelist, Saint John the Baptist

is in the window on the lower left in fig. 1.16, in the west aisle of the north transept. At the top of the window, enclosed inside a steeply pointed arch, is a great circle—or *oculus*—containing eight little petals or *cusps*.[62] Below the oculus are two vertical panels, or *lancets*, each capped by a pointed arch. This design belongs to the first generation of window tracery of the type deployed in the choir at Reims Cathedral around 1210 (fig. 4.6). Note that the Amiens window occupies the entire space between two buttresses— there is no flanking wall.

Now look up at the six clerestory windows in the upper nave—the great eight-cusped oculi are similar, but instead of two lancets, we now have four, grouped in two pairs, each capped by four-lobed units or *quatrefoils*. Exactly the same pattern is used each of the six clerestory windows. Now look down at the nave chapels. Although they are on the same level as the simple window to the left, they are much more complex, with different clumps of lancets and fascinating speculations on quatrefoils and trefoils. A horizontal band, or *transom*, cuts across each window at midheight—is this a reference to English *Perpendicular* church architecture? And closer

English gothic →

inspection reveals that the patterns of the window tracery window change toward the west (fig. 1.18: right side)—half-hidden in the trees we see complex double-curved forms in the tracery. This is one of the first (c. 1375) appearances of such *Flamboyant* tracery in France. In the north transept, the tracery of the great rose window, with its five-pointed star, also clearly belongs to the more complex type found in the eastern nave chapels.

What are we to make of all this? Two conclusions may be drawn, both vital for the understanding of Gothic. First, although the builders were able (if they wished) to repeatedly reproduce an identical form with mechanical precision, they were also ready to introduce variety, to undertake critical review of their work, and to make modifications as they progressed. The design of the upper nave windows is clearly later than the simple one of the first window we described, which must have been deemed old-fashioned. Such differences result from critical choices made by the builders— in some cases, we can even associate them with different master masons.[63] But why are the nave chapel windows so ornate? They look to have been designed later than the clerestory. The student-turned-detective may deduce that this is because the chapels were added in a sequence running from east to west—a process that began around 1290 and continued until around 1400 (fig. 1.19–20).

Originally, the rectangular mass of the great buttresses carrying the flyers continued all the way down to the ground, creating exterior spatial pockets and a wonderfully broken or fragmented appearance: set between them were aisle windows of the simple type found to the left. All this is masked by the smooth exterior periphery of the new chapels.

Before we move on, zoom in on the flying buttresses visible at the western end of the nave: they are composed of two solid arched struts. Now look at the comparable flyer against the west side of the north transept—it is made up of openwork panels, much like the lancets we have seen in the window tracery. A structural unit composed of nonstructural elements: Is this acceptable?[64] As we continue our exploration of the cathedral, we will encounter multiple signs of an architectural revolution in the forms of the upper transept and upper choir.

Continuing our clockwise perambulation around the flanks of the cathedral, we pass in front of the north transept with its beautifully austere portal (fig. 1.21). In the central column or *trumeau* stands a bishop generally

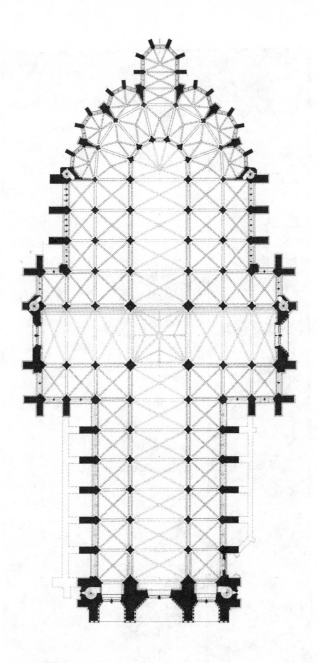

FIGURE 1.19 Plan of the cathedral as originally built (James Addiss and Stephen Murray)

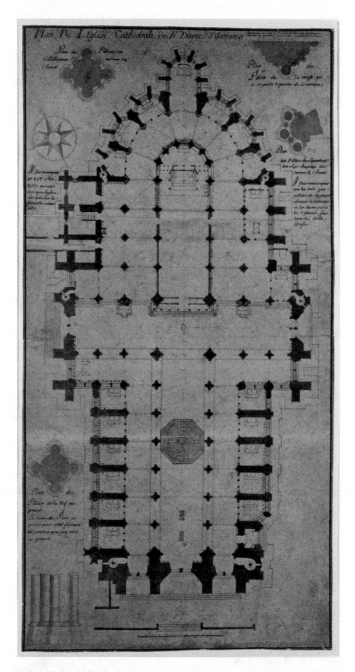

FIGURE 1.20 Plan of the cathedral with nave chapels added in the fourteenth century (Collections du Musée de Picardie, Amiens, Anonyme, France vers 1727. Plan de l'église Cathédrale de Notre Dame d'Amiens, plume et lavis sur papier, collection du Musée de Picardie, Amiens no inv: M.P.2072-18, photo Ludovic Leleu/Musée de Picardie)

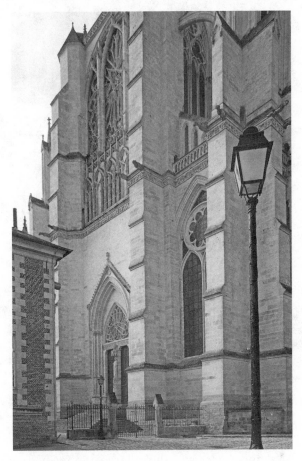

FIGURE 1.21 North transept façade. Bishop's palace to the left

thought to represent Saint Honoré—the figure may have been originally intended for the south transept portal. It is clear that the north portal had remained unfinished, without a *tympanum*—the glazed composition inscribed inside a spherical triangle was only installed around 1300.[65]

And now we have passed between the north transept and the seventeenth-century episcopal palace and reached the choir (fig. 1.22). Originally, the bishop could walk directly from his palace by means of an elevated passage or gallery leading to a door, now blocked, in the western bay of the north choir aisle. In the outer wall of the choir aisle the deep projection of the flat-sided buttresses continues all the way to the ground, just like the original disposition of the nave before the addition of the chapels. The choir

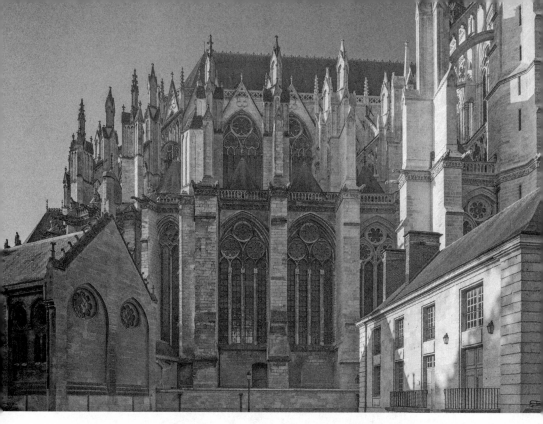

FIGURE 1.22 Chevet, north flank. Bishop's palace to the right, winter chapel to the left. See also color plate.

has double aisles, and the bays of the outer aisle already functioned partly as chapel spaces. The aisle windows are divided into four lancets, like those of the upper nave. But the process of critical choice and modification has continued—the designer has introduced three oculi of similar size, embellishing each with six cusps—the central oculus of the older aisle windows in the nave must have been considered much too large. The enclosing arches of the choir aisle windows are less steeply pointed than in the original aisle window we saw in the north transept. The stones that make up the three oculi merge with the enclosing frame. Minor changes, it might be said—but now look up. Above the level of the aisle roof the simple flat-sided buttresses explode into fragmented, cruciform shapes as they launch openwork flyers at a clerestory now crowned with steep linear gables. And just look at the tracery of the choir clerestory! It still retains the great central oculus, but the designers have indulged a passion for the number three. The cusping of

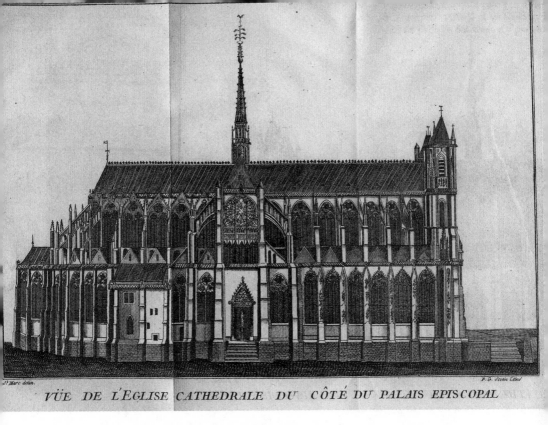

VÜE DE L'EGLISE CATHEDRALE DU CÔTÉ DU PALAIS EPISCOPAL

FIGURE 1.23 Engraving (18th c.) of the cathedral from the north (Louis-François Daire, *Histoire de la ville d'Amiens*, Amiens, Bibliothèque municipale Louis Aragon)

the great oculus has become trilobed, and there are now six lancets clumped in two groups of three and capped by cusped trefoils.

Whereas in the lower nave we saw that additions had been made—the chapels—here in the lower choir, there are signs that something has been removed (fig. 1.22). This was the two-story sacristy/treasury complex that once housed the upstairs chapel of John the Baptist, demolished in the eighteenth century because it had blocked the light from entering the north choir aisle—the walled-up doors once opened into this structure (fig. 1.23). Double-story sacristy/treasury complexes built contemporaneously with the cathedral may still be found at the cathedrals of Sens, Troyes, and Beauvais.

And now, skirting the winter chapel built by Eugène-Emmanuel Viollet-le-Duc in the 1850s, we will continue on around the radiating chapels of the east end (fig. 1.24). There are seven polygonal chapels grouped around the encircling ambulatory. One's first impression is of a bewildering succession

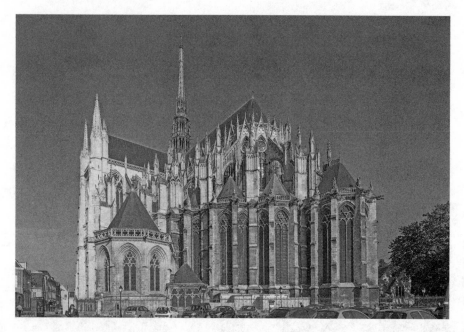

FIGURE 1.24 Chevet and south transept from the south east. On the left, the *Chapelle des Macchabées*, thought to have been the chapter house and part of the *Gallerie des Macchabées* rebuilt by Viollet-le-Duc

of angled surfaces: delicate buttresses with little weather moldings applied to their front surfaces, and tall windows occupying the entire space between the buttresses, all giving the impression of a multifaceted jewel. The delicacy of the composition is enhanced by the repeated forms of the stacked trefoils in the window tracery. The axial chapel—dedicated to the Virgin Mary and known as Notre-Dame de la Drapière—is deeper than the others, which are affiliated, for the most part, with local saints.

The delicate polygonal three-sided chapels with little buttresses at the angles are divided by great buttresses that ascend to project the flyers against the clerestory. Those flyers all point emphatically toward the upper hemicycle—in other words, the forms and surfaces of this complex composition are all generated from a single center: multiplicity from unity. The multiplicity and delicacy of the forms we have seen in the choir chapels become even more intense above the level of the roofs, where the buttresses supporting the flyers take on complex shapes and the steep gables over the clerestory windows create a jagged silhouette.

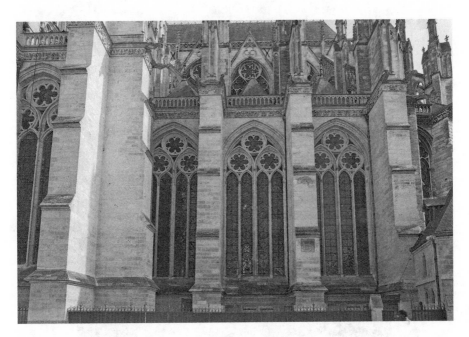

FIGURE 1.25 Chevet, south flank

As we complete our circle around the exterior of the choir we skirt a structure with a trapezoidal east end now serving as a sacristy, but originally built as the chapter house (fig. 1.24). It was linked with an arcaded gallery that encircled the former cemetery to the east of the chevet. Since this gallery was decorated with images of the *danse macabre*, the chapter house—no longer used after the Revolution—became known as the chapelle des Macchabées.[66] The south flank of the choir is very similar to the north, though no ancillary buildings ever existed here (fig. 1.25). In the Middle Ages the enclosing wall of the masons' yard extended around a court located just outside the south flank of the choir. At the center of the court was a well, the *puits de l'oeuvre*, still visible.

The south transept façade now offers itself directly to our gaze (fig. 1.26)—though this was not the case in the Middle Ages, when the street on the axis of the façade was narrow and crooked; the existing wide street was pierced only in the nineteenth century. The center of attention in the south transept is the sumptuously decorated portal known both as the Portal of Saint Honoré, whose story is told in the tympanum, and also as the Portal of the Golden Virgin (le portail de la Vierge dorée), who stands in the central trumeau.[67]

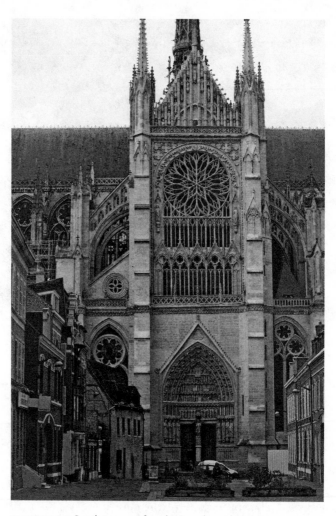

FIGURE 1.26 South transept façade. See also color plate.

The central segment of the lofty façade is defined by two great buttresses; to the left and right, windows open into the transept aisles. The left (west) window displays the same kind of simple tracery, with a great central oculus over two lancets as in the corresponding bay on the north side; while the right (east) window, less steeply pointed, has three small oculi. As we will see later, the upper transept façades, both this one and the one to the north, had chronic structural difficulties requiring multiple interventions (fig. 1.27).

The road that passes along the south flank of the cathedral, the rue du cloître Notre-Dame, follows the path of the Roman road leading to the city

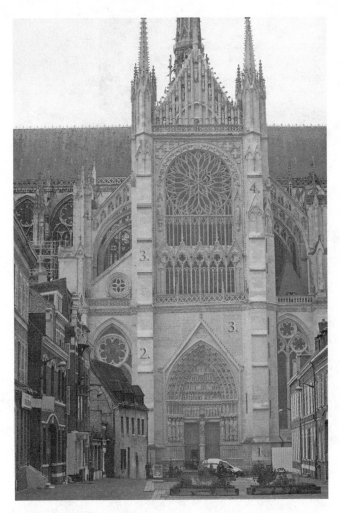

FIGURE 1.27 Chronology of the south transept façade
1. 1220s: Robert de Luzarches
2. 1220s–1230s: Robert of Luzarches and Thomas de Cormont
3. 1230s–1240s: Thomas de Cormont
4. 1240s–1270s: Renaud de Cormont,
5. c. 1500: Pierre Tarisel
See also color plate.

gate known in the Middle Ages as the porte de l'Arquet. The south side of this road was lined by houses occupied by the cathedral clergy or canons. The existing road is narrow, and we have to crane our necks to see the screen of chapels added to the south flank of the nave between circa 1290 and circa 1400, much like the ones on the north side (figs. 1.28–30). And again, we

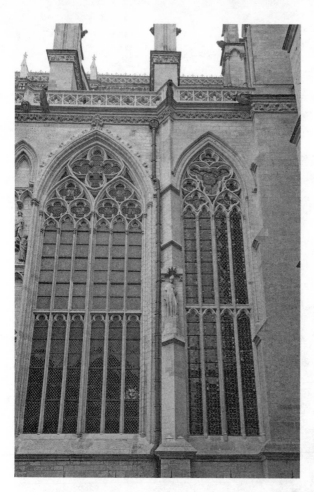

FIGURE 1.28 South flank of the nave: eastern chapels: right-to-left, Saint Margaret, Saint Stephen

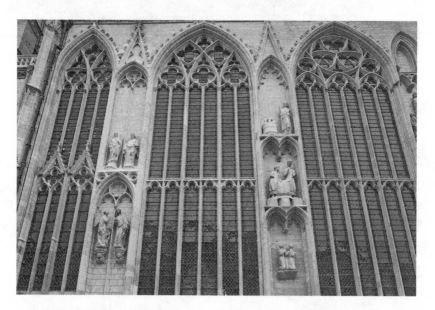

FIGURE 1.29 South flank of the nave: western chapels: right-to-left, Saint Nicholas, Annunciation and Saint Christopher

see modifications as we go to the west. The Chapel of Saint Nicholas, third from the transept, was financed by the merchants of blue dye from locally produced woad and served as a meeting place for their confraternity: we see a sculptured image of two woad makers with their sack, while the two kneeling figures express the pious intention of the chapel foundation (fig. 3.19).

Continuing westward, we pass the Chapel of Saint Christopher, patron saint of pilgrims—a large sculptured image of the saint has been mounted upon the west wall of the chapel, which has been angled inward to avoid encumbering the road (fig. 1.30). Finally, the last Chapel of Saint Lambert

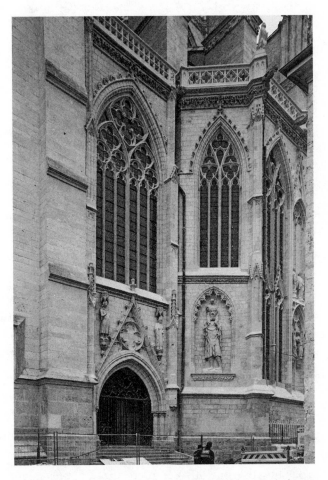

FIGURE 1.30 South flank of nave: west end with the portal of Saint Christopher and (above) the chapel of Saint Lambert. To the right, the chapel of Saint Christopher

FIGURE 1.31 South flank of the west façade

was built atop the vaulted porch leading to the small portal known as the portail Saint-Christophe, dating from the 1220s.[68]

Passing around the southern flank of the western frontispiece (fig. 1.31), we note that the western towers are very shallow in their east-west dimension; the plan of each tower is formed around a double square. The frontispiece (fig. 1.32) is best understood as the weaving together of emphatic verticals and horizontals. Four great verticals, the main buttresses, define the edges of three gabled porches, while two towers and three strong horizontals bind the composition together. The three horizontal elements are quite striking: at the top, under the rose window, stands a gallery of kings; in the middle nestles an arcaded passage corresponding to the interior triforium; and at the bottom, a line of fifty-five life-size statues of human figures parade across the front surfaces of the buttresses and the sides of the portals. Visitors approaching this line of solemn, idealized figures might think they were entering the company of the elect who, in bearing up the Church, enjoin them to enter.

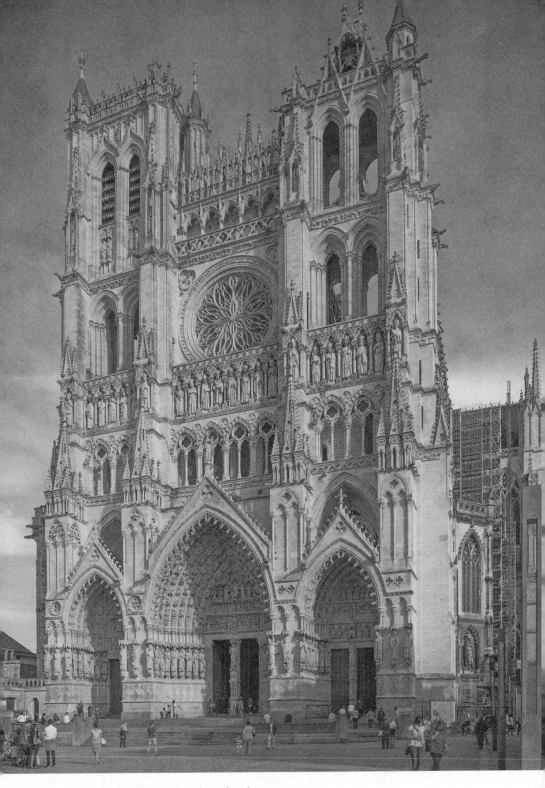

FIGURE 1.32 West façade. See also color plate.

ii) Passing Through

John Ruskin realized that different entrances to the cathedral will lead to very different experiences, and he chose to lead his imaginary companions through the south transept portal in an accelerated passage to the heart of the cathedral before then focusing upon the choir (fig. 0.4).[69] Making one's passage through the west portals at Amiens also affords a dramatic experience owing to the unique design of the western towers. Whereas in most Gothic cathedrals (including Chartres, Reims, and Notre-Dame of Paris) entrance through the west portal leads into a dark space encumbered with the massive supports of square western towers, here, at Amiens, the visitor passes under the tower directly into the brightly lit space of the nave (fig. 1.33). This triumphant entry results from the ingenious design of the

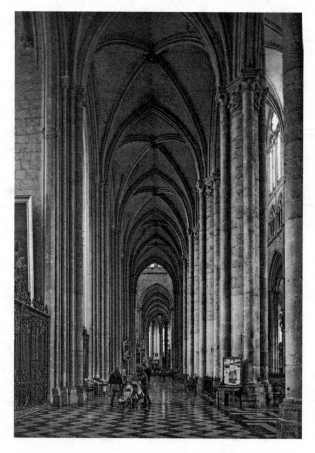

FIGURE 1.33 Nave north aisle, looking east

western frontispiece, which features compact, rectangular towers supported entirely by the substantial blocks of masonry between the portals.

Most visitors, both medieval and modern, would enter through one of the western side-portals—the central portal was reserved for the use of kings or bishops during special occasions or on feast days such as Easter. Postponing for the moment our exploration of the extensive sculptural program, let us proceed through the left portal of the west façade—the one dedicated to Saint Firmin and the local saints. We move forward to experience the compressive force of the portal, passing under the tunnel-like pointed vault that helps support the massive weight of the tower above (figs. 1.33–34). Once inside the portal we find ourselves in the spatial corridor of the aisle. Brightly lit and airy, it is defined to our right by the main supports of the nave arcade, and to our left by the line of flanking

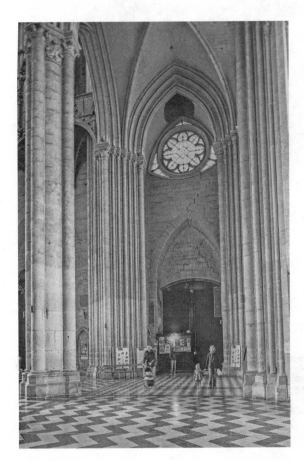

FIGURE 1.34 Interior of the north nave portal, looking west. Note the extensive cracking in the masonry above the portal

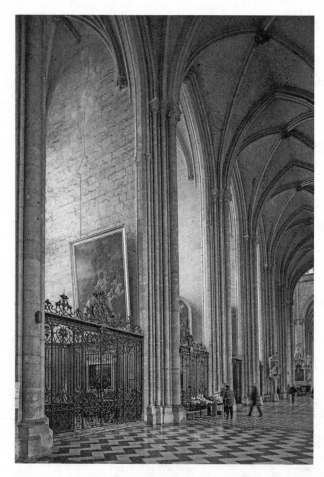

FIGURE 1.35 North nave aisle looking northeast. You can see the line of the old buttress before it was extended to create space for the chapel.

chapels (fig. 1.35). We have already ascertained from the exterior that these chapels were not part of the original construction: we may now imagine what was lost. In the original disposition, the spaces between the great exterior buttresses were entirely occupied by enormous windows glowing with stained glass.[70] Installed in the 1230s, the glass might have resembled that found in the nave aisles of Chartres Cathedral; in further parallel, it too was probably donated by the trade and professional groups of the city. The addition of the chapels necessitated the extension of the great buttresses (culées) forming the dividing walls between the chapels—we can

see the sutures between the original buttresses and the extensions and the exterior weather moldings of the buttresses. The result of the new spatial disposition was the distancing of the window from the viewer and a sharp reduction in the amount of light penetrating the aisle.

All along the lowest level of the original outer wall of the aisle ran a line of little trilobed arches (a blind arcade, or *dado*); the original arrangement is still visible in the choir aisles (fig. 1.50). Unencumbered by tombs, plaques, or shrines, this arcade, conceived in relation to the size of visitors, might have provided a rhythmic mechanism marking their passage forward. The spatial effect of the aisle bays with their steep verticality was originally *compressive*—the peripheral skin of the enormous aisle windows would simultaneously force the visitor's attention upward, to the square ribbed vaults, and inward, to where the arcade opens into the vertiginous central vessel.

The openings of the arcade are wide and the supports slender (fig. 1.36). Each support is formed of a central cylindrical core—like an extended column—with four slender shafts or *colonnettes* placed on the major axes: north, south, east, and west. This kind of support, known as a *pilier cantonné*, is found in several of the great Gothic cathedrals of the period, including Chartres, Reims, and Beauvais; but at Amiens the units are unusually elongated and slender in relation to the thickness of the arcade wall. The columnar core of the pier and the attached colonnettes form parts of a language of design derived ultimately from the classical orders of Antiquity—the same is true of the plinths and moldings that form the base, and the capitals that crown it. It is as if the cathedral remembers the glory of Greece and Rome, and has extracted the key architectural elements contributing to that glory. The cathedral fundamentally transforms these elements—taking them apart and sticking them back together in novel ways; extending them into impossibly attenuated vertical forms in order to create the new world of Gothic.

From our vantage point at the west end of the south aisle (fig. 1.36) we can already grasp the essential components of the architectural system of the cathedral nave. It is formed of two side aisles with square rib-vaulted bays flanking a main vessel, which in turn is made up of three levels: the arcade opening into the aisle, the middle triforium level, and a huge upper window or clerestory. To fully understand the triforium you have to climb up there—which we will do presently—suffice it to say at present that it occupies the space between the top of the arcade and the point where the

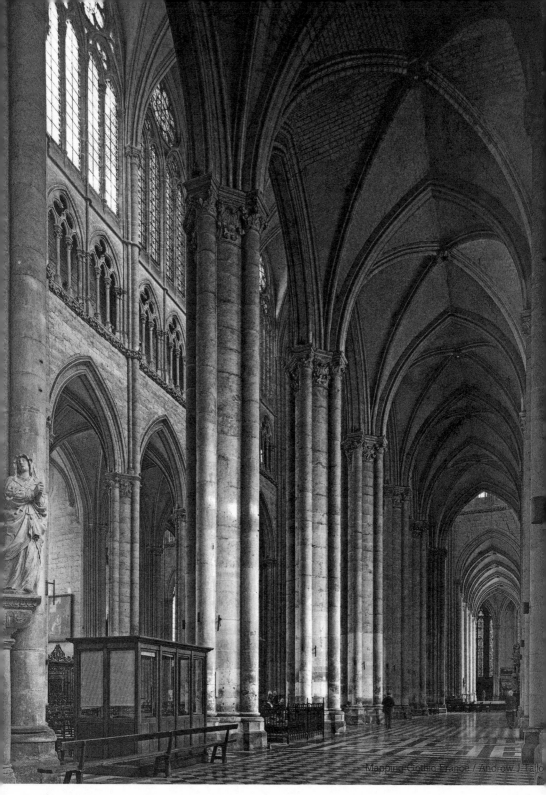

FIGURE 1.36 South nave aisle looking up into elevation of main vessel (Media Center for Art History, Andrew Tallon, photographer.). See also color plate.

lean-to roof of the aisle abuts the central vessel. Each bay of the triforium is divided into two groups of three lancets capped by a generous trefoil, which appears to be pierced through a continuous skin or plate of stone. Behind this lacy screen runs a dusky passage.[71] The upper elevation seems to dissolve into a spidery network of slender colonnettes linking the triforium with the clerestory. The division between the massive material world of the arcade and the fictive fantasy of the upper elevation is marked by a sumptuous foliate garland: the leaves and flowers provide an undying and festive reminder of the miraculous flowering that accompanied the invention of the relics of Saint Firmin. This band, at twenty-one meters above the pavement, marks the halfway point in the steep elevation (fig 1.37).

The design of the Amiens triforium must be considered one of the most brilliant manifestations of the work of the first two master masons,

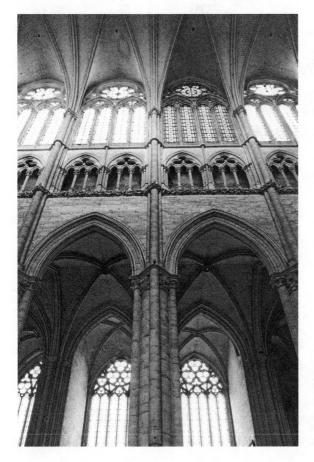

FIGURE 1.37 Nave elevation
(Media Center for Art History)

Robert de Luzarches and Thomas de Cormont. Eschewing the obvious models provided by the cathedrals of Soissons, Chartres, and Reims, with their emphatically horizontal triforia composed of a continuous band of little arches (figs. 4.7–8), our master masons have chosen to make visual reference to the galleries of older cathedrals such as Notre-Dame of Paris, Laon (fig. 4.4), and Noyon. Other structures of particular importance as prototypes were the abbey of Saint-Germain-des-Prés (Paris), Sens Cathedral, and, possibly, the former cathedral of Amiens.

Let us return to the cathedral right before us. The overall proportion of the main vessel of the nave is about three to one, with a total height of about 42.30 meters and a span of 14.60 meters. Looking upward we may compare the square vaults of the aisles with the double squares found in the main vessel (fig. 1.38). With the exception of the easternmost bay, the nave plan can

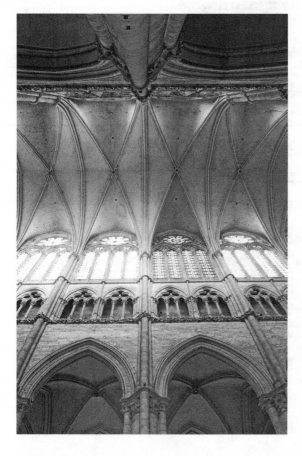

FIGURE 1.38 Nave vaults (Media Center for Art History)

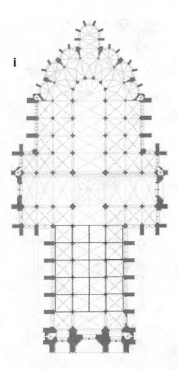

FIGURE 1.39 Nave plan: plotting the squares and double squares

be plotted as a grid of squares and double squares (fig. 1.39). The essential spatial concept of the cathedral may be understood as a cellular honeycomb composed of multiple rib-vaulted units that seem to hover on <u>walls of light</u>, even as they remain anchored to the ground by attenuated shafts.

A most intriguing dimension of the spatial experience of the cathedral is provided by the pavement.[72] The nave aisle bays are delineated by panels of black-and-white tile that approximate squares, matching the vaults. Within the panels we find various pattern types, including checkered and meander. The floor of the nave main vessel is dominated by the central labyrinth. The other panels contain various checkered and meander patterns that do not correspond to the bay divisions, and the decorative meanders invite our gaze to linger.[73] The centerpiece of the pavement—itself already a kind of maze—is the famous labyrinth with an octagonal plaque at the center commemorating the role of the founding bishop and the three master masons (fig. 1.40). A path delineated in black tiles invites us to enter the octagonal space, leading us directly to the middle but then insistently directing our steps

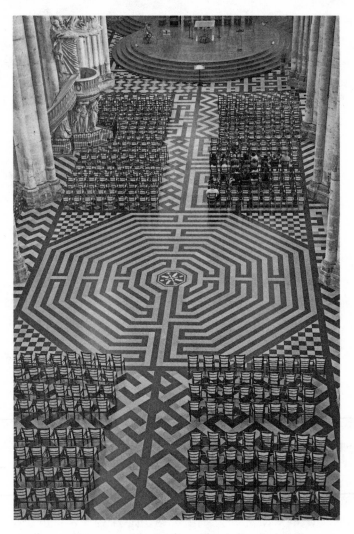

FIGURE 1.40 Nave pavement with the Labyrinth seen from the organ tribune

through its looping turns, ever outward and away from the object of desire at the center.[74] Modern visitors quickly sense a kind of intriguing conundrum or game; however, those familiar with classical mythology might be wary of the threat posed by the Minotaur residing at the center of the famous labyrinth constructed by Daedalus on the island of Crete. Those with the determination and patience to reach the center will find nothing more challenging than the task of unscrambling the meaning of the terse inscription

identifying the founding bishop (Évrard de Fouilloy) and the three master masons (Robert de Luzarches, and father and son Thomas and Renaud de Cormont).[75] In a larger sense, the thoughtful visitor may be led to reflect on the connections and contrasts between the writhing dark loops of the House of Daedalus and the self-evident clarity of the House of God.

Entry into the cathedral has brought the visitor into a new kind of reality—entirely different from the mundane world of the city. Most visitors are at a loss for words adequate to describe what they see, and many resort to figurative language: "it's *as if* I had entered into heaven. . . ."[76] The interlocutor would do well to leave the visitor in this rapt state awhile before intervening to focus the attention by providing nomenclature and interpretation.

While we may be able to grasp some understanding of the Gothic architectural system from a static position, to gain a deeper understanding of the genius of this particular cathedral we must move around and through it—collecting visual images and committing them to memory while doing so. The accumulation of memory images leads us to compare the parts already seen and remembered with new spaces yet to be seen, as *anticipation* of the hidden areas of the cathedral pulls us forward.[77] The discovery of the cathedral may thus be understood in terms of the dynamic perception of sameness and difference, as well as the search—entirely compulsive for some—for an overall governing matrix or plot embodying the idea entertained by the builders at the start of work.[78] Passage down the length of the nave leads the visitor through seven bays—five identical, and two (westernmost and easternmost) a little bigger. In each of the five identical units we find square-vaulted bays in the aisle and double squares in the main vessel (figs. 1.38–39). The vaults, all quadripartite ribbed units, have been *imprinted*: the carefully cut stones of the arches and ribs, and the small stones (known as *pendans*, or hanging stones) that compose the webs of the vaults, have been laid in place over wooden centers or formwork left in place while the mortar set. The formwork would be removed after a period of three months or so, allowing the vaults to appear to float free, to hang. The complex, curving shape of the vault has thus been imprinted or impressed. The idea of images printed or stamped upon the softened consciousness provided a common medieval metaphor for memory and knowledge.[79] It has been suggested that the pilgrim, suspended in a kind of liminal state, might be particularly susceptible to such powerful impressions.[80]

Sameness in other forms of the edifice, such as piers and window tracery, has been secured by means of the template—a rigid pattern made of a thin sheet of wood or metal used to guide the chisel in the serial cutting of the stones of any given unit—pier, window, or vault. The multiple elements of the cathedral are thus obedient to the now-unseen template and the wooden form. There are obvious parallels here with the sameness of the apostles lining the sides of the main portal, obedient to the template provided by the central image of Christ (figs. 2.29–30).

Having become accustomed to the elements of the architectural system repeated down the length of the nave, the forward-moving visitor will become aware of radical changes in the seventh bay and the area of the central crossing space.[81] The transformative mechanism works both horizontally and vertically. The last (easternmost) bay of the nave adjacent to the crossing is significantly wider than the others; this allows the visitor's gaze, previously framed by the tunnel-like length of the basilica, to extend laterally (horizontally) as the full extent of the transept arms and the outer walls of the choir are discovered (figs. 1.42–43). A closer look at the plan (fig. 1.39) reveals that a similarly enlarged bay exists on each of the four sides of the crossing. The bays of the cathedral open up toward the middle and contract toward the periphery—this is particularly evident in the transept arms. The space of the crossing with the added enlarged bay on each side forms a great central square of 110 local feet—I will demonstrate in chapter 4 that this central square provided the starting point for the dynamic geometry that governs the entire plan (fig. 4.12).

The *vertical* transformation of cathedral space is even more spectacular. Passage down the nave has led us to become accustomed to the dark middle level (triforium) of the elevation. Approaching the crossing area, however, we encounter a blaze of light admitted from a new feature—the glazed triforium—that first appears on the east side of the transept arms and continues into the chevet (figs. 1.42–44). [82]

The spatial drama of the crossing space would have been greatly enhanced by the presence of the original choir screen, or *pulpitum*, demolished in 1755 (fig. 1.45). We will look at this monument in more detail later, but in order to appreciate the impact that arrival *in medio ecclesiae* might have had upon the medieval visitor, consider the presence of this sumptuously arcaded screen with its black-and-white marble arcading and brightly

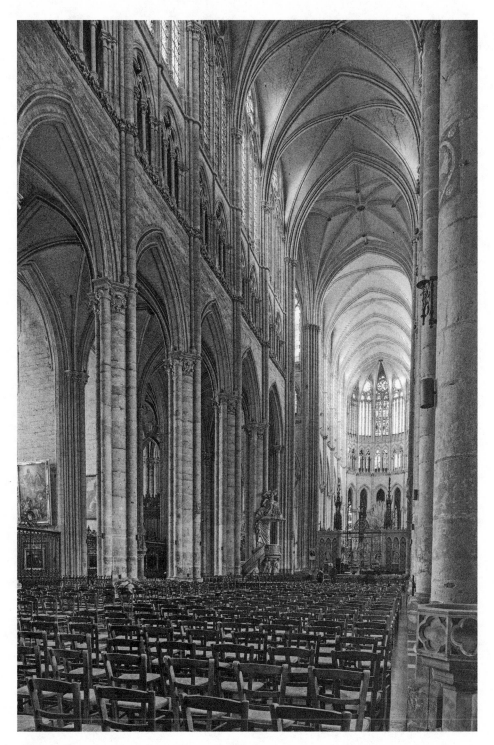
FIGURE 1.41 View down the nave

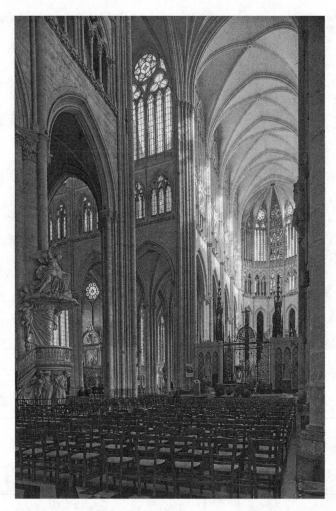

FIGURE 1.42 Enlarged easternmost bay: *In medio ecclesiae*

painted sequence of sculptured scenes from the Life and Passion of Christ with the Last Judgment in the center, glittering with gold leaf highlights.[83] Towering atop the screen, a great crucifix rose high above the pavement, with Mary and John flanking the central cross. Modern art historians, preoccupied with the careful observation of architectural forms, tend to forget that devout medieval visitors were probably transfixed by the sight of the great cross, which would provide a kind of beacon inviting forward movement. The fourteenth-century addition of the nave lateral chapels may have created the incentive to look transverse-wise across the nave and into these

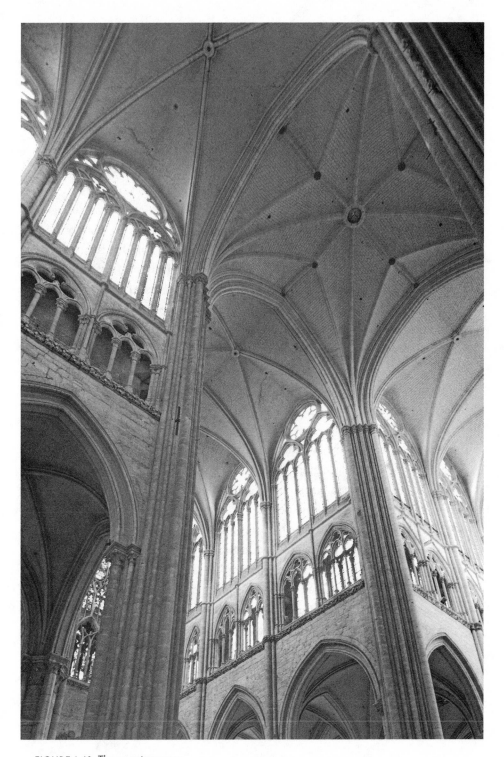

FIGURE 1.43 The crossing space

newly created spaces with their altars, tombs, and shrines. The great cruci-
fix, however—projecting the central belief of the Church in the Incarnation,
Crucifixion, and Resurrection of Christ—helps reestablish the axial focus.

It was in this great central space, *in medio ecclesiae*, that medieval lay-
people would gather to listen to sermons and readings delivered from the
tribune atop the pulpitum, and to venerate the relics of the saints exhibited
from the same tribune or on a platform directly to the west of the screen.[84]
In other words, we are dealing with the coordination of architectural design
and what might be called *paraliturgical* practice: the projection of devotional
and liturgical activities beyond the confines of the choir. One can imagine
the founding master mason, Robert de Luzarches, working closely with
the dean, Jean d'Abbeville, and with Bishop Évrard de Fouilloy to anticipate
and realize this happy union of architectural space and liturgical practice.

Our passage has allowed us to experience architectural *transformation*,
as the tunnel-like nave space (which Ruskin found oppressive) opens up with
diagonal views into the transept arms and glimpses of the brilliant upper
choir, flanked by spacious double aisles (figs. 1.41–43). The fact that laypeo-
ple are not allowed to penetrate the central part of the choir, reserved for the
clergy, only serves to make it more enticing. From the aisles we command
oblique views of the upper choir (which, as we have seen, is much more bril-
liantly lit than the nave)—you can see that the middle level of the elevation,
the triforium, now frames windows admitting a flood of light, in addition to
the light coming from the great clerestory windows.[85] When we ascend to the
upper choir we will see that this arrangement necessitated a new roof system
in order to allow the light to penetrate the rear wall of the triforium. We may
also notice that the form of the triforium has changed in the choir: each bay
is now capped with a little gable. Modifications have also been introduced
into the tracery of the clerestory. The brightness of the choir in its original
state would have been enhanced by the quality of the stained glass—the sur-
viving glass of the upper choir, characteristic of the 1260s, introduces much
more uncolored *grisaille* glass than what we could expect to have seen in the
(mostly lost) windows of the nave dating from two decades earlier (fig. 3.23).

Where does this new architectural regime begin? At first glance it looks like a
simple transition: the west side of the transept, with its dark triforium, belongs
to the old system of the nave; while the east side, with glazed triforium, goes
with the choir (fig. 1.44). Matters were, in fact, more complicated—we will

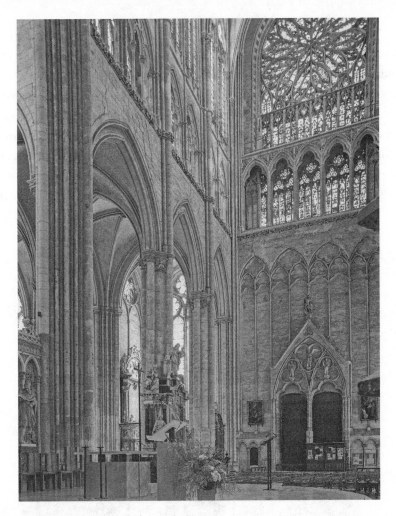

FIGURE 1.44 East side of the south transept

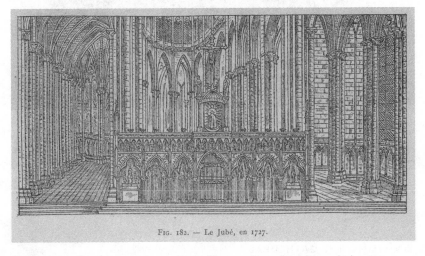

Fɪɢ. 182. — Le Jubé, en 1727.

FIGURE 1.45 The choir screen or *pulpitum* (Georges Durand. *Monographie*)

sort out the chronology in chapter 4 when we come to consider the work of the founding master masons and the sequence of construction.

Let us now circle around the enclosed space of the central choir, exploring choir aisles, ambulatory, and chapels. The widened bay that opens into the southern choir aisles welcomes our passage as we look down the four-bay, double-aisled space (fig. 1.46). Although so many ancient shrines and altars have been swept away, here to the east of the south transept we encounter an altar that bears testimony to one of the most powerful groups of laypeople

Consequence of the Reformation

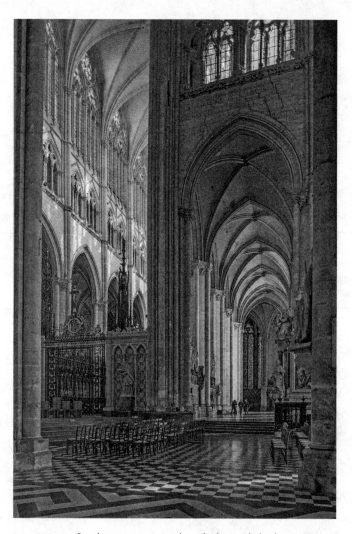

FIGURE 1.46 South transept arm and south choir aisle looking east

FIGURE 1.47 South transept arm, chapel of Notre-Dame du Puy

using cathedral space—the confraternity of *Puy Notre-Dame* (fig. 1.47). This group of prosperous merchants, lawyers, and clergy dedicated to propagating the cult of Notre-Dame sponsored an event each year involving the commissioning of a work of art.[86] The names of the Puy masters are inscribed in gold in the black marble plaques set in the dado arcade to the west of the south transept; this must have seemed their own special space.[87] The existing altar dates from the seventeenth century: we see a great painting of the Assumption of the Virgin Mary flanked by statues of strong women—Genevieve and Judith with the head of Holofernes—and, above, David and Moses. Atop the shrine the Virgin Mary has just rescued a child from drowning in a well.[88]

To the right, nestled in the east side of the south transept arm, is the oldest chapel in the cathedral: the Chapel of the Conversion of Saint Paul, established in 1233 by the founding dean, Jean d'Abbeville, just thirteen years after the start of construction (fig. 1.48). In its original state this chapel

FIGURE 1.48 South transept chapel of the Conversion of Saint Paul

would have received the full flood of morning light through its eastern window—prompting the devout user to think of the blinding light that led to Saint Paul's conversion and vision of Christ on the road to Damascus. Unfortunately, the eastern window has been partly blocked—presumably in response to structural concerns (this is a weak point in the structure of the cathedral) and to provide a backdrop for the baroque altar.

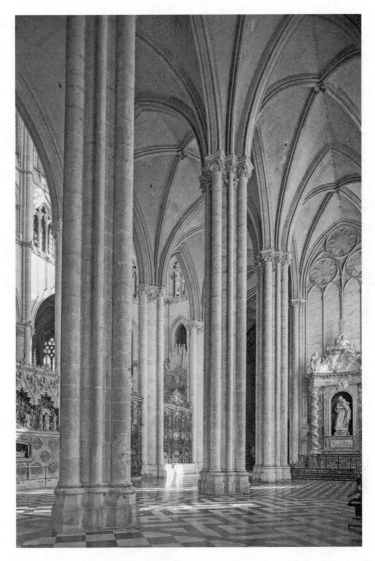

FIGURE 1.49 South choir aisles looking north east

We now find ourselves in the spacious double aisle of the choir (fig. 1.49). Quadripartite rib vaults are supported on slender, elegant supports where the cylindrical core is enclosed in a cage of eight colonnettes, expressing the support of the transverse arches and ribs. Along the three bays of the outer aisle wall is a dado arcade of exactly the same type as the one that originally existed in the nave—here you can get an idea of the original

FIGURE 1.50 Dado in south choir aisle, westernmost bay. Cunningly concealed in the two left bays is the door to the masons' yard.

disposition of the outer wall of the nave aisle with its enormous windows and uninterrupted dado (fig. 1.50). The experience of the dado might be somatic—the trilobed top of each bay recalls the form of the frame that encloses the head and shoulders of the founding bishop, Évrard de Fouilloy, in his bronze tomb effigy (fig. 3.2). The socle bench invites us to sit and, in a sense, to *incorporate* ourselves into the wall.

The division between the aisles and the central vessel of the choir is marked by a lateral screen (*clôture*), its lower part carrying tomb effigies (*gisants*) of the fifteenth-century bishop Ferry de Beauvoir (he was buried in the pavement below) and Dean Adrien de Hénencourt, who presided over the chapter when the screen was built and who commissioned the start of work on the screen around 1490 (fig. 1.49). The upper level, articulated with rich Late Gothic arcades and finials, carries a sculptured narrative of the arrival in Amiens of the founding bishop, Saint Firmin. The story of the saint is told in two main episodes: first, his arrival in Amiens, his conversion of the people, and his execution; and second, the miraculous discovery of his lost body and the triumphal procession back to Amiens with the relic box, or *châsse*, containing his mortal remains (figs. 5.10–11).

FIGURE 1.51 Dado in choir chapel of Saint Eloi

The story establishes a powerful west-to-east narrative sequence, moving pilgrims forward to the point where, having seen the image of the châsse carried triumphantly to the cathedral, their gaze could then penetrate to the inner choir where Firmin's actual châsse was displayed high on a gallery behind the main altar, together with those of other principal local saints.

We are now led to circumnavigate the facetted spaces of the ambulatory (fig. 1.52). There are seven trapezoidal bays opening on their long side into radiating chapels and on their short side into the arcade of the hemicycle. In six of the chapels, three tall windows topped by stacked trefoils are flanked by solid dividing walls, their tapering plan forming arrows pointing inward. An arcaded dado runs around the lowest level of the outer wall of the chapels (fig. 1.51). In the central chapel, two additional bays lend extra depth and convey to the visitor that this particular chapel—dedicated to the patron of the cathedral, Notre Dame, and serving some of the functions of a parish church—is the most important. The other chapels are mostly occupied by local saints.

The visitor negotiating the passage around the ambulatory quickly loses directional sense, overwhelmed by the succession of wedge-shaped bays and

FIGURE 1.52 Ambulatory and radiating chapels

multiple polygonal chapels with their steep, faceted windows filled with colored glass. The central radiating choir was screened in the Middle Ages by a series of sumptuous tombs (some with diaphanous canopies) and screens with sculpture depicting stories of the saints and the Virgin Mary. Although most medieval pilgrims would not have been able to penetrate into the main body of the choir and sanctuary, with its polygonal eastern termination or *hemicycle* framing the principal altar, these chapels—each with its altar and precious relics of the saints—effectively mimicked that central space and served as a substitute.

The modern visitor or art historian, endowed with powers of observation and memory, might notice that certain architectural features are quite

different in the turning bays of the ambulatory. All the way down the length of the cathedral, from western frontispiece to the base of the hemicycle, the dado with its trilobed arches has remained entirely uniform (fig. 1.50). Now look at the dado in the chapels: instead of the old trilobed arches, here we see cusped pointed arches (fig. 1.51).[89] The supports grouped around the outer edge of the ambulatory between the chapels are clad in a cage of colonnettes of extraordinary slenderness: they carry capitals that are no longer square-set (as in the nave) but beaked: the transverse arches supported by these beaked capitals have a wedge-shaped profile (fig. 1.52).

We finally emerge from the turning bays of the ambulatory to find ourselves again in the spacious double aisles of the choir—now on the north side (fig. 1.53). Once again, we see the original lower wall with its continuous

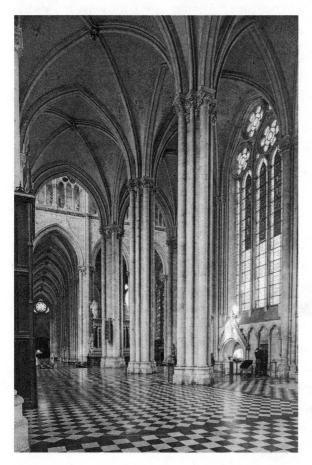

FIGURE 1.53 North choir aisles, looking northwest. See also color plate.

dado. Doorways penetrate the dado level in order to provide access to the (now-lost) sacristy/treasury complex, which existed on the northern flank of the chevet, and to the bishop's palace. And we also see what must have been one of the first violations of the dado—the insertion of an episcopal tomb that appears to date from the mid-thirteenth century, and is usually assigned to Bishop Gerard de Conchy. Closely matching the west-to-east narrative of the life of Saint Firmin in the south choir aisle, here on the north side we find the story of Saint John the Baptist. The pilgrim advancing eastward along the northern aisles would be led forward by the sculptured narrative that begins with his preaching and baptism of Christ and ends with his execution (figs. 5.12–13). Having seen the image of John the Baptist's severed head, the pilgrim can then turn aside to pass through the doorway in the outer aisle, climb the steep stairs, and encounter the actual head preserved and displayed in the upper chamber. The experience of climbing the dark steps and emerging into close, uncanny contact with the crystal container of the saint's head must have provided an unforgettable crescendo to many a pilgrimage.

iii) The Desire to Ascend

Our passage through the spaces of the cathedral may have left us unsatisfied. Looking up at the glimpses of dark spaces of the triforium passage—or, on the exterior, at the forest of flying buttresses, pinnacles, balustrades, and towers—we may long to climb and explore. Surely, the building would reveal itself much more completely if surveyed from considerable height? Whereas the ascent of the two western towers was probably always open (at a price) for laypeople, exploration of the roofs and multiple passages at triforium and clerestory levels is permitted only to the privileged few. Just as entry into the central choir becomes more desirable because it is denied by encircling screens, so the upper passages and spaces tease the visitor with the *desire to ascend*.[90]

Ascent is facilitated by six stone spiral staircases set in the flanks of the western towers, at the eastern edge of the central segment of each of the transept façades and in the staircases enclosed in the buttresses at the base of the hemicycle (fig. 1.20). The generous size of the western staircases reflects their frequent use; the other staircases, considerably narrower, were principally for the use of the artisans. During major construction campaigns, heavy materials (stone, mortar, roof timbers, bells) would have been

hoisted aloft with great wheels set in the scaffolding or in the structure of the roof. The artisans themselves would have needed continuing access to the upper levels both for construction and maintenance, but beyond this immediate function, the provision of so many permanent stone staircases seems to glorify the business of climbing.

Let us now ascend by means of the south transept stair—we will find the entrance cunningly concealed behind the eighteenth-century wooden paneling in the Chapel of the Conversion of Saint Paul (fig. 1.48)—a secret for the initiated only. And so, we pass from the expansive, light-filled spaces of the cathedral interior into the oppressive space of the dark, curving, and steeply ascending spiral cage of the staircase. The climber may marvel at the simple ingenuity and regularity of the assembled stones, where each step is made up of a wedge-shaped slab that is integrated with the central column (*newel post*) and with the cylindrical enclosing wall. Multiple doors open from our staircase, giving access to the triforium of the transept, to the roof of the choir aisle, and to exterior and interior passages across the south transept façade. If we have remembered the correct door we will finally end the rhythmic circling of our onerous and echoing ascent and emerge out of darkness and disorientation into the brilliant light, unified space, and rigorously controlled envelope of the south transept at the level of the triforium passage (figs. 1.54–55). As in the Conversion of Saint Paul, we have passed from darkness into light, from blindness to sight—and our expectations of an extraordinary vision are fully met. The intense pleasure induced by the silvery light shot through with brilliantly colored flashes of stained glass, and by the proliferation of finely worked forms—vegetal as well as architectural—is actually enhanced by the sense of the *precariousness* of the place as one feels drawn forward into this vertiginous space. How to prevent oneself from lurching forward into the void? An element of fear is an essential part of the sense of the sublime.[91]

Getting beyond the first intense sensation of the *awesomeness* of the place, we may begin to identify three different avenues of investigation. First, as we view the cathedral from this height, we will gain new insights into the various phases of its construction. Second, our new vantage point will allow the cathedral itself to reveal its basic geometry more clearly. And third, through our access to this new perspective, we will become acutely aware of the structural problems that have plagued the cathedral throughout its life.

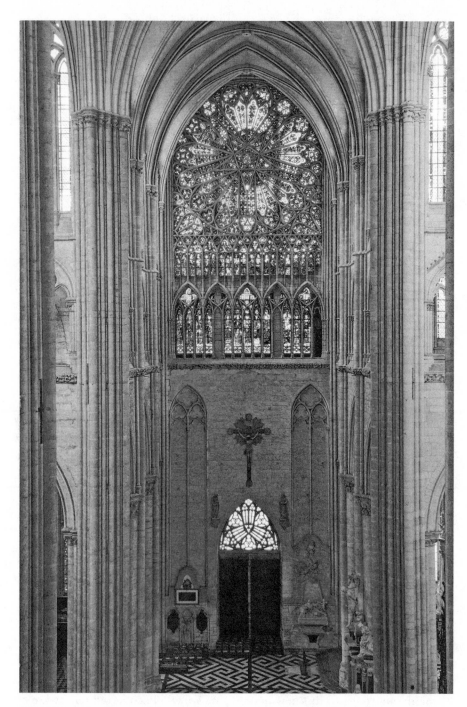

FIGURE 1.54 View from south transept triforium: inner north transept façade

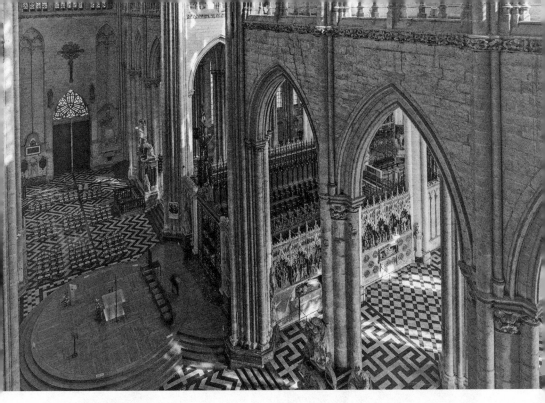

FIGURE 1.55 View from south transept triforium: crossing space: *in medio ecclesiae*. You can see the lateral screen of the choir (1490s–1500s), the tombs of Bishop Ferry de Beauvoir and Dean Adrien de Hénencourt, and the choir stalls. The wooden podium was built recently.

Looking to our left, toward the west side of the transept (fig. 1.56), we see the three-story elevation of the same type as the nave: in the middle a dark triforium passage enclosed behind a tracery screen with great trefoils surmounting groups of three lancets. The generously sized trefoil, seemingly cut out of a continuous surface or slab of stone, is rendered in *plate tracery*. Behind the triforium opening is a passage bounded by a blank wall closing off the "dead" space enclosed between the aisle roof and vaults. What a transformation in the east side, seen to our right (fig. 1.57)! Here the middle level, the triforium, is broken open with windows in its rear surface—there is no dead space and no lean-to roof over the aisle. We may surmise that the aisle roofs outside must be flat, low-pitched, or pyramidal. And there are further differences. In the two bays closest to us on the right, the triplets of the triforium are surmounted by great trefoils, like the ones in the nave and west side of the transept, but now rendered in delicate sticks of stone or *bar tracery*. In the last bay, adjacent to the crossing, the great trefoil has

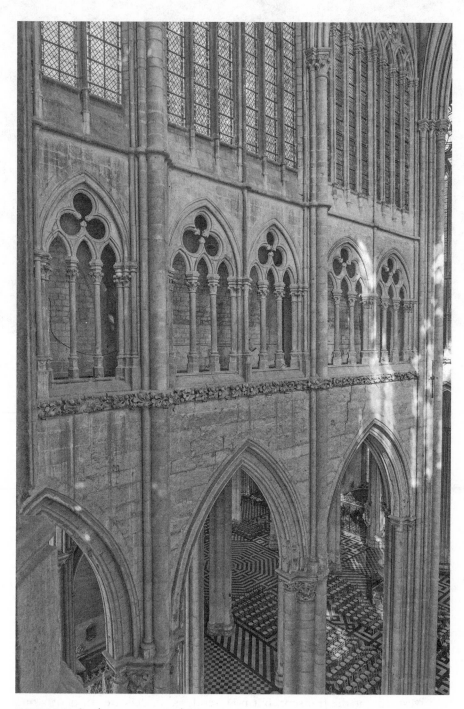

FIGURE 1.56 South transept, west side

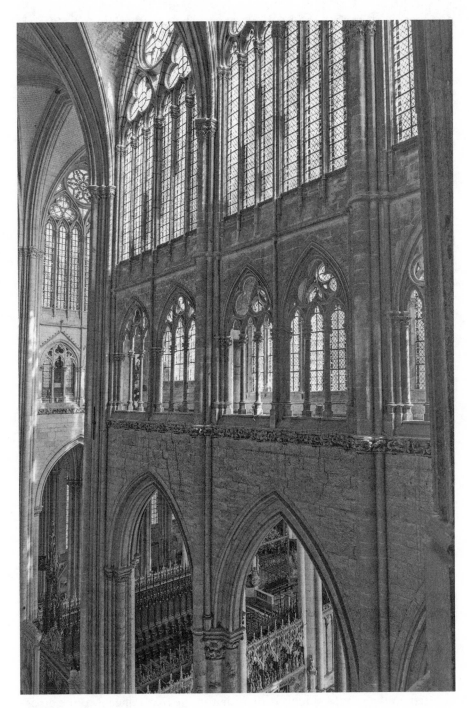

FIGURE 1.57 South transept, east side

disappeared altogether and has been replaced by a much more complex pattern with three smaller trefoils. And look at the foliate garland at the base of the triforium. On the west side of the transept it is composed of luscious, fleshy, round-lobed leaves interspersed with little bunches of berries, and it has a clear directional character: it runs toward us. On the east side, although the foliage continues its directional flow (now away from us), it is much less rich. In the choir the garland is replaced by desiccated vertical sprigs.

What is going on here? The fashionable explanation insists that the forms of Gothic architecture were subservient to liturgical practice and that more elaborate forms were developed because they were considered appropriate in the eastern part of the cathedral, the seat of the clergy and theater for the Eucharist.[92] But this does not explain why the form of the third bay of the triforium on the east side is different from the other two bays or the changes in the foliate band. There are two other possible mechanisms of change. One results from human agency and shifting taste. Amiens Cathedral was under construction for centuries: while so much of the technology of architectural production (the use of templates, for example) was geared to *avoiding* unwanted variation, the forms of the building would obviously have become increasingly unfashionable over time. We have learned from the names recorded in the central plaque of the labyrinth that three master masons were involved in the enterprise. I will suggest in chapter 4 that a gap of some ten or fifteen years (c. 1240–c. 1250s) separated the work on the triforium on west and east sides of the transept, and that during that time a young master mason, Renaud de Cormont, replaced his father, Thomas.[93] Thus we are dealing, at least in part, with *creative agency*: to our left and right we see the work of a father and a son. The dynamic relationship between generations (fathers and sons; masters and apprentices) was certainly one of the key elements of the force of "change" in Gothic architectural production.

There is another aspect to the phenomenon of architectural change. In Amiens Cathedral we have an edifice that was being reconstructed even as it was being constructed. If we choose to walk along the narrow passage behind the "changing" tracery of the east side of the south transept we will encounter multiple signs of structural distress and repair. The fragile bar tracery, badly dislocated, is actually held in place by wooden beams inserted on the reverse side: it is clear that in the bay adjacent to the crossing, the widest one, the original tracery, presumably embodying a great

trefoil, has failed and been replaced by a pattern that is denser, and therefore stronger—it has been *changed* in the physical sense of *replacement*. The reason for this failure is well known to students of Amiens Cathedral. The four main crossing piers are heavily bowed inward at arcade level and outward in their upper parts: a banana configuration.[94]

In the years just before 1500 great iron chains were installed in the triforium to arrest further movement—their terminals are still visible in the four crossing piers and the chain itself still trips us up as we make our way along the narrow passage (fig. 1.58). Signs of movement or deformation must have made themselves noticeable even during construction: the replacement tracery in the third bay of the eastern south transept triforium is of the same general type as that found all around the choir, work done around 1260: it must have been considered a prototype. Deformation in the crossing and transept started early and has persisted down to the present day: we see alarming cracks in the base of the triforium and arcade wall of the eastern arcade of the south transept. Worries about the security of the south transept façade

FIGURE 1.58 Interior of triforium passage: the iron chain is visible on the floor at the left.

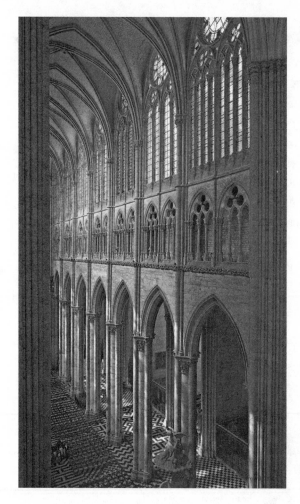

FIGURE 1.59 Nave elevation, looking north west (Media Center for Art History, Andrew Tallon, photographer). See also color plate.

led to modifications even during construction: the structural frame has been consolidated through the addition of a substantial strip of masonry on either side of the central window above the level of the triforium sill (figs. 1.26–27).

But I imagine my companions fretting over this extended business of close looking and speculation, which can quickly become tedious—let us therefore move on, passing along the triforium passage to the southwestern crossing pier. To the west of this pier we command an uninterrupted view of the seven bays of the nave, while on the southeast side our gaze can take in the space of the crossing as well as the choir, surrounded by its screens and the sumptuous wooden stalls of the clergy, or *canons*, lining the choir arcade (figs. 1.59–60). The view of the nave confirms our first impression

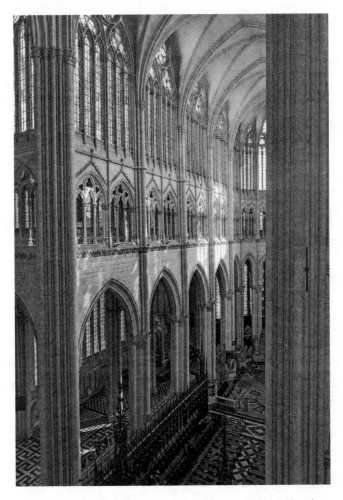

FIGURE 1.60 Choir elevation, looking northeast. See also color plate.

gained already in the south transept—that this is an extraordinarily har-
monious and balanced composition. We see a grid of intersecting horizon-
tals and verticals woven together with almost mechanical perfection. There
are few *signs of change:* forms and dimensions seem to repeat themselves
relentlessly from one end of the nave to the other. Yet our perception of an
oversized bay immediately in front of us and adjacent to the crossing is not
an optical illusion. We have already seen that this bay really is indeed con-
siderably wider, and has suffered the same structural distress of all of the
enlarged bays on all four sides of the crossing. The lancets of the clerestory

tracery have been doubled: six nave clerestory windows have four lights; the seventh, easternmost bay has eight.

The intense pleasure of the experience of the cathedral interior, seen from this height, may stimulate us to inquire whether any geometric formula lies behind such an immediately agreeable composition. Many of us will own up to a certain kind of *jouissance* in the discovery of proportional systems.[95] The principal means by which the composition was achieved were no more complicated than the application of a one-to-one ratio: standing on the triforium sill we are exactly halfway up to elevation: hence the absence of the unpleasant convergence of verticals.[96]

Passage along the length of the nave triforium allows the visitor to finally grasp its surprising spaciousness—and its function. The solid wall to our left closes off the dark, dusty, and drafty space under the aisle roof: a space reserved for maintenance staff, archaeologists, and pigeons (fig. 1.58). This wall is enclosed inside a relieving arch, and it is quite possible that when construction started the builders had intended to leave the arch wide open into the space below the aisle roof.[97] The effect from the ground would have been dramatic, with the delicate screen of triforium tracery highlighted in front of the dusky darkness of the aisle roof. However, serious problems would have resulted from the penetration of winter winds through that roof into the main space of the nave, and the builders sensibly decided to close the arch with a thin wall.

With the image of the nave fresh in our minds, let us now return along the triforium passage to the choir via the south transept. After the initial experiments in the triforium on the east side of the south transept, the builders fixed the repeating forms of the triforium down the length of the choir—though the big trefoil reappears in the hemicycle. Little gables cap the triforium openings throughout the choir (fig. 1.60).

Several surprising discoveries offer themselves in the choir triforium here on the south side. First is the presence of stones that have been reddened and degraded—apparently as a result of a fire. This is particularly notice-able in the area to the east of the southeastern crossing pier. Second are the windows set in the rear wall of the triforium along the south side of the choir, inserted somewhat brutally into an already-existent frame. An arson fire damaged the cathedral in 1258: it is very likely that it burned parts of the scaffolding erected to facilitate both the construction of the upper choir

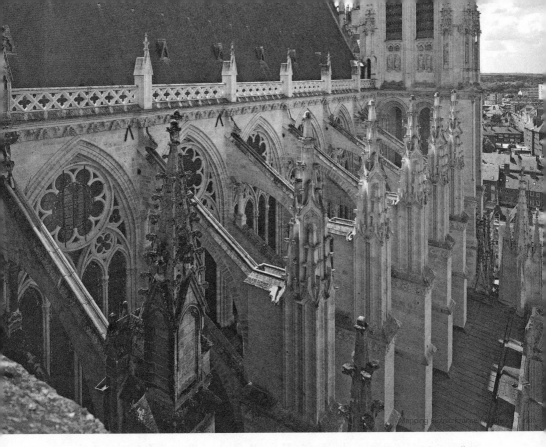

FIGURE 1.61 Exterior upper nave, north side flyers (Media Center for Art History, Andrew Tallon photographer)

and the roofs of the southern choir aisles. Construction at Amiens generally went from the crossing out in both directions, with the south side preceding the north: it seems likely that the upper piers and triforium along the south side of the choir had recently been completed and still under scaffold in 1258, whereas the upper north side had not yet been started.

And now to the upper exterior of the cathedral where our exploration requires us to move around at three different levels: the roofs of the lateral chapels, the exterior passage that runs atop the triforium at the sill of the clerestory window, and the passage atop the clerestory wall at the base of the great roof. We begin from the upper clerestory wall on the west side of the north transept where we have a commanding view of the essential elements of the upper nave (fig. 1.61). We see a breathtaking display of Gothic skeletal structure: receding away from us, from left to right, the clerestory

wall offers a great arcade of pointed arches each filled with a delicate tracery pattern framing a membrane of glass. Set at ninety degrees to the clerestory wall is a skeletal armature of supports made up of massive uprights, or *culées*, from which flying buttresses are launched at the clerestory. From our vantage point we see only the upper flyers, intended to stiffen both the upper wall and the roof, which is subject to violent buffeting by high winds. Atop the upper flyer a gutter evacuates rainwater from the roof, delivering the flow to an outer gargoyle that spouts away, clear from the building. The lower flyer providing support for the main vaults, invisible here, is similar in design to the upper one but without the gutter.

Now look more carefully at the outer culées that support the flyers. In the nave, as originally built, they jutted out from the aisle wall, lending a dramatically broken appearance to the exterior mass. As we see them now, however, they appear to grow out of the continuous roof of the line of chapels. We see five identical units, but the one closest to us in the angle between nave and transept is different: it has a pinnacle set atop a square base whose sides are decorated with panels formed of pointed cusped arches with gables. The remaining five pinnacles are much more complex: the diagonally-set upper part of the pinnacle appears to grow out of the square-set base whose sides are articulated to allow you to see the angles of the upper diagonal square inscribed inside the lower one. This is the famous system known as *quadrature*, or rotated squares. Such dynamic geometric mechanisms were much loved by Gothic master masons in the later Middle Ages. Thus, we may conclude that the pinnacle nearest to us belongs to the original construction (1230s–40s), whereas the five others resulted from a much later intervention, probably around 1500 when money was plentiful and the cathedral clergy were engaged in a campaign to update the exterior of their cathedral.

From a single vantage point we have grasped the essentials of the exterior architecture of the upper nave—notably, the ingenious and efficacious means by which the magic of the interior has been accomplished: vaults that appear to hover without support; and a new relationship between interior and exterior mediated by the translucent membrane of the clerestory windows. We shall now continue on to the aisle roofs and the clerestory passage. It is from the clerestory passage that we gain the best views and can assess the extreme thinness of the upper wall—at the major points of

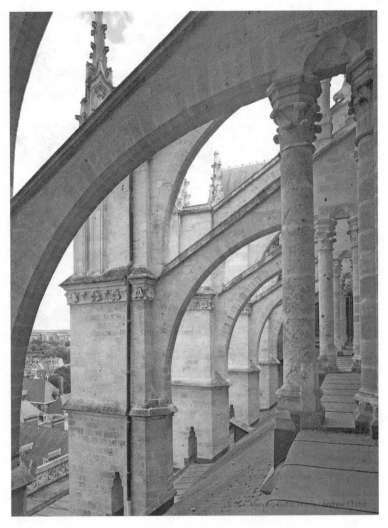

FIGURE 1.62 Flyers on the north side of the nave (Media Center for Art History, Andrew Tallon photographer)

support it is pierced by a passage topped by a trefoiled cap and defined on its outer edge by a little column that supports the head of the lower flyer (fig. 1.62).

Now, as we find ourselves on the nave clerestory passage close to the angle of the north transept, we are witness to yet another transformation in the forms of the cathedral (fig. 1.63). From our memory of the forms of the nave we might have expected to see two solid flyers supporting the transept

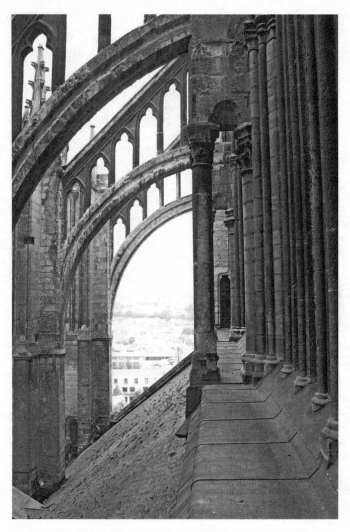

FIGURE 1.63 Flyers on the west side of the north transept

clerestory; instead, we now find a single flyer made up of a curved lower
supporting arch, a straight upper rim, and openwork tracery panels linking
the two. The angle of the unit seems more steeply pitched than in the nave: the
lower arch meets the clerestory wall at a most awkward angle. The clerestory
passage still has its trilobed cap as in the nave, but the strip of solid masonry
above comes to a hesitant termination, topped by one of the openwork pan-
els. The deployment of the openwork flyer clearly marks the beginning of

the shift away from the architectural mode of the nave to the new forms of the choir. This was no premeditated and controlled transition; indeed, it signals an ongoing experiment rather than a predetermined shift of mode. This becomes especially clear in the upright at the angle between the nave and north transept (fig. 1.64). To our left, we see the reassuring forms of the solid nave flyers; to the right, the newfangled openwork unit. The projecting molding that caps the lower flyer of the nave (left) runs into the upright— the builders had clearly intended to continue it into a matching unit (right) in the transept. It has left a telltale trace of that intention.

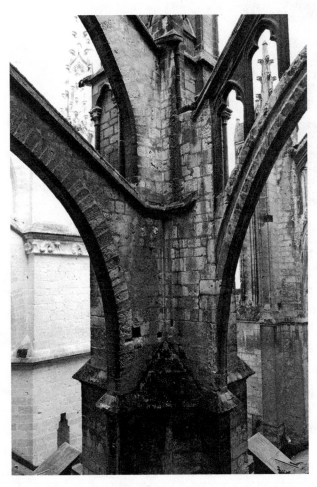

FIGURE 1.64 Upright supporting the flyers against the eastern bay of the nave and the west side of the north transept

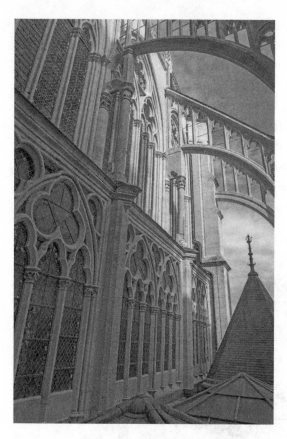

FIGURE 1.65 North transept, east side, glazed triforium and flyers

The transitional forms that first appeared tentatively on the west side of the upper transept are more fully worked out on the east—it is here that we first encounter the exterior of the glazed triforium made possible by low-pitched, double-sloped roofs over the aisles (fig. 1.65). The last vestige of the system of the nave flyers—the little strip of solid masonry above the clerestory passage—is abandoned in favor of a much more delicate open-work *aedicula* capped by a gable marking the point where the lower arch of the flyer meets the clerestory. And so, through this surprisingly hesitant and fumbling process of experimentation, the builders reached the solution of the openwork flyer and glazed triforium that was applied throughout the upper choir (figs. 1.66–67). Was it a good solution? It certainly produced the elegantly fragmented "postmodern" look that the builders apparently desired, thus bringing Amiens into line with other buildings where similar

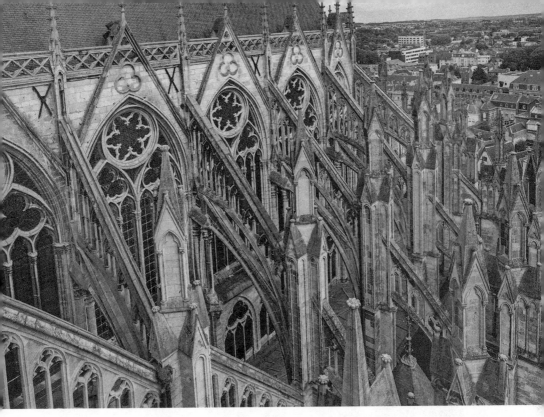

FIGURE 1.66 Upper chevet, south side, looking east, flying buttresses. See also color plate.

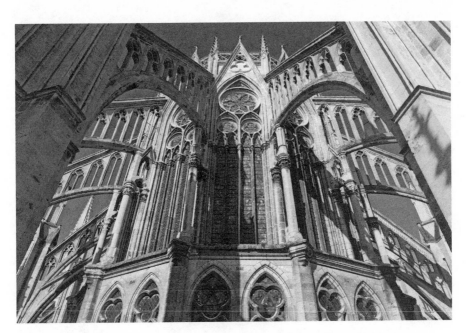

FIGURE 1.67 Upper chevet, hemicycle, seen from the east. See also color plate.

openwork flyers were used: the cathedrals of Troyes and Auxerre, and the collegiate church of Saint-Quentin.

Structurally, the lightweight flyers might well have seemed desirable, given the extreme slenderness of the piers dividing the choir aisles, considered inadequate to support traditional solid flyers (figs. 1.49 and 53). And the units offered real advantages in the process of construction: the lower arch could be put in place early as a lightweight provisional support for the upper choir; and the upper rim, which provides the charge, then added only when the vaults were installed. However, subsequent deformation of the upper piers of the choir suggests that the lower rim was placed too high to meet the thrust of the main vault. The problem could only grow worse with the passage of time and the buffeting of high-velocity winds. By the late fifteenth century, it was clear that additional flyers would be necessary. The story of this radical intervention, undertaken by the master mason Pierre Tarisel under the direction of Dean Adrien de Hénencourt, will be recounted in later pages.

The Portals | 2
Unscrambling the Plot

PREVIOUSLY WE HAVE ENTERED the cathedral directly, passing through its transformative interior spaces before embarking upon the triumphal ascent into the heights. Although during that passage and ascent our thoughts turned to those medieval builders and users of the cathedral who came before us, the experience principally involved ourselves in relation to our immediate surroundings, both seen and unseen. In order to get beyond the limitations of this narcissistic—though thoroughly engaging—vision, let us return to reconsider our point of entry into the Gothic cathedral: the portals (fig. 2.1).

The portals of a Gothic cathedral provided a richly receptive armature for multiple cycles and clusters of three-dimensional images that could be endowed with meanings in a variety of ways.[1] Individual images point to their diverse sources: written, oral, performed, or the multiple monumental prototypes available to the creators, especially the recently completed portals of the cathedrals of Senlis, Laon, Noyon, Reims, Chartres, and Notre-Dame of Paris. The imagery of the portals of Amiens Cathedral also points beyond these nearby sculptural prototypes to Italo-Byzantine art, particularly the mosaics of Rome and Ravenna—works that might have been experienced by the reform-minded participants returning from the Fourth Lateran Council assembled in 1215 in Rome and attended by the bishop of Amiens and other members of the local clergy. But the images in a Gothic portal are not perceived one by one, but in clumps, taking on additional

FIGURE 2.1 (overleaf) The three western portals. See also color plate.

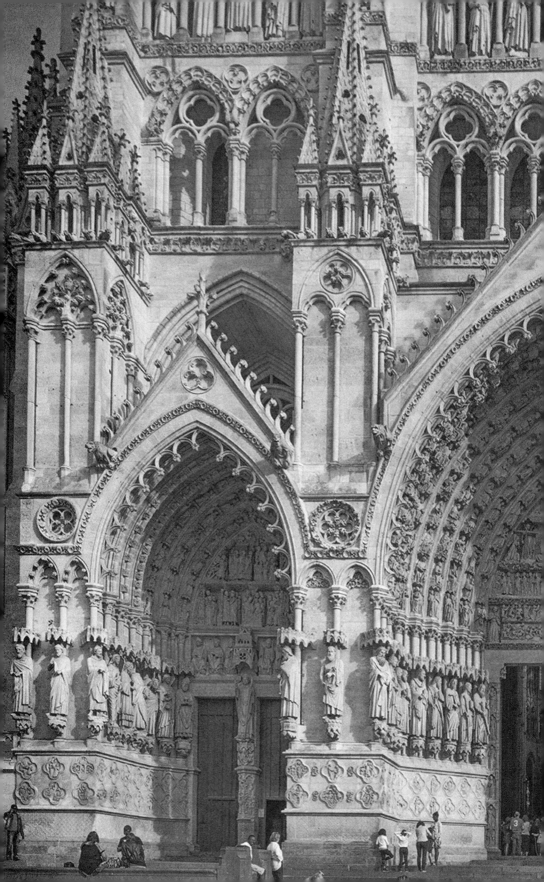

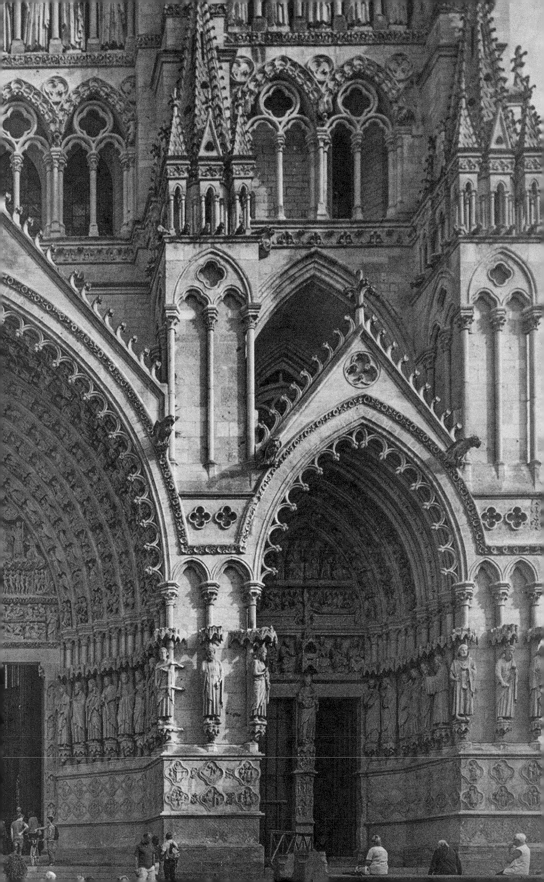

levels of meaning from their position within the architectural frame. Visitors to Amiens Cathedral will be particularly struck by the continuous line of larger-than-life human figures that flank the portals, extending across the front surfaces of the buttresses: these figures, like columns, palpably bear up the great edifice of the church. Each of the upright column figures stands atop a console with a little crouching personage below, conveying the notion of triumph. This is particularly evident in the three freestanding figures—true statues without columns—on the central supports or *trumeaux* of each portal. And there is something inherently triumphant about the three great tympana surmounting the portals, framed and recessed in multiple arches (*voussoirs*) and crowned by gables. The lifelike elevated column figures, once painted, seem to hover between our reality and the visionary; while the more distant imagery of the three tympana projects us forward in time to *theophany*, or the revelation of the divine and the miraculous.

Our own somatic experience plays a vital role in the construction of the meaning of the portals: since these are points of entry, we experience them through our own passage. Anthropologists have taught us that pilgrims and other visitors, sometimes having undertaken a long and arduous journey, may be in a particularly impressionable state as they finally approach the object of their desire. In such a liminal state, one might be quick to construe meaning and be retentive of things seen.[2]

There is an inherent tension between the urge to press forward and enter the cathedral, and the growing desire to linger in order to unscramble the meaning of these interlocking cycles of images: between *ductus* and *stasis*. We quickly sense the presence of a grand scheme or plot of some kind, apparently generated from the central portal, as well as multiple visual resonances linking the two lateral portals. Instead of continuing our forward rush to enter—whether, like our medieval predecessors, to venerate the head of John the Baptist; or like many modern tourists, to negotiate the loops of the labyrinth or to seek out the famous Weeping Angel (*l'ange pleureur*) of Amiens—let us linger for a while on the far side of the cathedral square or *parvis*, in order to consider what we can see and reflect on what we cannot see.

Four great flat-faced buttresses provide substantial "bookend" support for the west end of the nave and the west towers; because the inner buttresses flanking the central portal have a heavier burden (they support the high nave), they are appropriately very slightly thicker. Opening between the buttresses,

the three funnel-like portals invite us to enter.[3] The viewer may sense a simple modular plan: the span between the inner surfaces of the buttresses flanking the center portal equals the span of the side portal *plus* the thickness of the flanking buttresses. This scheme allows the center portal to be deeper and wider, with its flanking walls or embrasures splaying at a shallow angle and the attendant figures spreading out to greet us. In the narrower lateral portals, the sharply receding embrasures cause the flanking figures to hide one behind the other. The rectangular aperture of each doorway has been formed as a perfect square-root-of-two rectangle. Between the flat-faced buttresses three gables are pitched somewhat awkwardly, crowning each of the portals. This structural frame is overlaid with a fictive architectural language of colonnettes, panels, and projecting moldings closely linked with sculptured effigies representing human figures. The figures seem to want to engage the viewer, yet find themselves bound back into the greater scheme of the cathedral. The sense of a flat, forward-facing screen created by the gables is enhanced by the presence of twelve human figures forming a line on the front surfaces of the buttresses. These figures looking sternly out at us are the minor prophets.[4]

a) Minor Prophets

Each of the twelve minor prophets carries a scroll or *banderole*, and some of the figures gesture emphatically toward the words that were presumably once painted upon them.[5] They urgently want to speak to us: we must learn to listen (figs. 2.2–5). Following the order of their Old Testament books, the procession of prophets proceeds from right to left like Hebrew writing (and these four figures in this book reflect the same, ordered from right to left on the page), starting with Hosea on the extreme southern (right) end and ending with Malachi on the north (left). Accustomed to listening to sermons, medieval visitors might well have seen these eloquent individuals as preachers, God's interlocutors, offering consolations and emphatic admonishments. Those visitors might also have been familiar with the role of the preacher as prophet in announcing the advent of Christ's incarnation through the performance of the liturgical drama known as the *Ordo Prophetarum*; Laon Cathedral, not far from Amiens, has an early version of this manuscript.[6] While it is unlikely that the lay visitor will be able to identify many of the prophets by name or unscramble the meaning of many of the prophecies depicted in the low-relief sculpture below the prophets, even

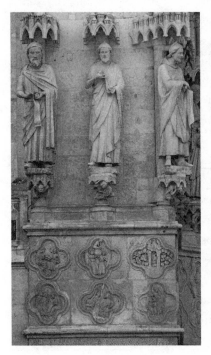

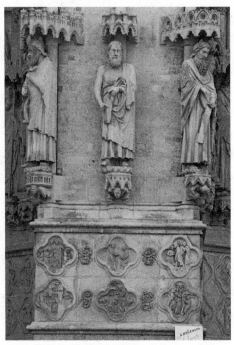

FIGURE 2.5 The minor prophets, right to left: Haggai, Zechariah and Malachi

FIGURE 2.4 The minor prophets, right to left: Nahum, Habakkuk and Zephaniah

the uninitiated can see that the prophet Nahum with his fierce mustache and severe look, standing on the angle of the buttress to the left of the central portal, is scolding us (fig. 2.4). This is made abundantly clear in the low-relief sculptured images enclosed in the quatrefoils below that depict scenes of the prophet cursing Nineveh, the desolation of that city, and the flight of its inhabitants.[7] Zephaniah develops the theme of desolation even further with the unforgettable images of ruined Nineveh occupied by beasts, while Haggai is forced to bear witness to the ruin of the Temple (fig. 2.6). Some consolation might be found in the messages conveyed by the prophets on the two buttresses to our right— particularly beautiful are Micah's images of swords transformed into plowshares and spears into pruning hooks, and each man at peace under his vine (fig. 2.7). However, it is really not necessary to understand each prophecy in order to grasp the concept of a community of individuals endowed with vision and eloquence. Fittingly, this community of figures is simultaneously unified by their position in a forward screen, even as they lead the viewer into the funnel-shaped spaces of the three portals, which are lined with similar column figures.

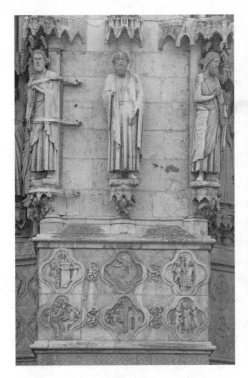

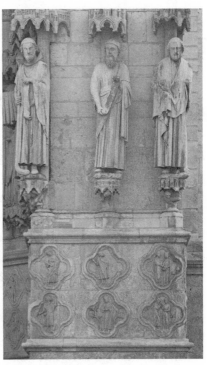

FIGURE 2.3 The minor prophets, right to left: Obadiah, Jonah and Micah

FIGURE 2.2 The minor prophets, right to left: Hosea, Joel and Amos

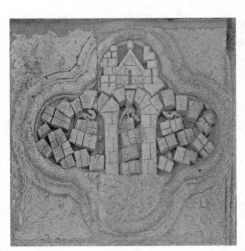

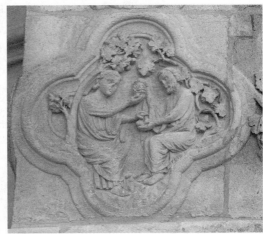

FIGURE 2.6 Quatrefoil image under Haggai: the ruin of the Temple

FIGURE 2.7 Quatrefoil image under Micah: every man under his vine

b) South Portal of the Virgin Mary, the Mère Dieu

Does the overall scheme require us to consider the three portals in any particular sequence? No; despite the linear, right-to-left reading sequence established by the minor prophets, the user can make sense of the iconographic program from multiple starting points—this is truly an interactive system.[8] Medieval visitors who understood the role of the prophets in the spirit of the *Ordo Prophetarum*—as heralds of the Advent season and the impending Incarnation of Christ—might first be led to the story of the Incarnation as it unfolds in the right-hand portal (fig. 2.8). Just as the prophets might be associated with liturgical drama, so the figures lining the right portal have a strongly histrionic character. The sides of the portal recede steeply, forcing the viewer to step forward and to the side in order to respond to the flanking figures who tower above. To our left (figs. 2.9–10), Solomon interacts with the Queen of Sheba: their affective relationship anticipates the Coronation of the Virgin in the tympanum, a vision derived from Solomon's Song of Songs. Next, we see King Herod, his face contorted in a fierce grimace, admonishing the Magi to bring him news of the birth of the infant King. However, only one of the three stops to listen; the other two turn to offer their gifts across the space of the portal to the infant Christ, held in the arms of the queenly Virgin Mary standing in the center of the portal on the trumeau (figs. 2.11–12). Whereas the dependence of the Amiens prophets upon the *Ordo Prophetarum* performance for the Christmas season is a distant one, here, in the right portal, we have a clear link with the liturgical performance known as the *Officium Stellae* or Ceremony of the Star, performed at Epiphany (January 6), and known at Amiens as the Feast of the Kings (*la fête des Rois*). At Amiens, the roles of the Magi were performed by three cantors who would enter the choir carrying their gifts and then proceed to the middle of the choir, where they would point to a star suspended from the vaults before leaving their gifts at the altar.[9] It has been suggested that an image of the seated Virgin and Child in the Throne of Wisdom pose (*Sedes Sapientiae)* might be placed upon the main altar. In some versions of the play a messenger brings news to Herod of the hasty departure of the Magi: hence his scowling face. The guiding star for the Magi was provided in the space of the portal by a great lamp suspended on a cable from the voussoirs above: we can still see the hole through which the cable passed. Postmedieval accounts record the practice of the veneration

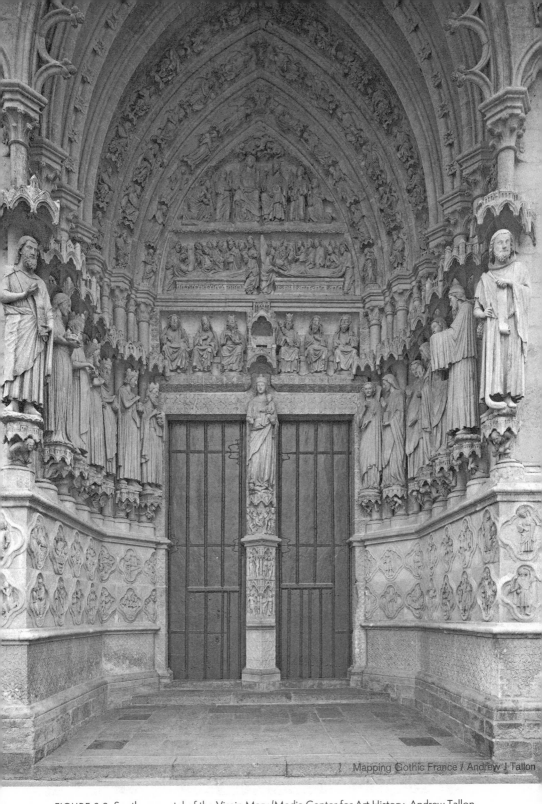

FIGURE 2.8 Southern portal of the Virgin Mary (Media Center for Art History, Andrew Tallon photographer). See also color plate.

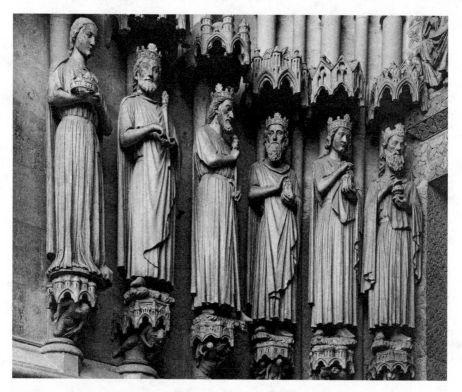

FIGURE 2.9 Portal of the Virgin Mary, left embrasure, column figures left to right: Sheba, Solomon, Herod, Three Magi

FIGURE 2.10 Portal of the Virgin Mary, left embrasure, quatrefoils

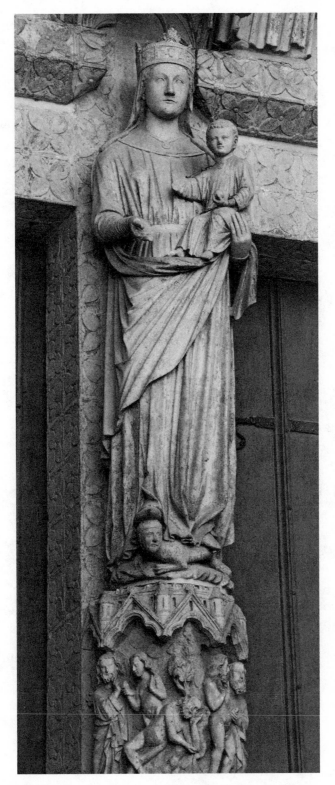

FIGURE 2.11 Portal of the Virgin Mary, trumeau: the *Mère Dieu*

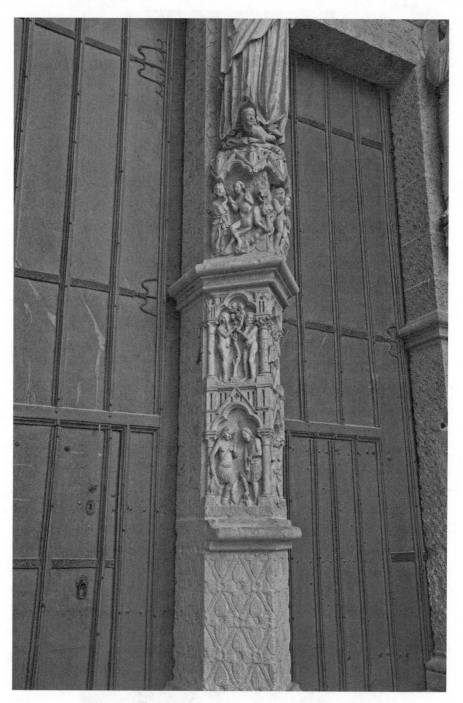

FIGURE 2.12 Portal of the Virgin Mary, base of trumeau: the story of Adam and Eve

of the Mère Dieu at dusk with the illumination of the suspended lamp.[10] The idea—an original one—of incorporating the illuminated space of the portal itself into the gift-giving narrative is brilliant, pulling visitors forward into the drama.[11] The story told by the column figures is enhanced by reference to the low-relief images in the quatrefoils below (fig. 2.10).

While the left side of the portal narrates the revelation of the impending incarnation of Christ to the Gentiles, the right side continues with the Jews; as the angel brings news of the birth to the Virgin Mary (the Annunciation), Mary is greeted by her cousin Elizabeth (the Visitation) and baby Jesus is presented to the High Priest in the Temple (the Presentation) (figs. 2.13–14). The dynamic interactions of these larger-than-life, once brightly painted figures would have reminded medieval viewers of dramas staged in sacred space; the sculptured low-relief quatrefoils below would have allowed them to expand the story, developing the idea of the conception of Christ, the birth of John the Baptist, and the fall of the idols that accompanied

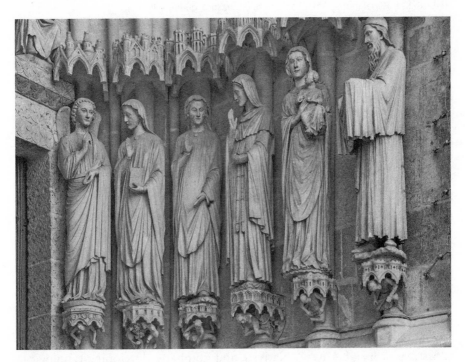

FIGURE 2.13 Portal of the Virgin Mary, right embrasure, column figures left to right: Annunciation (Angel and Mary), Visitation (Mary and Elizabeth) and Presentation of Christ in the Temple (Mary and Simeon)

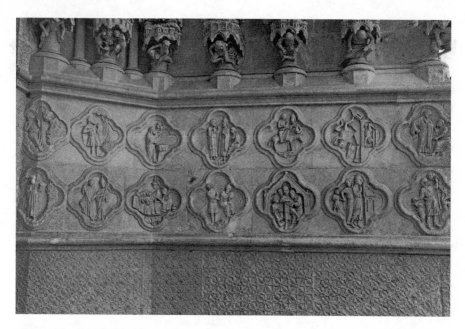

FIGURE 2.14 Portal of the Virgin Mary, right embrasure, quatrefoils

the Holy Family's flight to Egypt (fig. 2.14). The difficulty of untangling the meaning of these images allows the well-prepared interlocutor to assume authority in the eyes of the audience.

Standing far above the heads of those who enter the space of the south portal is the central figure of the Virgin Mary, known locally as the Mother of God, or *Mère Dieu*, here crowned and depicted as the Queen of Heaven and trampling the serpent who had seduced Eve and Adam (fig. 2.11). The figure, with its pronounced verticality, finely crinkled drapery, and serious-ness of expression, may have been inspired by an ivory statuette of the Virgin *Hodegetria* (the *Theotokos*). This statuette, like the Magi, also came from the East—brought back from Constantinople after the city had been seized by crusaders in 1204. The low-relief foliate decoration of the doorframe is referred to in some of the older texts as *la mosaïque*—once brightly painted, it was intended to reference the mosaics of an Italo-Byzantine church.

The images directly below and above the Virgin take us far beyond the Christmas story of Advent, Nativity, and Epiphany, developing typological links with the Books of Genesis and Exodus. The triumphant Virgin Mary is the *nova Eva*, or New Eve: through the creation of a new contract, she

provides the prototype allowing humans to transcend the ultimate punishment resulting from the Original Sin of Adam and Eve.[12] In the base of the central trumeau (fig. 2.12) the visitor finds the familiar scenes of the creation of Adam and Eve: the Temptation, the eating of the apple, and the Expulsion from the Garden of Eden. Particularly memorable is the image of Adam choking, his hand to his throat, as he struggles to swallow the pernicious fruit. Thus, the images in this portal provide the beginnings of both the Old and New Testament stories of creation and re-creation in the Incarnation of Christ: we will see later that the same emphatic starting point of Old and New Testaments was recreated three hundred years later in the images clustered around the dean's stall at the southeastern end of the choir stalls.

Typological references to the Old Testament are also placed above the Virgin: the architectural canopy above her head represents the shrine enclosing the Ark of the Covenant (fig. 2.15). The arrangement was certainly inspired by the northern portal of the west façade of Notre-Dame of Paris completed a decade or so earlier. At least three levels of meaning are conveyed by the Ark. First: because the Ark was long thought to be preserved in the basilica of Saint John Lateran in Rome, clergy (including Bishop Évrard de Fouilloy) returning from the Fourth Lateran Council of 1215 would have associated it with Church reform. Second: because the Ark is associated with the notion of a *covenant* or contract between God and his chosen people, its referential placement above Mary's head now extends this contract of salvation, through the agency of the Virgin Mary, to *all* people. And finally: because the Ark contained the life-sustaining *manna* gathered by the Israelites roaming in the arid desert, just as the Virgin Mary's body contained the life-giving Savior, the viewer now has more extensive context in which to understand the necessary connection between the Old and New Testaments. In this vein, the six magnificent seated Old Testament patriarchs (with Moses and Aaron in the middle) clearly go with the Ark: but more than this, they must also be seen in relation to the six seated bishops framed as their counterparts on the opposite matching portal of saints (figs. 2.16 and 2.21). The role of Christian priesthood is justified through Old Testament precedents: Jewish priests and patriarchs have palpably *become* Christian bishops in the right-to-left viewing sequence.

In the middle level of the tympanum we come to the end of the Virgin's sojourn on earth (figs. 2.16–18). Just as the image of the Virgin Mary

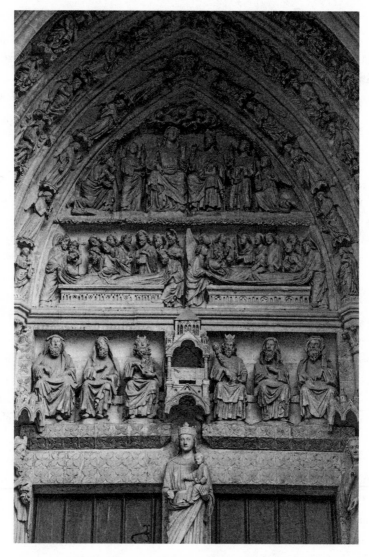

FIGURE 2.15 Portal of the Virgin Mary, tympanum

FIGURE 2.16 (*top, opposite page*) Portal of the Virgin Mary, lintel: seated Old Testament patriarchs and the Ark of the Covenant

FIGURE 2.17 (*middle, opposite page*) Portal of the Virgin Mary, Dormition and Assumption of the Virgin

FIGURE 2.18 (*bottom, opposite page*) Portal of the Virgin Mary, Coronation of the Virgin

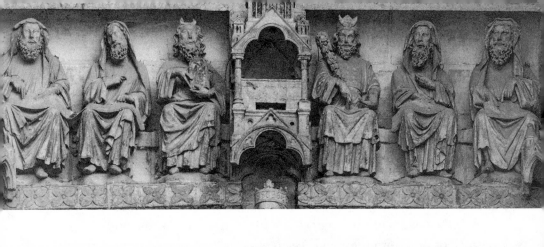

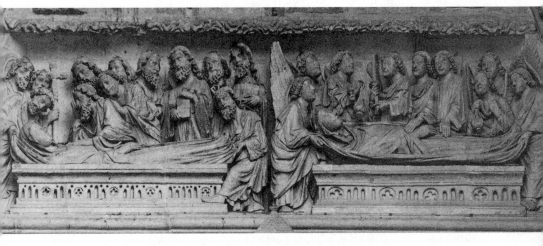

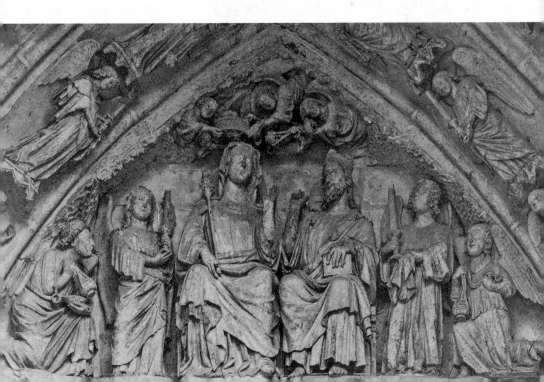

points in formal terms to prototypes in Byzantine artistic production (ivory Virgin Hodegetria images), so does the theme of the end of the Virgin's life point to the Eastern Church where the celebration of the Dormition and Assumption of Mary had been adopted at an early date.[13] In the Dormition, to the left, we see two groups of grieving disciples huddled around the apparently lifeless body of the Virgin laid out atop a sarcophagus; on the right, the Virgin's body is seen to be levitating slightly above the sarcophagus, and grieving disciples are replaced by joyful angels.

If the images of the Virgin Mary to the right side of the portal and the story of her Dormition and Assumption belong to past time (Mary precedes us into heaven to serve as our advocate), the Coronation of the Virgin at the top of the tympanum reveals a vision of the future: at the end of time it was anticipated that Mary would be crowned in heaven immediately after the Final Judgment, here depicted in the central portal (fig. 2.18). In addition to its prominence in the apse of Santa Maria in Trastevere, the Coronation had been featured in the portal sculpture of the abbey church of Saint-Denis (the lost tympanum of the northwest portal), Notre-Dame of Senlis, Notre-Dame of Laon, and Notre-Dame of Paris.[14] We see Mary enthroned as Queen of Heaven to the right of Christ, who is smaller than his mother and who appears to start away almost like an annunciate Virgin. The couple is flanked by angels who provide light and sweet odor (candles and incense), while three high-flying angels crown Mary, adding more incense. Medieval visitors might have be familiar with this image through sermons: one of Bernard of Clairvaux's most popular sermons linked the bride seen by John in Revelation 21 with the *sponsa* and *sponsus* described in the Song of Songs where the loving relationship of bride and groom is expressed with the warmth of spring, the prolific flowering of trees, and sweet odors. Dean Jean d'Abbeville of Amiens, who was certainly involved in the planning of the portal program, was also noted for his sermon on the Song of Songs.

The little sculptured figures of the voussoirs that frame the tympanum include angels, kings, and the patriarchs of the Tree of Jesse expressing the genealogy of Christ.

We have seen that the portal of the Virgin Mary provides a clear starting point in the order of the prophets, as well as the stories of the Old (Adam and Eve) and New (Incarnation of Christ) Testaments. But which portal

should we consider next? For reasons of visual symmetry, as well as its role in the liturgical celebrations of the Christian year, I suggest that we next go the north portal of the saints.

c) North Portal of Saint Firmin (Fig. 2.19)

The disposition of the northern lateral portal rhymes with that of the Virgin portal, with six column figures on each side. At the center, the Virgin Mary is matched by a statue of Saint Firmin the Martyr who was revered as the principal saint of the city and cathedral: his feast day was celebrated on September 25 (fig. 2.20). He is clad in full episcopal gear: sandals, alb, fringed stole, dalmatic, chasuble, hood, and miter.[15] His right hand is raised in blessing, and in his left hand he carries his episcopal crozier with which he strikes the Roman officer (sometimes identified as Sebastianus) responsible for his death, now trampled beneath the saint's feet.

The designers of the portal program have created links between the three trumeaux: Christ in the center portal tramples the beasts; Mary tramples the serpent. All three stretch out their right hand in blessing; all three have the power to rescind your contract with sin and death.[16] Above Firmin's head, matching the Ark of the Covenant in the Virgin portal, is an image of a shrinelike container that can be understood as the reliquary (*châsse*) containing his remains. Six seated bishops (fig. 2.21) flank the châsse. Thus, through our sequence of looking and with the persistence of vision, transformation has occurred: the Ark has *become* the châsse; the priests of the Old Testament have become Christian bishops; and the Church universal personified in the Virgin of the Coronation has become the local church with its saints, bishops, sacraments, and miracles. All this is visible. What is not visible is that the feast of the Discovery (*Invention*) of the body of Saint Firmin was celebrated in the week directly after Epiphany: in addition to being matched visually, the two lateral portals were thus linked in a great two-week celebration that united city with cathedral, and the feast of Christmas with that of the principal local saint.

Let us now turn to the column figures. The minor prophets on the front surfaces of the buttresses lead us into this portal with dire warnings: to the right Zephaniah shows us the Lord searching Jerusalem with lanterns and the desolation of Nineveh, while to the left Haggai points to the decadent

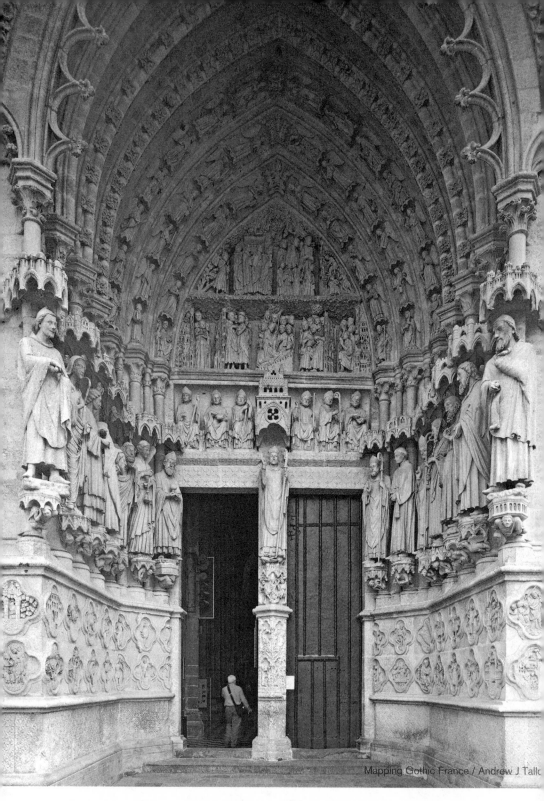

FIGURE 2.19 Northern portal of Saint Firmin (Media Center for Art History, Andrew Tallon, photographer). See also color plate.

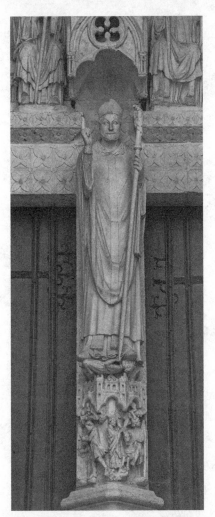

FIGURE 2.20 Portal of Saint Firmin, trumeau:
Saint Firmin

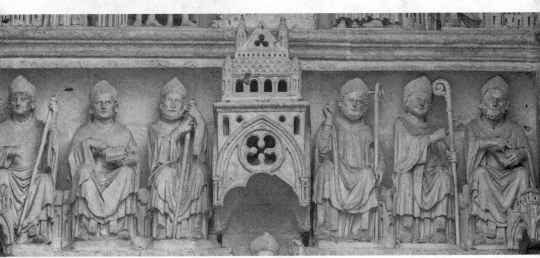

FIGURE 2.21 Portal of Saint Firmin, lintel: seated bishops flanking *châsse* of Saint Firmin

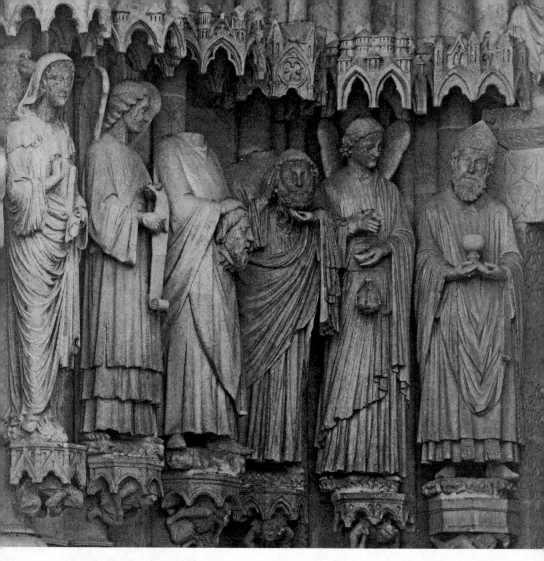

FIGURE 2.22 Portal of Saint Firmin, left embrasure, column figures left to right: St Ulphe, angel, Ache and Acheul, angel, St Honoré

house of the Jews and the desolation of plants. The urgent necessity to rebuild the ruined Temple would resonate with the cathedral builders. Particularly memorable, in relation to this portal devoted to the local church, are the prophetic images of unworthy priests being punished under the prophet Malachi on the front surface of the left buttress.[17]

The images of local saints lining the embrasures (figs. 2.22–23) also gained additional power through their visual reference to individuals

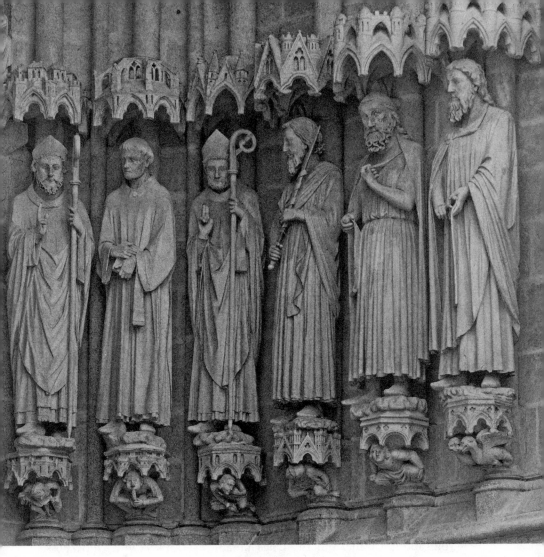

FIGURE 2.23 Portal of Saint Firmin, right embrasure, column figures left to right: St Firmin the Confessor, St Domice, St Sauve, St Fuscien? St Gentien? St Victoric?

actually present inside the cathedral—embodied in the relics preserved in a number of glittering shrines mounted upon an elevated gallery or tribune behind the principal altar in the sanctuary.[18] Each saint's figure would assume special significance on his or her feast day when their relics were honored, sometimes with sumptuous processions.

Let us begin with Saint Ulphe (Ulphia), who stands beside the prophet Haggai on the extreme left and who was celebrated on January 31 (figs. 2.22

and 3.16).[19] Haggai has shown us the collapse of the old order, and Malachi has warned us against unworthy priests: appropriately enough, in Saint Ulphe we find an antiestablishment figure. The image is utterly different from the stolid, firmly planted figures around her. Ulphe's slender body curves in delicate contrapposto, her drapery crinkles in the hooked folds of the Antique Revival style, and her face is idealized with almond-shaped eyes and curved brows.[20] The story of her life, composed by later hagiographers, followed the pattern of many a Christian virgin. Devoted to Jesus Christ, she declined all offers of marriage; and when her parents attempted to impose a secular life upon her she feigned madness, running half-clad through the streets, her hair and clothes in disorder and her face soiled. Abandoning her father's house in Amiens she sought solitude in the wilderness, where she fell asleep by a spring. In the night the Virgin appeared, resplendent in light, holding the infant Jesus who told her to establish a house where other women could follow her example. Passing by the spring came Domice (Domitius) (portrayed on the right side of the portal), another antiestablishment figure, who had renounced his canon's prebend to live the life of a hermit. Alerted to his arrival in a dream, Ulphia begged him to adopt her as his spiritual daughter.

Meanwhile, the bishop of Amiens also had a dream. Unhappy about the lack of young women taking vows of perpetual virginity, the bishop was granted a vision of a young woman who had come to him seeking to make such a vow. With appropriate celebration the bishop accepted Ulphe's vow, entrusting Domice with her spiritual welfare. A popular local story was told about Ulphia and the frogs inhabiting the swampy wilderness where she led her solitary life. Unable to sleep because of the raucous croaking, and tardy for the morning office, our saint prayed for nocturnal silence. Ever thereafter, it was said, local frogs have remained taciturn; taken elsewhere, however, they would resume their boisterous croaking. Ulphia died on January 31 and her relics were later transferred to the cathedral. Her cult was well established by the thirteenth century: Bishop Arnoul de la Pierre (d. 1247, one of the building bishops) left 60 sous for the celebration of her anniversary, and probably at the same date a chapel was established for her in the ancillary structure flanking the north choir aisle that also housed the head of John the Baptist.[21] Pilgrims visiting her shrine would thus pass directly under her image in the northern portal.

Saint Ulphe's aberrant status, expressed in the clear formal differences outlined above, permits an intriguing double reading. The (post)modern beholder might want to find here a commentary upon the construction of gender difference and the status of women. Yet what we now read as visual aberration may, paradoxically, have originally been intended to provide a prototype. In her stance and attributes our saint is similar to the Virgin of the Annunciation in the south portal (fig. 2.13). The figure we call "Ulphe" may actually have been first carved to represent the Virgin Mary of the Annunciation, only to be put aside—presumably because of changing taste—and then later employed as a *type* of Virgin.

To Ulphe's left (our right) is an angel followed by two *cephalophores*—decapitated figures carrying their own heads—flanked by angels. These figures have been identified as the little-known third-century local saints, Ache and Acheul, who had been buried at Abladana (Abladène, later Saint-Acheul), to the east of Amiens, close to the tomb of Saint Firmin the Martyr—a spot commemorated with the construction of a church later known as Notre-Dame-des-Martyrs. The names of these saints, commemorated in thirteenth-century litanies on May 1, are not associated with any specific thaumaturgic attributes. The identities of these two decapitated figures resonate with those of two much better-known members of the local saintly community—Saint Firmin the Martyr and Saint John the Baptist—who were also decapitated.

Immediately to the left of the door stands a bearded figure in episcopal gear holding a chalice. He is one of three bishops in the portal, all very similar, and is generally identified by local interlocutors as Saint Honoré (or Honoratus), seventh bishop of Amiens (died c. 600) whose feast was celebrated on May 16. Honoré is said to have resisted his vocation as bishop: his reluctance was overcome by a miraculous consecration resulting from an effusion of holy oil from heaven. Many more miracles followed, some of which we will find depicted in the tympanum of the south transept portal. The most important event that secured the preeminence of this bishop among the saints of the diocese was the discovery of the relics of the martyred saints Fuscien, Victoric, and Gentien. Childebert I (c. 496–558) himself had allegedly attempted to take possession of these relics, but was miraculously prevented from moving them. The king subsequently made generous gifts to endow the cult of the three saints and sent goldsmiths to Amiens to make a silver châsse.

The innermost figure to the right side of the portal is also a bishop, and is assumed to represent the fourth-century Firmin the Confessor—son of Faustinian, the Roman senator converted by Firmin the Martyr (fig. 2.23). The Confessor, whose feast was celebrated on September 1, was the patron of the parish and collegiate church that existed on the northern flank of the cathedral nave just to the left of this portal. After a stay in Rome he returned to Amiens to rebuild the churches destroyed by the Huns, erecting a church on the site of Firmin the Martyr's tomb at Abladène, where he himself was finally buried.

Next to the Confessor is a deacon generally identified as Saint Domice, the spiritual guide and protector of the saintly virgin Ulphe, and once a major player in the company of local saints with a major annual procession on Palm Sunday during which his châsse would be carried out to the nearby Church of the Jacobins. Domice's feast was celebrated on October 23. Given the simultaneous proximity and distance that (according to legend) characterized their relationship, it seems appropriate to find Ulphe and Domice here on opposite sides of the same portal. In this figure the sculptor has succeeded in breaking away from the too-well-established Amiens saintly type, carving a figure that is full of humanity.

The next figure in the sequence, our third bishop, is generally identified as Saint Sauve (Salvius or Salve) who succeeded Honoré and died in 615. His feast was celebrated on October 28–29. Born of a wealthy family of Amiens he gave up his wealth in order to construct a monastery at Montreuil-sur-Mer, of which he became first abbot. The story of Bishop Sauve's discovery of the lost relics of Firmin the Martyr is told in the tympanum above. In the spirit of local tradition, it is to Bishop Sauve that we owe the existence of the cathedral in the city—legend had it that the original episcopal seat was outside the city at Notre-Dame-des-Martyrs.

After Sauve come three male figures, sometimes identified as the local saints Fuscien, Warlus (or Warlois), and Luxor. The relics of Warlus and Luxor were contained in a châsse mounted on the tribune in the sanctuary and their feast day was celebrated on November 20, but we know little about their lives. Perhaps Fuscien's companions, depicted here, were Victoric and Gentien, said to be part of a group of evangelists who came from Rome in the third century. Endangered as a result of the persecutions of Rictius Varus, Fuscien and Victoric were sheltered by Gentien.

All three were then executed. The place of their burial was said to be revealed in the sixth century to Lupicin (Lupicinus), a priest of Amiens, whose joyful singing came to the ears of Bishop Honoré—an event we will find depicted in the tympanum of the south transept portal. One of the three column figures is depicted with a sword in reference to his execution. The other two carry scrolls—the figures actually look as if they had been intended to play the role of prophets rather than martyrs. The feast of the three saints was celebrated on December 11.

Below the column figures, the signs of the zodiac and labors of the months convey the cyclical nature of life and of the liturgical year (figs. 2.24–25). The year begins to the right of the portal with the double-headed Janus, proceeds to the outer edge of the embrasure, and finally returns from outer to inner on the matching embrasure on the left. It is within the revolving sequence of the year that the saints are remembered, each on their appropriate feast day, keeping the saint alive and present within current time and space.

In the middle and upper levels of the tympanum we encounter the story of the discovery (Invention) and triumphal procession (Translation) of the relics of Firmin the Martyr—a story lying at the very root of the existence of Amiens Cathedral (figs. 2.26–27).[22] Whereas clearly established proto-types in monumental sculpture existed for the other two tympana, here the

nonchristian influence

FIGURE 2.24 Portal of Saint Firmin, left embrasure, quatrefoils: Zodiac signs and monthly labors

FIGURE 2.25 Portal of Saint Firmin, right embrasure, quatrefoils: Zodiac signs and monthly labors

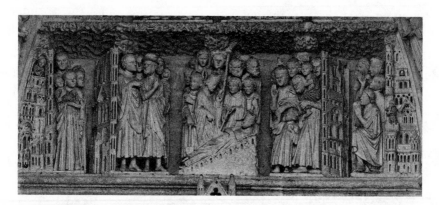

FIGURE 2.26 Portal of Saint Firmin, invention of the relics

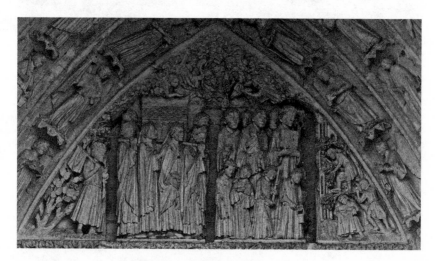

FIGURE 2.27 Portal of Saint Firmin, translation of the relics

composition is novel.[23] The sculptor has set shallow, carved blocks in front of the masonry field of the tympanum. In the center of the middle register the fully clothed body of a bishop rises out of a sarcophagus set at an angle as if to provide a better view. How can one fail to remember the similar form of the sarcophagus and the peculiar head-upward levitation in the matching scene of the Assumption of the Virgin Mary (fig. 2.17)? Instead of angels around the body, however, Bishop Sauve and his followers are illuminated by a central ray of light (oddly resembling a twisted cable) that strikes the ground where the body was hidden.[24] The bishop pokes with a diminutive spade; he is accompanied by others wielding spades and a multigenerational audience including older men with beards, children, and a praying woman who wears a nun's veil. On either side of the central scene are four city images with people emerging—the neighboring cities mentioned in the written accounts of the miracle are Thérouanne, Cambrai, Noyon, and Beauvais. Notable is the variety in each group of people: the old, adult men and women, and children of both sexes—this, again, corresponds to the written sources compiled by the editors of the *Acta Sanctorum*.

The festive translation of the body of Saint Firmin, from the place where it was unearthed at Saint-Acheul to the east of Amiens into the city, is depicted in the top register of the tympanum (fig. 2.27). According to the written sources, as the procession approached the city the cold winter's day miraculously turned to warmth: flowers bloomed, the air was filled with sweet odors, and the trees became green with leaves.[25] In our sculptured depiction the city gate (the eastern gate of the Roman city) known later as the Porte de l'Arquet—the miraculous gate of Saint Martin and the beggar—is seen on the far right. Youths climb trees gathering the fronds of foliage to strew in the path of the procession, which is clearly intended to echo Christ's Triumphal Entry into Jerusalem. The link was enhanced by the fact that close to the Roman gate was a tower known as the Tower of Jerusalem. In the sculptured depiction the procession is led by five choirboys in albs, carrying censers and a candle. A boy points to an open book he carries as if to validate the depiction through reference to a written source. Behind come clerks in dalmatics carrying a closed book and an arm reliquary. Then follows (carved in a separate block of stone) the steep-roofed châsse of Saint Firmin carried by two mitered bishops and four clerks. The châsse, with its arcaded side panels and lid decorated with quatrefoils, makes reference to

the real object of many a pilgrimage: the relic box raised aloft at the center of the gallery behind the main altar in the choir.

Behind the châsse follows a young man in a broad-skirted garment holding a flowering branch in his left hand. Overcome by the excessive heat generated by the miracle, he has thrown off his coat and carries it on a stick over his right shoulder. On his head he wears a foliate crown, while behind and above him sprout luxuriant leaves. This is the Green Man (*l'homme vert*) who, as enacted by the beadle of the church of Saint-Firmin-en-Castillon on the anniversary of the miracle of the leaves, would come into the choir and present each canon and chaplain with a foliate crown.

This portal was clearly designed to help enhance the position of the cathedral clergy within the city and the status of the bishop as principal *seigneur* of the city.[26] Thus, the bishops who presided over the construction of the cathedral were directly associated with their saintly predecessors, and the emphasis upon urban space and the enthusiastic support of the ordinary people is very striking. Amiens is seen as a type of Jerusalem, a place of saints and miracles, and the very center of devotion for a larger area reaching well beyond the confines of the city and region to include Cambrai, Noyon, Beauvais, and Thérouanne.

d) Central Portal of the Triumphant Christ, the Beau Dieu (Fig. 2.28)

First, let us stand back and assess the difference between the central portal and what we have just seen in the lateral portals whose narrow configuration causes the column figures to recede sharply, hiding one behind the other (fig. 2.1). Here in the central portal the shallow splay of the embrasures allows the line of column figures to spread out and greet viewers, inviting them into the church—a role entirely appropriate for the prophets and apostles (figs. 2.29–30). The transition between the minor prophets on the buttresses and the apostles flanking the portal is made first by the angry Nahum (left) and consolatory Micah (right), and next (on the inner angles of the front buttresses) by the four major prophets on the inner faces of the buttresses: Daniel and Ezekiel to our left, and Jeremiah and Isaiah to our right. The prophecies illustrated in the quatrefoils below were chosen in order to negotiate the transition from Old to New Testaments: thus, the

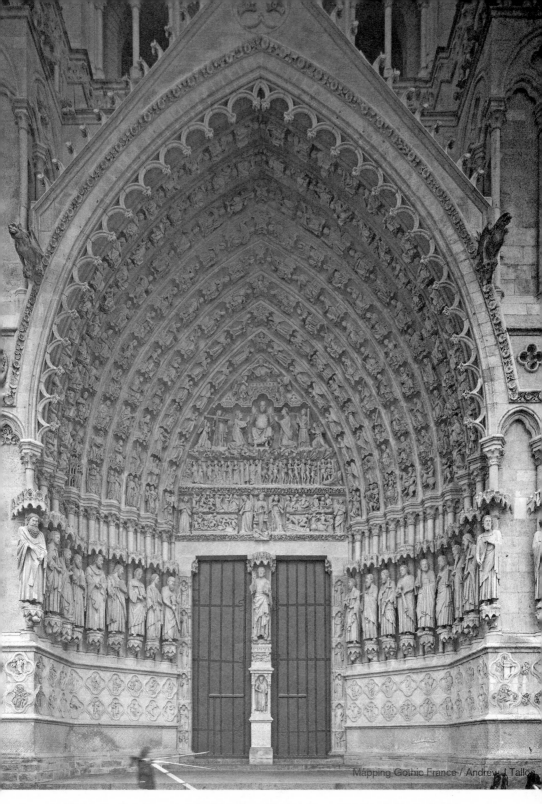

FIGURE 2.28 Central portal of the Triumphant Christ, the *Beau Dieu* (Media Center for Art History, Andrew Tallon photographer). See also color plate.

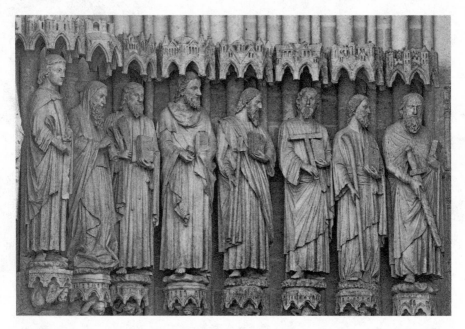

FIGURE 2.29 Portal of the Triumphant Christ, left embrasure, apostles and major prophets left to right: Daniel, Ezekiel, Simon/Jude, Philip? Matthew? Thomas, James the Lesser? Paul

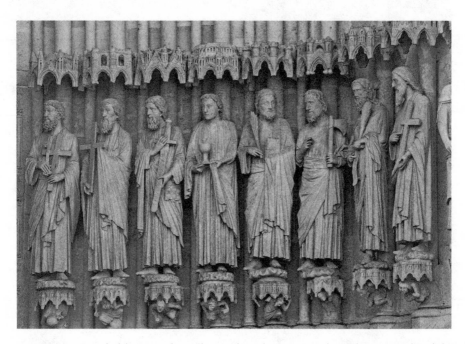

FIGURE 2.30 Portal of the Triumphant Christ, right embrasure, apostles and major prophets left to right: Peter, Andrew? James the Greater, John, Simon/Jude? Isaiah, Jeremaiah

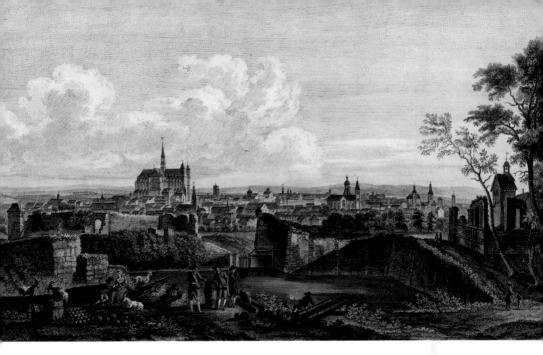

FIGURE 0.1 View of Amiens from the walls of the Citadel: drawn by Basire, engraved by Duparc, c. 1780 (Archives départementales de la Somme)

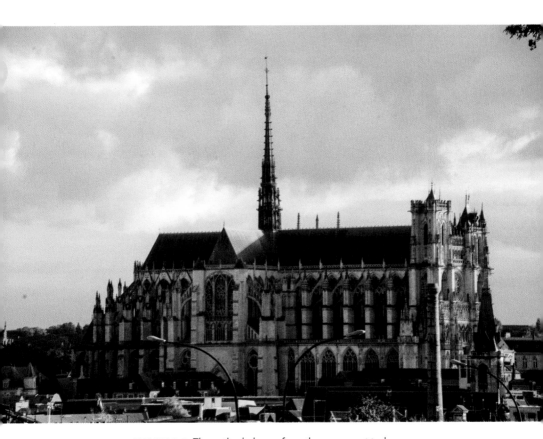

FIGURE 0.2 The cathedral seen from the same spot today

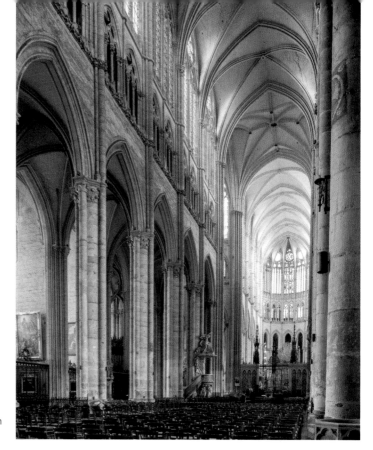

FIGURE 0.3 View down the length of the nave

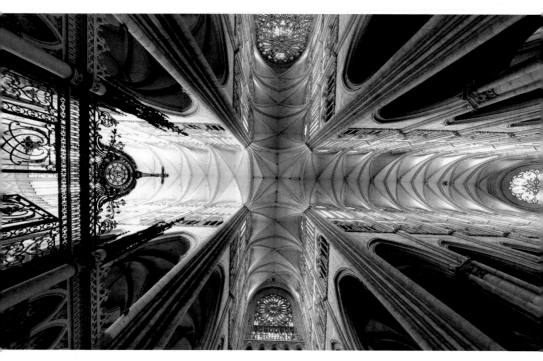

FIGURE 0.4 Spatial envelope of the cathedral: we are in the middle: *in medio ecclesiae*

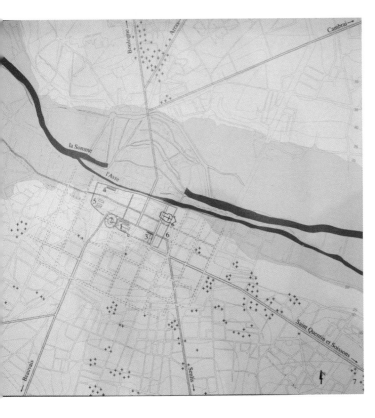

FIGURE 1.3 The late Roman wall c. 300 (La marque de Rome. Samarobriva [Amiens]). 1: forum, 2: amphitheater, 3: sword manufacturing, 4–5: storehouses, 6: St Martin's gate, 7: necropolis of S-Acheul

FIGURE 1.6 Distribution of power in the medieval city (from Massiet du Biest, reworked by Emogene Cataldo). Pink indicates land controlled by the bishop; yellow the chapter; white, the commune. The small circles indicate water mills.

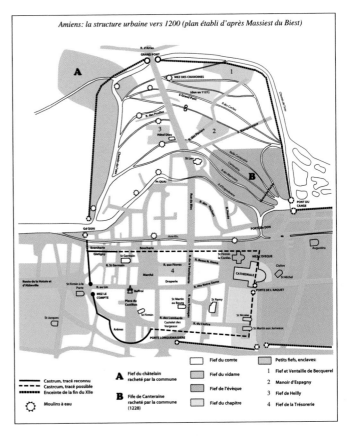

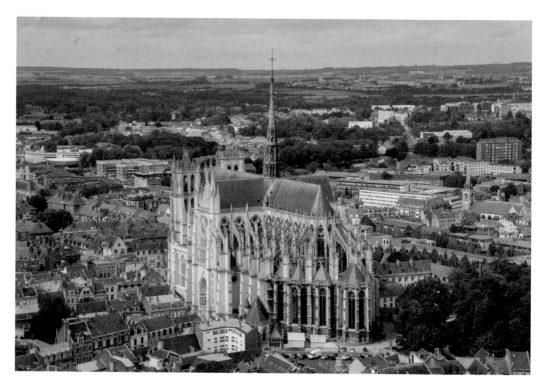

FIGURE 1.7 View from the *Tour Perret*, 104m high. The tip of the cathedral steeple is 112m.

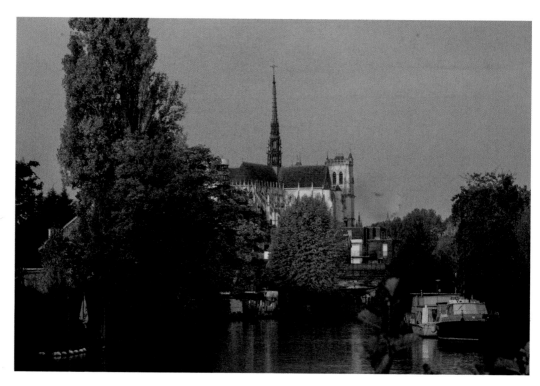

FIGURE 1.10 View of the cathedral from the bank of the river Somme, upstream

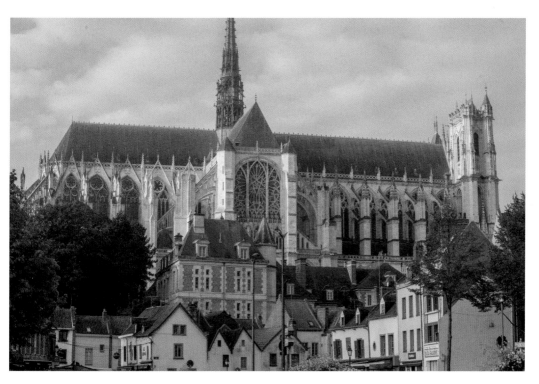

FIGURE 1.12 Cathedral from the north, *Quai Bélu*. The bishop's palace is the brick-and-stone structure in front of the north transept. The saw-toothed houses in front are of the type inhabited by medieval laypeople and artisans.

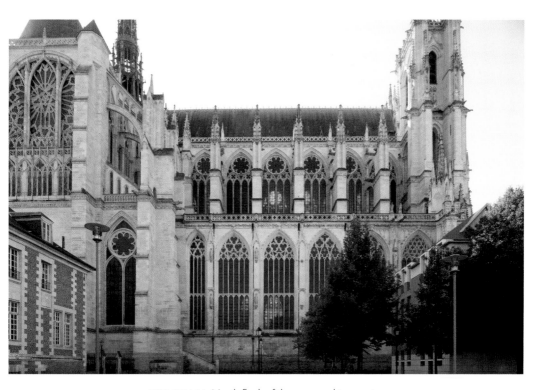

FIGURE 1.16 North flank of the nave and transept

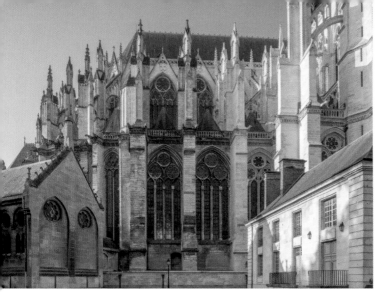

FIGURE 1.22 Chevet, north flank. Bishop's palace to the right, winter chapel to the left

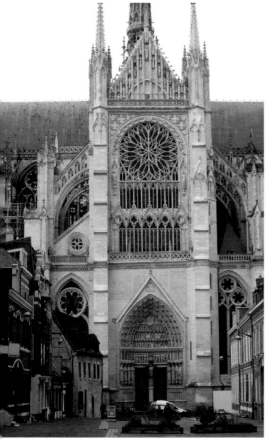

FIGURE 1.26 South transept façade

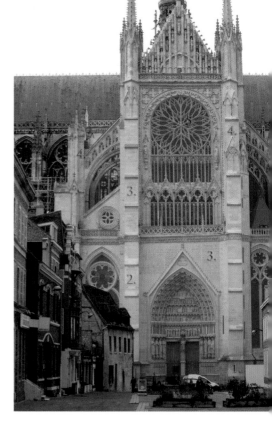

FIGURE 1.27 Chronology of the south transept façade

1. 1220s: Robert de Luzarches
2. 1220s–1230s: Robert of Luzarches and Thomas de Cormont
3. 1230s–1240s: Thomas de Cormont
4. 1240s–1270s: Renaud de Cormont,
5. c.1500: Pierre Tarisel

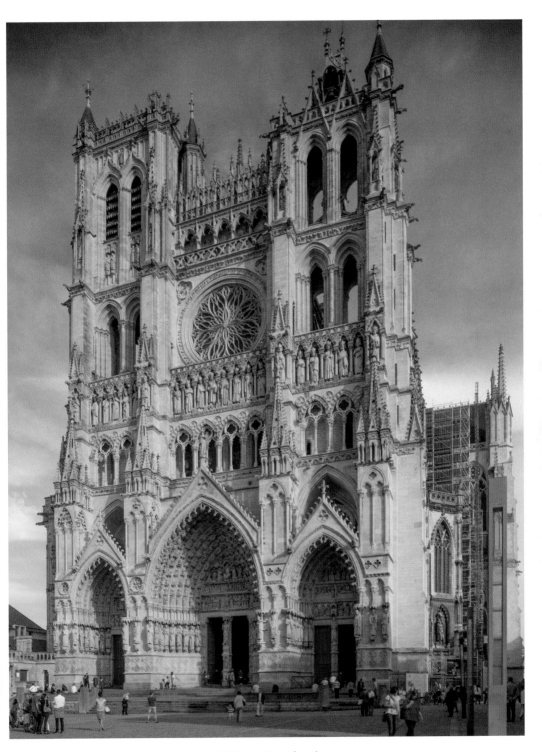

FIGURE 1.32 West façade

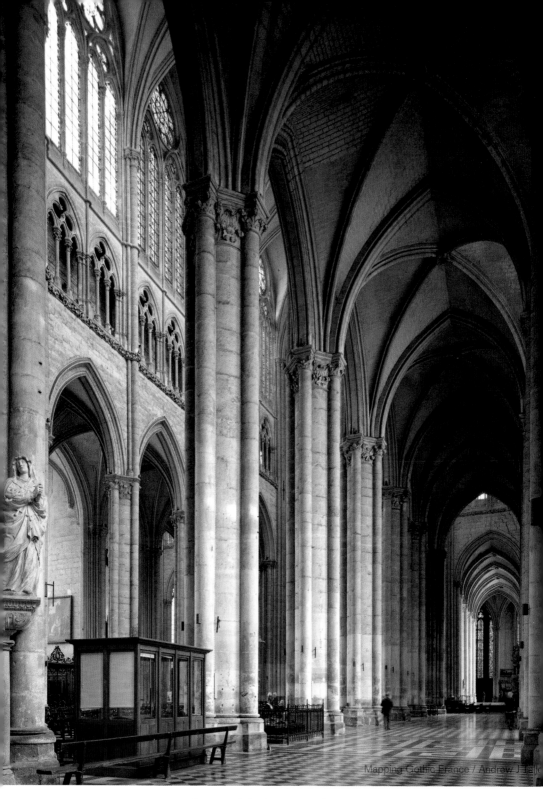

FIGURE 1.36 South nave aisle looking up into the elevation of the main vessel
(Media Center for Art History, Andrew Tallon photographer)

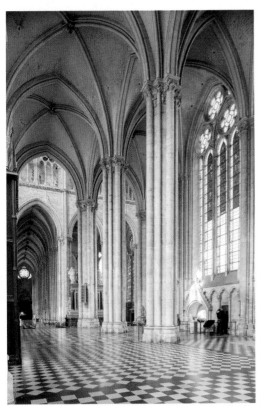

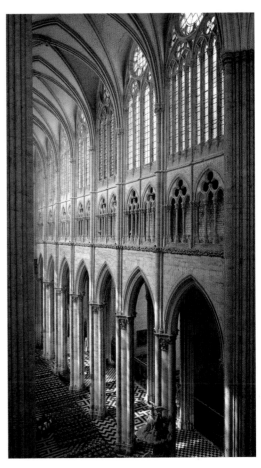

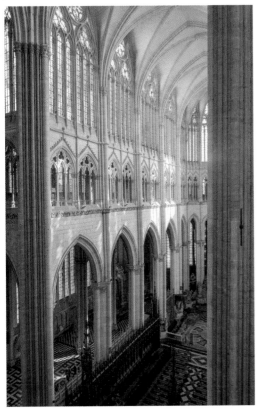

FIGURE 1.53 (top, left) North choir aisles, looking northwest

FIGURE 1.59 (top, right) Nave elevation, looking northwest (Media Center for Art History, Andrew Tallon photographer)

FIGURE 1.60 (right) Choir elevation, looking northeast

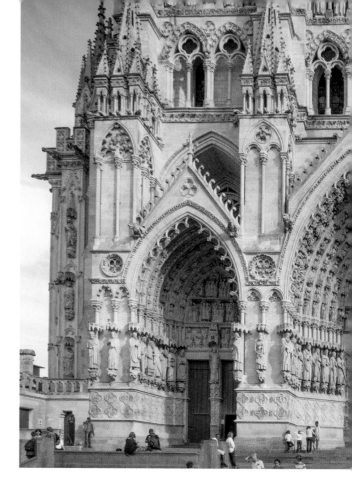

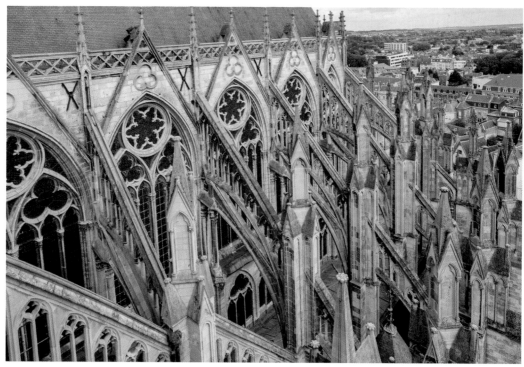

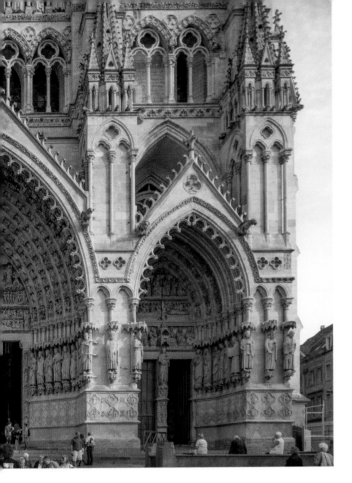

FIGURE 2.1 (*left*) The three western portals

FIGURE 1.66 (*bottom, left*) Upper chevet, south side, looking east, flying buttresses

FIGURE 1.67 (*bottom, right*) Upper chevet, hemicycle, seen from the east

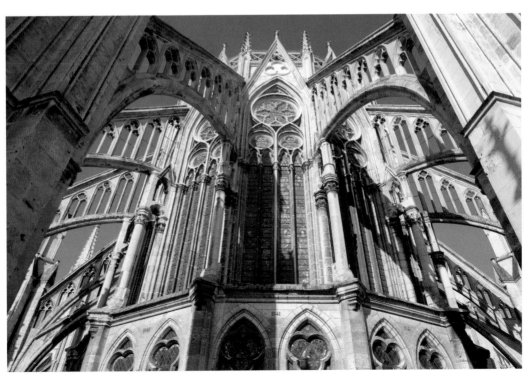

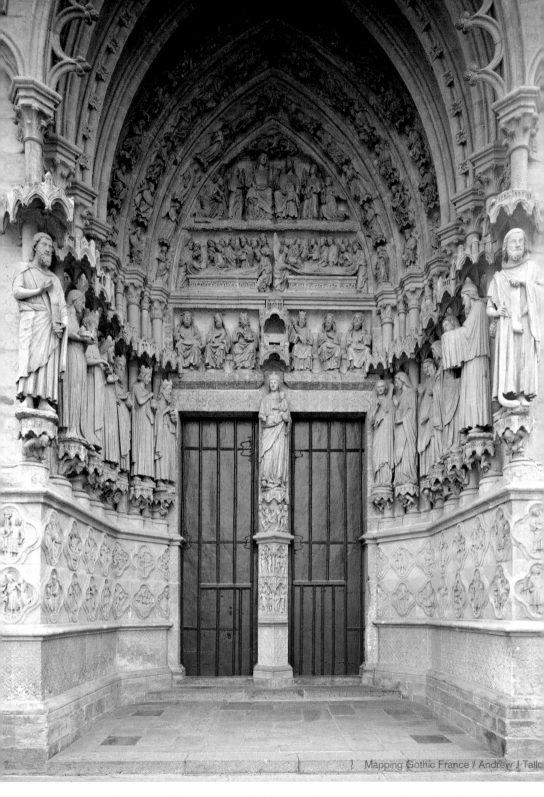

FIGURE 2.8 Southern portal of the Virgin Mary (Media Center for Art History, Andrew Tallon photographer)

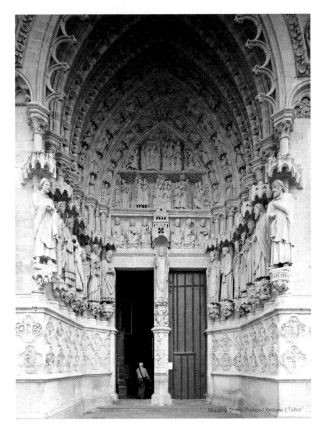

FIGURE 2.19 Northern portal of Saint Firmin (Media Center for Art History, Andrew Tallon photographer)

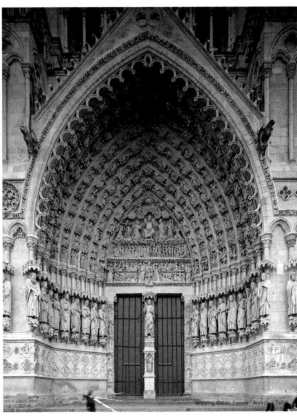

FIGURE 2.28 Central portal of the Triumphant Christ, the *Beau Dieu* (Media Center for Art History, Andrew Tallon photographer)

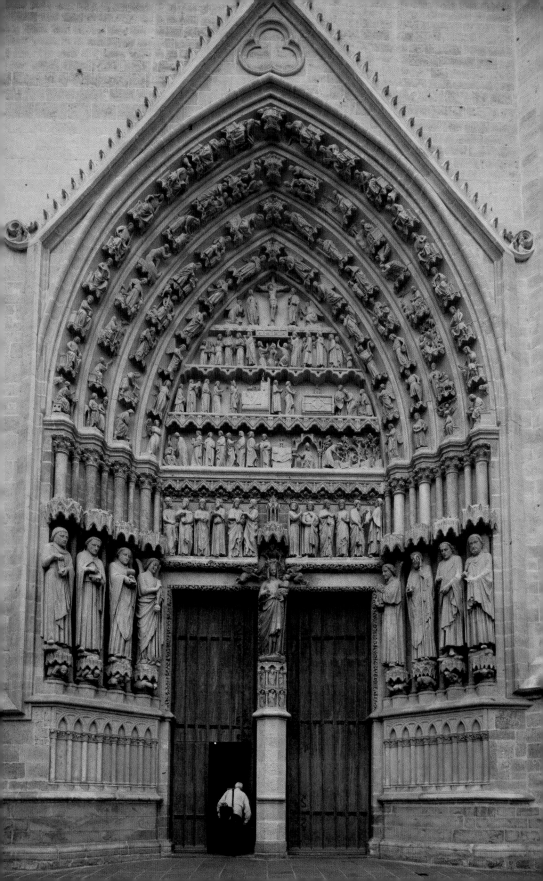

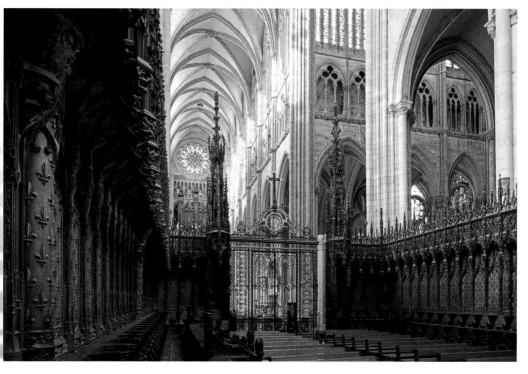

FIGURE 3.1 General view of choir, looking to the west

FIGURE 2.39 (*opposite page*) South transept, portal of Saint Honoré

FIGURE 3.2 Tomb of Bishop Evrard de Fouilloy

FIGURE 3.3 Tomb of Bishop Geoffroy d'Eu

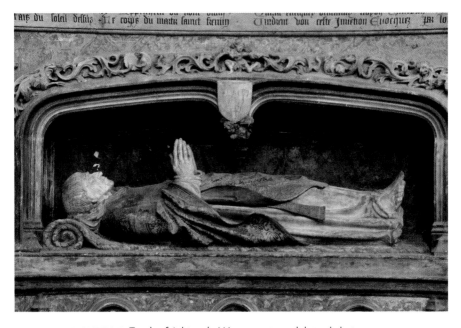

FIGURE 3.9 Tomb of Adrien de Hénencourt, south lateral choir screen

interlocked wheels under Ezekiel and the two seraphim under Isaiah refer to the two testaments; the Old Order is put straight by the New with Christ correcting Jerusalem under Ezekiel; and Isaiah has his lips purged by a hot coal held in tongs, the two parts of which symbolize the two testaments.

The attentive viewer who remembers the comparatively regular figures of the minor prophets might be struck by the different forms assumed by the prophet Isaiah. In contradiction to the pronounced verticality seen elsewhere, Isaiah assumes a gentle contrapposto stance and his robe falls in the crinkled hooked folds of the Antique Revival style. His face, with almond-shaped staring eyes and wavy hair carved with geometric regularity, is quite different from those of his companions to either side. It may be that this mode, also seen in the figure of Saint Ulphe, was an early experiment in the sequence of sculptural production at Amiens later rejected in favor of the more severely columnar type of figure that I have associated with the mosaics of Ravenna. The matching prophet on the left side of the portal, Ezekiel, is also rather odd. His short and stocky body is enveloped in an oversized robe and his head is covered in a cowl, although a short fringe of hair is visible on his forehead.

The aberrant forms of Isaiah and Ezekiel lead us into the emphatic regularity of the twelve apostles who line the widely splayed embrasures of the portal on either side of the triumphant Christ in the central trumeau. The verticality of each figure's stance is enhanced by the contrast with the little crouching figure in the supporting console below—figures generally identified as the Roman emperor or governor responsible for each martyrdom. The images of the apostles with their vertical stance and (with two exceptions) heads turned inward to the portal are so repetitive that only four individuals are readily recognizable: Peter, to Christ's left, has tightly curled hair and beard and bears a cross; Paul, to Christ's right, is bald and heavily bearded and carries a book and sword.[27] John is young and unbearded; James, next to him, has a pilgrim's pouch with cockleshells. The others have been identified by their attributes but some ambiguity remains, in part due to nineteenth-century restorations. The apostles to the right of Christ (at our left) all carry books, whereas only one book appears on the other side.

Unlike the figures lining the Virgin portal, who are energized by their role in the Christmas story, the images of the apostles appear timeless, as if suspended between heaven and earth. Might these really be living, breathing human beings, or have they reached the perfection of their post-resurrection state?

They gain levels of meaning through their attachment to the architectural frame by a column anchored to the back (they *support* the church/Church) and through the perfection of the serial production that lends to each member of the group a high level of likeness one to another. Within the Augustinian theology of medieval thinkers like William of Saint-Thierry (Guillaume de Saint-Thierry), likeness conveys the idea of *participation:* a saint's proximity to Christ will be conveyed by physical similitude.[28] The key to the achievement of this level of proximity to Christ is provided by the way we live—by the choices between virtue and vice. These choices are expressed in the images in the low-relief quatrefoils placed below the apostles (figs. 2.31–32). Here the designers of our portal program have avoided a binary opposition of virtue to Christ's right side and vice to the left: they have instead placed the vices, explicitly depicted, within the distance of our touch; and the virtues, female personifications, hovering just out of reach. A similar arrangement had already been deployed in the central portal of Notre-Dame of Paris. At Amiens the exception to the personified virtues is Charity, where the depiction of the dividing of a cloak for a poor beggar carries the specifically amiénois memory of Saint Martin. The repetitious quality of the quatrefoil frames with their low-relief

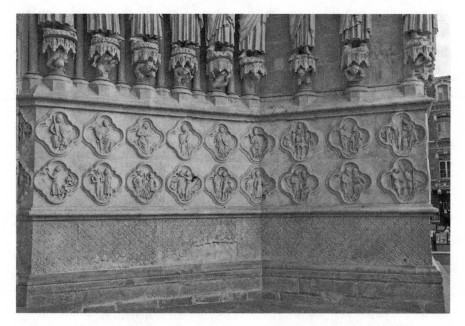

FIGURE 2.31 Portal of the Triumphant Christ, right embrasure, quatrefoils: virtues and vices

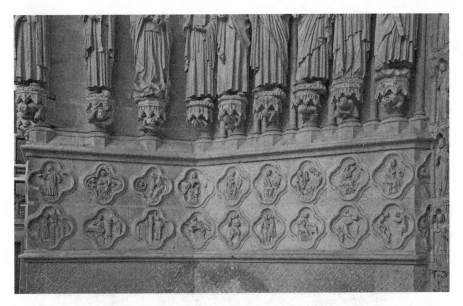

FIGURE 2.32 Portal of the Triumphant Christ, left embrasure, quatrefoils, virtues and vices

images is reminiscent of wax impressions mechanically produced through the imprint of a seal. Such impressions are synonymous with memory images.

The majestic figure of Christ on the trumeau, the Beau Dieu, provides the prototype: a template or mold forming the image of each of the apostles (fig. 2.33).[29] We see that Christ has triumphed over evil and death as expressed in the two beasts, leonine and serpentine, trampled under his feet. His right hand is raised in blessing; the left, holding a book, hitches up the drapery swathing his waist to create a handsome diagonal cascade of folds. Christ's feet seem to ride forward on the beasts; high above us, his wide-open eyes stare out into the middle distance. The beasts trampled by Christ refer to Psalm 91: "Thou shalt tread upon the lion and the adder; the young lion and the dragon shalt thou trample under thy feet." In the *Speculum ecclesiae* of Honorius of Autun, the sermon for Palm Sunday is based upon this text.[30] The idea of the Palm Sunday Triumphal Entry of Christ into Jerusalem with Christ as the door thus lies at the center of the sculptural program, just as the Easter celebration of the resurrection of Christ and the Eucharist lie at the center of Catholic dogma and faith.

Saint Augustine and other church fathers stressed the link between Psalm 91 and Matthew's account of the temptation of Christ.[31] The devil, tempting

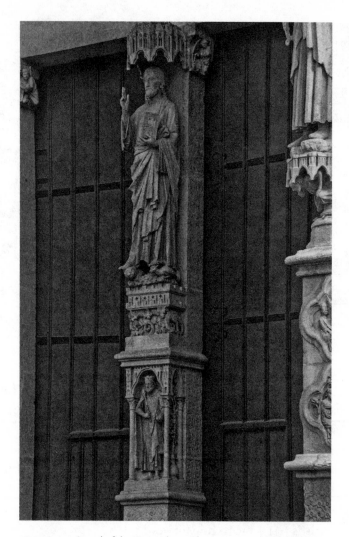

FIGURE 2.33 Portal of the Triumphant Christ, trumeau: the *Beau Dieu*.
In the base, an image of Solomon

Christ to leap from a high pinnacle of the Temple, had the wit and cunning
to quote the psalmist's words: "for it is written, He shall give his angels
charge concerning thee; and in their hands they shall bear thee up, lest at
any time thou dash thy foot against a stone." Beholders may, if they like, see
the architectural canopy above Christ as the pinnacle of the temple. Christ's
ability to triumph over the devil and resist temptation provides the living
model or template for those who would wish to emulate him and join the

elect.[32] We can see that the apostles are human beings formed according to the template provided by the living Christ. The visitor to the church, invited to aspire to the same form, is provided both a map (the quatrefoil images of the virtues and vices) and the door (Christ) through which to enter.

That Christ is the physical embodiment of the new *Logos*, the ordering principle, is made manifest in the base of the trumeau, below Christ, with the image of the figure who expressed the wisdom of the Old Testament: King Solomon, thought to have been the author of the Song of Songs. Solomon is enclosed in a canopy and flanked by the lilies featured in the Song.

While the designers of the portal have avoided the binary division of good and evil in the figures lining the embrasures, it is introduced in two sets of images: those in the doorposts immediately flanking the portal, and those above in the tympanum where we encounter the Last Judgment at the end of time: the elect go to Christ's right (our left), and the damned to Christ's left. On the side of the saved (to our left) immediately flanking the door we see the wise virgins with their lamps upright, indicating that they are full of oil and lighting the way forward; while to the right the foolish virgins allow their lamps to dangle uselessly. The story of Christ's parable is recounted in Matthew 24:3 as a sign of the imminent ending of the world and final judgment. The ten virgins were bridesmaids invited to a wedding feast: in the context of the portal that feast might be understood as the Eucharistic banquet.

In the tympanum above the portal, the events of the Last Judgment and the end of time unfold with dreadful inevitability from bottom to top (fig. 2.34). In the lowest level, the lintel, we see the resurrection of the bodies of all humans who have ever lived and died, and who now rise up from the detritus of the tomb to be reconstituted as human beings (fig. 2.35). While theologians might worry about the logistical problems attending this surprising reembodiment, it was left to the *tailleurs d'images*, the sculptors, to picture this transformative process. The corporeality of the resurrected body lends itself particularly to the art of the sculptor working in the three-dimensional medium of stone, assisted by his colleague, the painter, who rendered the bodies in living shades of pink and red (traces of color are still visible). Naked and seminaked men and women, some still wearing their tomb shrouds, are seen forcing their way out of the heavy-lidded sarcophagi in the eight deeply carved blocks and in front of the masonry field of the lowest register of the tympanum. The newly incorporated look up in

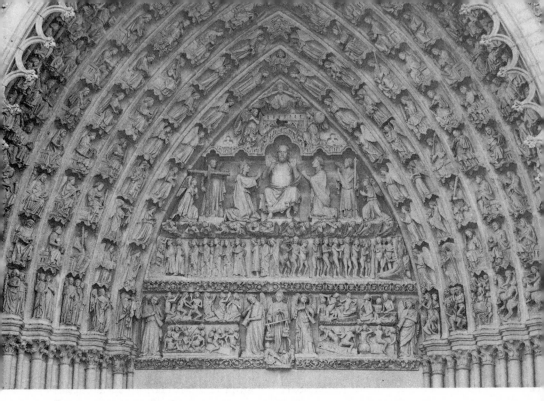

FIGURE 2.34 Portal of the Triumphant Christ, tympanum

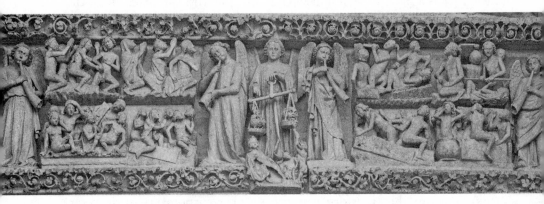

FIGURE 2.35 Portal of the Triumphant Christ lintel, resurrection of the Dead

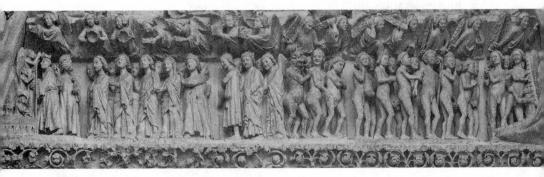

FIGURE 2.36 Portal of the Triumphant Christ, separation of the saved and damned

reaction to ongoing events with a variety of emotions: fear, anticipation, confusion. Some clasp their hands in prayer. They are surrounded by trumpeting angels. In the center stands Michael with his scales. To be found worthy one needs weight. To our left the weight of the *Agnus Dei* tips the scales, while the devil's head is found worthless (without weight). At the very front of the stage a tiny image of *Synagoga*, blindfolded, slumps under the devil; while under the Agnus Dei, *Ecclesia* (with head replaced) sits up and points to her scroll.

The division of saved and damned as it unfolds above follows Saint Matthew's narrative (fig. 2.36).[33] On the left side a devil chivvies a miserable band of naked people through the gauntlet line of angels with flaming swords toward the mouth of hell. One man staggers under a heavy weight slung around his neck—a miser punished by his own moneybags. Only two women share the fate of this mostly male group that includes a king and a bishop. Clutching on to each other they are hustled forward; the two leaders look back in anguish but it is too late: a long hairy arm reaches out from the very mouth of hell as a devil pulls them in. The horrors to be encountered by the damned—strangling, scalding, and torture concentrating on the sexual organs—are continued in the lowest elements of the voussoirs, which could represent purgatory or hell itself.

The elect, a mixed group of men and women (including one crowned figure) wearing the same long robes as the apostles and prophets in the jambs of the portal below, are ushered off to our left by angels offering crowns. They are led by a friar clad in a cowled habit fastened with a triple-knotted girdle. He covers his hands—doubtless a reference to Saint Francis of Assisi who habitually concealed his stigmata. Saint Peter welcomes the elect to heaven, depicted here as an oversized door attached to a miniscule church with buttresses and spire. Angels provide light (candles) and sweet odor (censers), and crown the triumphant Francis at the gates of heaven.

Heavenly images are carried over into the bottom of the voussoirs, matching the infernal scenes on the other side. Thus, we see souls in Abraham's bosom and pairs of people, male and female, some accompanied by angels, heading toward heaven. The leading couple carries posies and birds.

Above the separation of the saved and damned sits Christ the Judge, framed within a trilobed architectural canopy (fig. 2.37). Above the canopy

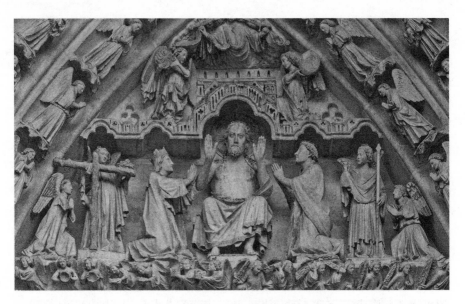

FIGURE 2.37 Portal of the Triumphant Christ, Christ the Judge

is a basilical structure with seven red-painted windows (referring to the Apocalyptic narrative that unfolds in sevens), encouraging us to see this as the New Jerusalem. The seven bays of the nave of Amiens Cathedral, and the seven segments of the hemicycle, make sense in relation to this dominant theme. Christ the Judge is not a fearsome or godlike figure: with his upper body naked except for a fold of drapery covering the left shoulder, and seated on a low pedestal (hardly a throne), he raises his hands, palms forward, to display his wounds that were once painted. However, the sinner might find Christ's eyes quite alarming: wide open, and with the dilated pupils splaying slightly outward—unfocused, yet seeing everything. With this image, an axis is created down the length of the cathedral, since the body and blood depicted here are the Eucharistic body and blood of the resurrected Christ transformed from the wine and bread on the high altar at the center of the sanctuary. It was at the Fourth Lateran Council of 1215 that the Catholic dogma of Transubstantiation was codified in the presence of the bishop of Amiens, Évrard de Fouilloy.

Christ is flanked by the intercessors, Mary and John the Evangelist (wearing ecclesiastical garb), while angels on each side bear the instruments of the Passion: cross and crown to his right, spear and nails to his left.

At the tip of the central tympanum is the awesome image of Christ of the Second Coming: the apocalyptic Christ described by Saint John in the first chapter of Revelation. Two swords issue from his mouth while he holds in his hands two scrolls that disappear into the clouds described by the Revelation text. Traces of bright red and blue paint can still be seen in his halo: this image was once ablaze with color. The finality of Christ's Second Coming is underlined by the interruption of the comforting alternation of sun and moon—here held by a pair of flanking angels.

In the voussoirs framing the tympanum, images of heaven and hell (or purgatory) occupy the lowest level to our left and right, while above we see orders of angels, patriarchs, virgins, apocalyptic elders, kings, and prophets.

e) The Grand Scheme: God's Plot for Humanity

The west portals were completed quite rapidly without major revisions. The project started soon after 1220 in the south portal of the Mother of God, continued into the 1230s with the north portal of the saints, and concluded with the central portal toward 1240. What we have here is a coherent body of thought, expressed visually. Modern visitors may engage with this extended and complex program as they would with a kind of puzzle.[34] Intent on teasing out meanings, they may focus upon this or that cluster of images, or linger back to puzzle over the overall meaning of the ensemble. In this way we engage with the minds and the creativity of the cathedral's makers in their attempt to comprehend, visualize, and propagate the Divine Plot.

Based on the written evidence of the later Middle Ages, we may surmise that a small group of clergy led by the cathedral dean (and possibly including the bishop) constituted an iconography committee, entering into extended conversations with the master mason and with a select group of gifted sculptors or *tailleurs d'images*.[35] In these conversations we might expect the dean to take the lead, projecting his own preoccupations and objectives, which might then be modified in the ensuing give-and-take.

The Amiens dean at the start of work was a noted theologian and churchman destined for an illustrious future. Jean d'Abbeville (also called Jean Halgrin) was born north of Amiens around 1180 and studied theology in Paris, where he must have absorbed the thought and the teachings of illustrious figures like Hugh and Andrew of Saint Victor, Peter the Chanter, and

Stephen Langton.[36] D'Abbeville became dean at Amiens in 1218 but left in 1225 to become archbishop of Besançon. Having been nominated patriarch of Constantinople, he was called into papal service by Pope Gregory IX as cardinal-bishop of Sabina. His engagement with Amiens continued after his departure: he is remembered as the founder of the first cathedral chapel, established in 1233 to the east of the south transept arm and dedicated to the Conversion of Saint Paul. The dean's affection for Paul is expressed in that saint's position to the right of Christ in the central portal. Our dean died in 1237.

While studying in Paris, Jean d'Abbeville would have spent countless hours considering the multilevel reading of the scriptures.[37] Following the medieval hermeneutic methodology know as the *quadriga*, readers were encouraged to embrace four levels of meaning: first, the literal reading of the text as an historical account of what actually happened; second, the extraction of the underlying symbolic or allegorical meaning of the text, often involving the interpretation of the prophets and the exploration of the typological links between Old and New Testaments; third, the tropological or moral application of the textual message to the life of the reader and the wider public; and fourth, the anagogical or upward-lifting approach, leading to a perfect union with God. Memories of the teachings of Hugh of Saint Victor (d.1141) would lead students to be particularly interested in visual representations of these levels of meaning.[38]

The sculptural program at Amiens Cathedral engages the user on all four levels. Understood literally, the interwoven stories of the Old and New Testaments and the lives of the saints flow from right to left, with the Genesis story of Creation and the Gospel story of the Incarnation both starting in the south portal—appropriately enough, the first work to be undertaken soon after 1220. The equivalent portal to the north, on the other hand, belongs to the post-Incarnation age of the saints. In the sculptural program of Amiens Cathedral, the literal level of understanding as a reading of his-torical events was enhanced by multiple borrowings from representations in liturgical dramas where Old and New Testament events and stories of the saints came alive, enacted by living people in contemporary time and space. Particularly exciting was the recreation—in the realistic three-dimensional medium of painted stone—of the multiple miracles recounted in the writ-ten sources and involving, above all, miraculous transformation. Thus, in

the Mère Dieu portal, as our attention shifts from the inanimate body of the Virgin Mary in the Dormition on the left of the tympanum to the animated scene of the Assumption on the right (figs. 2.17), she is actually *seen* to levitate; and when she is crowned in heaven, following the words of the Song of Songs, flowers bloom and wonderful scents fill the air (fig. 2.18). As we then turn to the northern portal of the saints, Old Testament patriarchs change into bishops before our very eyes; similarly, the shrine of the Ark of the Covenant becomes the châsse of Saint Firmin (figs. 2.16 and 2.21). In the narrative of the discovery of the relics of the saint, a cold winter's day miraculously turns to spring (figs. 2.26–27). But the most dramatic change comes in the central portal where bodies long since dissipated into dust through the corrosion of death and decay are seen to be miraculously reincorporated and animated (fig. 2.35). And at the center of the program an axis is formed along the length of the entire cathedral, beginning with the tympanum image of Christ the Judge showing his wounds, continuing with the great crucifix mounted high above the choir screen, and culminating in the high altar where bread and wine are changed into Christ's body and blood in the Eucharistic sacrament. As if to confirm this point, an image of the resurrected body of Christ is set into the keystone of the hemicycle directly above the altar.

If the material media of stone and paint provided a dramatic, if challenging means of exploring and representing literal meanings, the groupings, juxtapositions, and hierarchy of the portals lent themselves admirably to the second, or allegorical level of understanding. Such allegorical readings can be found especially in the prophesies depicted in the quatrefoils, and in the linkages between Old and New Testaments (Song of Songs and Revelation) developed in the south portal, with the image of the Triumph of the Virgin. Dean Jean d'Abbeville was known both as a biblical commentator on the prophets and as a preacher: his allegorical and affective interpretation of the Song of Songs emphasizes the dynamic and dramatic unfolding of a programed sequence of events: *For this canticle unfolds like a prophecy, for people are transformed all of a sudden.* D'Abbeville, like Bernard of Clairvaux and many other contemporaries, turns the passionate movements and yearnings joining both lover and beloved in the Song of Songs to the understanding of the relationship between Christ and his spouse the Church—represented by his mother, the Virgin Mary—as they

are finally united at the end of time. The dramatic events of Song of Songs are accompanied by bursts of burning warmth, sweet odors, and prolific foliage—resulting in the liquification or meltdown of the obstinate soul.[39] It is in this semi-molten state that the soul can receive the form imprinted upon it by the Great Artifex, namely the Holy Spirit. In the preface of his homily for Advent, d'Abbeville emphasizes the role of the prophets, and Isaiah in particular because this prophet spoke of the mountains laid low and the cleansing fire. It is through the fire of charity that human pride will be replaced by humility; and what is cold, compact, and hard through malice and obstinacy will melt in repentance at the appearance of the Lord. At Amiens, of course, the prophets prepare us for the incarnation of the Man-God and the shock of entry liquifies even the most hard-hearted, preparing them to receive the extraordinary sequence of impressions that will be imprinted unforgettably upon the mind during the course of the visit whose crescendo is reached below the great central crucifix *in medio ecclesiae*.

Human transformation is essential to the third, or tropological level of understanding. While the allegories of the Song of Songs were popularized in Bernard of Clairvaux's sermons, Dean Jean d'Abbeville's studies in Paris would have exposed him to what Beryl Smalley has called the "Biblical moral school" and its lively debates on the essential quality and role of virtue.[40] The task of the student was not just to read and dispute the multiple understandings of the text, but also propagate those understandings to a wider audience—in other words, to preach (*lectio; disputatio; praedicatio*). Jean d'Abbeville was known above all as a preacher, and most interesting, in relation to the demotic character of the Amiens portal program, is his own characterization of the agenda for his sermons: eschewing the highly worked prose meant to charm the ears of the sophisticated in favor of addressing simple words to simple people. D'Abbeville's sermons include vehement attacks on self-indulgent prelates, clerks, and monks; and upon vainglory, ambition, avarice, simony, luxury, nepotism, harshness toward subordinates, and complaisance toward the powerful. He was sympathetic to the mendicants, Dominicans, and Franciscans, and worked to facilitate their establishment at Abbeville and Besançon.

It is quite possible that such a mendicant was responsible for composing a sermon delivered in the vicinity of Amiens at a time when the portals had been recently completed: the vernacular text from the library of pre-Revolutionary historian Pierre Nicolas Grenier (better known as Dom Grenier) has been preserved in the Collection de Picardie at the Bibliothèque nationale.[41] This is a fundraising sermon, apparently occasioned by the less than successful attempt of questers to raise money—no doubt for the construction of the cathedral—by carrying the relic boxes of the cathedral out into the churches of the diocese. At a time of fiscal crisis in 1240 the relics of Saint Honoré were put to exactly such a purpose. Reception of the relics had not been as generous as had been hoped, and parish priests were blamed for this lack of respect; when the sermon alludes to the disobedience of priests, it reminds us of the prophet Malachi's warning.

The sermon resonates with the cathedral portals: the same essential persuasive mechanism is employed in both. In Larissa Taylor's words: "a pessimistic anthropology [flawed human nature; final judgment] was therefore balanced by an optimistic soteriology [the pursuit of salvation] in which, thanks to God, everything was possible for the repentant sinner."[42] The preacher goes straight to the cause of this pessimistic anthropology: as children of Adam and Eve we are all condemned to final judgment: *Sinner, said our Lord, there where I find you, there I shall judge you. Know therefore and doubt not that the men and women who stayed away* [from church] *as I said will be taken in an evil hour. Know in good sooth that if they were taken on their land without having confessed their sins and repented they would be condemned to death and suffer the pangs of hell, as God is God, he shall not spare them.* The preacher's persuasive strategy thus begins in the images of the original sin in the pedestal of the Mère Dieu trumeau (fig. 2.12); it continues in the Last Judgment in the center (fig. 2.34).

Despite this dreadful prospect (the negative anthropology), the preacher weaves together three most efficacious strategies open to the listener who wants to make a new contract in order to avoid hell. The first path of salvation comes with repentance and a life devoted to following virtue and eschewing vice. By inviting the visitor to emulate the apostles by avoiding vice, and following virtue—indeed, by inviting the visitor to follow the

prototype of the apostles who have themselves been formed after the image of Christ the Beau Dieu—the central portal constituted a powerful mechanism of behavioral change. The second path of salvation operates through the efficacy of the Church with its abbots, bishops, priests, and sacraments (north portal). And finally, the third path is the agency of the Virgin Mary herself, who *is* the Church (south portal). These three paths of salvation correspond to the three west portals of Amiens Cathedral.[43]

Particularly interesting is the preacher's repeated references to vows and contracts. Humans can break the contract with death and Last Judgment by means of a new contract—a great bargain since, unlike Christ and the apostles, one does not actually have to give up one's life. And although he is initially a little coy, our fundraising preacher makes it progressively clear that a cash contribution will help ease the way along this path, thus effectively establishing a transactional relationship between the cathedral and its users.

Each of the three great trumeaux figures—Christ, Mary, or the bishop who stands for Christ on earth—can break your bad contract. In order to illustrate Mary's contract-breaking power, the sermon's preacher recounts the story of the clerk Theophilus who was rescued by the Virgin Mary from the consequences of his contract with the devil. Indeed, there can be no doubt that the iconlike image of the Queen of Heaven in the right portal assumed apotropaic powers for many medieval users (fig. 2.11). A sixteenth-century witness recounts a practice that had probably already started in medieval times.[44] At dusk, city folk and pilgrims would gather at the portal to kneel at the statue of the Virgin. As darkness fell and the rest of the sculpture faded into obscurity, a lamp hanging from a rope suspended from the voussoirs illuminated Mary, who might then become an object of intense personal devotion. It seems that this is the only portal painted soon after its completion—the others came later.[45] Continuing devotion to Mary is attested in multiple coats of paint.

With this we have surpassed the purely text-based understanding of the kind that our dean might have acquired in the Paris schools, and witnessed the power of images to stand as surrogates for the thing itself while providing mechanisms for transformation understood as behavioral change. In the same realm, we might consider the reification of figurative language in material images. Thus, Saint Paul might compare the prophets and apostles

to pillars bearing up the superstructure of the church/Church: our masons and the tailleurs d'images have made this metaphor palpable.[46]

Meanings can also be derived from references that images may make to other images—such allusions can result from the experiences of the makers, and they can trigger specific responses from the users. At the time of the start of work on the sculptural program, members of the higher clergy of Amiens had recently returned from Rome where they had attended the Fourth Lateran Council of 1215. The tropological program embedded in the sculpture reflected the new age of reform. Is it possible that the Italian experience may also have inspired some of the purely visual aspects of the work? We make a mistake to consider the Amiens portal program exclusively in the context of French Gothic stone sculpture: it was painted, and it drew upon sources well beyond the purely sculptural production of northern France (the familiar sequence of portal production from Saint-Denis, to Chartres, Senlis, Laon, Paris, and Reims). We have seen how the program is dominated and unified by the screen of columnar figures extending over the front faces of the buttresses: such a continuous line of figures cannot be found in any other sculptural program, and is more reminiscent of the long-robed martyrs and virgins who process down the nave of Sant'Apollinare Nuovo in Ravenna than any French portal.[47] This same prototype is also recalled by stance and the fall of the drapery of the majority of the Amiens figures. Such a connection is certainly consistent with the presence of the founding bishop, Évrard de Fouilloy, at the Fourth Lateran Council.[48] In the forms of the individual figure, the Amiens sculptors moved away from the crinkled damp fold drapery and the lively rhythmic interactions created by the contrapposto stance associated with sculptural production at Reims Cathedral (seen, for example, in the figures of Saint Ulphe and Isaiah) in favor of a repetitive solemn stance seeming to anticipate the appearance of individuals in their perfect postresurrection state. Yet these figures have been rendered in a three-dimensional form on a scale not much larger than the visitor's who, invited to join the company within the enclosed space of the portal, might reflect upon the teaching of Saint Paul standing proudly to Christ's right in the central portal. This emphasis upon Paul probably reflects the disposition of the founding Dean, Jean d'Abbeville, who had made this saint his own.

I have suggested that users might be induced by the sculpture of the portals to engage in a kind of compulsive unscrambling of a puzzle. Whereas for many modern beholders that puzzle might be of an intellectual, archaeological kind, medieval viewers familiar with the formal teachings of the church and sermons like the one rehearsed above might engage in a different kind of reading in which the plot they might seek to unscramble was God's own: nothing less than the salvation of all humanity. In addition to the rhetorical and conspiratorial meanings of *plot*, the spatial dimensions are vital. Christ, the Beau Dieu, stands at the center of that spatial plot inviting—even compelling—us to enter.[49]

f) Epilogue: Transept Portals

In the wider context of Gothic sculptural production, the west portals of Amiens Cathedral are most unusual, having been completed quite quickly while closely following a coherent plan. A very different story may be told of the portals of Notre-Dame of Paris, Chartres, Reims, or Auxerre Cathedrals, where major changes of intention affected work while it was still in progress. In the transept portals of Amiens Cathedral, we encounter similar delays, problems, and prevarication.

This situation can be understood in relation to location, chronology, and changing circumstances. Whereas the west portals—directly facing the principal urban spaces of Amiens—addressed townsfolk and pilgrims, the north transept portal (fig. 2.38) opened toward secluded spaces hemmed in by the bishop's palace and the church of Saint-Firmin the Confessor. The bishop's normal access to the new choir was not through the transept portal, but via an elevated passage leading to a small door (now blocked) in the westernmost bay of the north choir aisle wall. The north transept portal is austere: apart from minor decorative details and the beautiful low-relief lintel, the only major sculptured figure on the central trumeau is that of a bishop, thought to represent Saint Honoré. Interestingly, on the plinth of the trumeau are scenes (now much eroded) of the Annunciation and Nativity. Was a Mariological theme once intended in this portal? The portal must have remained unfinished for more than half a century: around 1300 it was decided to complete the tympanum not with traditional stone

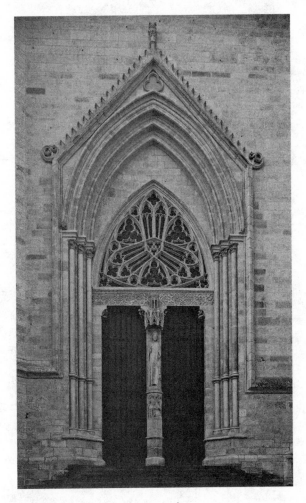

FIGURE 2.38 North transept portal

sculpture, but with a glazed composition with attenuated tracery that has been compared with a spider.[50]

The matching portal in the south transept provided the principal access for members of the cathedral chapter as they moved between the celebration of the offices in the choir and their residences in the cloister to the south of the nave; it also served as passage for the clergy in procession as they would sometimes carry relic shrines into the cloister and the streets of the city beyond (fig. 2.39).[51] This ceremonial emphasis is reflected in the unusual tracery

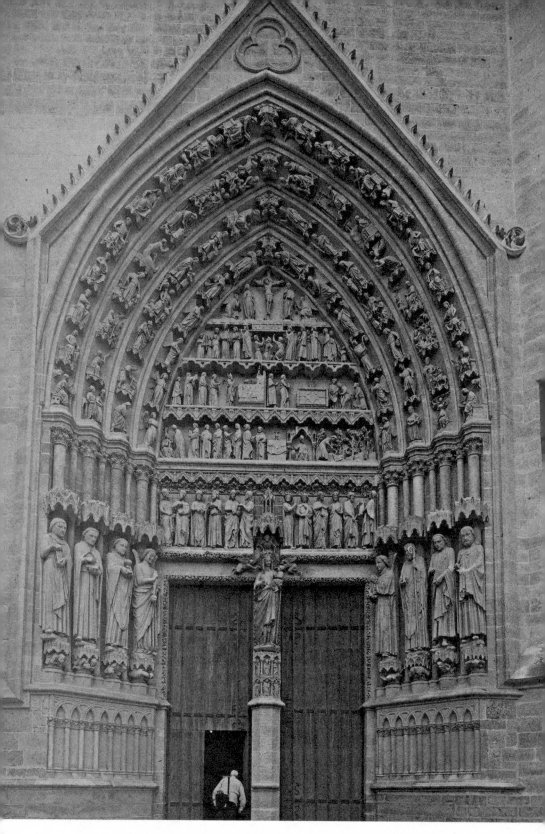

FIGURE 2.39 South transept, portal of Saint Honoré. See also color plate.

composition applied to the inner wall, where we find three angels (c. 1250) watching over the entrance and Saint Michael (c. 1500) at the summit (fig. 1.44).[52] The east-west street that ran in front of the south transept, the rue du cloître Notre-Dame, provided public access to the city gate known as the Porte de l'Arquet, although a great iron hook anchored in the western-most buttress of the cathedral suggests that the street might be occasionally closed.[53] It should be added that the masons had their workshop immediately adjacent and to the east, up against the south wall of the choir: building materials must have passed through the south transept portal. In order to allow access, the installation of the central trumeau and the tympanum it supports was probably delayed.

Despite their very different appearance, the north and south transept façades shared a similar construction history—a protracted business involving financial crisis, external tensions, and major changes of intention. In exploring the construction sequence of the cathedral in chapter 4, we will see that the first master mason, Robert of Luzarches, quickly laid out the lowest part of the outer wall of the south nave aisle up to the sill of the aisle windows soon after 1220—this included the lowest level of both transept façades with the portals and the straight bays of the choir down to the base of the hemicycle (fig. 1.27). But when it came time in the later 1220s to raise the work up to the nave aisle vaults, the choice was made to start on the west side of the south transept (including the buttress to the left of our south transept portal) and western bays of the southern nave, leaving only the lowest level of the portal embrasures completed. When construction had reached the upper nave by the 1230s–40s, work was resumed on both transept arms and continued into the choir aisles. This hiatus in the construction of the transept façades left plenty of time for disagreements and changes of plan.

The 1240s and 1250s brought difficulty and debate for the Amiens clergy. In 1246, in the context of a struggle between the secular nobles of France and the clergy, the nobles made a protest to the Pope concerning the arrogance of the clergy who, as sons of serfs, had arrogated to themselves great powers and jurisdictions.[54] The clerks were exhorted to return again to the state of the Apostolic Church: in this way miracles, long since unseen, would again manifest themselves. Moreover, members of the secular clergy (cathedral canons) must have worried about the increasing power of the

mendicant orders who were at that time establishing themselves in northern cities including Amiens.[55] These struggles are reflected in the lintels and tympanum of the south transept portal where we find references to apostolic roots, the sacramental role of the clergy, and miracles associated with sainted Bishop Honoré.

Two other factors may have caused intense debates among the planners of the south transept portal. First, the succession of master masons at Amiens had led to reevaluations of the appropriate architectural forms. Thomas de Cormont, as he assumed direction of the work after the death of his former master Robert de Luzarches, may have been worried about the inadequate mass of the transept terminal wall: the framing wall of the south transept portal is thicker than its counterpart to the north, accommodating four orders of voussoirs instead of three. And then a funding crisis arose: in 1240, presumably in response to a shortage of funds for the fabric, the reliquary of Saint Honoré was carried through the region around Amiens as part of a quest to appeal for funds. In this context, the emphasis upon the thaumaturgical powers of the relics of the saint was of obvious relevance.

In difficult circumstances the members of the clergy probably debated how to distribute the cult of the Virgin and that of local saints on the north or south flanks of the cathedral and whether the promotion of a sainted bishop or an eloquent Virgin would be their best recourse in a time of crisis.[56] In the south transept portal, as it was actually built, they attempted to have both.

Having sketched the locational and historical circumstances, let us now examine the magnificent southern portal named both for the figure in the central trumeau—the Golden Virgin or Vierge Dorée—and for Saint Honoré, whose life and miracles are depicted in the tympanum (fig. 2.39). Although it has no porch sheltering it, the designers attempted to make the south transept portal look something like the portals we have already seen in the west façade: it has about the same dimensions and proportions of the central west portal and is capped by a gable that, though two dimensional, resembles in its proportions the gable of that portal.

The lowest level of the embrasures of the portal, however, is quite different, featuring an oddly archaic-looking band of interlocked round arches recalling Anglo-Norman practice (fig. 2.39).[57] Eight column figures

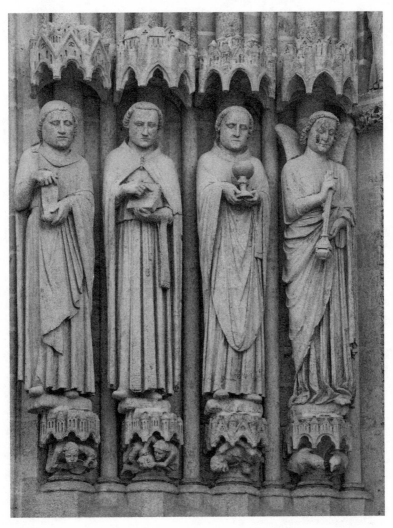

FIGURE 2.40 South transept, portal of Saint Honoré, left embrasure, column figures

flank the portal (figs. 2.40–41). The innermost figure on each side is an angel carrying an incense burner: the drapery of the figure to the left is crinkled in the "Antique" style. The other figures include generic ecclesiastical types, including one holding a chalice and one a bishop's crozier, but the four others are not in clerical garb and point to written sources: books or scrolls—are they prophets? Deep, broadly cut vertical folds groove their drapery. Faces have a dispiriting monotony and look

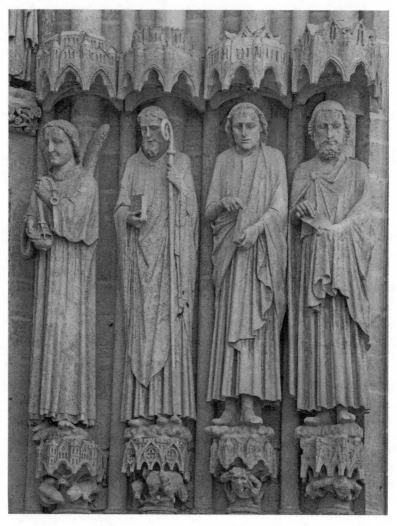

FIGURE 2.41 South transept, portal of Saint Honoré, right embrasure, column figures

somehow bloated, particularly in the three neckless clerics on the left—similar facial types can be found in tympanum of the Saint Firmin portal. The work has a rough and unfinished appearance: the canopies and bases also look maladroit (as does some of the work in the Saint Firmin portal). The corbels below the bases carry a range of figures clearly intended to appeal to a popular audience: we see a broad-faced squatting African,

wrestlers, a spread-eagled man who carries the console on his back, birds, a blacksmith, a man and his dog, a devil with a (restored) baby devil in its lap, and a crouching figure. We might deduce that the column figures, together with the base of the trumeau featuring an image of a bishop, were carved early on (in the 1220s)—perhaps as experimental forms originally intended for the west portals—and that they lay for a while in the workshop before being deployed later (despite being distinctly out of date) when funds ran short.

In contrast to the demotic character of the column figures with their pedestals, the voussoirs of the south transept portal carry a learned program populated by elegant figures providing a breathtaking overview of sacred history from Adam to the apostles. The four orders include angels, precursors from Adam to John the Baptist, the major and minor prophets, and finally the apostles and evangelists interspersed with holy women. The presence of the prophets and apostles is reminiscent of the program for the west portals, and aspects of the carving are quite similar to the sculpture of the central portal of the west façade. Such a grandiose frame might have been considered appropriate for a portal featuring a Mariological cycle, but as a foil for the popular story of a miracle-working local bishop it seems odd. The date for the foundation of the chapel of the Conversion of Saint Paul (to the east of the south transept), 1233, is sometimes assigned to the work on the voussoirs. Such dating can only be considered approximate, however, and the work could have been undertaken a little later.[58]

In portal construction the tympanum and its supporting trumeau are normally installed last.[59] The composition of the tympanum with its five horizontal bands reflects a compromise between the forms of the central and side portals of the west façade (fig. 2.42). Thus, the edge of the lowest lintel is placed below the canopies of the column figures as in the lateral portals, whereas the overall dimensions and proportions closely resemble the central portal. The lowest band is considerably larger than the others, allowing the figures to assume a more monumental scale.[60] Twelve robed men elegantly grouped in pairs engage in conversation, some referring to scrolls or books in their hands. They can be seen as apostles: the young John and James the Pilgrim are readily recognizable. The grouping in pairs

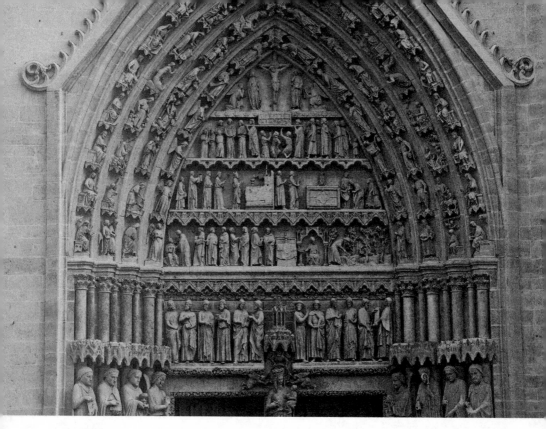

FIGURE 2.42 South transept, portal of Saint Honoré, tympanum

refers to mendicant practice—Franciscan and Dominican friars often went about their mission in tandem with a partner.

In the next horizontal level—considerably narrower—Honoré, seated on the far left, is consecrated bishop. His initial reluctance was overcome by a miraculous effusion of oil gushing down from behind his head. To the right, three pairs of witnesses engage in conversation. These figures might provide a further clue for the understanding of the twelve figures below. There, mysteries are explored through reference to the written text. Here, on the other hand, miracles are actually being witnessed. Toward the center of the band a clerical figure gestures to our right inviting us to witness another miracle. To the right of an altar carrying a chalice and backed by a low screen with a cross we see a miniature edifice in which the bishop is enthroned with his hand upon a book placed on a lectern. Sitting in his church, he turns his head to listen to the song of praise uttered by the priest Lupicinus as he digs in the ground, discovering the bodies of the

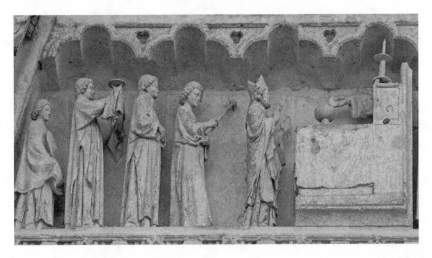

FIGURE 2.43 South transept, portal of Saint Honoré, detail of the Eucharist

three lost saints, Fuscien, Victoric, and Gentien. As with the invention of Saint Firmin in the northwest portal, the transformative significance of the event is marked by the blossoming of flowers.

On the third level, as Honoré celebrates mass, the hand of God blesses the sacrament (fig. 2.43). Once again there are witness: three clerics and an acolyte stand behind the bishop. To the right a blind person is healed through the touch of the cloth covering the altar where the statue of the saint stands while behind the blind person comes a lame man with his crutch and dog.

The fourth register shows a procession with the châsse of the sainted bishop displaying decorative quatrefoils on the sides and the lid. In the real châsse, displayed behind the high altar, the quatrefoils carried enameled scenes telling the story of the saint's life: Crippled men are healed as they touch the shrine; witnesses congregate; and a group of people on the right—including a Jew and several women, one with child—engage in a lively debate.

At the crown of the composition the crucified Christ—heavily restored in the nineteenth century—is flanked by Mary and John and censing angels. This image has been interpreted in relation to the story of the *châsse* of Saint Honoré carried past the great cross that stood atop the choir screen of the church of Saint-Firmin the Confessor when the crucified Christ bowed his head in recognition.

Thus, we have seen that the column figures do not go with the voussoirs, which themselves, given their grandiose program, do not go with the more parochial story of the sainted bishop in the tympanum. The figures in the voussoirs and tympanum are rendered in an elegant style characteristic of Parisian sculpture dating from around 1240. Finally, there is the famous Golden Virgin, or Vierge Dorée, in the trumeau: the statue is incongruously placed atop a plinth with images of a bishop, suggesting that the builders had probably planned to install an image of Saint Honoré in this place of honor (fig. 2.44). The existing Virgin is a copy: the original, suffering badly from the corrosive effects of atmosperic pollution, was taken inside the south transept in 1980 and cleaned in 1992. The statue is a little smaller than the other column figures, and in the sweet expressiveness of her face and her elegant stance she could not be more different. The Virgin's right leg is free of any weight-bearing function, yet her upper body curves over this nonstructural support. This is the reverse contrapposto so characteristic of Gothic—perhaps the most famous examples can be found at Reims Cathedral in the Annunciate Angel and then, later, in the so-called Smiling Angel (*l'Ange au sourire*). The child is held somewhat precariously in the Virgin's left hand; her right hand, now restored, gestures toward the child. A swath of the Virgin's robe is brought up over the left hand and wrist, projecting a chute of drapery down the center of the Virgin's body and pulling a broad V-shaped pattern of folds over the right leg. The converging lines created by these folds fix the viewer's attention on the child whose weight is counterbalanced by the Virgin's upper body. The two sides of the Virgin's body are thus very different: her right with a powerful succession of V-folds like waves, and her left with columnar verticality. In direct contrast to the majestic and austere Mère Dieu of the western frontispiece, there is a certain sensuality to this curving form. The face is most expressive with its slightly upturned smiling mouth pressuring the cheeks and lower eyelids. If any one of the sculptured figures at Amiens can be considered a masterpiece, this is it.[61]

The sculptural mode of the Vierge Dorée is already anticipated in the lively and expressive figures in the tympanum; these seem to belong to the middle of the thirteenth century and to participate in that elegant style associated with the Smiling Angel of Reims Cathedral and the statues of the apostles in the Sainte-Chapelle.[62] It is tempting to suggest that a wealthy

FIGURE 2.44 South transept, portal of Saint Honoré, the Golden Virgin (now relocated inside the south transept)

member of the clergy or member of the urban elite offered a substantial sum of money to install the exquisite Virgin in place of the stolid bishop intended for this location. Like her counterpart in the south portal of the west façade, she probably attracted a cult following. Her robe, originally painted blue, was later gilded—presumably in response to another gift. Standing here she welcomed members of the clergy in their daily passage to their offices, and also lay members of the Puy Notre-Dame, the lay confraternity dedicated to the honor of the Virgin, whose headquarters were here in the south transept.

Clergy, Artisans, and Laypeople | 3
Makers and Users

I N THE OPENING CHAPTERS of this book I invited readers to experience the cathedral as a pilgrim: approaching from afar, entering and passing through, and climbing to hidden high places before then attempting to unscramble the messages encoded in the complex figurative programs of the portals. During these passages the voice of the interlocutor has continued to urge visitors to consider unseen contexts and the presences of our medieval predecessors: clergy, artisans, and laypeople.

a) Who Were the Clergy? Apostles of Picardy

The understanding of the world of the medieval clergy brings us back to the establishment of Christianity in the late Roman city and suburbs. We have seen that the stories of the missionaries who brought Christianity from the Mediterranean world to the north were embellished some six centuries after the events they purported to describe: nevertheless, there is no reason to doubt that by the end of the third century a Christian community had been established in Amiens.[1] That community had been allocated space on the eastern edge of the Roman walled city: at some undocumented date, probably in the fourth century, one or more churches were established between the eastern wall and the Via Agrippa, the line of the great road that linked Lyon to the coast.[2] Meanwhile, the secular authority continued to dominate the western part of the city, where the fortified amphitheater provided a powerful defensive position.[3] Outside the city walls lay the ruins of suburban Roman Samarobriva, dotted with

burial places or necropolises favored by members of the early Christian community who sought burial *ad sanctos*—close to the tombs of the mythic saints, Firmin the Martyr and his associates. A shrine church dedicated to the Virgin may have been established at an early date at Saint-Acheul, just to the east of Amiens, in order to celebrate the cult of the martyrs.[4] Funerary inscriptions from between the fourth and sixth centuries have been unearthed both in the vicinity of Saint-Acheul and around the existing cathedral inside the Roman wall.[5]

The first unambiguous evidence of the existence of an episcopal church in Amiens is provided by the list of bishops attending the Church Council of Cologne in 346: Amiens was represented by Bishop Eulogius I (d. 608) (*Eulogius Amcianorum*).[6]

By the ninth century Amiens was served by two principal churches, one dedicated to the Virgin Mary and the other to Saint Firmin.[7] A baptistery and hospital (*hôtel-Dieu*) probably also formed part of the early medieval episcopal group. The nonmonastic or secular clergy serving such churches were inspired, above all, to emulate the *Vita apostolica*—the life of the apostles—organized in the service of a bishop, the earthly representative of Christ. The bishop might provide specific guidelines for community life in the spirit of the monastic rule created by Saint Benedict of Nursia. The Carolingian age saw determined efforts to ensure uniformity of practice, as the exemplary rule of Bishop Chrodegang of Metz (d. 766) was codified and disseminated by the Council of Aix-la-Chapelle (816). With the reform movement of the eleventh century the resources and institutional life of the chapter were largely separated from that of the bishop.[8]

Several other satellite groups of clergy or chapters were formed in the vicinity of the episcopal group, serving the collegiate churches of Saint-Firmin the Confessor to the north and Saint-Nicolas-au-Cloître, as well as Saint-Martin-aux-Jumeaux to the south of the cathedral adjoining the cloister.[9] The church that we now call Amiens "Cathedral" was then known as the "Mother Church" or the "Great Church"; the designation "cathedral" was established by the eighteenth century. The bishop was housed in a fortified residence (*domus*) in the extreme northeast angle of the old Roman wall: the bishop's tower (*tour de l'évêque*) matched the fortified position of the count of Amiens in the opposite, or southwest, corner of the city. The regular clergy of the episcopal group, at first part of the bishop's household,

were, by the eleventh century, accommodated in individual houses in the cloister (*cloître*) to the south of the cathedral.[10]

The clergy of Amiens Cathedral were rich in land and other rights and possessions—the acquisition of extensive landed estates probably began in the late Roman period with the legendary donation by Senator Faustinian.[11] Beginning in the ninth century the possessions of bishop and chapter were divided, with the chapter becoming one of the wealthiest in the province of Reims.[12] The twelfth-century growth of the textile industry in Amiens contributed greatly to this wealth, since the clergy had extensive rights over river navigation, water management, and mills. In the period immediately preceding the construction of the Gothic cathedral the number of canons increased from thirty-eight to forty, and three new officers, or dignitaries, were created to make a total of nine.[13] The dean, the chief executive officer, was the only one elected by the chapter. Newly created (by Bishop Évrard de Fouilloy, founding bishop of the Gothic cathedral), were the positions of precentor (in charge of music in the choir), schoolmaster, and penitentiary. The other dignitaries included the provost, chancellor, chanter, and archdeacons of Amiens and Ponthieu, who assisted the bishop in diocesan administration. Each member of the regular clergy received a payment known as a *prebend* derived from the landed holdings and other rights and dues held by the chapter; beyond this, the dignitaries received a substantial supplement. While members of the chapter might be involved in the secular affairs of the diocese, their regular meetings would principally involve their own business and ordering the liturgical life of the choir.[14]

In addition to the bishop, canons, and dignitaries, the ranks of the clergy included a growing number of chaplains—twelve in 1216, and sixty in 1372 when the nave chapels were nearing completion. There were also around ten choirboys, plus eight vicars with responsibility for the music under the direction of the precentor, as well as professional musicians. Our total count is coming close to one hundred, and we must add the presence, on special occasions, of the clergy from the chapters of the neighboring collegiate churches. This mighty host occupied the double ranks of seats or stalls ranged on either side of the choir with the cathedral canons assigned to the upper stalls. Two special seats (*stalles d'honneur*) crowned by enormous pinnacles were provided: one on the northwestern side for the king who, in his absence, was represented by his bailiff; and one on the southwestern side for the dean (fig. 3.1).

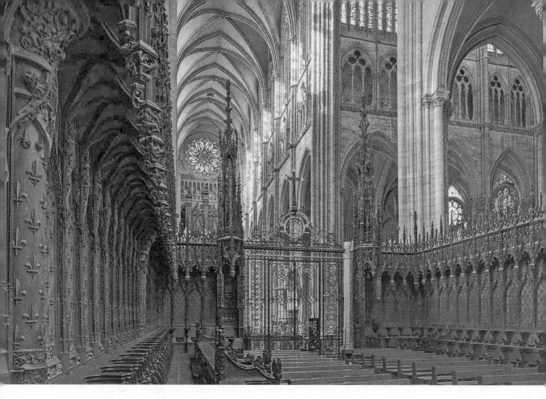

FIGURE 3.1 General view of choir, looking to the west. See also color plate.

In principle, the canons represented the apostles just as the bishop himself represented Christ.[15] The task of the clergy was to sustain continuous daily prayer and praise, expressed in the performance of the Divine Office—particularly the chanting of the Psalms—and the celebration of the sacraments.[16] In this respect, the life of a secular canon resembled that of a monk; we should note that in preparation for special feast days the clergy had the crowns of their heads shaved like monks. However, the life of a canon was far from monastic: members of the clergy remained closely integrated with the great local families, including especially the landed families of the surrounding area.[17] Though not allowed to marry, a canon might own property and would generally purchase a house in the cloister. On his death he could dispose of a certain amount of his own property: he might even exert some influence in the appointment of his successor.

Some of the canons had achieved a high level of education and learning—most famously, Richard de Fournival.[18] Born in Amiens in 1201, Richard was the son of Roger de Fournival, physician to King Louis IX. Richard was educated first in Amiens then Paris before pursuing further studies in

medicine and serving as physician for Cardinal Thomas of Capua—work that took him to Rome and Salerno where he encountered the new learning derived from Greek and Arab sources that had, already in the twelfth century, begun to transform the scope of university education organized around the traditional structure of knowledge in the trivium and quadrivium. Returning to Amiens, between 1240 and 1260 Richard served as cathedral chancellor where his responsibilities included a supervisory role over the cathedral school. He has been credited with the organization of the first public library, the contents of which, organized around an encyclopedic catalogue (the *Biblionomia*) were available to the cathedral clerks and others. This was knowledge that ranged from the theoretical to the applied, some of which had direct application upon the construction of the cathedral. In addition to the *Biblionomia*, Richard is remembered for his *Bestiaire d'Amour* and the *Roman d'Abladane*, composed by one of his followers.[19] The presence of Master Richard as one of the most powerful dignitaries of the Amiens chapter contributed to a real epistemological revolution.[20]

At the time of the construction of the Gothic cathedral, bishops were elected by the chapter and generally were drawn from the petty aristocracy of the surrounding area, often having held office at Amiens or in another cathedral.[21] Of course, the very word cathedral stems from the fact that the bishop had his formal seat or throne (*cathedra*) in this church, on the south side of the sanctuary adjacent to the altar. He was, in addition, one of the two principal seigneurs of the city of Amiens, thus exercising considerable jurisdictional and economic powers.[22] However, his responsibilities extended far beyond the city to a great diocese with 736 parishes organized in two principal regions, each headed by an archdeacon.[23] His landed estates extended in a vast triangle to the east of the city with its tip in urban space including areas to the north and east of the cathedral.[24] The bishop, like members of his clergy, was integrated in local secular culture and had many of the same responsibilities as his secular seigneurial colleagues.

It is likely that directly after the fire that damaged the old cathedral, bishop and chapter each committed a fixed part of their revenues to the construction on the new cathedral.

In the bishop and clergy of Amiens we encounter a paradox—a community that consciously modeled itself upon stories and images that belonged to far-distant times and places—Christ and his apostles in Jerusalem.[25] Yet these

were men with deep local roots in the soil of Picardy. The cathedral, with its architectural spaces, its figurative programs and its liturgical performances, provided the mechanism to facilitate this miraculous transformation.

b) The Presence of the Clergy in the Space and Time of Amiens Cathedral

During the three-hundred year "Life" of the Gothic cathedral the presence of the clergy in the cathedral was overwhelming, as spaces were filled with the sound of their chant during the Divine Office and Eucharist, and as they moved out in procession into the choir aisles, ambulatory, nave, and beyond to celebrate special feast days.[26] And memory of clerical presence was deepened through the Office for the Dead and daily prayers for deceased members of the clergy and others whose generosity was recorded in the cathedral necrology.[27] That daily presence continued until the Revolution, when the chapter was dissolved.

The function of a cathedral is to provide living space not just for the liturgical activities of the clergy, but also for the material commemoration of the dead. Bishops might be buried in the immediate surrounds of the principal altar or at other key points in the cathedral. Canons were laid to rest in the space of the cathedral or in the cemetery directly to the east of the chevet. And some pious laypeople, generous benefactors, might also be accorded burial in sacred space: the pavement was formerly dotted with inscribed slabs locating the tombs of laypeople and clergy alike—unfortunately, almost all of them were removed in the eighteenth and nineteenth centuries.

Let us now follow the institutional life of the Gothic cathedral as well as the progression of the work of construction by looking at the sequence of still-surviving episcopal tombs, in this way becoming more acquainted with some of the key clerical builders.

Évrard de Fouilloy, 1211–1222 (fig. 3.2). We find the bishop represented in a magnificent bronze tomb originally located at the west end of the central nave, now displaced to the southern arcade.[28] Although the body of the bishop with its flanking figures of clergy and angels is rendered in high relief, giving the impression of mass and solidarity, in fact the metal skin is very thin.[29] Our bishop is depicted approximately life-size, lying on a bed measuring 2.40 meters by 1.07 meters, cast in bronze integrally with the effigy.

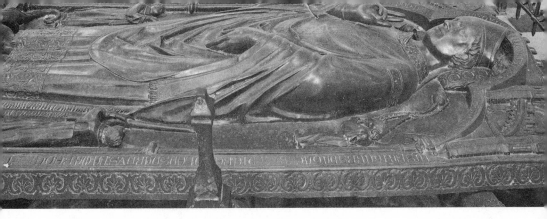

FIGURE 3.2 Tomb of Bishop Evrard de Fouilloy. See also color plate.

The chamfered edge of the bed is richly decorated with five-petal palmette motifs. Évrard, with his head resting upon a cushion embroidered with frontal lion heads, blesses with his right hand while his empty left hand presumably once held his episcopal staff. He wears on his head a simple miter (*mitra simplex*) and is clad in a chasuble over a dalmatic, which is richly embroidered at the bottom with images of frontal birds.[30] At his neck he wears an embroidered amice; he has an embroidered maniple over the left arm, and he wears thin, undecorated gloves. The tips of his stole protrude beyond the dalmatic at his feet under which are placed two dragonlike beasts, one biting the other. He is flanked by two little images of clerics holding candles while two angels hold censers—the sweet smell of incense redolent with everlasting life. The enclosing frame with its inscription makes very clear architectural references. The trefoiled arch that encloses his head and shoulders mirrors the form of the dado arcade—the characteristic feature of the first campaign of construction undertaken while Évrard was still bishop (fig. 1.50). And the pinnacles and cusped flyers above project his vision of a completed Gothic cathedral. The battlemented wall above his head looks like a city wall—the bishop was one of the seigneurs of the city. The inscription emphases the benevolent role of the bishop and lord of the city and specifically ascribes to him the start of work on the new cathedral: "he who . . . laid the foundations. . . ."[31] We will see in chapter 4 that the continuity of the trilobed dado arcade along the entire length of the straight bays of the cathedral suggests a rapid and highly controlled start of work that we can associate with the tenure of Bishop Évrard de Fouilloy and the master mason, Robert de Luzarches.

Thus, the tomb effigy has directly conveyed two vital bits of information—first, that the individual depicted is a bishop distinguished from ordinary

mortals by his episcopal gear: miter, richly embroidered dalmatic, chasuble, maniple, stole and staff. Second, the inscription reveals not only that he lived a virtuous life and fulfilled his role as the protector of the people of the city, but also that he initiated construction of the cathedral: specifically, the foundations. By deduction and association we may draw several more conclusions: most obviously that this is a rich bishop and that the workshop was capable of high-level metallurgical production.[32] The location of the tomb toward the west end of the nave provides useful supporting evidence for a conclusion that can be established on archaeological and textual grounds: that the nave was built before the choir, generally preferred for episcopal tombs.[33] But, most important, the image of a man with the right hand raised in blessing and feet atop the beasts is a clear reference to the great trumeau image of the *Beau Dieu* at the center of the main portal (fig 2.33). Do we need any further confirmation of the conclusion that the bishop is Christ's representative on earth?

What do we know about Bishop Évrard de Fouilloy? His family were lords of an estate located to the east of Amiens near the monastery of Corbie on the Somme.[34] Cousin of Guillaume de Joinville (archbishop of Reims) and brother of Nicolas (archdeacon of Amiens), Évrard must have been born before the mid-twelfth century—he became a canon of Amiens Cathedral by the 1160s. From 1198 to 1210 he left the Amiens chapter for that at Arras: he was named canon of Arras Cathedral in 1198, and chanter in 1202, serving in these roles until 1210. Elected bishop of Amiens in December 1211, in 1215 he participated in the Fourth Lateran Council in Rome and on his return to Amiens reorganized the chapter, creating three new officers: precentor, schoolmaster, and penitentiary. The assignment of responsibilities for the conduct of the Divine Office was reorganized at the same time.[35] When fire had destroyed the old cathedral there is every reason to believe that Bishop Évrard played a key role in the decision to rebuild on a much grander scale. The new project demanded substantial adjustments to the urban fabric in the immediate vicinity: the eastern end of the new cathedral would project beyond the old Roman wall. To the north, the old Hôtel-Dieu and collegiate church of Saint-Firmin would both have to be relocated: the bishop would need all his powers of persuasion to make it happen. Évrard died in November 1222, having conceived the great project and witnessed the establishment of the mighty foundations.[36]

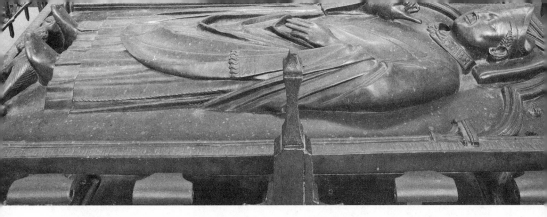

FIGURE 3.3 Tomb of Bishop Geoffroy d'Eu. See also color plate.

Geoffroy d'Eu, 1223–1236 (fig. 3.3). The tomb of the second building bishop is now located opposite in the north arcade of the nave: it was originally on the central axis directly inside the west portal and to the west of his predecessor. Although it matches in a general sense the tomb of the founding bishop, it is more austere and the quality of the work seems inferior.[37] The architectural frame is much simpler without pinnacles or flying buttresses.[38] Episcopal garments are less sumptuously decorated and the inscription appears to have been thinly engraved rather than cast.[39] His dalmatic is somewhat shorter than that of his predecessor. However, the posture is the same: he also treads the beasts, and placed directly behind the Beau Dieu in the central portal he also may clearly be seen as a type of Christ. While Évrard's inscription stressed his role as protector of the city, Geoffroy is portrayed as a paradigm of humility and learning. The inscription reminds us that this is the bishop who brought the construction "up to the immense heavens." His tenure corresponded with the work of Master Mason Thomas de Cormont who did, indeed, bring the nave up to the high vaults.

Geoffroy came from the neighboring diocese of Rouen, and some historians have suggested that he was descended from the counts of Eu.[40] A doctor of theology, he had studied medicine in Paris and was nominated by Pope Gregory IX as apostolic protector of the privileges of university masters and students. He had joined the Amiens chapter in 1218, the year that the old cathedral was destroyed by fire, and he also held the position of canon at the nearby church of Saint-Nicolas-au-Cloître. In 1223 he participated in a council summoned by Pope Honorius III to address the problem of the Albigensian heresy; in the same year he attended the funeral of King Philip

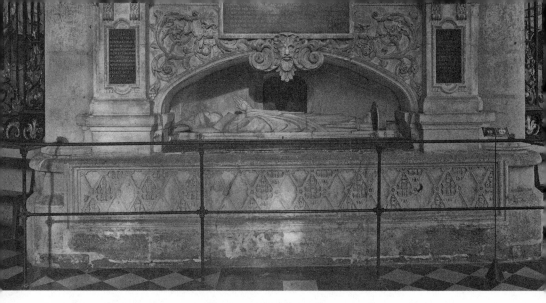

FIGURE 3.4 Tomb of Bishop Arnoul de la Pierre. The *gisant* was taken from the tomb of Jean de la Grange

Augustus at Saint-Denis. Three years later he attended the coronation of King Louis IX in Reims Cathedral. Bishop Geoffroy remained loyal to the king during the bitter struggle between the bishops of the province of Reims and Louis IX in the aftermath of the royal confiscation of the possessions of the bishop of Beauvais.[41] At the ecclesiastical council of Saint-Quentin in 1233, Geoffrey's representative, Simon d'Arcy, opposed the imposition of an interdict on the province. Finally, Bishop Geoffrey expedited the transfer of the hospital and collegiate church that had encumbered the site to the north of the new cathedral; by his death on November 26 1236, the nave was almost completed.

The memory of the role of these two bishops as church founders was ensured through liturgical commemorations, especially in the celebrations of All Saints' Day when the clergy processed down the nave to the tombs for prayers and song.[42]

Arnoul de la Pierre, 1236–1247 (fig. 3.4), is thought to have been buried in the Gothic choir—the first bishop to occupy this space. The base of his tomb (now without its effigy or *gisant*) is located in the ambulatory between the axial piers of the hemicycle it bears the arms of Castile, in reference to the mother of King Louis IX, Blanche of Castile, quartered with the lilies of France—the latter effaced during the Revolution.[43] His effigy has been replaced with that of Bishop (later Cardinal) Jean de la Grange.

This was originally a canopy tomb surmounted by *galleries et de petits clochers*.[44] Arnaud's tenure as bishop coincided with the later work of Master Mason Thomas de Cormont, who had completed the choir aisles and hemicycle and had just installed the vaulting of the ambulatory in time to permit the installation of the bishop's tomb.

Bishop Arnoul was born in Amiens and had studied theology in Paris.[45] He had been chancellor of the Amiens chapter since 1221. He was a supporter of the new mendicant orders who established houses in Amiens in 1243–1244 and is remembered for working to propagate the cult of the local saints recently depicted in the sculpture of the north portal of the western frontispiece, writing a life of Saint Domice (whose relics he transferred to the cathedral), and leaving funds to support the celebration of the feasts of Saint Sauve and the hermits Ulphe and Domice.[46]

More than twenty years of construction had been accomplished, probably financed mainly from the regular revenues of the bishop and chapter and, as far as we know, with continuing good relations with king and commune—Amiens was spared the violent insurrections associated with cathedral construction in nearby Laon, Reims, and Beauvais. However, in 1244 an incomprehensibly violent incident ensued.[47] In July of that year the king's representative in Amiens, Bailiff Geoffroy de Milly, had seventeen clerks accused of having violated the bailiff's daughter seized by the royal provost: they were beaten and imprisoned in the city belfry (*beffroi*). Five were summarily executed, and a sixth died from his mistreatment. Bishop Arnoul imposed humiliating punishment upon the miscreant bailiff: he was condemned to be stripped and to carry each of the bodies to the cathedral and then to the cemetery of Saint-Denis to the southeast of Amiens. He was to make amends at all the cathedrals of the province and to pay a heavy fine. The commune, also implicated, was required to establish six chaplaincies— two at the priory of Saint-Denis, Amiens, and four in the cathedral—they were attached to the chapel of Saint Quentin, which became known as the *chapelle de Saint-Quentin-des-Meurtris*.

Gérard de Conchy (or Coucy), 1247–1257 (fig. 3.5), is thought to have been buried inside or in front of the memorial monument inserted into the dado of the north choir aisle near to the little door leading to the bishop's palace. The bishop, depicted in full episcopal garb (chasuble, short dalmatic showing undergarment, decorated miter, gloves, and staff), is

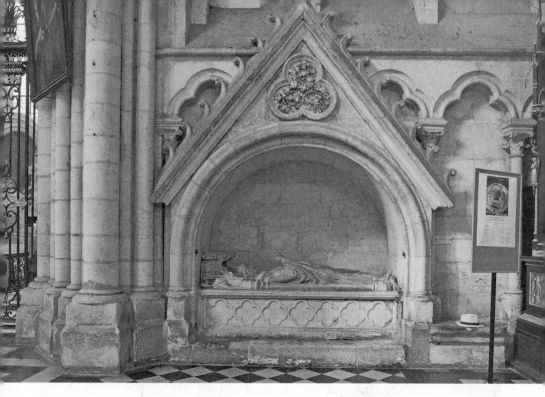

FIGURE 3.5 Tomb of Gérard de Conchy

enclosed in an architectural frame topped by an elaborate deeply project-
ing hexagonal canopy similar to the canopies sheltering column figures
in the west portals. A repeated decorative motif (on miter, amice, gloves,
dalmatic, etc.) embodies a quatrefoil enclosing a square—such motifs are
often found in the enamels depicting the story of a saint's life decorating a
châsse. The effigy lies atop a stone sarcophagus with quatrefoil medallions
along the side. Similar geometric motifs were painted on the back wall and
enclosing arch. Both gisant and sarcophagus are sheltered under a rounded
arch topped by a crocketed gable. The bases of the canopy supports have a
deeply grooved scotia, suggesting a date toward the mid-thirteenth century.
The monument has clearly been inserted into the already existing dado,
beginning the practice of destroying the outer wall of the cathedral in order
to appropriate the space for tombs, chapels, and monuments.

Bishop Gérard was son of a lesser noble family from the west of the dio-
cese and had been canon, penitentiary and dean of the chapter before his
election as bishop of Amiens.[48] He accompanied Louis IX on his crusade in
1249. That crusade was financed partly by taxation levied upon northern

cities and dioceses, drawing off the funds that had previously been used in cathedral construction.[49] The defeat and capture of the king provoked widespread unrest—the rising of the Pastoureaux—in northern France and Flanders: a ragtag army estimated at 30,000 arrived at the gates of Amiens on the way to the Mediterranean to deliver the king. Bishop Gérard died soon afterward in 1257.

Alleaume de Neuilly, 1258–1259 was also from a local noble family: during his brief term a second incident occurred that, like the 1244 killing of the clerks, could be interpreted as a sign of anticlericalism. On August 31, 1258 a fire broke out in the scaffolding on the south side of the upper choir, and in the ensuing pandemonium a chest containing precious charters was broken and the documents stolen.[50] An inquiry identified three suspects, all bourgeois of Amiens: Robert Disaos, Anseau Sermonet, and Enguerrand. It is not known whether the three were finally convicted and punished. Bishop Arnaud's tomb was said to be in the same general vicinity as his predecessor, but no trace of it remains.

Bernard d'Abbeville, 1259–1278. This bishop's term coincided with the work of Master Mason Renaud de Cormont on the upper choir. The envelope of the cathedral nave and chevet was now almost finished and vaulted but still sheltered under a provisional roof. Bishop Bernard also had local roots: he was descended from the counts of Ponthieu and a cousin or nephew of Jean d'Abbeville, dean at the start of construction.[51] Bernard had already held the office of canon of Rouen Cathedral and then of Amiens (1257). In 1269 he donated the great clerestory window in the axis of the choir where the bishop is depicted giving a window to the Virgin with the inscription: BERNARDUS EPISCOPUS ME DEDIT (fig. 3.23). The location of his tomb is not recorded.

Guillaume de Mâcon, 1278–1308 (fig. 3.6). With this bishop we come the end of the period where bishops had been recruited from the ranks of the local petty aristocracy and had generally already held office in the chapter of Amiens Cathedral. The creation of Gothic architecture had owed much to such bishops who formed a closely interacting ecclesiastical mafia, and who must have been acutely aware of cathedral construction in neighboring dioceses, exchanging information and artisans. And we have seen how the placement of their funerary memorials was closely linked with the progression of construction of the cathedral. Future generations of bishops,

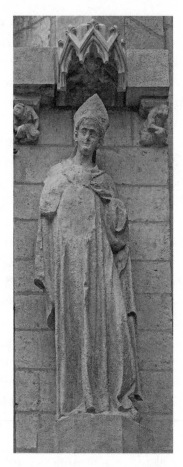

FIGURE 3.6 Statue of Bishop Guillaume de Macon, chapel of Saint Margaret, cleaned and restored c. 2018

however, owing their positions to papal and royal patronage, lacked local roots and were frequently absent. Rather than integrating his tomb into the existing structure, Bishop Guillaume felt it necessary to create a new space, initiating the slow process of destruction of the original outer wall of the nave aisles. Lighting of the aisle was obscured by the extension of the outer buttresses or *culées* necessary to create the spaces for lateral chapels where tombs could be located and mass said by chaplains in intercession for the dead. The prototype for the addition of such chapels was undoubtedly found in Notre-Dame of Paris.[52]

Soon before 1296, Bishop Guillaume founded the chapel of Saint Margaret (a reference to Marguerite of Provence, wife of Louis IX) in the

easternmost bay of the south nave aisle (fig. 5.6). The glass was knocked out of the window tracery in the transept aisle that formed the eastern side of the new chapel, and the aisle window and lower wall in the eastern bay of the nave were entirely demolished, though elements of the dado were recuperated and reused in the outer wall of the new chapels. Bishop Guillaume had his own tomb placed in this first chapel: it was said to have been made of copper.[53] Was he trying to emulate the sumptuous bronze tombs of the two founding bishops? The tomb is gone, but a statue of the bishop remains on the exterior wall of the chapel he had founded.

Bishop Guillaume belonged to the family of the counts of Mâcon in Burgundy. Having studied in Paris and Bologna, he became doctor of canon and civil law.[54] He worked for the papal curia and had been one of Louis IX's clerks, accompanying the king on Crusade, attending his death in 1270, and helping propagate the canonization process.[55] His high connections allowed him to collect a considerable number of benefices.[56] Unlike his predecessors, he was hostile to the mendicants.[57] In May, 1279 Amiens was chosen as the city most appropriate for the meeting between Philip, King of France and Edward I of England to ratify the terms of the treaty already made between Louis IX and Henry III.[58] At the great ceremony that took place in the cathedral, still incomplete, the relics of Saint Firmin the Confessor and of Saint Ulphe were transferred into new châsses.[59] Soon before 1308, Bishop Guillaume had the chapel of Saint Louis built in the second bay of the north aisle—this was one of the first chapels established for the royal saint soon after his canonization in 1297.

This is not the place for a complete list of the bishops of Amiens. However, let us introduce the names of two more bishops whose tombs are lost, yet whose presence is embodied in the material fabric of the cathedral. It is probable that the western frontispiece had been built rapidly in the first two decades of work, with the upper parts left unfinished. The elaborate arcade at midlevel corresponding to the triforium with the gallery of kings was inserted toward 1300, and towers added in the fourteenth century.[60] The south tower is associated with Bishop Jean de Cherchemont (d. 1372), who set aside funds for this purpose in 1366; and the north tower with Bishop Jean de Boissy (c. 1401).[61]

Jean de la Grange, bishop from 1373 to 1375, then cardinal, d. 1402
(fig. 3.7) was one of the best known of all the medieval bishops of
Amiens.[62] His sumptuous canopy tomb (demolished in 1751) was located
in the north arcade of the choir just west of the hemicycle. The gisant,
carved in Paris, survived and was set in the axial bay of the hemicycle
atop the plinth of the tomb of Arnoul de la Pierre (fig. 3.4). Jean de la
Grange is clad in episcopal garb little changed from the time of Évrard de

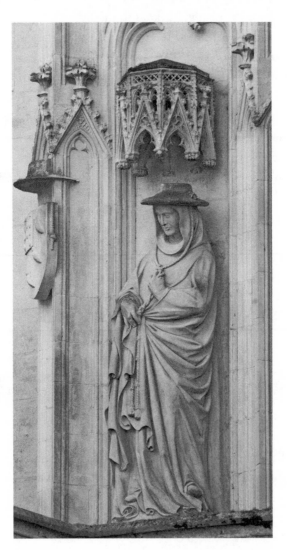

FIGURE 3.7 Statue of Jean de la Grange on the *Beau Pilier*

Fouilloy. Bishop Jean established the two last western chapels on the north side of the nave dedicated to John the Evangelist and John the Baptist, the latter chapel embellished with the famous Beau Pilier carrying images of Charles V with his family and entourage with their saints (figs. 3.7 and 5.9).[63] The window of the chapel of Saint John the Evangelist provides one the earliest datable (c. 1375) windows in France where the tracery is entirely curvilinear or Flamboyant (figs. 1.18 and 5.8).

Jean de la Grange was born in the diocese of Lyon of a noble family; he had been a Cluniac monk, was *docteur en décret*, and had developed close ties with the Avignon papacy as well as the royal court where he was president of the Cour des Aydes, superintendent of royal finances, and tutor for the king's children. In 1370 he became abbot of Fécamp, and in 1371 King Charles V attempted to get him appointed as bishop of Laon; when this failed he was promised the next bishopric—which was Amiens. He spent very little time in the diocese. In 1375 he assumed the rank of cardinal and played an important role in the papal court in Avignon until his death in 1402. His bones were buried in Amiens and his entrails in Saint-Martial in Avignon.[64]

In the fifteenth century with the weakening of royal authority resulting from wars with the English and Burgundians, bishops of Amiens were often appointed through papal patronage. But in the mid-fifteenth century Bishops Jean Avantage (1437–1456) and Ferry de Beauvoir were appointed by the Duke of Burgundy, who at that time controlled Amiens.[65]

Ferry de Beauvoir (1457–1473, d. 1479) (fig. 3.8), has a splendid painted effigy—set in the first bay of the southern choir clôture. The bishop lies with his gloved hands together in prayer; he wears a full-sized episcopal miter adorned with jewels and is clad in a richly decorated golden cope with images of the apostles together with a stole and dalmatic. The bishop's head is comfortably supported on a cushion and his feet rest upon a little lion. In the depth of the recess the twelve apostles recite the verses of the Credo (inscribed on their banderoles) while a member of the mendicant orders grieves at each end. Below the bishop is a painted altar frontal with the Lamb of God at the center of a painted cross and the evangelist signs in the quadrants. Two painted deacons pull back green curtains to reveal the altar. Are we supposed to see the body of the bishop as analogous to the body of Christ on the Eucharistic altar? On great feast days the

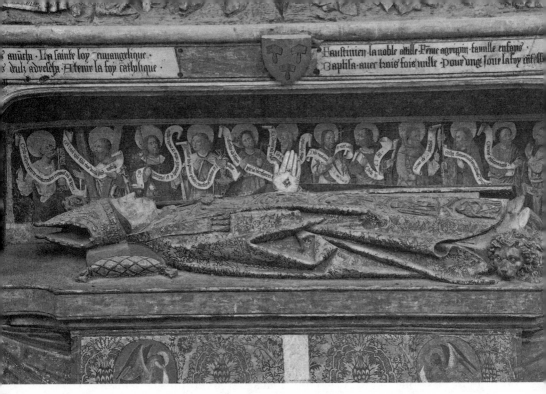

FIGURE 3.8 Tomb of Bishop Ferry de Beauvoir, south lateral choir screen

altar retable would be veiled and revealed in this way. And this is a double revelation since on the outer edges, angels pull back red curtains to reveal the entire composition. When King Louis XI regained control of Amiens, Bishop Ferry was forced into exile: the king imposed his own favorite candidate, Jean de Gaucourt, who became bishop in 1473 at age twenty-two. Although the cathedral was about to enter into a period of acute structural crisis, there is no sign that any of the bishops of the period were involved in the fabric. This task fell to the dean of the chapter.

The deans of Amiens played a more important role than bishops in the daily life of the cathedral and its construction; their presence in the daily liturgy of the choir was marked by the ornate *stalle d'honneur* occupied by the dean on feast days (fig. 3.1). Yet there are few monuments in the cathedral to bear witness to their agency.

Dean Jean d'Abbeville was the critical figure behind the spatial and iconographic plan of the new cathedral after the fire of 1218, yet he left his post to go elsewhere and his tomb is not in the cathedral. However, he

left remarkable monumental testimony to his engagement in the life of the cathedral in the form of the first chapel founded to the east side of the south transept and dedicated to the conversion of Saint Paul (fig. 1.48). The date of the foundation, 1233, fits well with what we know of the sequence of construction: by this date Thomas de Cormont was bringing the choir aisles up to the level of the vaults with the south side preceding the north. This chapel, which would receive the full brilliance of the morning sun, was sometimes referred to as the Chapel of the Dawn (*chapelle de l'Aurore*),[66] and the brilliance of the light was well-matched to Saint Paul's experience on the road to Jerusalem.

Who was Jean d'Abbeville? Born in Abbeville in Ponthieu to the north of Amiens, our dean had been canon in the church of Saint-Vulfran in that city; he had studied and taught in the University of Paris, becoming master regent in 1217.[67] Having been a canon and chanter at Saint-Wufran in Abbeville, he then joined the chapter of Amiens Cathedral. It appears that the Pope may have played some role in his election to the position of dean in 1218; he remained in this position only until 1225, when he was made archbishop of Besançon.

The three-hundred-year "life" of the cathedral is neatly framed by the tenure of its two greatest deans.

Dean Adrien de Hénencourt's funerary monument is located in the second bay of the choir clôture on the south side: his body was buried under the pavement in front (fig. 3.9).[68] In an astonishing departure from the episcopal tombs we have looked at, our dean is depicted bareheaded and barefoot, humbly lying on a straw mat rolled up to receive his head. Is this a portrait of the good dean with his bony, deeply grooved face and hooked nose? He wears a chasuble decorated with foliate motifs on a gold field, and a stole over his dalmatic. The tomb effigy is deeply recessed in a vaulted niche in the choir screen, and behind him are two pairs of grieving mendicants: his body was carried by mendicants and the sermon at his funeral was preached by a member of the same order. The audacity of the dean's program to refurbish the choir is conveyed by his painted motto, a quote from *Pharsalia* by the Roman poet, Lucan (d. 65 AD): *Tolle moras; Nocuit differe paratis*: Don't delay: when you are ready, just go.[69]

Dean Adrien de Hénencourt was the greatest patron of the arts in the late-medieval cathedral of Amiens. Born around 1445, he was the second son

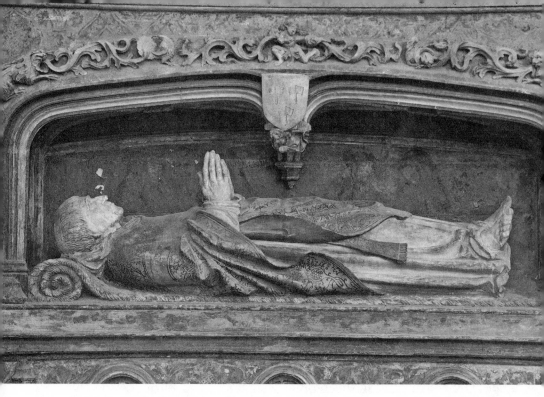

FIGURE 3.9 Tomb of Dean Adrien de Hénencourt, south lateral choir screen. See also color plate.

of the powerful aristocratic family of Mailly-Conty, seigneurs of Hénencourt, some twenty kilometers to the north east of Amiens—the area from which the founding Bishop Évrard de Fouilloy came. His mother, Isabelle de Beauvoir, was of the same noble family as Bishop Ferry de Beauvoir. Adrien, as second son, was destined for the Church: he entered the chapter of the cathedral in 1460 when he was probably less than twenty years old. The premature death of his older brother, Jean, left Adrien in possession of great wealth—like several of his fellow canons at the time, he chose to divert a substantial part of this wealth to artistic projects in the cathedral. Having studied canon law in Paris, he became provost of the chapter in 1465. These were difficult years for the city of Amiens owing to the struggle between King Louis XI and the Duke of Burgundy for control of the cities of the Somme, including Amiens, Abbeville, Saint-Riquier, Corbie, and Saint-Quentin. In 1465, when Duke Philip seized Amiens, Bishop Ferry de Beauvoir declared for the Duke who had been instrumental in his appointment while much of the population of Amiens remained loyal to the king. We have seen that the bishop was

forced to flee and it was only in 1489 that his nephew, Adrien de Hénencourt, was able to transfer his body to the cathedral: this within the context of a grand plan to completely renovate the choir.

In 1492 Adrien de Hénencourt was elected master of the confraternity of Puy Notre-Dame. This position had normally gone to a layperson from the urban elite and had been headquartered in that person's parish church. Dean Adrien changed this practice, establishing the south transept of the cathedral with its altar of *Notre-Dame du Puy* as the seat of the confraternity. Henceforth the pictures commissioned each year by the confraternity were displayed in the cathedral.

Two years after Adrien had become dean, alarming signs of deformation in the four crossing piers led to the installation of great iron chains stretching in all directions (on each side of the nave, transept arms, and choir) to prevent the main piers from buckling inward—we will explore this intervention in chapter 5. The dean played a key role in the deliberations and decision-making process. This work was followed soon afterward by the rebuilding of the choir flyers, aisle piers, and vaults at the west end of the south choir aisle, as well as the redecoration of the chapel of Saint Eloi at the southern base of the hemicycle where images of sibyls can still be seen. And, finally, in the last years of his life the dean lent his financial support to the remarkably speedy reconstruction of the central steeple. He was the last great patron of the Gothic cathedral and his death in 1530 ends the three-hundred-year period of artistic production that I have called the "Life" of the Gothic Cathedral.

c) The Fabric

The mission of the clergy was the daily praise of God in the choir. The physical structure of the cathedral provided the principal tool facilitating this undertaking—not just appropriate shelter, but an edifice that actually expressed and projected in its forms, spaces, and lighting some of the dynamic ideas and beliefs animating liturgical practice. But how did the members of the chapter—mostly local men, some with a formal education in theology, law, or medicine—manage to organize the planning, design, and construction of this mighty edifice? And where did they find the resources—principally in cash—to pay the artisans and purchase materials?

The key agency in the apparently miraculous process by which the essential raw materials—stone, wood, iron, lead, and river sand for glass—were transformed into cathedral space and light may be found in the office of the cathedral *fabric*. The word *fabrique* in French or *fabrica* in Latin did not just refer to the physical envelope of the cathedral and its furnishings, but also to its human and institutional structure and the mechanisms of production. The institution of the cathedral fabric emerges with increasing clarity in the age of Gothic.[70] At Amiens and in most other French cathedrals, one or two members of the regular clergy (canons) were normally appointed to administer the fabric; other members of the clergy might also become involved where appropriate. The first mention of such agents at Amiens is recorded in a 1234 agreement recording the sale made by the canons of Saint-Martin in Picquigny to the "procurators" (or procurers) of the fabric of Amiens Cathedral (*procuratoribus fabrice ecclesie Ambianensis*) of the right to extract stone from their quarry at Beaumetz.[71] Such an agent might also be known as a *procureur, magister fabrice*, or *maître de l'oeuvre*—in England the job was often assigned to the sacristan.[72] Assisted by a clerk, a *varlet de la fabrique*, the procurator at Amiens presided over a kind of committee, the composition of which varied according to the task in hand. Included, might be the dean, the bishop, other canons, artisans, and sometimes representatives of the local municipal or royal administrations.

A variety of revenue sources was assigned to the fabric: the procurator was responsible for keeping accurate written records of income from such sources together with a day-to-day account of expenses including purchases of materials, artisans' wages, and additional expenses like consultancy fees. The resultant document was known as a fabric account (*compotus fabricae; compte de la fabrique; compte de l'oeuvre*) and such documents, which begin to survive in the second part of the thirteenth century and in considerable numbers from the fourteenth and fifteenth, provide invaluable evidence for the historian engaged in the study of the means of production.[73] Unfortunately only one such account (1357–1358) survives at Amiens: while it provides useful indications of the sources of revenue for the fabric, we are a century beyond the period of major construction, and the budget does not necessarily correspond to the earlier situation.[74]

Our fabric account provides specific information about a single year when no major construction was taking place—let us now review the situation

more generally. Revenue would normally be derived from collecting boxes placed in the cathedral and in churches in the city and throughout the diocese. Contributions to specific boxes associated with saints' relics would obviously increase on feast days. The cult of John the Baptist at Amiens Cathedral must have been particularly lucrative.[75] Relic boxes might also be carried out into the surrounding country in quests: such a relic quest took place in Amiens in 1240. Charismatic preaching, sometimes done by members of the mendicant orders, might help in the propagation of such quests.[76] Payments and contributions made in relation to the daily administrative and liturgical life of the cathedral might also be directed into the fabric fund. This included penalties paid by cathedral clergy for infractions of chapter rules (*marances*—a major source of funding for the choir stalls), as well as contributions made at specified masses and fees levied on new appointments of priests and canons. The clergy of the entire diocese might be required to contribute, as when *annates* were assigned to the fabric.[77] Legacies provided an important source of income. In the later Middle Ages confraternities, or groups of laypeople, might contribute—at Amiens the most important such group was the confraternity of Puy Notre-Dame, which had its chapel and headquarters in the south transept.[78] Legacies were often made in the form of the gift of a garment or robe: in the surviving fabric account of 1357–1358 this was the largest single item of income.

Such regular income was adequate for the maintenance of the cathedral together with its furniture and vestments—but not for major construction. While no documents exist, we may suppose that at the start of work in 1220 bishop and chapter committed some part of their regular income to defray the enormous cost of clearing the site, digging the foundations, and starting major construction.[79] This substantial institutional funding may have continued for a decade or two at Amiens: by the 1240s it is clear that the fabric was facing budget shortages perhaps as a result of the withdrawal of this support.[80]

Did the commune play a role? Elite members of the bourgeois certainly contributed as individuals to the construction of Amiens Cathedral, but there is no documentation of an institutional contribution.[81] Bourgeois support for construction is shown most clearly in the windows of the nave clerestory given by, for example, Drieu Malherbe (mayor in 1292), Guillaume li Ours, Raoul des Fossés, Liénard le Sec (who served as mayor four times,

from 1296–1309), and the Saint-Fuscien family.[82] One window was given by the town, others by the mayor of the corporation of woad producers, and yet others by the different deaneries of the diocese.

Construction might also be supported through substantial contributions by outside agents. Amiens Cathedral was certainly close to the heart of King Philip Augustus, who was married there in 1193; and to King Louis VIII, who may have spent time in Amiens when engaged in his unsuccessful invasion of England—but there is no evidence that this attachment translated into royal contributions to the fabric.

d) Artisans: Masons and Carpenters[83]

The fabric provided the institutional mechanism for construction; the material transformation of the raw materials (stone, timber, sand, lime, iron, lead, etc.) took place principally in the masons' yard located just to the east of the south transept in an enclosed court where a well provided water for the masons' workshop or lodge: the Cour du Puits de l'Oeuvre (fig. 3.10).[84] The stoneyard was enclosed by small houses accommodating the office

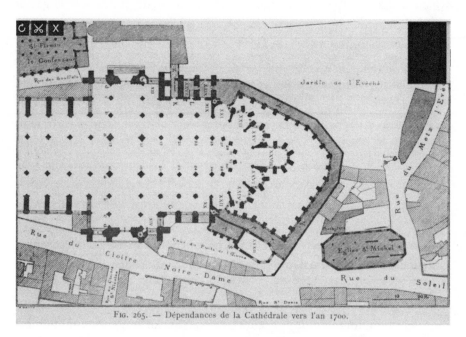

Fig. 265. — Dépendances de la Cathédrale vers l'an 1700.

FIGURE 3.10 Plan of the cathedral precinct (Georges Durand, *Monographie*)

of the clerk of the fabric and others who served the physical needs of the cathedral. Payment of masons' salaries was said to have taken place on a great stone in the yard that communicates directly with the interior of the cathedral via a door pierced in the outer wall of the westernmost bay of the south choir aisle; the adjacent chapel dedicated to the conversion of Saint Paul was also known as the *chapelle de l'oeuvre*. The masons' yard communicated directly with the chapter archive where financial records were kept and was adjacent to the chapter house where the clergy conducted their business affairs including deliberations on how to proceed with the construction. This was the hub of cathedral administration and production.

The structure of the masonic professional community becomes increasingly clear in the age of Gothic. Passage through the ranks from apprentice to master was tightly controlled by municipal regulations like the *Livre des métiers* of Étienne Boileau, Provost of Paris from 1261 to 1270.)[85] However, while such ordinances provide much information on the terms of apprenticeship and control of masonic knowledge, the elite master masons who directed the construction of Gothic cathedrals lived in a different world. These were individuals who had not just advanced to the rank of master according to the professional rules of the masonic community, but who had been selected to direct the work of construction of a major project.[86] They frequently came from elsewhere and would presumably be free from the corporate rules of the local masonic community that tended to protect local artisans.[87]

The master mason(s) responsible for the initial construction of Amiens Cathedral are identified in two inscriptions—the first one set in the nave pavement, and the second at midlevel on the south transept façade. The original nave pavement with its magnificent labyrinth, finished in 1288, was destroyed between 1827 and 1830; the central octagonal plaque bearing the images of the three master masons and the founding bishop is a replica (fig. 3.11)—the original is now in the Musée de Picardie.[88] Fortunately, the inscription set in a bronze strip framing the central plaque was recorded in a fourteenth-century martyrology: *Note on when this church was first begun, just as it is written in the slab of the House of Daedalus [i.e., the Labyrinth]. This work was begun in the year of grace 1220. At that time the bishop of this diocese was Évrard, blessed bishop. And the king of France was Louis who was the son of Philip the Wise. He who was master of the work was named Robert and surnamed de Luzarches. Master Thomas was after him*

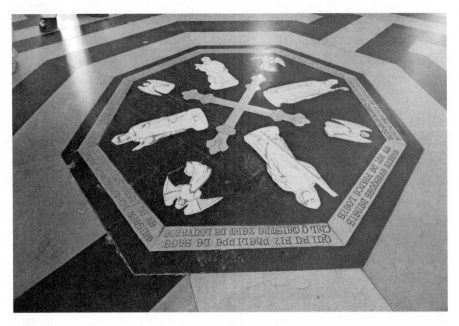

FIGURE 3.11 Central plaque of labyrinth (replica: original in the *Musée de Picardie*)

and afterward his son Master Renaud who had this inscription placed here in the year of Incarnation 1288.[89] The presence of the names of the master masons inscribed in the central nave just to the east of the tomb of the founding bishop, Évrard de Fouilloy, provides eloquent testimony to their elevated status—enhanced by the placement of the images of the masons at the heart of the "House of Daedalus"—pointing to the heritage from the legendary builder of the labyrinth on the island of Crete: the maker of wonderful things and the first man to fly.[90]

The second inscription runs at the base of the triforium of the south transept façade. Unfortunately, having become badly weathered and semilegible, it was clumsily restored in the nineteenth century—the full meaning is impossible to unscramble. Certain, however, is the date 1220, reference to laying the first (foundation) stone and the name of Robert.[91] At the base of the same transept façade is an image of what appears to be a mason's trowel depicted in low relief on the left embrasure of the south transept portal (fig. 3.12).[92] It is tempting to associate this motif with the agency and possibly the burial of the founding master mason, Robert de Luzarches, especially since we will see in chapter 4 that it is likely that this

FIGURE 3.12 Low-relief image of a mason's trowel in south transept portal embrasure

was the area where the walls of the cathedral first began to rise up above the foundation level.

We can assume that like Master Reginald, named in the 1357–1358 fabric account of Amiens Cathedral, the master masons named in the labyrinth would receive not only a generous daily wage but also an annual salary in token of the sumptuous hood trimmed with ermine that marked his office. The tomb effigy of Hugues Libergier, master mason of Saint-Nicaise of Reims, provides a glimpse of such a master elegantly clad in cape with hood and beret and carrying a model of his church and a ceremonial measuring cane. While the measuring rod allows him to control the arithmetic dimensions of the building, the key to geometry is provided by the flanking instruments—dividers and square (fig. 3.13). We should also recall the name of Master Pierre de Montreuil, master mason of Notre-Dame of Paris and Saint-Germain-des-Prés, described in his tomb inscription as *doctor lathomorum*—a teacher of masons.

When considering the elevated status of the Gothic master mason it is hard to forget the disapproving words of the Dominican preacher, Nicolas de Biard: "The masters of the masons, holding in their hands [measuring] rod and gloves, say to the others 'Cut it [the stone] for me in this fashion,'

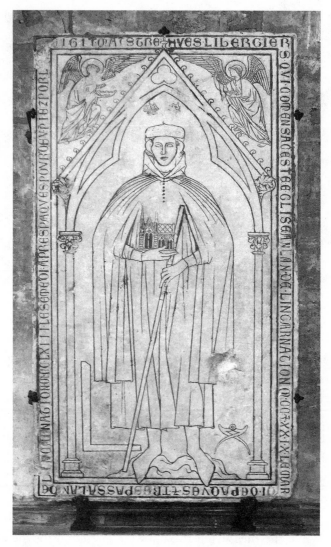

FIGURE 3.13 Tomb slab of Master Hugues Libergier, formerly in the church of S-Nicaise in Reims, now in the cathedral (Wikipedia)

and they do not work; yet they receive greater pay than many experienced men do."[93] This judgment draws upon a well-established trope: to be an architect is to devise the building, just as God devised the world—not to actually engage in the construction oneself.[94] Did our master masons of Amiens Cathedral actually involve themselves directly in the daily business of construction? We might remember the words of the chronicler Gervase

this dude again

of Canterbury when describing the role of Master Mason William of Sens. This master was given the commission to rebuild the choir of Canterbury Cathedral not just because of his "lively genius and good reputation," but also because he was "as a workman most skillful both in wood and stone" and able to procure appropriate stone and build the necessary lifting gear.[95] The "lively genius" of the master mason presumably allowed him to envisage an entire cathedral, to endow it with dynamic spatial characteristics, and to represent it in words and images. The logistical skills included the ability to control the form of all the multiple parts of that building and to maintain that control for long enough to get the thing finished. Geometry played a key role in both dimensions of the enterprise. That look of perfection so characteristic of Amiens resulted from absolute mastery of all aspects of the craft.

The master masons of Amiens Cathedral belonged to a very small, elite group that had more in common with the clergy than with the laborer who dug the foundations or mixed the mortar. By the later middle ages this group had established itself with protocols that matched those of the clergy: ceremonial entry into the profession, characteristic garb, and regular meetings (like synods) to maintain the control of knowledge and professional standards.[96] When it came to the construction of a great Gothic cathedral, the relationship between the leading members of the clergy and the master mason was a symbiotic one.

The masons could not have accomplished their mission without the help of the carpenters, the unsung heroes of the enterprise, who provided the essential mechanisms of construction, finally crowning the finished work with its protective roof and the wild flourish of the central spire. Later medieval written sources suggest that the master carpenter might command a daily wage that matched that of the master mason.[97] Let us look at the carpenters' essential work with the masons: building props, making ties, constructing scaffolds, and lifting gear and formwork.

Construction of the lower walls up to the sill of the aisle windows could be completed by the masons with little help from the carpenters: long ladders would suffice. This was why the earliest work at Amiens was concentrated upon this task along the entire length of the cathedral, south and north sides, with the exception of the eastern hemicycle (fig. 4.16.1). However, the next phase of construction would necessitate a range of different kinds of scaffolding (fig. 3.14).[98] At the level of the arches of the aisle windows and of the main arcade the contribution of the carpenters became critical to the struc-

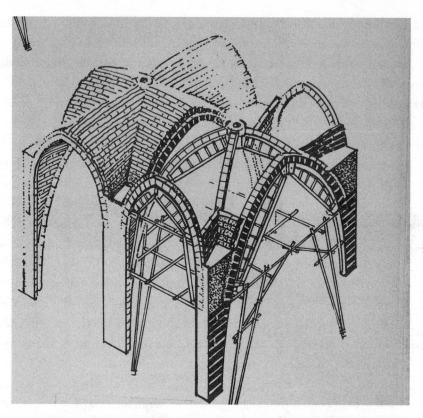

FIGURE 3.14 Scaffolding and centering to construct rib vaults (James Ackland, *Medieval Structure: the Gothic Vault*).Copyright University of Toronto Press, 1972, Reprinted with permission of the publisher.

tural integrity of the building as it went up. Prior to the installation of each arch in the main arcade a wooden tie beam, around twelve or thirteen centimeters square, was anchored in the masonry at the base of the arch in order to prevent the thrust of the arch from pushing the slender supports outward; the piers might also be temporarily propped with diagonal wooden braces to counter the thrust of the recently built arch. At the start of work in the angle of the southern aisle of the nave and the western aisle of the south transept, the tie beams were placed well above the capitals of the main arcade: as work progressed it was decided to place the ties lower, directly atop the capital where the stump is less visible once the beam has been cut out. With the ties in place, a rigid wooden formwork could be put in position upon which the stones of the arcade arch would be laid up.[99] We have an image of such formwork in

FIGURE 3.15 Panels of stained glass window originally from the nave aisle, reset in the north choir aisle: Adam and Eve and the Tree (top) and signature of the carpenters, hewing a beam and constructing formwork for an arch (bottom). See also color plate.

a thirteenth-century stained glass window of Amiens Cathedral presumably donated by the carpenters (fig. 3.15). The masons might tentatively assemble the stones (*voussoirs*) of the arch on the ground before laying them into place atop the formwork with a thin layer of mortar between them—not to stick them together, but to cushion the liaison of each stone with its neighbor.[100] Similarly, the stones of the transverse arches and diagonal ribs of the aisle vault would also be laid up over wooden formwork; the stones of the *severies* or vault webs might be put in place over more flexible centering.[101] Once the vault unit was complete, the mortar was allowed to set for a few months before the formwork was removed and the tie beams cut out. This was the invisible magic of the carpenters, making it all possible.

All of the concave surfaces of the cathedral—arches and vaults—were constructed in this way over wooden formwork. And all of the convex

surfaces—piers, colonnettes, tracery elements—were shaped through the application of wooden templates that were the work of the carpenters' colleagues, the cabinetmakers (*huchiers*).[102] It was in the workshop at Amiens that serialized stone production was perfected.[103]

The windows of the aisles and clerestory might be closed in with provisional wooden screens: this was particularly important at clerestory level where wind gusts might penetrate the interior and inflict damage. The supporting structure of the same screens might then be adapted to facilitate the installation of the slender sticks of stone forming the window tracery.

e) Artisans: Sculptors (*tailleurs d'images*)

[handwritten: image tailors!]

i) Thirteenth Century

The story of the life of the gothic cathedral begins with the creation of the four great portals of Amiens Cathedral in the three decades between the 1220s and circa 1250. The task faced by the artisans was enormous: the three western portals alone contain fifty-two column figures, three trumeau figures, and about two hundred and thirty voussoir figures: three great tympana with multiple images, not to mention the low-relief sculpture of the embrasures and infinite decorative elements. The modern student might conclude that there must have been an enormous and extremely well-organized workshop to complete this amount of work in such a timely way.[104]

Just as Master Mason Robert de Luzarches came from elsewhere, probably with Thomas de Cormont and a small number of skilled masons, so it is likely that the sculptors arrived in Amiens in small groups, attracted by the prospect of an extended period of lucrative employment.[105] They would have previously worked on one or more of the great contemporaneous cathedral portal projects, including Laon, Noyon, Chartres, Reims, or most especially Notre-Dame of Paris; and while they might have their own ideas about the overall sculptural program, it is likely that they reported directly to the fabric committee that included one or more clerical iconographers and probably also the dean, Jean d'Abbeville. The master mason, Robert de Luzarches, would fix the overall design of the portals including the dimensions and geometric underpinnings of the portals and porches.

The sculptors of Amiens were provided the same high-quality chalk that their colleagues the masons were using, extracted from nearby quarries at Ailly-sur-Somme in the Noye River valley, as well as Camon and la Faloise in the Somme River valley. This fine-grained stone is quite porous and ranges in hue from nearly white to yellowish. It contains lumps of black flint, which might emerge unexpectedly from a block of stone at any time during carving, potentially ruining a sensitive area like the features of a face.

Work probably began on the low-relief sculpture of the west portal embrasures including the foliate decoration and the 118 quatrefoils that were completed without major modification.[106] This sculpture is carved from sizeable blocks of stone and was probably begun in the workshop with finishing work done in situ.[107] In the work of constructing the portals the first sculptured elements to be installed would be the voussoirs: the great enclosing arches of the portals. Tympana and trumeaux would be inserted into the finished arch. Preparation might start early on the carving of the column figures: at 2.30 meters they are slightly larger than life-size, and each statue has a column attached to its back that engages with an architectural canopy above and an elaborate console below. They would probably be carved in the workshop and could be installed either during the construction of the portal or soon afterward.[108]

Attempts have been made to determine the authorship of each element of the sculpture on the basis of style, with a name invented for each hypothetical artist.[109] However, I prefer to look more broadly for various different approaches to modeling the human form, stance, and garments, thinking of these approaches as modes of production that might be shared among multiple individuals and groups of carvers and that can sometimes be matched in other great cathedral portals. We will find at least four such modes, which, while they can be arranged in a broadly sketched chronological order, also overlap widely one with another.

While the lowest courses of the frontispiece, including the quatrefoils, were probably laid out as a unified campaign, the fact that the south nave aisle was clearly constructed and vaulted before the north determined the chronological priority of the south portal, that of the *Mère Dieu*, where work on the sculpture began soon after 1220. In the voussoirs, lintels, and tympanum of this portal we find the crinkled drapery of the Antique Revival style, associated especially with the cathedrals of Reims and Laon (fig. 2.15–18).[110]

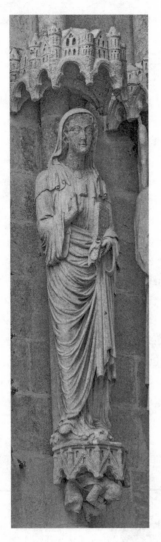

FIGURE 3.16 West façade, north portal: Ste Ulphe

This phase at Amiens includes some of the highest-quality work found anywhere in the west portals: the energetic kings in the voussoirs of the southern portal, the grieving Apostles grouped beside the Virgin's bed in the Dormition, and the six seated patriarchs flanking the Ark of the Covenant. The same Antique Revival style can be found in some of the column figures, expressed in their elegant contrapposto stance, crinkled drapery, almond-shaped eyes and curved brows: most notably in the poignant image of Saint Ulphe in the north portal, and Isaiah in the central portal (fig. 3.16). These were clearly among the earliest column figures carved in the 1220s.[111]

The second mode of sculptural production (c. 1230s) at Amiens can be found in the north portal of Saint Firmin and the column figures of the south transept portal of Saint Honoré (figs 2.21; 2.26–27 and 2.40–41). I call this the "demotic" mode. In the tympanum of the Saint Firmin portal, the story of the discovery of the relics of the saint and the procession back to Amiens is carved in blocks of stone that are laid up in front of the masonry field. The rectangular shape of the block impinges heavily upon the composition, which was a novel one.[112] The crowds of cityfolk press tightly together and their rounded heads seem piled up one on top of the other. Faces are rotund and jolly, necks are short, and drapery is flaccid. The contrast between the six seated patriarchs in the south portal and the six seated bishops in the north is striking: the latter seem deprived of dynamic life (figs 2.16 and 21). Architectural elements are clumsy. The same characteristics can also be found in the column figures of the south transept portal (figs. 2.40–41).

The third mode of sculptural production (1220s–1240s) brought references to prototypes in Byzantine and Italo-Byzantine art. It begins with the overt reference to a Byzantine ivory image of the Virgin Mary *Hodegetria* that provided the model for the trumeau figure in the south portal.[113] The Byzantine Mother of God (*Theotokos*) has become the Gothic Mère Dieu (fig. 2.11). Then, the prototype shifted from a portable ivory object to the Italo-Byzantine mosaics of Rome and Ravenna probably seen by the clergy on their visit to Rome for the Lateran Council of 1215.[114] This link is seen most powerfully in the apostles of the central portal (figs. 2.29–30). There is little or no contrapposto here: figures stand squarely, mostly looking inward toward Christ, the Door. Drapery folds are broadly vertical, though cut through by strong diagonal swathes. Faces are serene, somewhat expressionless. There is a high level of sameness from one figure to the next: these are human beings cast in the same mold—the one provided by Christ, the Beau Dieu, at the center (fig. 2.33). This mode can also be found in the tympanum of the northwest portal of Notre-Dame of Paris: it almost certainly reflects clerical intervention in the business of sculptural production. The stance and drapery of the Amiens apostles bear a strong resemblance to those found in the solemn line of martyrs, rendered in mosaic, processing down the north side of the nave of the basilica of Sant'Apollinare Nuovo in Ravenna.[115]

The final mode, characteristic of the 1240s and 1250s, can be related to the famous Smiling Angel of Reims—the work of the "Joseph Master" of Reims Cathedral—as well as the Apostles of the Sainte-Chapelle, the image of King Childebert from the trumeau of the refectory portal of Saint-Germain-des-Prés in Paris, and much of the sculpture of the transept portals of Notre-Dame. I will call this the "Parisian Beautiful Mode": it brings expressive faces and rhythmically curved bodies together with broadly carved drapery with zigzag folds. At Amiens it is found principally in the tympana of the Last Judgment and Saint Honoré (south transept) portals, reaching its culmination with the famous *Vierge dorée* installed in the trumeau of the south transept portal at an undetermined mid-thirteenth-century date (fig. 2.44). This mode of production is associated particularly with the emergence of Paris as artistic capital of northern Europe, and was eagerly adopted by *tailleurs d'images* and *imagiers* in multiple media: manuscript painting, ivories, and metalwork.[116]

In 1992 a major campaign of cleaning and consolidation was begun on the portals: it was to continue for more than two decades.[117] The sculpture had become blackened by pollution from nineteenth- and twentieth-century industrial production and smoke from the coal fires of the houses and factories of the city. Exterior surfaces, especially sculptural elements, were covered by a millimeter or more of oily soot and massive amounts of pigeon excrement, and some had suffered serious deterioration owing to the action of salts within the stone. Cleaning techniques included pioneering use of the laser to burn away the accumulated grime, as well as fine sand blasting (*microsablage*) and cellulose compresses. Enormous public excitement was generated by the revelation of traces of the polychromy or paintwork: this excitement has been fed in the past two decades by a light show where, on a summer night, viewers can see the portals lit up and the figures glowing in a surprising range of very bright colors.[118]

However, in reality, surviving evidence is fragmentary and the understanding of the original color scheme is very far from complete. Scholarly and scientific analysis of, for example, the image of the apocalyptic Christ at the tip of the central tympanum has revealed that his halo, beard, and swords were once gilded (there are traces of red underpaint); his face was pink with features picked out in black; his robe was white and green with a red lining and cuffs; and his banderole was white. The color red dominated

much of the rest of the central tympanum. Analysis of the surviving paint on the central trumeau, the Beau Dieu, has revealed repeated repainting. A coat of white lead prepared the surface to receive the pigments that included red (vermilion) for his coat, blue (azurite) for his tunic, pink (ocher and vermilion mixed with white lead) for his flesh, and black and white for the eyes (black derived from charcoal). Liberal use was made of gold and tin leaf. The Mère Dieu in the south portal has no less than twenty-six layers of paint—it seems that this portal was the only one painted immediately after the sculpture was completed.

Despite our skepticism about the authenticity of the colors projected upon the sculpture at Amiens, there is little doubt that the painted statues would have created the effect of miraculous hyperreality that would have excited the emotions of medieval viewers, preparing them for the revelations of the interior spaces.

ii) Later Middle Ages

When reviewing the work of the masons I warned against the assumption that the cathedral was completed in the first half-century of work; the same caveat applies to sculptural production. Although the sculptural program of the four great portals was complete at that time, work had probably already begun on a sumptuous choir screen or *jubé* that carried an extensive program of figurative sculpture (figs. 1.45 and 3.17).[119] The commissioning of the choir screen suggests that after a prolonged exile the clergy were anxious to resume their daily offices in their own space: this would involve the completion of choir stalls—work of the *huchiers* and *menuisiers* or cabinetmakers—as well as all the other necessary liturgical equipment and choir books—work of the metalworkers, scribes, and painters.

We have seen that soon after the completion of the liturgical choir, work began on the addition of lateral chapels flanking the nave. The tombs, shrines, and screens that once embellished the interior of each chapel have been destroyed; however, much of the exterior sculptural program survives.[120] The earliest work from around 1300 continues the mode of carving I have dubbed "Parisian Beautiful": the two monumental figures in the upper south transept façade and the Wheel of the Ages around the rose window belong to the same mode of sculptural production. However, as

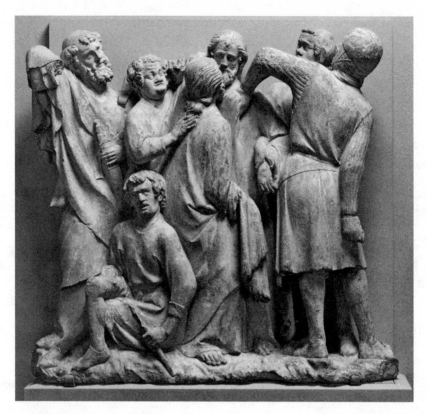

FIGURE 3.17 Fragment of sculpture from the destroyed jubé sculpture: the Betrayal of Christ (Metropolitan Museum, New York)

work progressed, we find direct infusions from Paris at Amiens: the Annunciation, where the Virgin has been compared with the famous silver Virgin commissioned by Jeanne d'Evreux for the abbey of Saint-Denis around 1339 (fig. 3.18); the use of the "Demotic Mode" to render the devout members of the woad merchants' community (fig. 3.19); as well as a trend toward more voluminous and animated drapery.

Sculptural production associated with the nave chapels reached a crescendo in the last decades of the fourteenth century with the *Beau Pilier*, a decorated buttress at the west end of the northern chapels of the nave intended, no doubt, to help support the soon-to-be-built northern tower of the western frontispiece (figs. 3.20 and 5.9).[121] Here we encounter a systematically programed sequence of sculptured figures integrated with the architectural frame in the form of three vertical supports each carrying three figures.

FIGURE 3.18 Exterior nave, southern chapel of the Annunciation: the Annunciation

FIGURE 3.19A Exterior nave, southern chapel of Saint Nicholas: woad merchants in prayer

FIGURE 3.19B Exterior nave, southern chapel of Saint Nicholas: woad merchants, tall and short, with their merchandise

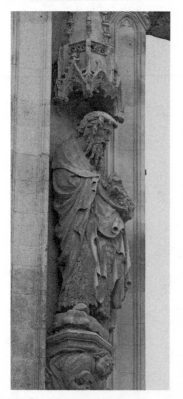

FIGURE 3.20 Exterior nave, northern chapel of John the Baptist: John the Baptist

At the top are the three patrons of the cathedral, the Virgin Mary, John the Baptist (fig. 3.20), and Saint Firmin; in the middle are three representatives of royal dynastic power, King Charles V and his two sons; and at the bottom are three figures representing royal government—Jean de la Grange together with the great chamberlain and admiral.

With the two northwestern chapels commissioned by Jean de la Grange we enter into a new world of Gothic (fig. 1.18).[122] The tracery forms of the windows of the new chapels parallel those of distant monuments including Prague Cathedral and York Minster, and the voluminous and mannered forms of the sculptured drapery (particularly of John the Baptist) have been associated with the work of Claus Sluter. Links with Paris are powerful—the overall program of the Beau Pilier with its emphasis upon kingship echoes that of the *Grande vis*, an elaborate staircase, lined with statues of kings, that was added to the Louvre in the 1370s. The effigy for the cardinal's tomb in the cathedral was actually carved in Paris and carted to Amiens. This is an international style that matches the international agenda of its patron, Cardinal Jean de la Grange. The same mode of carving, which I would term the "Voluminous Mode," continues in the sculptured prophets attached to the upper southwest tower, completed around 1400.

After the completion of the southwest tower there was a gap in sculptural production at Amiens Cathedral: the disasters of the Hundred Years' War, Burgundian presence, and heavy taxation diverted funding away from the fabric of the cathedral. When the clergy was able at last to undertake major sculptural projects toward the end of the fifteenth century, the world of the artisans had radically changed. Whereas the sculpture of the west portals was probably the work of small groups of sculptors who traveled from site to site (Laon, Paris, Noyon, Reims, etc.), by the later middle ages sizeable communities of artists resided in Amiens: these were the artisans employed by the cathedral clergy to embellish the cathedral in the last great phase of image production that began toward 1490 and continued for almost half a century, marking the end of the life of the Gothic cathedral.[123] We will look closely at this work in chapter 5.

f) Artisans: Glaziers[124]

Gothic was, above all, an architecture of light; and yet we know almost nothing about the circumstances of the production of the thousands of

square feet of colored translucent membrane filling the windows of the great cathedrals of Notre-Dame of Paris, Laon, Chartres, Reims, Soissons, and Amiens, transforming the earthly into a heavenly realm. Workshops would be established on each cathedral site where glass could be smelted, the lead H-section binding pieces molded, and the iron bars of the armature forged.[125] Whereas the work of our masons and carpenters was directed by a master artisan, it seems likely that the glaziers responsible for the windows of the thirteenth-century cathedral reported directly to the fabric committee. The production of stained glass windows was a highly specialized operation, appropriate mainly for great churches, and it is unlikely that thirteenth-century Amiens would be home to a community of such artisans, who probably traveled in small groups from cathedral site to site.[126] As the first windows were installed in the Amiens nave aisles toward 1230 the enormous glazing operation at Chartres Cathedral was beginning to wind down, and some of the artisans may have found their way to other cities.

The production of glass is also very different from stonework or carpentry since a window was very often the gift of a wealthy individual or urban group. We can think of such a donation as a votive offering or prayer, and it is unthinkable that the donor would take no interest in the subject matter—although the fabric committee and the chapter would presumably retain ultimate control of the overall program while at the same time responding to changing circumstances and gift opportunities.

Piecing together the glazing program at Amiens is difficult, given the extent of the losses incurred when the nave aisle windows were torn out and mostly destroyed (1290s–1370s). The destruction reached a crescendo in the eighteenth century with massive losses resulting from a series of accidents (windstorms and explosions) and from the desire of the clergy of the *siècle des Lumières* for brighter, clearer interior illumination. Sadly, some the qualities we most admire at Amiens Cathedral—above all, that silvery light playing upon delicately wrought surfaces—is the result of the combination of natural disasters, changing taste, and vandalism that led to the installation of vast expanses of clear glass.[127]

The enormous original windows of the nave aisles, each with two broad lancets and upper oculus, were filled with deeply saturated colored glass arranged in a variety of quatrefoil patterns, as in the nave aisle at Chartres or the ambulatory of Bourges Cathedral. The panels would be occupied

by narrative scenes including multiple figures and backgrounds formed of *rinceaux* or mosaic. The dominant colors were red and blue. These were windows donated by the different professional groups (*corps de métier*) of the city to tell stories from the Bible developing typological and allegorical links between the Old and New Testaments and performing the role of informing and enlightening the beholder, as would a sermon.[128] Fragments of one such window survive in the north choir aisle: the window tells the story of Adam and Eve (fig. 3.15).[129] The "signature" panel at the bottom shows the carpenters preparing a great beam, drilling a hole and, most interesting, assembling the formwork for an arch or window. We can only dream about the splendor of the line of such windows illuminating the steep space of the nave aisles and allowing the visitor/interlocutor to recount the essential tales of the Bible and explore their deeper allegorical levels of significance. More than that, the windows provided a visual expression of the role of the different groups of artisans whose presence was vital to the life of the cathedral and the city of Amiens.

About a decade later, in the 1240s–1250s, the windows of the choir aisles and chapels were ready to receive their glass. Here the program was largely determined by the presence in the chapels of the various saints, and the cult of the Virgin Mary in the axial chapel (fig. 4.21). Although the choir did not suffer the same radical architectural transformation as the lower nave, the glass has been decimated and very little is in its original place. And yet we can get an idea of the glazing program of the axial chapel of Notre-Dame-de-la-Drapière, which also served the parishioners of the area of the cloister to the south of the cathedral and the confraternity of textile merchants. Windows in the Notre-Dame chapel depicted the genealogy of the Virgin in the form of a great Tree of Jesse, and also the Infancy and Passion of Christ. Surviving elements of the Tree of Jesse window, supplemented by extensive restorations, have recently been reinstalled in the chapel of Saint Nicaise providing a general idea of the appearance of the original windows of the lower choir (fig. 3.21). The "signature" panel of the weavers was relocated in the adjacent chapel of Saint Augustine and shows the drawing out of the woolen yarn and the production of cloth on a horizontal loom—probably among the earliest representations of mechanized cloth production (fig. 3.22).

In the choir aisles and chapels the windows have tall narrow lancets, and the crowded compositions of the nave were no longer possible. Blue and

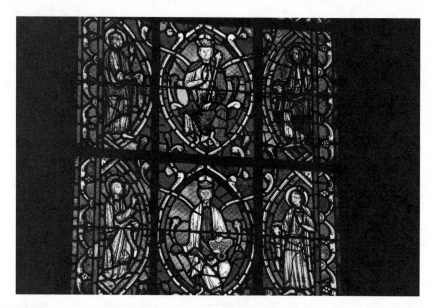

FIGURE 3.21 Panels of stained glass depicting the Tree of Jesse originally in the axial chapel, restored and reset in the chapel of St. Nicaise. See also color plate.

FIGURE 3.22 Panel of stained glass window originally in the axial chapel, restored and reset: weavers at a horizontal loom. See also color plate.

red are still dominant, but we also find green yellow and purple. One choir chapel, that of Saint Eloi, still has fragments of its original glass in place. In the famous Tree of Jesse window the level of color saturation is reduced, enhancing refulgence (fig. 3.21). Most fascinating are the fragments from a window devoted to English saints, including Edward the Confessor and Edmund—the fragments were reassembled in a window in the west aisle of the north transept. The English connection can also be found in a window of the Life of the Virgin apparently given by Eleanor of Castile, wife of King Edward I of England.

The glazing of the nave clerestory also belonged to these years (1230s–1250s). Unfortunately, while the identity of some of the donors was recorded before their destruction, it is impossible to be certain of the content of the windows, which probably framed monumental standing figures, perhaps of local saints.

In the following decades (1260s–1270s) the glaziers at Amiens, responding to a wider trend in stained glass production, began to deploy large areas of the silvery-gray glass known as *grisaille*.[130] Set in this field are broadly depicted, brilliantly colored monumental figures. The use of an elaborate architectural enclosing frame becomes increasingly common. Such a combination, lending greater visibility, is particularly suited to upper windows. The color palette changes, as we find the increasing use of yellow, green and purple. Such windows are present in the Amiens upper choir. The axial bay is dominated by the Virgin Mary: in the central window of the clerestory Bishop Bernard d'Abbeville presents a gift of a window to the Virgin Mary: the inscription records the 1269 gift (fig. 3.23). The cartoon renderings are turned to make a second image of the bishop and Virgin, now in reverse—the viewer may see this as another image of the same bishop or one of his predecessors or successors. Above, the slender lancets are filled with a bevy of elegant angels. The Virgin is also present in the axial bay of the choir triforium where the Annunciation is flanked by images of the two principal saints whose relics were lodged in the cathedral: Saint Firmin and John the Baptist.[131] In the straight bays of the choir the triforium is occupied by monumental figures of apostles and bishops (fig. 3.24): the combination of the Virgin in the center and the flanking ranks of Apostles provides a clear evocation of the Church, and it is likely that the windows of the choir clerestory, now lost, would have continued the same theme.

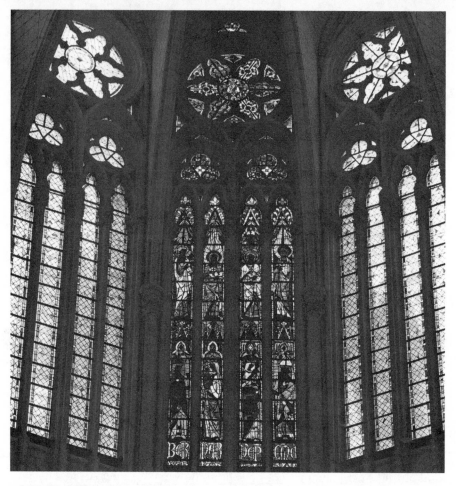

FIGURE 3.23 Axial window of the choir clerestory donated by Bishop Bernard d'Abbeville in 1269. See also color plate.

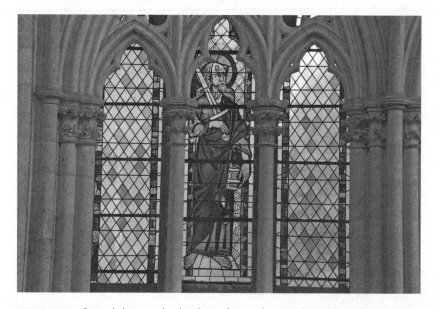

FIGURE 3.24 Stained glass panel in the choir triforium: the Apostle Paul. See also color plate.

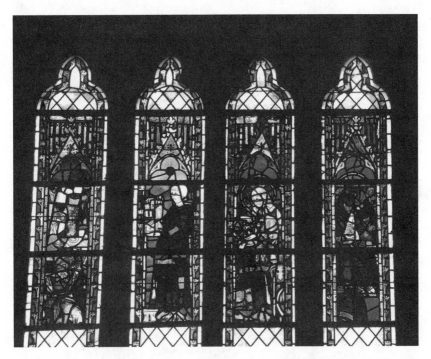

FIGURE 3.25 Stained glass window in the nave chapel of Ste-Agnes, founded by Mayor Drieu Malherbe in 1296: the mayor donates his chapel, images of Saints Catherine and Agnes. See also color plate

The copious use of a field of *grisaille* glass into which is set a monumental figure or simplified scene in an increasingly elaborate frame is characteristic of much of the stained glass production of the fourteenth century: at Amiens it is expressed most beautifully in the surviving glass of the first chapels of the nave. The easternmost chapel on the north side was dedicated to Saint Agnes and offered by the mayor of Amiens, Drieu Malherbe (fig. 3.25). We find the mayor together with his patron saints, Agnes and Catherine. The elaborate architectural frames with their gables and vertical panels are reminiscent of contemporary small-scale objects (ivories and metalwork), was well as the windows of Saint-Ouen in Rouen. Similar grisaille glass with figurative panels can also be found in the slightly later chapel of Saint Michael.

As the first chapels were being added to the nave, work was also under way on both transept façades. On the south side, from the late thirteenth century, we have a gallery of bishops at triforium level: the upper level of the window (the rose) was entirely rebuilt two centuries later. The bishops have

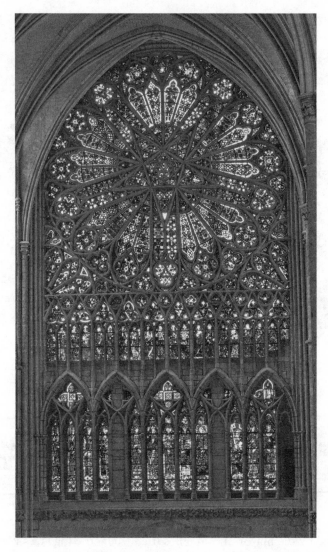

FIGURE 3.26 North transept rose window and triforium. See also color plate.

the characteristic monumentality of the period and are enclosed in architectural frames, however, there is not much use of grisaille. The matching gallery on the north side, produced a little later, is occupied by kings and also brightly colored and with little grisaille (fig. 3.26). The glaziers of this period had access to heaps of glass fragments from the demolished nave aisle windows—is it possible that some of this glass found its way into the transept façades?[132]

social change leading to architectural change

The last decades of the fifteenth century saw an extraordinary flowering of stained glass production, with the return to prosperity after the end of the Hundred Years' War and the struggle with the Burgundians. Families of glaziers established themselves in cathedral cities like Troyes, Beauvais, and, probably, Amiens. The austerity of the grisaille window was abandoned in favor of brilliant color, enhanced by new production techniques and embellished with exquisite painted effects. Learning from their colleagues the panel painters, glaziers began to introduce enhanced levels of modeling and limited depth into their compositions.

This final phase of medieval glass production is represented at Amiens in the two splendid rose windows of the south transept and the western frontispiece (figs. 3.27–28). In the south transept rose, twenty-four brightly colored angels have crowded into the sinuously curved petals of the Flamboyant rose, probably installed by Master Mason Pierre Tarisel around 1500. This is the second rose window that has existed in the upper south transept: the first rose would have belonged to the second part of the thirteenth century, and was possibly the work of Renaud de Cormont circa 1260s–1280s. We have seen that the precariousness of the location was

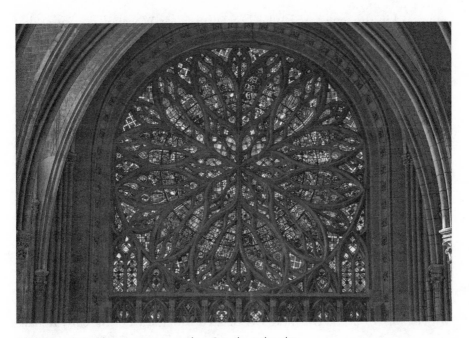

FIGURE 3.27 South transept rose window. See also color plate.

FIGURE 3.28 West rose window. The lilies of France mingle with the ivy of Amiens. See also color plate.

expressed in the sculptured Wheel of Fortune (or Wheel of the Ages) that turns around the exterior rim of the rose, ultimately throwing off its occupants. The glaziers picked up the theme by placing the heads of the upper angels toward the center of the composition: thus, while the lower angels appear to surge upward, the upper angels plunge down, expressing their flight in a variety of expressive gestures.

The west rose, donated by canon Robert de Cocquerel who had held the office of Master of the Confraternity of Notre-Dame du Puy (d.1521), is equally brilliantly colored and delicately painted (fig. 3.28). The nonfigurative composition was intended to celebrate the reunion of the city of Amiens with the kingdom of France after the period of Burgundian domination. Golden fleurs-de-lys on a blue field are sprinkled both at the extremities of the petals and at the center, while the petals themselves are filled with elaborate foliate compositions—presumably intended to represent the ivy emblem of the city of Amiens.[133] The glaziers have embellished their composition with a range of decorative motifs associated with the art of the early Renaissance in France: cornucopia, fluted urns, candelabras, and fantastic animals.

g) Laypeople in the Cathedral

That members of the clergy, on the one hand, and laypeople, on the other, had very different roles to play in the cathedral at first seems self-evident. Clerical ordination brought *transformation:* the canons of the cathedral lived an institutional and devotional life intended to be apostolic; they were present in the cathedral choir at all hours, day after day. Ordinary folk, on the other hand, including townsfolk, pilgrims, and modern visitors, come and go: our presence in the cathedral is ephemeral. And, of course, this was a *cathedral*, seat of a bishop—parish functions were confined to the enlarged axial chapel of Notre-Dame known as the *Petite Paroisse*, which served the lay residents of the neighborhood of the cloister.[134]

The role of laypeople in the medieval cathedral was, however, more extensive and more complex than the modern visitor might suppose: while some aspects of their involvement have left visible signs in the building, much can only be assessed from the study of the written sources.

First, we might remember that the construction of this enormous Gothic cathedral in a densely populated city necessitated major urban rearrangements: the hospital that had crowded the northwestern side of the building site was moved to the parish of Saint-Leu, in the industrial northern suburb. Moving a hospital to a heavily populated quarter of the city could only be undertaken with the approval of the king and with formal consent from the commune: *de communi consilio.* The 1238 charter of Bishop Arnoul de la Pierre mentions the "many gifts and alms" that had been received for the new work being undertaken, as the charter specifies, "with the consent of the chapter and the citizens of Amiens who also obtained the favorable consent of our lord the king." Moreover, the transfer was facilitated through the generosity of a wealthy layperson—a citizen of Amiens, Jean de Croy, who purchased the site for the new hospital and donated it to the cathedral.[135]

Unfortunately, we lack documentation of the "gifts and alms" mentioned above in the form of fabric (or building) accounts: however, we have seen that in the surviving account for 1357–58 the largest receipt (45 percent of total) came from gifts from laypeople in the form of garments (*robes*). The second largest item of receipt in this year was from coins dropped in the various collecting boxes of the cathedral. When discussing the role of the clergy, I suggested earlier that such gifts were entirely inadequate for

major work and the first two decades of construction were likely to have been funded principally from the regular income of the bishop and chapter, However, by the 1240s increasingly urgent requests were being directed toward the laypeople of the diocese in the form of relic processions accompanied by fundraising quests.[136] The 1357–58 fabric account includes an item of payment for the copying of the letters of authorization for such a quest. Itinerant preachers accompanying the relics might offer relief from the painful prospect of purgatory in return for a gift to the fabric. It is possible that some laypeople were alienated by the increased urgency of the fundraisers: certainly, there were a number of violent anticlerical incidents in these years.[137] We tend to associate sales of indulgences with the end of the age of Gothic and the abuse that sparked the Protestant Reformation: here, however, we have the phenomenon from the start.

While contributions to the fabric fund by laypeople only amounted to a fraction of the cost of major construction work, individuals or groups might take responsibility for a *part* of the great edifice: a window or a chapel. We count principally the lost stained glass windows of the nave and choir aisles, many of which were given by professional corporations of the city. Such gifts might be associated with the adoption of various chapels by certain professional groups as their institutional seat.[138] In 1667, the great antiquarian and Latinist, Charles du Fresne du Cange, transcribed many of the inscriptions: however, the list is incomplete and other than the identity of the donor we have little information about the figurative subject matter of the windows.[139] In the nave clerestory, north side, we find a mayor of Amiens, Drieu Malherbe (d.1292), together with Enguerand de Saint-Fuscien; we also find the arms of the local families of Malherbe, Saint-Fuscien, and Conty, as well as Master Willaume le Ours, and the master of the woad producers who gave two windows. At the west end of the south side of the nave was a window given by the city of Amiens. In the north transept, in addition to Canon Raoul de Fosse, we also find another window given by a woad merchant. In the choir several clerestory windows were given by the deaneries and cities of the diocese, including Pois, Conty, Grandviller, Doulens, Abbeville, and Saint-Riquier. Interestingly, there was a window, probably in the eastern end of the choir clerestory, with an image of the Virgin and a queen given by Eleanor of Castile, wife of King Edward I of England. In the south transept a window dated 1280 was donated by

two of the "mayors" of the association of woad merchants who clearly played a dominant role in the donation of windows.[140]

When we read that a lay patron has" founded" a chapel, it is sometimes impossible to know if this involved the physical construction of the architecture of the chapel, or the establishment of the endowment to pay the chaplain(s). The inscription on the exterior of the nave chapel of Saint Nicolas, third on the south records that it was "made" by the vendors of woad from the villages around Amiens—this might well imply funding actual construction as well as the endowment of chaplaincies.[141] The inscription is accompanied by sculptured images of two devout woad merchants, while above, two men, one tall and skinny and the other short and stout, stand beside a sack bulging with woad boles (fig. 3.19). There is a story to be told here. Laypeople were responsible for founding three other nave chapels/chaplaincies: thus, we find Mayor Drieu Malherbe and his wife buried in the easternmost nave chapel on the north side; Jean d'Arc, who established a chaplaincy in the second chapel (Saint Louis), on the same side; and Enguerran d'Eudin in the chapel of Saint Christopher, the penultimate chapel on the south.

Only the very wealthy could afford to endow a chantry chapel—yet many other laypeople found burial inside the cathedral: until the early nineteenth century the pavement was dotted with the burial slabs.[142]

The same years in the fourteenth century that saw the construction of the nave chantry chapels also brought increased popularity of *confraternities*, or associations of laypeople brought together in cathedral space for devotional and cultural purposes. The Confraternity of the Annunciation to the Virgin with its seat in the fourth nave chapel on the south side was established in 1378, and Notre-Dame du Puy in 1388.[143] The latter confraternity united merchants, tradespeople, lawyers, ecclesiastics, seigneurs, and other notables around ceremonies devoted to the Virgin Mary. The term "Puy" is thought to be derived from the Latin for podium—the elevated platform from which poetry readings were delivered.[144] Once a year, on the Feast of the Purification of the Virgin (known as *Candlemas*: February 2), a poetry competition took place. The competitors were required to follow very specific guidelines—they had to develop an allegory glorifying the salvific attributes of the Virgin Mary. The theme was often a punning reference to the name of the person composing the poem, which had to follow the structure of a *royal chant*.[145]

A jury would select the winner who would become master of the Confraternity for the following year. Among the duties of the master was the organization, at his own expense, of a sumptuous banquet in the evening.

In 1452, sixty-four years after its creation, the Puy Notre-Dame acquired a new dimension. Revised statutes required the newly elected master to commission, at his own expense, a work of art in honor of the Virgin Mary. The work of art, normally a painting, would allegorize the same text extolling the virtues of the Virgin.[146] It would be displayed for one year at the *Pilier Rouge* on the east side of the south transept before then being replaced by the following year's picture. In 1493, with Dean Adrien de Hénencourt as master, the seat of the Confraternity became firmly established in the south transept at the Pilier Rouge and it was decided that all the pictures from previous years in the cathedral would be put on display. By the early eighteenth century there were around two hundred such paintings displayed on the pillars of the main arcade and elsewhere. With this growing presence in the space of the cathedral the Confraternity became more powerful, gaining the right to have Mass said in the nave on the great feast days of the Virgin—the Annunciation (March 25), the Assumption (August 15), the Nativity of the Virgin (September 8), and the Conception (December 8)—as well as on All Saints' Day and Christmas.

Maurice Duvanel has characterized the phenomenon most powerfully, if a little optimistically, "the Confraternity escaped from conventional social rules. . . . There were no more nobles, bourgeois, artisans and prelates but men united with the aim of extolling the Mother of Jesus. Eliminating their differences, they anticipated the relationships promised in Paradise where each would lose terrestrial trappings of wealth and power, where the humblest would gain, before the princes of this lower world, their place with God. In the Confraternity equality prevailed. And so, Jean de Berry, seigneur of Essertaux would feast at the same table as Jean le Barbier, pastry cook, his predecessor as master. Equally, Nicolas de la Couture, bishop of Amiens, master in 1519, would not be at all bothered finding himself under [the leadership] of Gille Damourette, merchant and [tax] collector, master the following year."[147] While this view is a little utopian, since of course one had to be wealthy to participate and to become Master, the Confraternity certainly served as a kind of medieval Rotary Club, facilitating social (and business) interactions among the elite of Amiens.

The egalitarian dimension of the confraternity was powerfully expressed during the mass conducted in the choir directly after High Mass on February 2, the Feast of the Purification of the Virgin and the day of the annual election of a new master. A young woman, presumably the daughter of one of the members, sat enthroned on a podium in the nave, decked out as the Queen of Heaven, wearing a robe trimmed in ermine and a jeweled crown. The baby Jesus cradled in her lap was made of wax. Accompanied by a throng of angels, one carrying the turtledoves required for the sacrifice, she descended regally from her throne to approach the altar, where she was greeted by a priest as the aged Simeon. Standing at the altar the young woman recited the verses from Luke recounting the Presentation of Christ in the Temple.[148]

The early eighteenth century brought the suppression of this most engaging *tableau vivant* along with many of the other ceremonies and practices that had bound laypeople to the cathedral. Particularly shocking was the removal of the pictures donated by the Puy Notre-Dame adorning the interior of the cathedral. The pictures generally featured a large central image of the Virgin and child linked with the salvific allegory defined for that year. In the lower part of the picture the master of the confraternity, surrounded by his family, would hold the scroll bearing the key text. The Virgin would be flanked by serried ranks of people including saints, clerics, and notables as well as ordinary folk (fig. 3.29). The pictures must have looked increasingly antiquated and the literary conventions of the royal chant were equally discredited.

Three remarkable physical testimonies survive to remind us of the presence of the Confraternity of Puy Notre-Dame in the spaces of the cathedral. First, we have some of the pictures themselves, together with the copies made of them presented by the Confraternity to the mother of King Francis I, Louise of Savoie, who had expressed great admiration when visiting Amiens Cathedral. Each picture is accompanied by its royal chant.[149] Second, we have the magnificent altar of Puy Notre-Dame, designed by the sculptor Nicolas Blasset and commissioned in 1627 by Antoine Pingré, seigneur of Genoville and collector of the salt tax or *gabelle* (fig. 1.47). The Flemish artist, Francken the Younger (1581–1642), painted the central picture of the Assumption; in relation to the archaic compositions of the paintings commissioned by the Puy Notre-Dame, this picture must have looked strikingly modern. The altar is flanked by Blasset's statues of strong

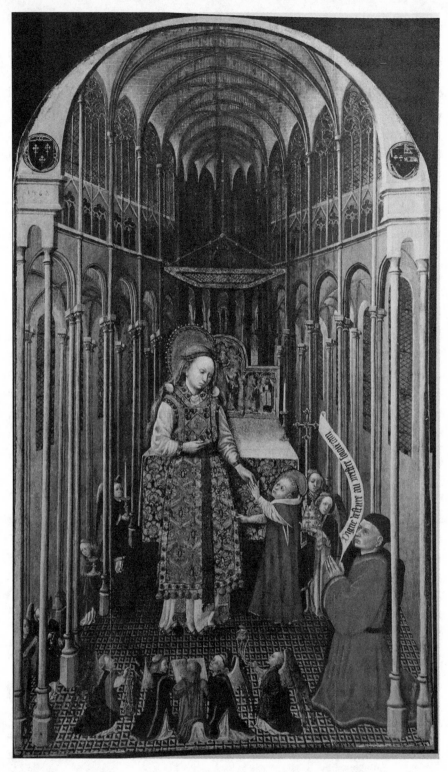

FIGURE 3.29 *Le sacerdoce de la Vierge*, offered by Jean du Bos, haberdasher (small ware merchant), master of the Puy Notre-Dame in 1437, now in the Louvre, Paris. We see the Virgin Mary as high priest in front of the main altar in a church recognizable as the choir of Amiens Cathedral (Editions de la Nuée Bleue, *Amiens, La grâce d'une cathédrale*). See also color plate.

women: Judith and Holofernes to the right and Esther to the left. The image of Esther was damaged in the Revolution and replaced by Saint Genevieve.

Third, the most remarkable testimony to the presence of laypeople in the cathedral can be found in the names of the masters of the Confraternity inscribed on black marble slabs mounted in the dado panels on the west side of the south transept (fig. 5.14).[150] Beginning in 1389, the list runs down to 1729. The name of each master is accompanied by the text that had inspired the poem and painting. The status of each master is defined—whether he was a member of the clergy, a city official, or merchant. At first many of the masters were canons lawyers and city officials, but then increasingly we find bourgeois, merchants, and tradespeople. Artisans, however, are mostly absent.

We do not have space here to deal adequately with the phenomenon of *pilgrimage*—a most important dimension of the life of the Gothic cathedral, but one that has left few visible traces. The precious relics of the cathedral included not just the local saints enshrined in their glittering châsses mounted on the tribune of the sanctuary but also relics of some major saints including James and John the Baptist. The chin of Saint James was enshrined in an altar in the choir screen, while the head (or rather, the face) of the Baptist was upstairs in the sacristy/treasury complex to the north of the choir. The popularity of the cult of the Baptist appears to have intensified toward the later Middle Ages and beyond: it can be measured by the fact that it was necessary to replace the treads of the stairs leading to the upper chamber, worn down by the volume of pilgrim traffic. We will end this brief reflection on pilgrimage with the most enigmatic statue of Saint Christopher attached to the angled chapel at the west end of the southern nave chapels, still welcoming the continuing flow of modern pilgrims to the cathedral (fig. 1.30).

h) Conclusion: "Makers and Users"?

Readers may be troubled by the provocative subtitle of this chapter. A cathedral, after all, is not like a modern corporate building where one group of people build the structure and an entirely different group occupy and use it. The phrase "makers and users" implies a transactional relationship—is this appropriate in a cathedral, where, after all, the makers *were*, to a great extent, users? The images of creativity shared by clergy and artisans linked artistic production by humans with God's Creation of the world.

However, there is a very real sense in which the cathedral can be understood as the visible sign of a great contract—and a contract is essentially transactional. Let us again turn to the words of the sermon preached in (or close to) Amiens in the age of cathedral construction circa 1270.[151] In the performance of the divine office the clergy were fulfilling their side of the contract: the securing of salvation not just for themselves, but for all members of the city and diocese: *My lord the bishop, to save your souls and those with whom you wish to associate, will send you all the benefits of his diocese, for I tell you that until the end of time, no mass will be sung, or matins or prayers of the holy church in which you will not share, and be assured that they will win for you such company and such a part as they hope to receive on the great day of judgment.*[152] This contract was expressed by the physical structure of the church or cathedral: *For know well that from the very hours that the first squared stone of this church was laid and the first children baptized . . . our enemy the devil was never so tormented as he will be today.* Understood in this way, the cathedral might be seen as a type of Ark of the Covenant—an image repeated several times in the figurative cycles at Amiens (figs. 2.16 and 5.25). For their part, members of the congregation are exhorted to mend their ways, venerate the Virgin Mary, respect the church with its clergy, saints, and sacraments *and*—to make a financial contribution. But what a bargain: *My lord the bishop sends pardon and absolution from all these sins to all men and women who send their alms to the church of my Lady, Saint Mary of Amiens; and so they will leave today on this holy morning as free [of sin] as Mary Magdalene when she went from [washing] the beautiful feet of our Lord.*[153]

And, of course, in addition to absolution, the citizens were left with the incomparably beautiful structure of the cathedral: an essential part of local identity, a pivot in their daily life, and a continuing source of inspiration. Let us end with the words of the merchant of Amiens, Jean Pagès: *Yes, indeed, I will repeat it once again: the citizens of Amiens are fortunate every day to be able to hear this great host of canons, chaplains, chanters, and choir boys mingling their voices in worship of their sovereign Lord with such devotion: singing the sacred psalms composed by the prophets, filled with the spirit of God.*[154]

Telling the Story of the Great Enterprise, I, 1220–c. 1300

4

Incomplete Completion

a) Plotting the Cathedral

HAVING FAMILIARIZED ourselves with the physical forms of Amiens Cathedral in chapters 1 and 2 through the visit, and having met its principal builders and users, clergy, artisans, and laypeople in chapter 3, let us now animate their great interactive enterprise, telling the story of the first eighty years of construction work on the Gothic cathedral.

Five years before the 1220 start of construction, freshly returned from the great Church reform council in Rome known as the Fourth Lateran Council, members of the clergy were inspired to enliven their liturgical and pastoral practice in three ways: to bring greater rigor to the form of the daily office, to enhance it with improved musical performance, and to make it more accessible for lay consumption. In order to achieve the first objective, Dean Jean d'Abbeville reorganized the singing of the one hundred and fifty psalms (which, in ancient practice, were thought to have been performed each day).[1] With the new arrangement, each of the thirty-eight members of the chapter was assigned four or so psalms for which they would lead their colleagues in the chant. To meet the second objective, the otherwise tedious daily recitation of psalms was embellished through the addition of song in a variety of forms: of anthems, responses, hymns, and lessons. For the third objective, Bishop Évrard de Fouilloy (who was to preside over the start of work on the Gothic cathedral of Amiens) made two key changes: he established a new officer, the *precentor*, whose function was to direct the musical performance in the choir; and he expressly charged a number of vicars with

musical performance. Both of these changes effectively acknowledged that members of the regular clergy might not have had the musical ability necessary for such performances.[2]

However, such lively hopes were dashed by disaster: a fire, said to have occurred in 1218, destroyed or badly damaged the previous cathedral on the site.[3] In order to reconstruct the scenario and the ensuing sequence of events, we might draw upon the account of a parallel disaster written by the monk Gervase of Canterbury some twenty years earlier—the *Treatise on the Fire and Reconstruction of Canterbury Cathedral*.[4] Gervase provides what appears to be an eyewitness account of the destruction of the magnificent wooden roof of the choir of Canterbury Cathedral in a fire that took place in 1174. After surmounting their immediate anguish, the monks summoned masons from a variety of regions, interviewed them, and finally settled upon the choice of a certain Frenchman, Master William of Sens, both because of his lively genius and his ability to take control of the logistics of construction.[5] In the similar situation after the fire in Amiens: those interviewing the masons who presented themselves as candidates would include representatives of the cathedral clergy, especially the fabric committee, as well as some of the community of artisans who served the cathedral. While we do not know the name(s) of the *procurator(s)*, we may suppose that Dean Jean d'Abbeville and Bishop Évrard de Fouilloy played key roles. The townsfolk were probably represented, perhaps by the mayor or some of the aldermen (*échevins*) and leading members of the local masonic community. As at Canterbury, a master mason was chosen to lead the great rebuilding enterprise. We have found his name, Robert de Luzarches, is recorded in the inscription of the band framing the octagonal central plaque of the decorative labyrinth; in the tiles of the nave pavement (fig. 3.11); and in the inscription on the south transept façade.

The master mason would first have to work with the clergy and townsfolk to resolve logistical problems involving major urban relocations. The early-medieval episcopal group had already been transformed with the mid-twelfth-century construction of a great new church: the predecessor to our Gothic cathedral. Unfortunately, nothing is known of the form, or the exact site or shape, of this earlier cathedral. Situated to the north was a collegiate church dedicated to Saint-Firmin the Confessor, and to the west of that was the Hôtel-Dieu or hospital. A new wall skirting the city to the east had been built some decades earlier (1180s–90s) in order to accommodate urban expansion,

but it is not known whether the old Roman wall encumbering the site intended for the new choir had been entirely removed. The interests of the townsfolk were directly affected, since the new work would demand huge quantities of stone, timber, and other building material, much of which would have to travel from the principal quarry at Tirancourt on barges dragged upstream on the waters of the Somme and would require appropriate docking facilities and special passage through city streets. A chronic issue affecting relations between clergy and townsfolk was circulation along the length of the road running between the cathedral and the cloister leading to the eastern city gate.

But beyond such logistical problems, the principal task of the master mason was to help the clergy realize their liturgical and pastoral agenda in the architectural forms and spaces of a grand new cathedral. Let us now apply our imagination to the re-creation of the planning conversations that must have taken place in Amiens between 1218 and 1220.

First and most important, the clergy would insist upon an appropriate space to accommodate them in their daily liturgical activities: the Divine Office and the celebration of the sacraments and of the cyclical feast days of the year. The setup must include a principal altar, a location for the bishop's throne (*cathedra*), and appropriate seats or stalls for the canons—all this brought together in a magnificent space expressing reciprocal linkages between earth and heaven.

Second, the clergy needed to display and animate the precious relics of the saints and to propagate the growing cult of the Virgin Mary. These needs might be partly accommodated through the provision of an elevated gallery or tribune directly behind the high altar, at the center point of the sanctuary. From this point, radial lines would be struck to define the seven segments that would create separate spaces or radiating chapels for the ceremonies or offices associated with each of the saints who received special veneration at Amiens. A specially enlarged chapel dedicated to the Virgin Mary would serve the needs of the local parishioners; other chapels would facilitate the stational liturgy of the saints.

Reconciling clerical celebration and lay devotion required spatial *permeability:* in other words, the combination of a privileged and secluded space for the clergy with the simultaneous ability to project sights, sounds and processional movements to a lay audience beyond. That audience needed to be properly prepared to receive the experience, which could be achieved

by comprehensive sculptural programs deployed at the points of entry. The portals of the west façade and south transept offer a powerful instructional and inspirational map: they provide an introduction to the role of the institutional Church with its sacraments, as well as the agency of the saints and the Virgin Mary in the achievement of human salvation; and an initiation into some of the new teaching associated with the reforms of the Fourth Lateran Council (figs. 2.1 and 2.39).

The architectural envelope for facilitating such an agenda should provide the users, both clergy and laypeople, an artfully programmed, transformative experience of the celestial while at the same time allowing them to find their own place in the edifice through its artisanal qualities and associations, its power to tell stories, and its relationship with other great churches existing or being built in neighboring cities like Soissons, Laon and Noyon.[6] The church should simultaneously be familiar *and* other-worldly; it should both reveal *and* conceal.

Master Robert de Luzarches—like William of Sens in Gervase's story of Canterbury—must have impressed the clergy with his ability to envision a great church that would satisfy their programmatic requirements, reconciling conflicts and bringing everything together in a great plot or *schema* that made sense intellectually; that carried meaning soteriologically; and that appeared doable (fig. 4.1). Whereas we, the visitors, experience the cathedral bit by bit, approaching, entering and moving through it; and whereas the great edifice became itself little by little, through the laborious push and shove of construction, extended over centuries; the master mason must have had the Godlike ability to envisage the whole thing—process as well as product—from beginning to end. It is no accident that in telling the story of the construction of the new choir at Canterbury, Gervase appropriated the rhetorical structure of the Genesis narrative in which all was foreseen in the mind of the Great Artifex.[7]

Master Robert de Luzarches was certainly not a local man: he had been formed in architectural practice in one or more of the great cathedral construction enterprises, and elements of his design "fingerprint" can already be found in nearby Soissons and Laon Cathedrals.[8] The same monuments were also well known by his clerical colleagues: by conjuring up memory images of familiar churches, Master Robert was able to lead a discussion of the merits and problems in these earlier monuments. It is important to realize that what has sometimes been considered as "stylistic development"

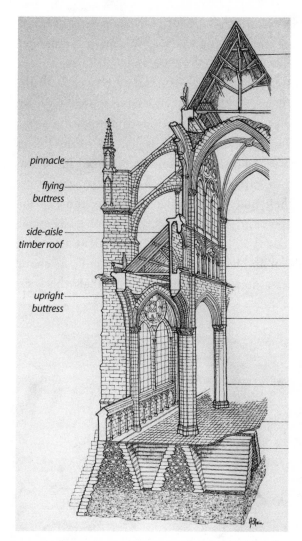

pinnacle

flying
buttress

side-aisle
timber roof

upright
buttress

FIGURE 4.1 Axonometric
rendering of the nave with
speculative reconstruction of
the foundations (*Architectural
Technology*, ed. Robert Mark)

in Gothic was actually the result of critical choice on the part of builders
and users. Some members of the clergy, including Dean Jean d'Abbeville,
had studied in Paris in the decades each side of 1200, and must have wit-
nessed the extraordinary sight of the cathedral of Notre-Dame, with its
seemingly impossibly skinny flyers, rising to a great height that matched
Constantine's Basilica of Saint Peter in Rome.

The master mason might also employ graphic means to develop and
to demonstrate his vision of the as-yet unbuilt cathedral in the form of

small-scale drawings, sketches made on sheets of parchment or, on a larger scale, lines incised upon a plaster drawing surface. We can get some idea of the appearance of such drawings through reference to the images in the little book compiled by Villard de Honnecourt at a date very close to the start of work at Amiens.[9] Villard de Honnecourt, having probably grown up in Picardy, traveled widely in northern France and beyond, gathering images of buildings and other artifacts as well as natural forms: birds, beasts and insects. Neither an architect nor a master mason, Villard was interested in more than just the surface appearance of things, wanting to explore the mechanics of their underlying design structure: thus, in fol. 14v. he shows us the geometric plot lying behind the design of a Cistercian church based upon squares and double squares (like the Amiens nave) side by side with a fully fleshed-out and beautifully rendered plan of the chevet of Cambrai Cathedral (fig. 4.2). Interestingly, Villard tells us that "this is the

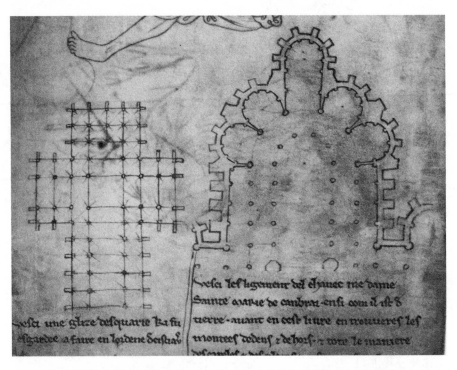

FIGURE 4.2 Villard de Honnecourt, plan of a Cistercian church and Cambrai Cathedral (Bibliothèque nationale de France ms Fr 19093 fol. 14v, Carl Barnes, *The Portfolio of Villard de Honnecourt*, Plate 31)

construction (*esligement*) of the chevet of Notre-Dame Saint Mary of Cambrai as it is on the ground."[10] In other words, Villard did not have a specific word to designate "groundplan."

i) Groundplan (Fig. 4.3)

The groundplan that resulted from Master Robert's conversations with the clergy may be understood in terms of three areas of critical choice: relating to the form of the eastern termination or *chevet*; the intersection of the

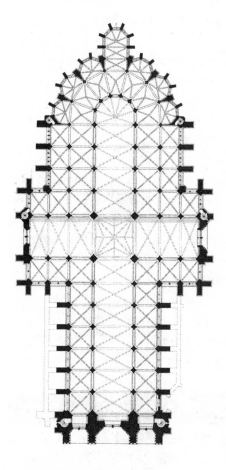

AMIENS
NOTRE DAME 1 : 100

FIGURE 4.3 Plan of Amiens Cathedral (Addis and Murray)

transept in the middle or crossing; and the western end of the cathedral.[11] Let us begin by considering the plan of the chevet—by far the most important part of the cathedral, as far as members of the clergy were concerned.

Amiens Cathedral has a long chevet: the distance from the center of the crossing to the eastern extremity of the axial chapel equals that from the center to the west portal (fig 4.13.9). In this respect, Master Robert and the clergy clearly decided to follow precedents at Notre-Dame of Paris, Chartres, and Laon rather that the abbey church of Saint-Denis or nearby Reims Cathedral, which have short chevets. The precedent of Laon Cathedral is particularly interesting, since Robert may have worked there before coming to Amiens—the two western frontispieces are certainly closely linked. Let us look more closely at Laon.[12]

Begun some sixty years earlier (c. 1160), the galleried elevation of Laon Cathedral was continued throughout the edifice, where work progressed from east to west over a period of around four decades (fig. 4.4).[13] The cathedral was first constructed with a stubby polygonal chevet, creating a space that was not considered adequate to house the unusually large chapter with its eighty canons: the liturgical choir therefore extended into the first bays of the nave, enclosing the spectacular crossing illuminated by a central lantern tower and opening into spacious galleried transept arms. However, just as major construction work was reaching completion at Laon in the years toward 1200, members of the clergy entertained a radical change of plan, deciding that they wanted a long chevet.[14] The new project would, of course, necessitate demolition of the recently constructed eastern termination. The new choir met the physical requirements of liturgical practice, providing sufficient space for the entire chapter and guests to sit enclosed behind a screen between the eastern piers of the crossing, and, to the east, a sanctuary with the high altar elevated a few steps above the level of the choir.

Yet there is much more to the symbiotic relationship between liturgy and architectural space than simply meeting immediate functional requirements. An essential element of liturgical practice is the desire for relative uniformity, with similar ceremonies performed in similar spaces in multiple churches spread over extended lands. In this respect Laon Cathedral was an outlier in French ecclesiastical practice. In the aftermath of the reconstruction of the chevet of the abbey church of Saint-Denis (c. 1140–c. 1144), the

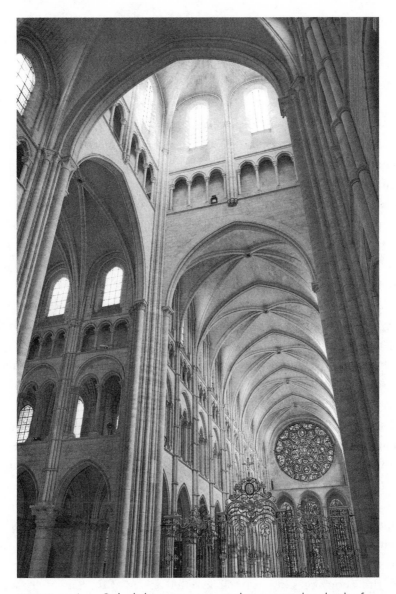

FIGURE 4.4 Laon Cathedral crossing space, north transept and north side of the choir.

use of a half-rounded or polygonal eastern termination surrounded by a passage or ambulatory opening into a crown of radiating chapels became the norm. This type of plan is often explained through reference to the so-called "pilgrimage churches," since the arrangement allowed pilgrims to

circulate around the curving passage or *ambulatory* that encircled the sanctuary, visiting the shrines and relics in the various chapels (and sometimes a central tomb at crypt level) without disturbing the conduct of the offices in the central choir.[15] In plan, each chapel mimicked the shape of the central sanctuary, a space unavailable to the lay user. Thus the visitor could, in a sense, enjoy a vicarious experience of the sanctuary through the direct accessibility of the spaces of the radiating chapels.

However, there are a number of further dimensions inherent in the choice of such a choir plan. The first was the practice of *stational liturgy* where the clergy would go out in procession from their seats in the choir, into the other spaces of the church and beyond, in order to conduct offices or ceremonies at an altar, chapel, or other significant place. Such events were generally associated with the feast day of the saint whose altar would be visited. At Amiens, the axial chapel of Notre-Dame (known as the *Petite Paroisse*) was a frequent destination on feast days associated with the Virgin Mary. The clergy favored processional patterns that looped or circled: thus, they might leave the choir through one of the lateral gates (generally the north), entering the spacious aisles, then circling around the ambulatory and reentering the choir on the other side or through the great west door via the choir screen.[16]

The second factor favoring the choice of plan featuring ambulatory and radiating chapels may be understood as part of the wider power of Gothic to transform physical observation and sensation into religious and spiritual affect. The sacred nature of the sanctuary is revealed not only by liturgical furniture, relics, and images, but also by the dynamism of space, light, and architectural form, animated by movement. The visitor advancing eastward down the length of the Amiens nave has been led forward by emphatic horizontal orthogonal projection—will we finally find the vanishing point where everything converges (fig. 1.41)? The radial design of the hemicycle marking the end of our pilgrimage rotates this horizontal track upward, creating a great vertical axis linking earth and heaven—or, more specifically, linking the resurrected body of Christ inherent in the Eucharistic sacrament on the altar to the image of Christ in the keystone above: Christ is the hidden center point (fig. 4.5).[17]

FIGURE 4.5 Amiens Cathedral, view down the choir to the sanctuary and hemicycle

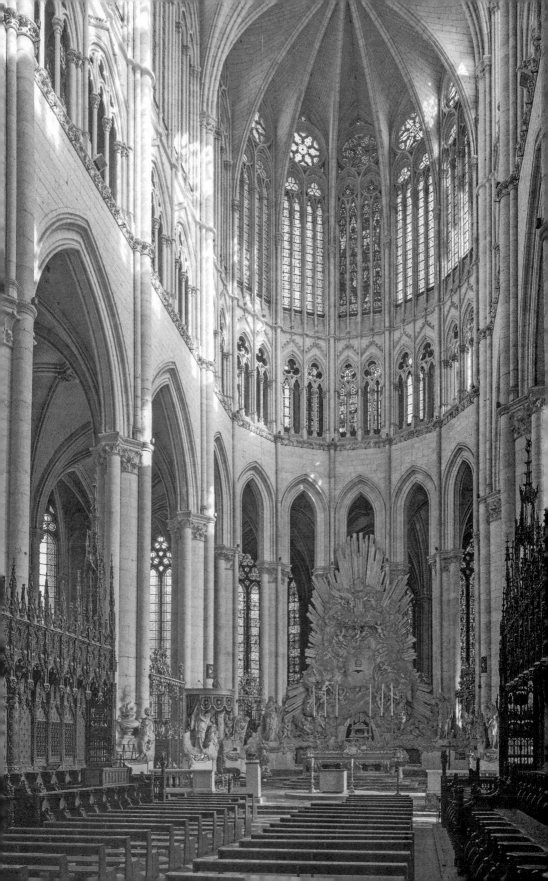

Members of the clergy seated in their stalls, facing each other across the central space of the choir engaged in a dialectical exercise, the antiphonal chanting of the Psalms: right choir; left choir. However, the concentric force of the hemicycle represented the hoped-for unity of their corporate life.[18] The celebrant, standing directly in front of the altar close to that center point, is privileged with the vision of all seven radiating chapels seen as a continuous faceted crown glowing with colored light.[19] What better architectural animation of the *Sursum Corda*, the Eucharistic invocation to "Lift up your hearts"?

The third factor conditioning the choice of the chevet type may be understood as the iconography of architecture, as buildings take on meaning by pointing to other buildings.[20] The first chevet to embody the characteristics of this chevet type, including the vision of optical unity afforded to the celebrant standing in front of the altar, was the church of Saint-Denis. Abbot Suger and his successors did their best to emphasize the royal connections of their abbey church, and subsequent iterations of the same type of plan design continued to emphasize that link.[21] The immediate prototype lying behind the Amiens hemicycle plan was the Cistercian church of Longpont, later refined at Royaumont, both favorites of the French kings Philip Augustus, Louis VIII, and Louis IX.[22] We have seen that these first two kings had very close links with Amiens, and that the city itself played an important role in the expansion of royal power in the north. Amiens Cathedral, with its prominent kings' gallery in the upper west façade mimicking the west façade of Notre-Dame of Paris, provides a powerful visual expression of the role of this most important new northern bastion of royal power.

Another area of critical choice in plan design involved the *middle* of the building. This was a key space in the projection of liturgical and devotional activities beyond the enclosed choir into the domain of the laypeople: spatial permeability. The rebuilding of the chevet at Laon Cathedral in the first decades of the thirteenth century must have caused a sensation: the spectacular space below the central lantern tower, flooded with light and extending into the deep transept arms, was now available to the laity, becoming the dramaturgical heart of the cathedral (fig. 4.4).[23] The construction of the Laon choir screen in the thirteenth century facilitated the animation of this space: readings, sermons, relic displays, and other activities would take place in the tribune or gallery atop the screen, whose great central crucifix providing a powerful focal point for those entering the nave.[24]

The builders of Amiens Cathedral—Master Robert in conversation with the clergy and other members of the fabric committee—devised a unique scheme to enhance the permeability of this critical space in the middle of the church by increasing the span of the bays of the main arcade directly adjacent to the square crossing, thereby creating a high degree of visual unity in the middle of the church (figs. 1.42–43). In our earlier passage through the cathedral, we had already seen that the regularity of the nave, with its square aisle vaults and double squares in the central vessel, is interrupted as we approach this space one bay from the crossing. On all four sides of the crossing square we find an enlarged bay creating a great double square.

The last area of critical choice in the planning of Amiens Cathedral involved a novel type of western frontispiece (figs. 1.31–32). In the course of the twelfth century the so-called "harmonious façade," with twin towers and triple portals, had become canonic: embodied in monuments like the abbey church of Saint-Denis and the cathedrals of Noyon, Laon, Notre-Dame of Paris, Soissons, and Reims.[25] As Master Robert and his clerical colleagues rehearsed their memories of such monuments in relation to their desired agenda at Amiens, they might well have debated ways to ensure that a visitor's entry into their cathedral space might be a dramatically *transformative* experience. Compressed by the funnel-like portal and inspired by the message conveyed by the sculptural program, the visitor should be projected directly into the brightly lit spaces of the nave (fig. 1.41). The traditional western frontispiece, with square towers supported by massive interior supports, encumbered and obscured the western bays of the nave.

Another problem with the traditional harmonious façade was the political one. Towers represented power: the identity of the Amiens commune was expressed in the great tower, known as the Beffroi, to the west of the cathedral. Anticipating the arduous economic effort involved in the construction of the new cathedral, together with the social frictions that might result, members of the clergy sought to preserve harmonious relations with the commune. The cathedral they envisaged was very tall: to crown such a structure with lofty, square western towers would be to flaunt signs of domination in the face of the commune.

In light of these concerns, Master Robert proposed a brilliantly innovative scheme: to support lightweight rectangular towers directly on top of the four great buttresses dividing the three portals, with no interior supporting piers.

The massive masonry embodied in the two central buttresses was projected back into the interior of the frontispiece and linked with the thick lateral walls by means of deep masonry arches (visible on the exterior as well as the interior), thus providing a bridge mechanism to support each of the two towers. For the first century and a half of its life, the façade rose only to the level of the top of the western rose. The towerless appearance of the frontispiece must have reminded people of a great Cistercian church.

ii) Elevation

How would the builders of Amiens Cathedral understand and designate the *elevation*: the way the levels or stories of the church are defined and articulated as it rises from the ground? Villard de Honnecourt provides the answer, calling his drawings of the interior and exterior elevations of Reims Cathedral *montées*, and showing us the three stories of that cathedral with its arcade, triforium, and clerestory (fig. 4.6).[26] Perhaps making use of such images, the Amiens builders made design choices in relation to the cathedrals in nearby cities. The principal choice was against the deployment of an elevation like that of Notre-Dame of Paris, Noyon, or Laon Cathedral, all of which have spacious galleries over the aisles and relatively stubby arcades. Galleries were expensive to create; they also darkened the interior and were of questionable functional value.[27] So, potential prototypes for the elevation were found at Chartres, Reims, and Soissons Cathedrals, all of which featured a triforium as the middle level (figs. 4.7–8).

Chartres Cathedral, with its enormous clerestory, was considered top-heavy and too massively articulated (fig. 4.7). The Amiens builders, like their colleagues at Bourges Cathedral (begun more than three decades earlier), realized that spaciousness has more impact upon the visitor or user when the expanded spaces are close: let us at Amiens, therefore, have a tall arcade and a clerestory relatively smaller than Chartres. Let the slender supports be quite widely spaced and the thickness of the arcade wall substantially less than Chartres or Reims; let the tall aisles be brilliantly lit by enormous lateral windows the same size as the clerestory. The daintiness of Soissons Cathedral must have seemed enticing (fig. 4.8), but rather than those skinny cylindrical supports with a single shaft on the forward surface, let us appropriate the reassuring form of the *pilier cantonné* with four

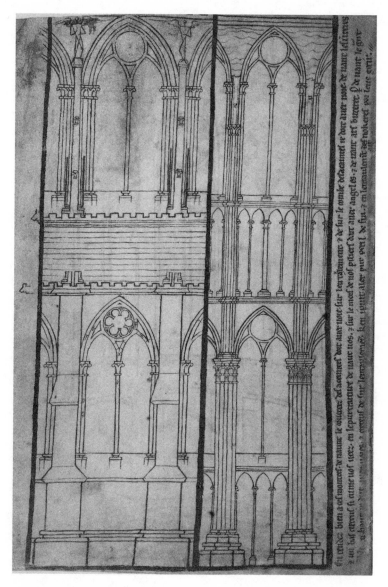

FIGURE 4.6 Villard de Honnecourt, elevations, interior and exterior of Reims Cathedral (Bibliothèque nationale de France ms Fr 19093 fol. 31v, Carl Barnes, *The Portfolio of Villard de Honnecourt*, Plate 65)

attached shafts, as at Chartres and Reims Cathedrals. The articulation of bay divisions should be less emphatic than in those earlier works, allowing the entire upper half of the elevation to fuse together a vast screen—there is a festive quality about the delicate composition of tracery and glass

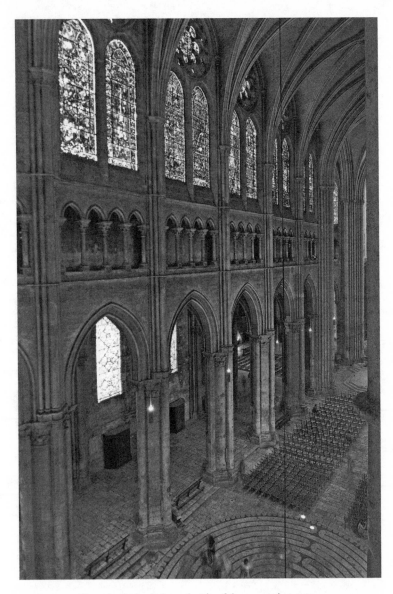

FIGURE 4.7 Chartres Cathedral, north side of the nave, elevation

above the sculptured foliate garland at Amiens, where the upper screen is set slightly back and the cathedral seems to blossom with sculptured foliage and myriad little shafts, capitals, and delicate tracery forms.[28]

The celebratory effect of the upper elevation is enhanced by the novel design of the triforium, which does not form a continuous horizontal band

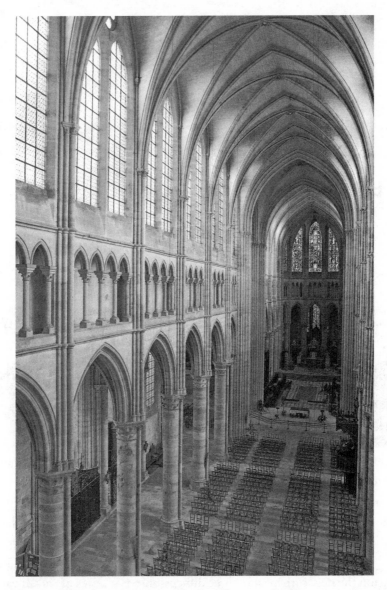

FIGURE 4.8 Soissons Cathedral, north side of the nave, elevation

(like Soissons, Chartres, or Reims). Such a horizontal arrangement can appear dull and heavy—almost as if it is sagging in the middle of each bay. At Amiens each bay of the triforium is grouped in two lively clumps of three lancets surmounted by generous trefoils pierced in a continuous skin of stone, or plate tracery (fig. 1.59). The central division between the

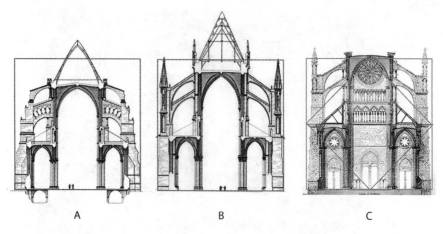

FIGURE 4.9 Transverse sections of A Chartres, B Reims and C Amiens Cathedrals, each inscribed inside a square.

two clumps of three is linked with the central mullion of the clerestory in a single vertical mullion.[29]

But the principal objective shared by Master Robert and the clergy was to create an edifice both taller and steeper than any previous cathedral, and with an overall profile defined by a square and a central vessel where the height is three times the width, thus producing a powerfully compressive effect (fig. 4.9).[30] The base of the triforium with its sumptuous foliate band marks the halfway point in the elevation; the level of the arcade equals the two upper levels combined.

But of course, the cathedral is much more that a two-dimensional entity to be understood entirely through reference to the diagrammatic flatness of a plan or section. Let us imagine the conversation where Master Robert then went on to suggest to members of the fabric committee that they might envision the new cathedral in three dimensions: as a series of linked vaulted canopies, with the lower ones forming the bays of the aisles, and the higher ones forming the upper central vessel.[31] Each cell was capped with a light-weight stone-ribbed vault defined by transverse arches and crisscrossed with diagonal ribs. The ideal units would be understood as squares for the aisles and double squares for the central vessel, though we have noticed variations on this theme in the choir and especially in the transept arms where the bays become dramatically narrower toward the outside. The four corners of each

FIGURE 3.15 Panels of stained glass window originally from the nave aisle, reset in the north choir aisle: Adam and Eve and the Tree (*top*) and signature of the carpenters, hewing a beam and constructing formwork for an arch (*bottom*)

FIGURE 3.21 Panels of stained glass depicting the Tree of Jesse originally in the axial chapel, restored and reset in the chapel of St. Nicaise

FIGURE 3.22 Panel of stained glass window originally in the axial chapel, restored and reset: weavers at a horizontal loom

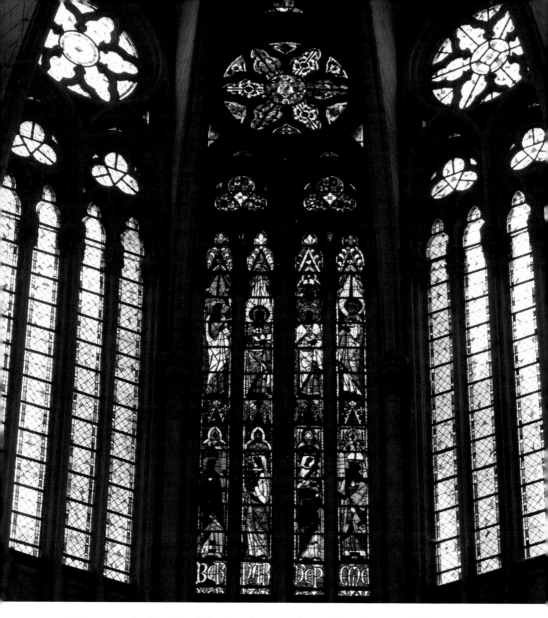

FIGURE 3.23 Axial window of the choir clerestory donated by Bishop Bernard d'Abbeville in 1269

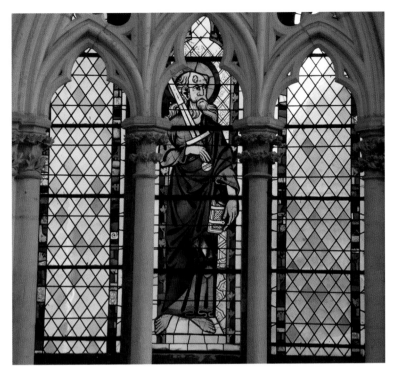

FIGURE 3.24 Stained glass panel in the choir triforium: the Apostle Paul

FIGURE 3.25 Stained glass window in the nave chapel of Ste-Agnes, founded by Mayor Drieu
Malherbe in 1296: the mayor donates his chapel, images of St Catherine and Agnes

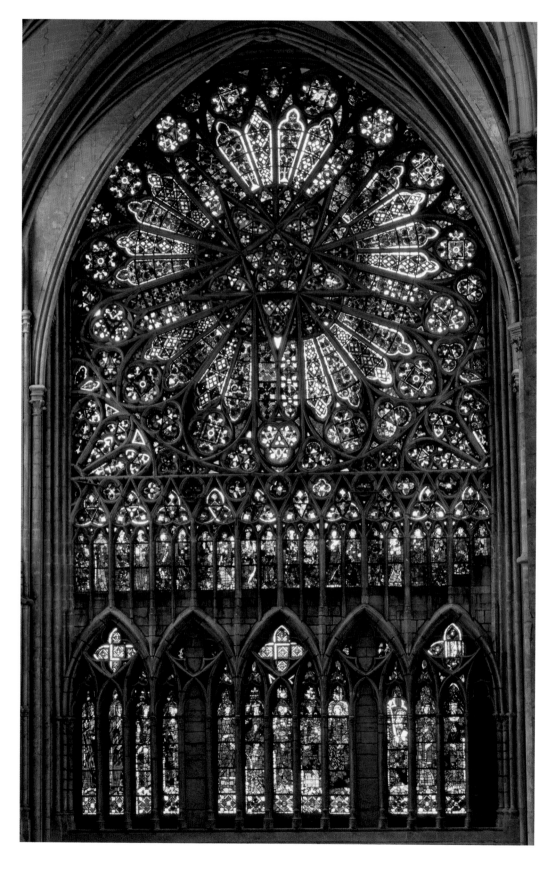

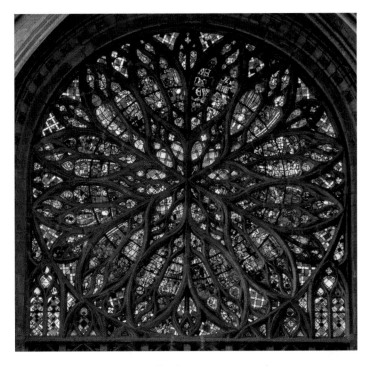

FIGURE 3.27 South transept rose window

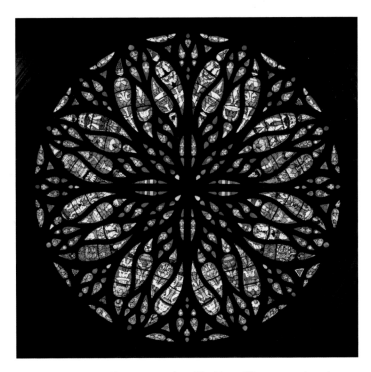

FIGURE 3.28 West rose window. The lilies of France mingle with the ivy of Amiens

FIGURE 3.26 (*opposite page*) North transept rose window and triforium

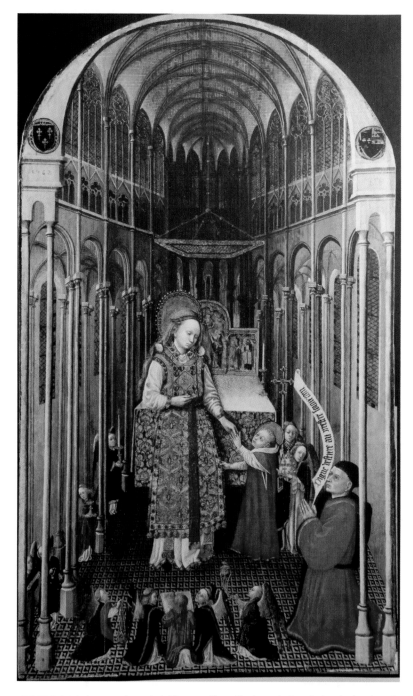

FIGURE 3.29 *Le sacerdoce de la Vierge*, offered by Jean du Bos, haberdasher (small ware merchant), master of the Puy Notre-Dame in 1437. We see the Virgin Mary as high priest in front of the main altar in a church recognizable as the choir of Amiens Cathedral (Editions de la Nuée Bleue, *Amiens, La grâce d'une cathédrale*)

FIGURE 5.16 (*opposite page*) Amiens Cathedral, view down the choir to the sanctuary and hemicycle

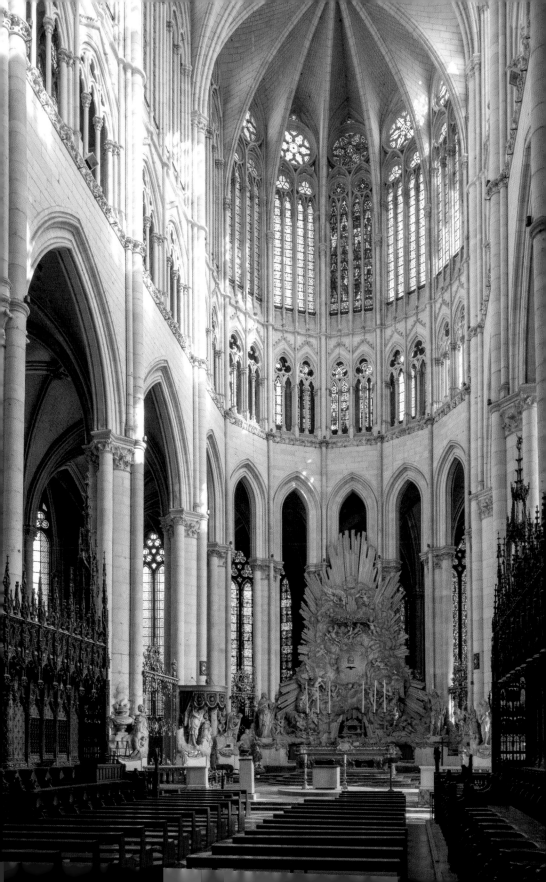

4

8

9

FIGURE 4.13 Dynamic geometry at Amiens

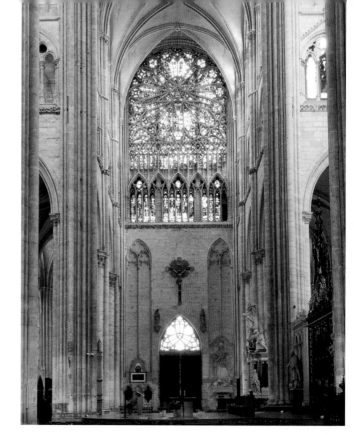

FIGURE 5.1 Inner north
transept façade

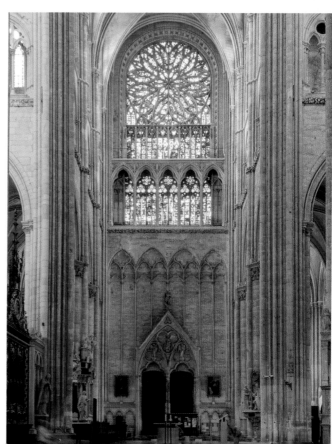

FIGURE 5.2 Inner south
transept façade

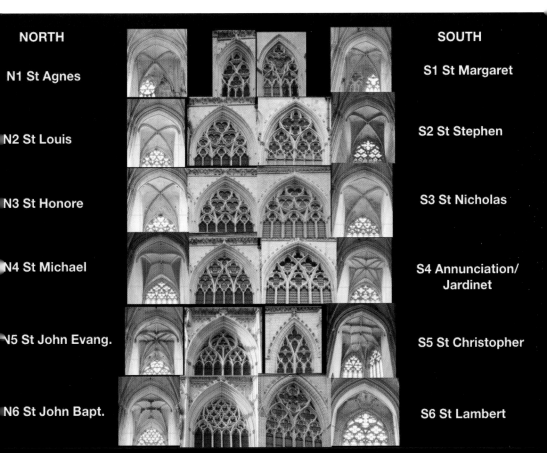

NORTH

N1 St Agnes

N2 St Louis

N3 St Honore

N4 St Michael

N5 St John Evang.

N6 St John Bapt.

SOUTH

S1 St Margaret

S2 St Stephen

S3 St Nicholas

S4 Annunciation/ Jardinet

S5 St Christopher

S6 St Lambert

FIGURE 5.5 Mapping the nave chapel windows and vaults

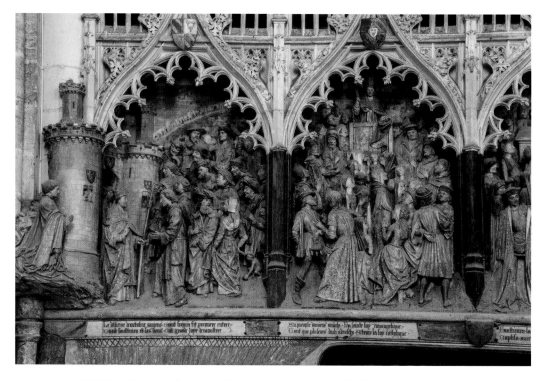

FIGURE 5.10A Lateral screen of the choir, south side, arrival of Saint Firmin; preaching

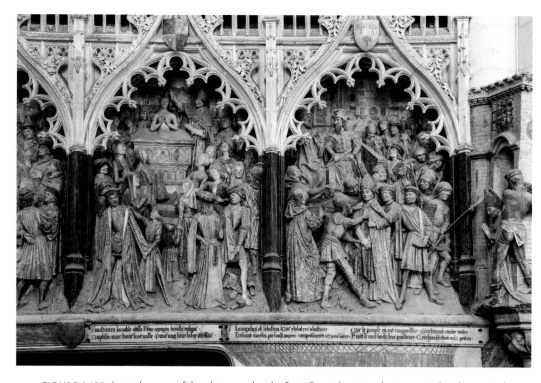

FIGURE 5.10B Lateral screen of the choir, south side, Saint Firmin baptizes; he is arrested and executed

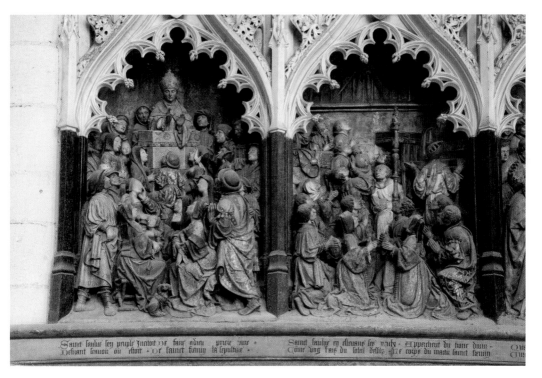

FIGURE 5.11A Lateral screen of the choir, south side, Bishop Sauve prays for revelation of location of the body of Saint Firmin; the location is revealed

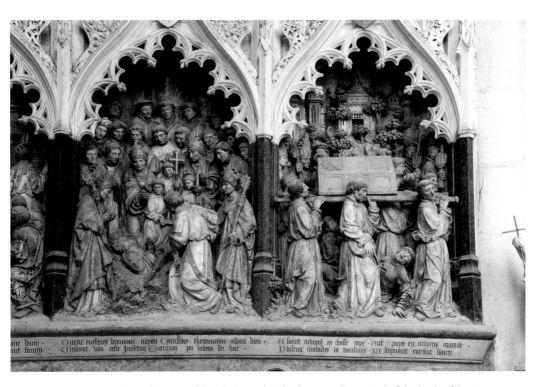

FIGURE 5.11B Lateral screen of the choir, south side, discovery (*Invention*) of the body of Saint Firmin; the *châsse* containing the relics is carried back into the city (*Translation*)

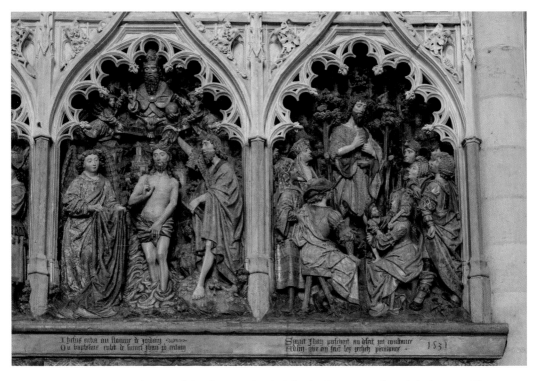

FIGURE 5.12A Lateral screen of the choir, north side, John the Baptist preaching; John baptizes Christ

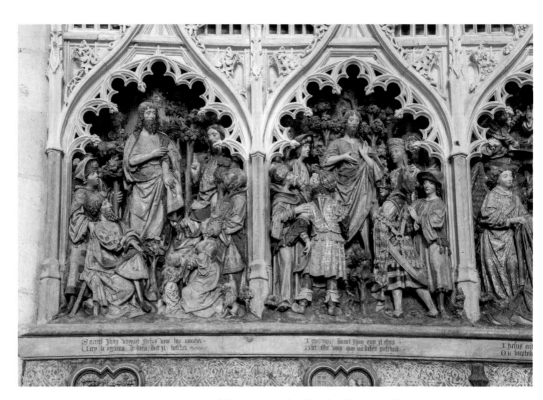

FIGURE 5.12B Lateral screen of the choir, north side, John, the voice of one crying in the wilderness; he reveals the identity of Christ

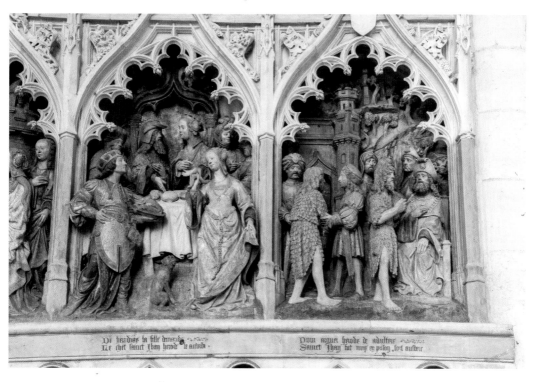

FIGURE 5.13A Lateral screen of the choir, north side, John is thrown into prison; Herod's feast

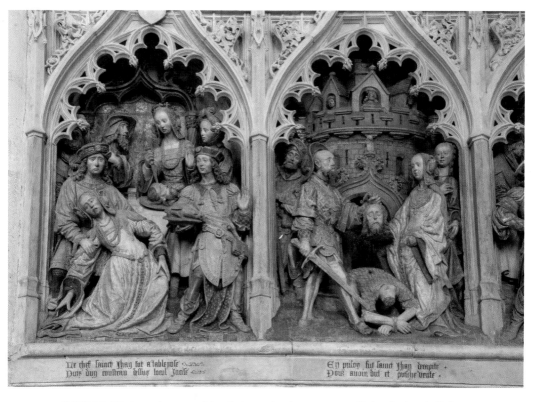

FIGURE 5.13B Lateral screen of the choir, north side, execution of John; the head of John is
stabbed with a knife

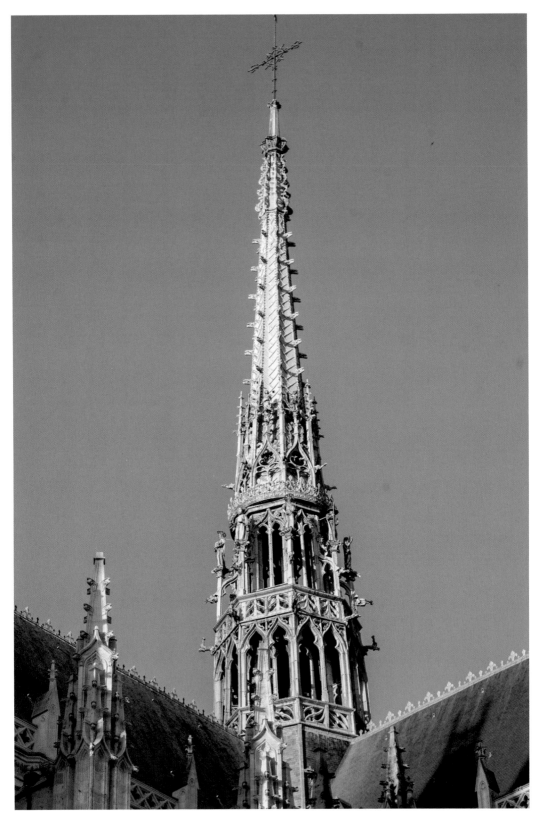

FIGURE 5.33 The central steeple seen from the southwest

of the double-square bays of the central vessel are supported atop *piliers cantonnés* that, as they ascend, transform themselves into bundles of delicate shafts—much too slender to actually support the ribs and arches of the upper vaults. That function of support is performed by substantial external flying buttresses (figs. 1.62 and 4.1). It is, of course, thanks to this robust external support that the enormous clerestory windows were possible.

While the cathedral was erected from the bottom up, it was conceived from the top down: the high vaults needed flying buttresses; the flyers needed massive rigid outer supports or *culées*. These were built into the outer wall and supported the outer edges of the lower square bays, forming the aisles.[32] Master Robert might have emphasized to the clergy that these external supports, a relatively novel feature of architectural production, provided the rigidity necessary to facilitate the magic of the new architecture, with its illusion of weightlessness.[33] The spaces between the buttresses were filled with magnificent aisle windows, each articulated with tracery forming a great upper oculus and two lower lancets: their form is indicated by the surviving windows on the west side of the transept arms (fig. 4.10). The inner corners of the aisle bays are supported on the slender *piliers cantonnés* of the main arcade, which allow great optical continuity from aisle to central vessel (fig. 1.36).[34]

iii) Dynamic Geometry and Spatial Transformation

To demonstrate the possibility that Master Robert de Luzarches produced drawings of both plan and elevation for his prospective employers, the better to provide a visual demonstration of his vision for the plan and elevation of Amiens Cathedral, we have invoked the contemporary words and images of Villard de Honnecourt and his followers. This same source will allow us to envision how Master Robert might also have explained the essential dynamism and illusionism of the architectural mode that we call Gothic. In a page of geometric devices in Villard de Honnecourt's little book we find an image of a square with a second diagonally turned square inside it, bearing the enigmatic caption: "in this way you can divide a stone so that the two parts are square [or equal]" (fig. 4.12).[35] The viewer can see that the four triangles making up the inner rotated square equal the four triangles making up the corners of the main square. Similarly, on the same page, another

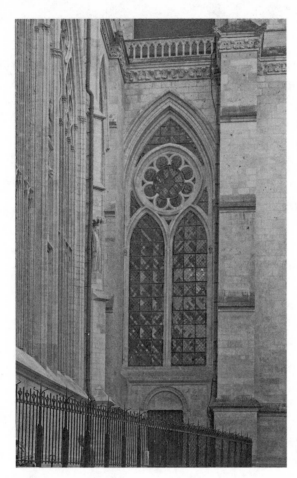

FIGURE 4.10 Amiens Cathedral, aisle window in west side of south transept arm

geometry

diagram shows such an inner square now aligned with the outer one, and a caption telling you that this is the way to design a cloister wherein the area of the four walks equals the area of the central space. These images provide a most intriguing reflection on the instructions outlined by Vitruvius, in his *Ten Books on Architecture*: one can double the area of a square plot by first finding the diagonal of that plot, and then using the length of the diagonal to project a second, larger square, rotated at forty-five degrees and containing the first.[36] Some of Master Robert's clerical employers were familiar with Vitruvius and the practical geometry laid out in the work of the Roman land surveyors or *agrimensores*, and they would certainly have understood the need to control the space of the unbuilt cathedral by stretching ropes on

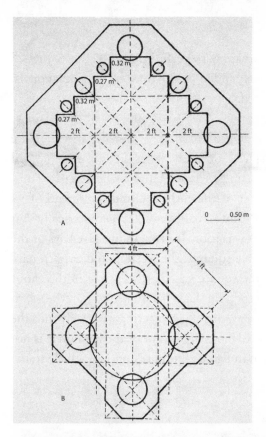

0.32 m
0.27 m
0.32 m
0.27 m
2 ft 2 ft 2 ft 2 ft

A

0 0.50 m

4 ft

4 ft

B

FIGURE 4.11 Amiens Cathedral section
of arcade pier and crossing pier

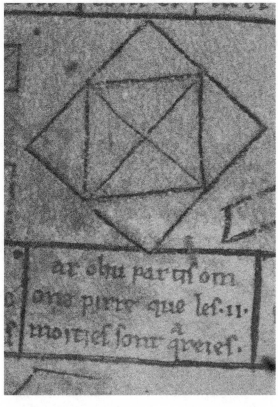

ar ohu partif om
one pirre que lef.ii.
moitief font greief.

FIGURE 4.12 Villard de Honne-
court or follower, rotated square
(Bibliothèque nationale de
France ms Fr 19093 fol. 20r, Carl
Barnes, *The Portfolio of Villard de
Honnecourt*, Plate 42)

the ground and creating a great square with perfect ninety-degree corners.[37] This great square could then be expanded by the rotation of its diagonals, just as Vitruvius had recommended.

Such dynamic geometry appears to have been applied to the business of plotting the configuration of the ground plan at Amiens, providing the means by which the complex spaces of the cathedral could be unfolded from the center using the mechanism of rotated squares (fig. 4.13).[38] Thus, the relationship between the center of the cathedral and the spread of its projecting arms—choir, transept, and nave—was fixed geometrically. But within that giant cross shape there was room for fungibility. Five bays of the nave are regular squares and double squares; the western and eastern nave bays are not. The regularity of the square schematism is lost in the choir; and the three bays of each transept arm dash from narrow outermost, to wider middle, to very wide inner bay, thereby projecting us briskly into the middle of the church. Furthermore, the center point of the hemicycle is not located exactly on point C shown in fig. 4.13.5, but is pushed a little to the

FIGURE 4.13 Dynamic geometry at Amiens. See also color plate.

FIGURE 4.13 (cont.)

east in order to give additional depth for the sanctuary and more room for the crown of seven radiating chapels.[39]

Precedents for this kind of design mechanism generated from the central crossing space can be found at Reims Cathedral, and soon after Amiens very similar dynamic geometry was applied in the parish church of Saint-Urbain in Troyes and in the abbey church of Saint-Ouen in Rouen.[40] The beauty of the thing was that it was not just a most effective way for controlling the site, making it "easier to work" (the words of Villard de Honnecourt), but the dimensions and proportions of the plot served to introduce various levels of meaning into the cathedral. The lofty proportions and sheets of translucent colored glass might incite viewers intuitively to the contemplation of the celestial, but the relationship with heaven was made specific in the great double square controlling the design (fig. 4.13.2).[41] The height planned for the main vaults at Amiens was 144 feet; the height of the Celestial City was understood as 144 cubits.

To reify biblical images, numbers, and metaphors in the very stones of the cathedral was obviously most satisfying for the clergy, but there was yet another way in which Master Robert promised convergence between the theological and the practical. Some members of the cathedral came from families making their living in the production and marketing of textiles, an activity that reached new levels of industrial efficiency with mass-produced lengths of woolen cloth whose dimensions and quality were closely controlled. Similar rationalization had been applied to stone production in the years before the start of work at Amiens: Villard de Honnecourt shows us how the elements of a window could be controlled through the use of templates (*molles* or *moules*); he also shows us how the stones should be shaped in the manufacture of a *pilier cantonné* or a compound pier.[42] With such techniques, all the individual elements of the cathedral—piers, responds, the moldings of arches and ribs, the elements of a window—would remain faithful to prototypes designed by the master mason, the great artificer. In similar fashion, the careful use of wooden formwork would ensure that all convex surfaces—arches and vaults—would remain obedient to the geometry designed by the master mason and imparted to the masonry through the wooden forms built by the carpenters. All elements of the cathedral would therefore *remember* the forms devised by the master mason, just as all elements on earth remember the Creation of God, the Great Artificer.[43]

b) Building the Cathedral; the Role of the Master Masons

Historians engaging in telling the story of cathedral construction generally draw upon three kinds of evidence: first, the close reading of the primary written sources (sparse though they may be); second, observations and conclusions teased out from the analysis of stylistic and archaeological data; and third, suppositions about constructional practice derived from extraneous, generally written sources. Extended textual and archaeological analysis, although essential for the historical interpretation of the mechanics of production, can make tedious reading: for the traditional archaeological and textual analysis, I refer the reader to my monograph on Amiens Cathedral and permit myself here to go straight to the story.[44]

When Master Robert de Luzarches was appointed master mason circa 1220, he probably brought to Amiens key members of his production team, including Thomas de Cormont who may have once worked with him as apprentice before becoming his lieutenant.[45] Perhaps Thomas was Robert's son-in-law: blood connections were very strong in the masonic community, and a master would often gather an extended family or clan around him. Thomas himself had a son/apprentice whose name was Renaud—probably born during the early work at Amiens. Other skilled masons may have come with Robert and Thomas, providing a core group supplemented through the addition of labor recruited from the local pool of masons and laborers.

Where did construction begin and how did it proceed? Is it possible to unscramble the signs embedded in the building to recognize the individual work of the three master masons whose names were recorded in the labyrinth? From our experience of approaching, passing through, and climbing in chapter 1, we have learned to see the cathedral as two distinct design entities: the nave, with its dark triforium and solid flying buttresses; and the choir with its glazed triforium, decorative openwork flyers, and jagged, gabled forms (figs 1.59–60). These two entities—generally understood as phases of construction—have been recognized in nearly all descriptions of the cathedral to have been published since the seventeenth century.[46] Because the nave was obviously built first, students of the cathedral have looked for some kind of obstacle blocking access to the site of the choir.[47] This might have been the old Roman wall that ran roughly north-south right through

the middle bay of the choir; yet this obsolete wall had probably been demolished already in the last decades of the twelfth century, well before the start of construction on the new cathedral.

Some historians of the cathedral had believed that the site of the new choir was encumbered by the presence of one of the other churches of the old episcopal group: however, this is based on a misreading of the written sources.[48] Unfortunately, much of the key evidence allowing us to ascertain the area where construction work started was destroyed in the fourteenth century, when the lowest part of the outer wall of the nave aisle was demolished to make way for the addition of lateral chapels. At that moment the builders reset elements of the old dado arcade in the new outer wall, modifying it to make it fit its new location. This is visible in the eighteenth-century graphic rendering of the cathedral known as the *Plan Saint-Marc* (frontispiece). Parts of this original dado still exist, though modified and badly mutilated, hidden behind the eighteenth-century altars set against the outer wall of each nave chapel (fig. 4.14). From these remnants, it can be ascertained that the forms of the dado and the articulation of

FIGURE 4.14 Fragment of the original dado of the nave, re-installed in the fourteenth-century chapels

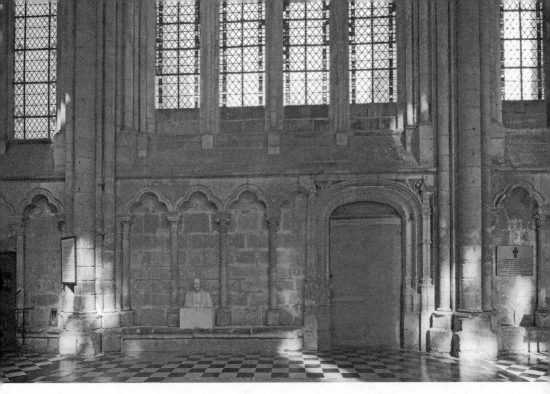

FIGURE 4.15 Choir north aisle dado. The doorway used to lead to the upstairs chapel of John the Baptist.

the outer wall up to the sill of the aisle windows remained the same down the entire length of the cathedral on both north and south sides, from the western frontispiece into the choir aisles up to the base of the hemicycle (fig. 4.15).[49] The extent of this outer wall corresponds to the great cruciform shape fixed by the dynamic geometry that Master Robert had used to plot the cathedral.

The architectural uniformity of the lowest part of the nave and choir suggests that the foundations below were also laid out all at once (fig. 4.1).[50] The overall shape of the cathedral must have first been laid out on the ground using pegged ropes—it corresponds quite closely to a double square (fig. 4.13.9). This would fix the extent of the excavated hole for the mighty bed of foundations necessary to support the ambitious superstructure. Because of an excavation conducted by Viollet-le-Duc, we know something of the foundations of the choir, formed of intersecting walls that become progressively thicker as they reach a depth of around twenty-six feet.

Recent analysis has shown that the foundations are well conceived in relation to the fact that they rest upon a bed of compressed clay and not on rock; calculations have shown that the weight of the superstructure bears fairly evenly on this vast masonry raft, reducing the potential problem of differential settlement. We can attribute this engineering feat to our first master, Robert de Luzarches. We might wonder about the response of local people to the digging of such an enormous hole and the establishment of a masonry raft that anticipates the unprecedented height of the cathedral yet to be built. With reference to the similar operation at Reims Cathedral, a contemporary clerical witness is said to have lamented the "lofty masses . . . reared up to the very sky" and the "foundations . . . laid in the abysses of the earth."[51] With the foundation raft in place, it would have been necessary to stretch ropes again in order to reestablish the exact location of the outer wall. It made obvious sense to build that outer wall as a single campaign since the stones could be laid up to the height of the sill of the aisle windows using only ladders, avoiding the use of expensive scaffolding (fig. 4.16.1).

Having thus controlled the site with the establishment of the outer perimeter, the next step was to raise up the outer wall with its buttresses and aisle windows, and to start to plant the piers of the main arcade and install the aisle vaults. This operation would demand the use of expensive

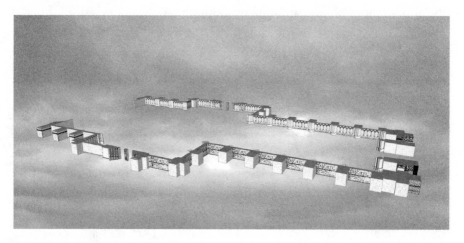

FIGURE 4.16 Sequence of construction

1. c. 1225 Robert de Luzarches

wooden scaffolding and formwork to shape the arches, window frames, and vaults: it would make sense to focus upon a limited area rather than trying to work simultaneously along the entire length and breadth of the cathedral. In this way the space of a side aisle could be completed, roofed, vaulted, and made available as a provisional space, especially for the clergy and parishioners of the recently demolished church of Saint-Firmin the Confessor.[52]

Much evidence suggests the earliest work focused upon the bays where the west aisle of the south transept turns into the south aisle of the nave (fig. 4.16.2). Thus, the stone bearing the image of the mason's trowel in the south transept portal may well have been intended as a celebratory sign to mark the start of work; it might also have served as a funerary marker of the grave of Master Robert (fig. 3.12). The earliest window in the west aisle of the south transept shows signs of experimentation and attempts to resolve problems that were fixed in later windows (fig. 4.10).[53] The north nave aisle, which was begun soon after the south (fig. 4.16.3) and also followed an east-to-west sequence, was laid out around the same time as the outer wall of the choir aisles (up to the sill of the aisle windows), though work did not continue up into the choir aisle vaults for a decade or so. Separate teams of masons built the two flanks of the nave up to the triforium level including the lateral portals of the western frontispiece: the south

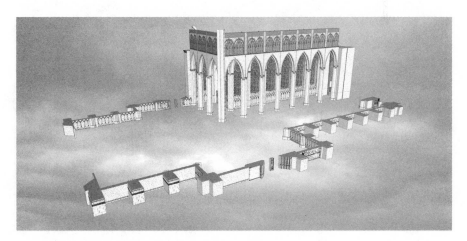

2. c. 1230 Robert de Luzarches and Thomas de Cormont

portal of the Virgin Mary is clearly a little earlier than the north portal of Saint Firmin.

The entire spread of the lower walls of the cathedral (without the hemicycle), and the nave aisles up to the vaults, embody a high level of unity that may be associated with the work of the founding master, Robert de Luzarches, who had probably already been working in partnership with Thomas de Cormont. Robert may have been already advanced in years when he came to Amiens, though there is no contemporary written

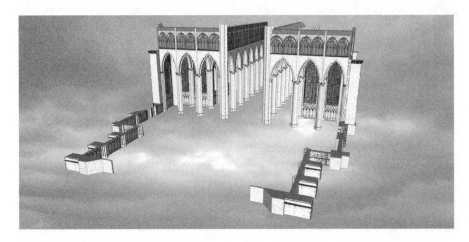

3. c. 1235 Thomas de Cormont

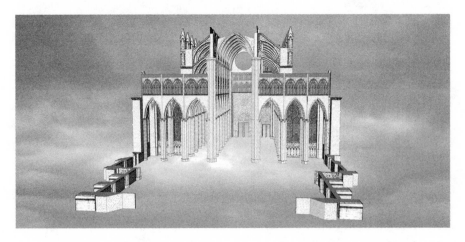

4. c. 1240 Thomas de Cormont

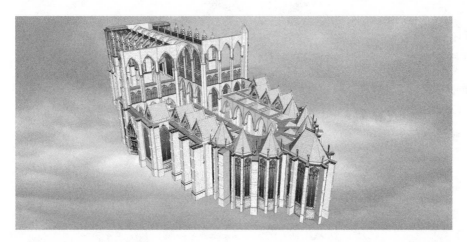

5. c. 1250 Thomas de Cormont

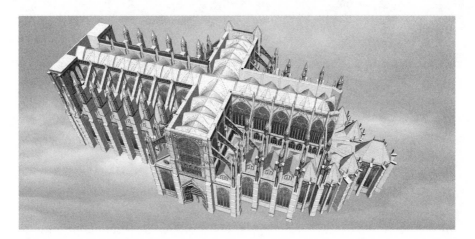

6. c. 1265 Renaud de Cormont

evidence attesting to the date of his death.[54] The fact that construction seems to have passed seamlessly from lower to upper nave suggests that Thomas was able to take over its direction and continue work through the 1230s without any major revisions to the original plan (fig. 4.16.4). The only date that we can find in the written sources to suggest completion of the upper nave—triforium, clerestory windows, high vaults and flying buttresses—is a text from 1243 referring to bells hanging in the southern belfry of the west façade.[55]

FIGURE 4.17 Dado in the choir chapel of St Eloi

While work continued on the completion of the upper nave, western frontispiece, and the upper west side of the transept arms in the 1230s and 1240s, it is probable that the lower choir was also under construction under the sole direction of Thomas de Cormont (fig. 4.16.5). First, the lowest level of the walls of the radiating chapels was laid out: the form of the dado in the chapels is significantly different from that in the straight bays (figs. 4.15 and 4.17).[56] Whereas we can associate the rounded trilobed arcade with Master Robert, it is tempting to conclude that Thomas, once he became principal master, wanted to establish his own trademark form—the cusped arch—much more fashionable by the 1230s–40s.[57] With the construction of the radiating chapels came work on the choir main arcade and hemicycle, as well as the choir aisle windows and vaults. For the choir aisle windows Master Thomas used an enclosing arch shaped quite differently from that used by Robert (figs. 4.10 and 18). The former master had favored a steeply pointed window framing an enormous upper oculus surmounting two lancets—a strongly hierarchical design. Thomas, on the other hand,

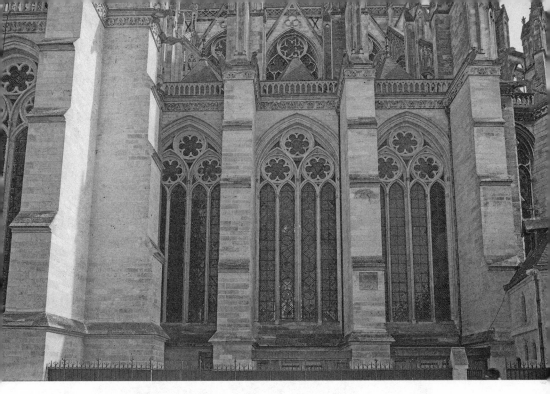

FIGURE 4.18 South flank of the chevet

designed a much more rounded arch enclosing three cusped oculi of equal size. Such windows exist in the choir aisles and eastern chapels of the transept arms. A charter dated 1233 for the establishment of chaplaincies in the southern chapel of the Conversion of Saint Paul is sometimes invoked as dating evidence for this work, through it should be noted that such arrangements could also be made either before or after the work of construction.[58] The outer walls of the choir straight bays enclosed a double aisle with inner and outer vaults of equal height: Thomas designed a new kind of support with eight slender shafts grouped around a central cylindrical core (fig. 4.19).[59] The supports marking the divisions between the radiating chapels have the same enhanced slenderness—the transverse arches that sit atop them have a wedge-shaped profile, unlike the flat soffits of the similar arches in the nave (fig. 4.20). Together with the work on the choir arcade came the arcade of the eastern side of the transept arms up to the triforium sill; this included the foliate band, which differs slightly from the foliate band in the nave and west side of the transept associated with Master Robert.

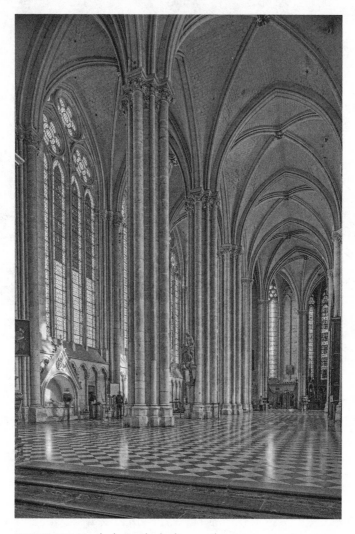

FIGURE 4.19 North choir aisles looking northeast

We have thus seen two decades of work, proceeding smoothly, apparently with ample funding and capable direction. Then, in the middle years of the thirteenth century, the situation changed sharply. It is likely that the funding structure shifted from one where the bishop and chapter contributed part of their regular income to one based upon "soft" funding where contributions from laypeople were raised through the aggressive use of relic quests. At the same time, King Louis IX was beginning to impose heavy taxation on cities and dioceses in order to raise money for his crusade.[60]

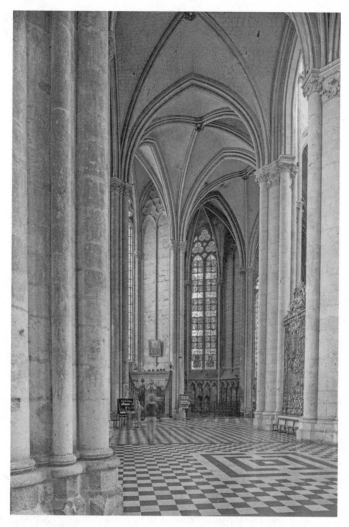

FIGURE 4.20 Ambulatory and radiating chapels

Anticlerical manifestations were documented in these years, and the documents also record an arson fire that broke out in 1258 in the scaffolding of the upper choir—members of the bourgeois were accused of having set the fire.[61] This fire, in turn, provides clear dating evidence for the completion of the upper choir: fire-reddened and cracked stones are visible in the triforium and upper piers at the west end of the south side of the choir. We know who was master mason in the years directly after the fire: Renaud de Cormont's name is mentioned in a 1260 charter relating to his tenure of a house in

the rue de Metz l'Evêque, just to the east of the cathedral.[62] We may thus be quite certain that Master Renaud completed the upper east side of the transept arms and upper choir in the 1250s and 1260s (fig. 4.16.6).

By the 1250s work at Amiens had been underway for three decades and the forms chosen by Robert de Luzarches and Thomas de Cormont looked increasingly old-fashioned. Young Master Renaud, having received his initial training with his father in the Amiens workshop, may have sought employment elsewhere—possibly in or around Paris where the new work on the upper choir and nave of the abbey church of Saint-Denis, with its glazed triforium and brittle calligraphic linearity, created a new paradigm for Gothic builders. And at Notre-Dame of Paris, Master Jean de Chelles had created new forms of articulation with his work on the north transept of the cathedral; after Master Jean's death in 1258, work continued by the great Pierre de Montreuil, who worked on the south transept before his death in 1267.[63] Renaud de Cormont was probably quite familiar with these great projects, and on the death of his father, Thomas, he assumed direction of the workshop at Amiens Cathedral.

The study of the father-son relationship expressed in Gothic form is fascinating—particularly in a context where the identity of the masons had been recorded in the House of Daedalus, the labyrinth on the nave floor that invites us to consider a Daedalus-Icarus relationship. It is perhaps too easy to find in Renaud a young man who attempted to fly too high, pushing the design of his architectural elements—particularly tracery forms and flying buttresses—too far in the direction of attenuation. However, as we will see, the blame for some of the problems that were encountered in parts of the cathedral for which Renaud was responsible can be shared with his father, Thomas, and also with the great founding master, Robert de Luzarches himself.

Master Renaud probably worked simultaneously in at least three different zones, and in each case we can draw a sharp contrast between the forms employed by father and son. First, Renaud brought the uprights (culées) for the choir flying buttresses to their full height. In the choir straight bays, these units had already been planted by Robert de Luzarches and brought up the aisles roof by Master Thomas, who went on to build similar flat-sided buttresses around the hemicycle (figs. 1.24 and 4.16.6). At the level of the aisle roofs we see a remarkable transformation: the mass of the buttress

is sharply reduced and its form fragmented with the addition of smaller buttresses creating a section that is T-shaped in the straight bays and Y-shaped in the hemicycle. The new form was clearly the work of Renaud de Cormont whose motivation was, to some extent, purely visual: he was seeking a much more broken and faceted "Post Modern" look. But he may have also been motivated by structural concerns: perhaps he knew that the addition of the little flanking buttress helped enhance rigidity, allowing the total mass and weight of the unit to be reduced.

Second, Renaud introduced a new kind of openwork flyer (figs. 1.63–67). We may surmise that he had quickly realized that new problems faced him in the upper choir. Whereas the nave has only one aisle on each side and the flyers could be firmly seated atop the great exterior buttresses rooted in the outer wall of the nave, here, in the choir, the double aisles necessitated double-rank flyers, and the intermediary upright would have to sit atop the very slender aisle piers planted by Master Thomas. Renaud de Cormont, realizing that the whole flying buttress system of the chevet needed to be reduced in weight, may have studied Troyes Cathedral where a similar problem had been solved through the use of openwork flyers, greatly reducing the weight imposed on the choir aisle piers.[64] Such forms had not been anticipated by Master Thomas; on the western sides of the upper transept arms we have tracked the surprisingly tentative transition from solid to openwork flyer: the second point of transition from father to son.

Third, Renaud transformed his father's triforium. Master Thomas had deployed a heavy composition where a generously sized trefoil rendered in solid slabs of stone (plate tracery) surmounts three lancets (fig. 1.56). Renaud began his work on the triforium on the east side of the south transept, starting with the two outermost bays adjacent to the façade (fig. 1.57). The big trefoil is still used in these bays, but now rendered in attenuated sticks of stone (bar tracery). The composition is much skinnier than in the nave and unable to resist settlement and deformation: it has been necessary to stabilize the wider unit in the second bay through the installation of a great wooden beam to support the fragile tracery. The third bay adjacent to the crossing is the widest and is subject to considerable deformation: here the original tracery has failed entirely, and has been replaced by a much denser composition featuring three small trefoils. A similar composition

was used on the east side of the north transept and, a little modified, all around the choir where a gable has been added to each unit.[65]

Perhaps the most telling sign of the identity of Master Renaud can be found in the form of the foliate band marking the sill of the triforium. In the nave and transept, the work of Masters Robert and Thomas, the foliate band is truly a garland wrapped around the cathedral running in a counterclockwise direction; in the choir there is no directionality, and the band is made up of little sprigs of desiccated (though exquisitely carved) foliage, vertically arranged.

Georgio Vasari, in *The Lives of the Most Excellent Painters, Sculptors, and Architects*, told a story of step-by-step progress toward the glories of the art of Michelangelo. Here at Amiens we have followed the story of an initial master, Robert, who seemed to have got things right; followed by a second, Thomas, who was content to follow; and then a third, Renaud, who inaugurated an architectural revolution that ended badly: with the near-collapse of the upper crossing space almost two and a half centuries later (c. 1500). Students of the cathedral have not hesitated to offer a moral conclusion: *c'est presque le commencement de la décadence.*[66] However, it must be remembered that the great Robert de Luzarches had laid the seeds of the structural problems at Amiens with his slender piers supporting a relatively thick arcade and the increased span of the bays adjacent to the crossing. Master Thomas added to the problem with his slender choir aisle piers that had a heavy load to bear: one wonders what kind of flyers he had envisaged. Master Renaud inherited all these problems. He directed work at a very difficult time: damage done by the arson fire in 1258 forced him to replace the exterior skin of the southern triforium in the chevet, as well as to reface considerable areas of fire-damaged masonry. And, as we have seen, the innermost bay of the south transept triforium, on the east side, was starting to fail even during construction and needed to be replaced.

c) The Clergy Occupy the Gothic Choir (Fig. 4.5)

Thus, we have watched the cathedral go up through the work of the masons and carpenters, fulfilling the desires of the clergy. In recounting the story of the great enterprise we have come to recognize the frustration of the clergy: displaced from their stalls in the choir in 1218, they waited for half

a century to be reseated. This situation arose since, unlike their colleagues in many other cathedrals, the Amiens builders did not begin the new work of construction in the choir, but rather in the middle of the edifice, with the nave going up ahead of the choir. Most of the participants in the initial planning conversations of circa 1220 were dead by the time that members of the clergy were finally able to enjoy the opportunity to link liturgical practice with custom-designed architectural space. Gervase, chronicler of the rebuilding of the choir of Canterbury Cathedral, compared the grief of the monastic community, exiled for a decade to a provisional space in the nave, with the despair of the Israelites in Babylonian captivity. These same years (1240s-1260s) also saw an acute funding shortage and anticlerical manifestations on the part of some of the laypeople.

We know nothing of the form of the old choir, or the extent of the damage wrought by the fire of "1218." Given the need to clear the site in order to lay the massive foundation raft, it seems unlikely that all or part of the old choir was retained in order to allow the continuation of the Offices. We do know that the clergy and parishioners of the church of Saint-Firmin the Confessor, demolished to make way for the cathedral, were assigned a space in one of the aisles of the nave (in uno latere) to allow them to continue their offices.[67] Might the cathedral clergy have used the other nave aisle until the completion of the upper nave (c. 1236) allowed them to occupy (provisionally) the main vessel of the nave?

We can track the progress of work on the new choir and its application to serve liturgical functions through the establishment of choir chapels.[68] A chapel may be understood as a discrete space equipped with an altar where mass and other offices may be said. The altar would generally house relics. Chapels also provided an appropriate space for burials, thus attracting the generosity of ecclesiastical as well as lay patrons and confraternities willing to to donate a parcel of land or a packet of fiscal rights in order to provide an annual income for one or more chaplains who would say the offices and pray for the dead at times prescribed in the charter of foundation.

The Amiens plan originally allowed for ten chapels: seven radiating around the ambulatory, one on the east side of each of the transept arms, and one at the east end of the south choir aisle (fig. 4.21). In 1233 Dean Jean d'Abbeville founded the first chapel dedicated to the Conversion of Saint Paul: it was located to the east of the south transept arm (fig. 1.48).

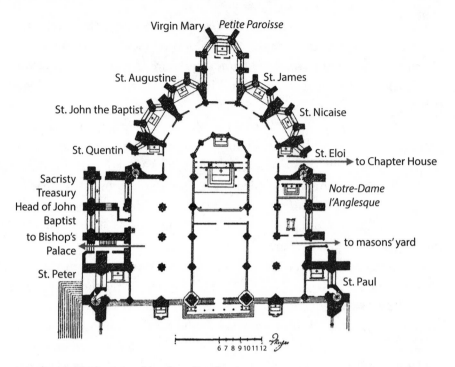

FIGURE 4.21 Dedications of the choir chapels

Although he was no longer dean at Amiens at the time of its foundation, Jean d'Abbeville might have reflected upon the proximity of the chapel to the seat allocated to the dean in the cathedral choir. The matching chapel in the north transept was dedicated to Saint Peter: the two chapels at the base of the chevet thus celebrated the two great pillars of the Church and the legendary existence of an early church at Amiens dedicated to the founding apostles, Peter and Paul.

The radiating chapels of the choir, under construction in the 1240s-50s, soon began to receive the endowments necessary to provide chaplains: Saint Eloi in 1243, Saint Quentin in 1244, and Saint James in 1253. The axial chapel of Notre-Dame was in use by 1262 (fig. 4.21). The clergy of Amiens followed well-established tradition in assigning this chapel to Notre-Dame, patroness of the cathedral: this space with its extended plan also served as parish church for residents of the area of the cloister, the Petite Paroisse. It is the only chapel in which tomb monuments survive: Canon Thomas de Savoie (d. 1332/6) and Bishop Simon de Gonçans (d.1325). Of the other chapels,

two were designated for great saints of international reputation whose relics resided in the cathedral: Saint John the Baptist, second chapel on the north; and Saint James, adjacent to Notre-Dame on the south. The other four radiating chapels were occupied by saints of a more local status: the presence of Saint Augustine of Canterbury reflected close links with England resulting from the cloth trade, and more specifically, the community that had been formed by the chapters of Amiens and the monks of Christ Church Canterbury. The other three saints express links with neighboring cities in the province of Reims: Saint Quentin, Saint Nicaise (Reims), and Saint Eloi (Noyon). These local links were also reflected in the imagery of the west portal's northern tympanum of residents of Noyon, Beauvais, Cambrai, and Thérouanne participating in the miracle of the invention of Saint Firmin.

Spaces in the choir aisles also served as chapels: the piscina at the extreme east end of the south aisle attests to the life of the medieval chapel of Notre-Dame-l'Anglette (Beata Maria Anglicus)—perhaps another indication of close links with England—and the enclosed space of this aisle served the community of chaplains (fig. 1.49). On the north side the principal relic in the possession of the cathedral was housed upstairs in an ancillary structure; demolished in 1759, it has left its traces against the outer walls of the two eastern bays of the north aisle (figs. 1.22–23).[69] The same building provided the canons with their *sacristy*—a space for robing and unrobing.

By the 1260s and 1270s major construction had reached the point where the clergy could prepare to take possession of their choir. The Corbie Chronicle claimed that the cathedral was complete by 1264: *Templum majus B. Marie Ambienensis consumatur anno 1264.* This claim may apply to the occupation of the choir: the axial window in the clerestory is dated 1269.

The last major undertaking necessary to render the choir space fully usable for the clergy was the construction of a choir screen or *jubé* pitched between the eastern piers of the crossing, work probably undertaken in the 1260s or 1270s under the direction of Master Mason Renaud de Cormont (fig. 1.45).[70] The screen, first mentioned in 1291, is referred to as the *pulpitum*, although modern usage favors the term *jubé* from the opening benediction preceding the reading of the Gospel: *Jube Domine benedicere.* . . . Although the screen was demolished in 1755 in order to create the present structure with a wider doorway, thus providing laypeople better visual access to the Eucharistic sacrament, we are well informed about its appearance

and fragments of the sculptural program are conserved in the Metropolitan Museum, the Louvre and in the Musée de Picardie in Amiens (fig. 3.17).[71] The screen was about 6.5 meters high, with an arcade of seven arches supported by glistening black marble columns. In the spandrels of the arcade, sculptured images of prophets and sibyls echoed the prophetic structure of the sculptural program of the west portals. This delicate arcade framed little rib vaults that enclosed a shallow space about 2.5 meters deep supporting an elevated platform or tribune accessible by means of staircases at each end. The wider central arch, with a gilded ironwork gate carrying the arms of chapter, opened into the choir. Set in the outermost bays of the screen against the crossing piers were two altars, the one to the south dedicated to Saint James and enshrining the relic of his chin, and the other to the north dedicated to the Virgin's ring. The upper tribune was bounded by balustrades about 1.16 meters high. Sculptured images were set in the panels of the west-facing balustrade: the Last Judgment in the center (again, echoing the west portal); and the narrative of the Passion in the twelve niches, six on either side, running from left to right from the Triumphal Entry into Jerusalem to the Descent to Limbo. Rising high above the center was an image of the Virgin Mary standing atop the moon and surrounded by radiant light. And crowning all was an enormous crucifix (about 6 meters high) flanked by Mary and John.

The great central cross surmounting the brightly painted, gilded, and glittering screen must have formed a visual beacon and magnet for pilgrims and visitors advancing eastward down to the nave. This visual power was enhanced through the play of light, color, odor, and spectacle. The jubé supported twelve great chandeliers lit at matins on major feast days and during stations in nave—the role of the screen as a linking mechanism between the liturgical activities conducted in the choir and projection of those activities beyond will be explored more fully below.

On May 16, 1279 a magnificent ceremony took place in which the relics of Saint Firmin the Confessor and Saint Ulphe were transferred into new châsses in the choir of the cathedral.[72] The ceremony marked the conclusion of a peace treaty between King Philip III (son of Louis IX of France) and Edward I of England. The event in the cathedral was attended by a splendid group of visitors, including the Papal Legate Simon de Brie (the future Pope Martin IV); the archbishop of Rouen; the bishops of Evreux, Beauvais,

Langres, and Bayeux; and the king of Sicily.[73] At this point the architectural envelope and the liturgical furnishings of the choir were in place—although the high vaults were still sheltered under a provisional roof. We can imagine the canons seated in their stalls lining the first two bays of the choir arcade. In the center between the ranks of stalls was a lectern formed in the shape of an eagle: groups of singers might assemble there for musical performances, or readings might take place. In the third bay, lateral gates provided access into the side aisles, and then two steps led up into the sanctuary. A "glory beam" carrying candles marked the transition from choir to sanctuary. The bishop's throne was set on the south side of the main altar, which was shrouded by a curtain. Directly behind the principal altar was a relic tribune carrying the châsses of the principal saints of the diocese. Behind the relic tribune at the center of the hemicycle was a little altar that might be used if there were a second mass in a particular day. The choir was closed in by the screen to the west that we have just examined: we know nothing about the original lateral screens.

d) The Cathedral Is Crowned by a Roof and Spire

Whereas the carpentry work facilitating the magic of the masons left few visible traces, the crowning glory of the cathedral is the great wooden roof that still provides tangible evidence of the genius of the artisans (fig. 4.22). The key structural device that lies at the heart of the work done by the roof's carpenters was the great triangle (*ferme*) formed of two substantial principal rafters (*arbéletriers*) securely pegged in place atop a horizontal tie beam (*entrait*). This beam, in turn, was anchored between the tops of the clerestory walls atop double wall plates (*sablières*) with little diagonal braces (*potelets*) (fig. 4.23). Vertical king posts (*poinçons*) planted at midpoint on the base of each triangle rise to the apex. A sequence of such rigid space frames (*fermes*), placed 3.7 meters apart, forms the essential structural skeleton of the Amiens roof: it is interesting to note that the bay system of the roof does not correspond with the transverse arches of the high vaults.[74] These main triangular assemblies are linked by longitudinal beams (*pannes*) and a ridge beam (*faîtière*). Diagonally crisscrossed beams in the form of Saint Andrew's crosses, inserted between the upper parts of the king posts, provide longitudinal rigidity. Between these major space frames are thinner

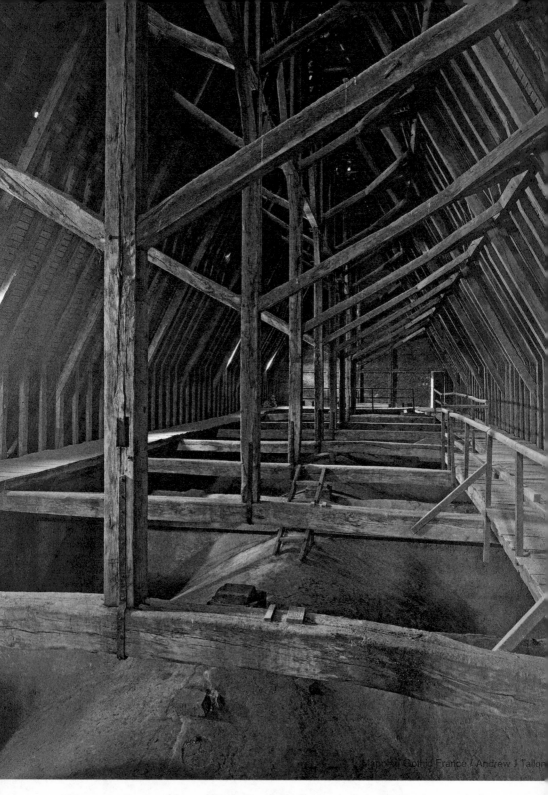

FIGURE 4.22 Interior of the roof (Media Center for Art History, Andrew Tallon photographer)

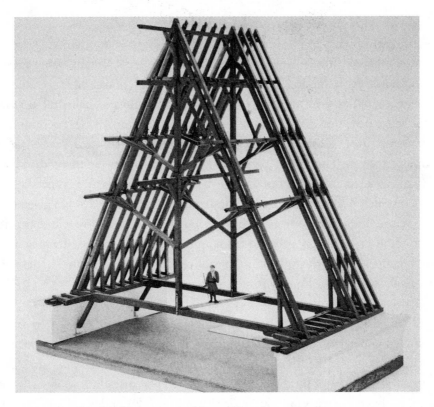

FIGURE 4.23 Model of the structure of the roof (*Les charpentes*)

rafters, five per bay, supporting the horizontally laid lathe upon which the slate tiles could be placed and pegged with copper pins. Perhaps the most spectacular features of the roof interior are the great diagonal forked braces (*contrefixes*), set at ninety degrees to the line of the rafters at two levels and pegged to the king post. These diagonally placed branched limbs, designed to brace the surface of the roof against wind gusts lend to the structure of the roof an organic look—almost like live trees in a forest. The sophisticated use of such diagonal braces, the relatively slender cross sections of the beams, and the apparently effortless control over the technology of wood construction and assembly had led Viollet-le-Duc and his followers to suggest a sixteenth-century date in the belief that the entire roof had been consumed in the same fire that destroyed the central steeple in 1528.[75]

However, the analysis of the growth rings (*dendrochronology*) in the lumber of the roof that took place around 1990 has demonstrated without

doubt that the entire structure was built between circa 1280 and 1310, working from east to west. Members of the fabric committee at Amiens Cathedral were fully aware of the structural problems already being experienced in their cathedral, especially in the transept arms and upper choir. The recent collapse of the upper choir at nearby Beauvais Cathedral in 1284 must have provided a frightening vision of the dangers of overloading the superstructure.[76] Compared with Beauvais, some thirty years earlier, the Amiens roof represented a great step forward in lightweight, rigid, rationalized construction. It is fascinating to find that a similarly advanced roof was installed over the nave of Chichester Cathedral around 1290: given the very close links that Amiens enjoyed with England, is it possible that this revolution in carpentry resulted from an infusion of expertise from across the Channel?[77] Was the revolution in roof construction motivated in part by an acute shortage of lumber resulting from deforestation?

If we accept the traditional understanding of cathedral construction, we will be led to believe that the high vaults of Amiens Cathedral were only installed under the shelter of the existing roof in the early fourteenth century.[78] This would be an astonishing conclusion since it is clear that the cathedral was in use by the 1270s and 1280s. The installation of vaults is a messy business with falling debris: it could not be undertaken while the clergy sat in their choir stalls. There is no sign of tardy installation of the nave vaults: although in the high vaults of the choir there is, indeed, a slight interruption in the form of the profile of the ribs and arches as they curve away from the clerestory, this is best understood in relation to a pause in construction after the 1258 fire. It is most likely that an earlier provisional roof had existed: perhaps at full height, or more likely sitting directly on top of the vaults coated with a skin of fine mortar to reduce water penetration. Rainwater could be evacuated through the generously sized spouts set into the upper wall in the pocket of each vault.

Soon after the completion of the main roof in the early fourteenth century, the cathedral was crowned by a central spire and the crossing vault was installed. The spire would survive for fully two hundred years, until it was consumed by fire in 1528.

Telling the Story of the Great Enterprise, II, c. 1300–1530 5

Continuing Work, Immediate Danger, Triumphant End

I N OUR STORY OF THE GREAT enterprise of construction we left the clergy recently seated in their new choir, reorganizing their liturgical life and rejoicing in glittering ceremonies like the one where the relics of Saint Ulphe were triumphantly installed in a magnificent new châsse placed upon the relic tribune in the sanctuary, in the presence of the kings of England and France. However, the clergy only had to look around to see that the major work of construction was far from accomplished—the upper transept façades and upper western frontispiece with its towers were still unfinished, and dangerous signs of structural instability were already being noticed in the area of the crossing. The clergy still lacked a chapter house for the meetings to discuss the management of liturgical and business affairs. And whereas during the first two or three decades of the life of the cathedral construction had proceeded under generally favorable historical and economic circumstances, the situation changed sharply in the years around 1300, and the fourteenth and fifteenth centuries brought repeated cycles of war, economic penury, and pestilence.

Change in economic standing

The prosperity of the city of Amiens appears to have peaked in the mid-thirteenth century when the taxes imposed by King Louis IX to finance his crusade took a heavy toll upon the cities and dioceses of the north. The first half of the fourteenth century was particularly hard, given the role of Amiens as a gateway between France, England, and Flanders. These relations had been compromised by the Franco-Flemish War beginning in the 1290s; the first effects of the Hundred Years War with the English were

felt in the area by the 1330s. Two of the greatest battles of the war were fought and lost in the close vicinity of Amiens: Crécy, in 1346, where the Amiens militia suffered heavily; and Agincourt in 1415.[1] In addition to the miseries of war came chronic pestilence (Black Death, 1348 and later), depopulation, popular uprisings, dynastic failure, and repeated military humiliation at the hands of the English. In the chaos that ensued after the defeat at Poitiers (1356) and the capture of King John, some of the leading bourgeois of Amiens made the disastrous mistake of siding with the revolted bourgeois of Paris led by Étienne Marcel and Charles d'Évreux, king of Navarre, whose lineage from the Capetian monarchs of France had led him to aspire to the French crown. Charles received a triumphal welcome in Amiens in 1357. Soon afterward, however, the forces of the dauphin, the future King Charles V, entered Amiens in a surprise attack and seventeen leading citizens were executed in the marketplace, including the mayor, Firmin de Coquerel, and the captain of the militia, Jacques de Saint-Fuscien.

The reign of King Charles V (1364–1380) brought increasing financial demands upon the city, both to support the king in his struggle against the English and to renew urban defenses. The cathedral clergy were obliged to contribute to the expense of new fortification for the southern part of the city. An enquiry resulting from the protest against such financial exactions in 1380, the year of the death of King Charles V, revealed that the city owed 24,000 pounds—equaling two or three times its annual budget. The principal economic activities of the city—the production and marketing of woad and woven textiles, and the purveying of wine—were particularly heavily taxed: violent protests followed in 1382.

Under such unfavorable historical circumstances, it is hard to understand how resources were found to undertake any major construction projects at all. However, we will see that a series of major projects can be associated with the early decades of the fourteenth century. There was probably a hiatus in the 1340s and 1350s associated with the Black Death and the battles of Crécy and Poitiers. Another burst of work ensued in the decades before 1400. And finally, three or four more decades of intense activity from the 1480s to the 1530s marked the end of the life of the Gothic cathedral. Let us now look more closely.

a) Transept Façades

Even the most cursory inspection of the cathedral reveals that the great rose windows and tracery of the upper transept façades do not belong to the main thirteenth-century phase of construction (figs. 5.1–2). Two possible explanatory scenarios might be invoked. It is possible that the clergy, in their rush to take their seats in the completed choir, concentrated their limited resources on the east end of the cathedral, leaving the upper transept façades closed in with provisional wooden screens. Alternatively—given the multiple signs of structural distress we have noticed, especially on the east side of the transept arms—could the upper transept façades have already been completed in the middle decades of the thirteenth century, but redone later under structural duress? Three structural factors were at play. First, the great piers of the crossing had already begun to assume their banana configuration, bowing inward at arcade level and outward in their upper parts. Second, the westernmost vaults of the choir aisles were pushing the arcade piers on the east side of the transept arms westward toward the main vessel.[2] And third, the transept façades did not have the mass necessary to prevent the upper transept arms from rotating outward: this was particularly problematic on the east side, since the terminal buttresses here are hollowed out with interior staircase turrets.

In both transept façades the original intention (on the part of Master Mason Thomas de Cormont) had been to fill the upper space between the great buttresses flanking the central vessel entirely with tracery and glass—a lower level corresponding with the triforium, and an enormous upper rose. There are close links between the transept façades of Amiens Cathedral and those of Notre-Dame of Paris, where an external floral band frames the vast expanse of tracery in the central area of the exterior façade: Jean de Chelles used such a band on the north transept of Notre-Dame (c. 1245), and Pierre de Montreuil did the same on the south side (c. 1265). The same motif had been deployed by Thomas de Cormont as he started work on the west side of the upper south transept façade at Amiens (c. 1245): he brought the main buttress on the west side of the façade almost to the top; the eastern buttress was probably up to the sill of the clerestory window (fig 1.27).[3] We normally think of Thomas's son, Renaud, as

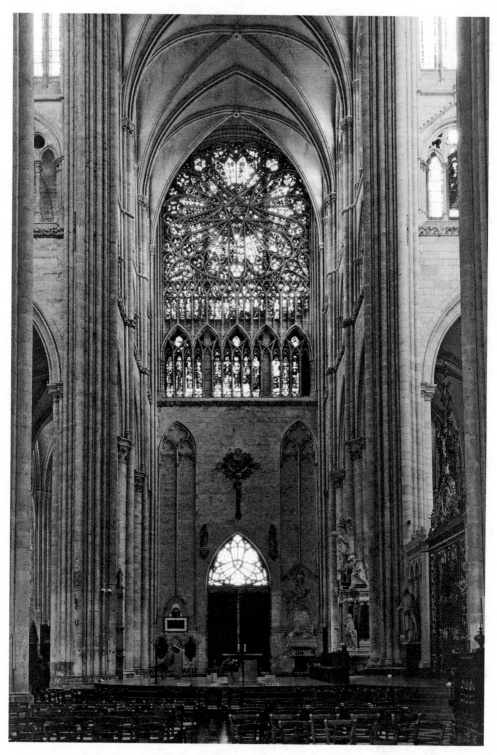

FIGURE 5.1 Inner north transept facade. See also color plate.

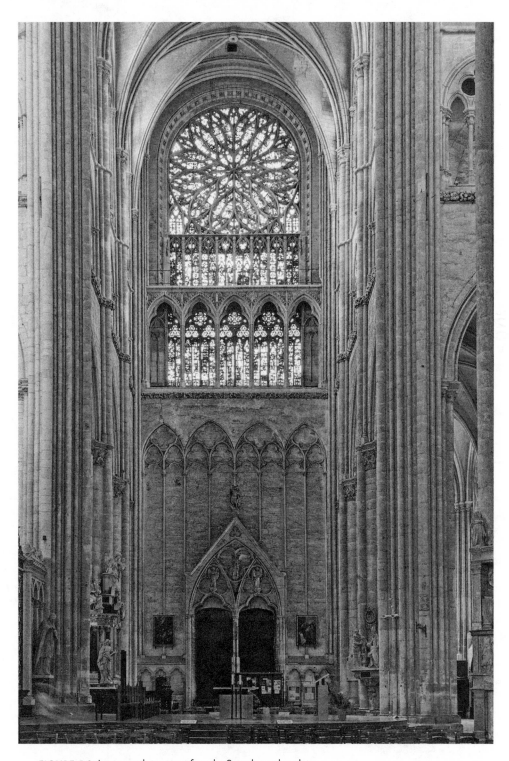

FIGURE 5.2 Inner south transept façade. See also color plate.

a risk-taker—one who favored attenuated masonry forms. However, given the multiple signs of structural distress described earlier, Renaud must have worried whether the two main buttresses flanking the upper south transept façade had enough mass to ensure their structural security: as he brought the work up above the level of the triforium sill, he added a substantial strip of masonry inside the floral band that was originally intended to frame the tracery-and-glass composition.[4] Renaud was also probably responsible for the five gabled panels that form the outer skin of the south transept triforium.[5] He continued the work into the upper façade with its continuous strip of masonry framing the central rose: this includes the sculptured images of the Wheel of the Ages of Man and two enigmatic standing figures—a man on the left and a woman on the right, each with the bust of a woman underneath.[6] It is possible that Renaud also installed a rose window in the upper south transept—it might have resembled the south transept rose at Paris's Notre-Dame cathedral. However, the existing rose is the work of Master Pierre Tarisel from around 1500—when the interior passage and arcade of the triforium was installed and the mullions of the existing tracery reinforced. At the very top of the south transept façade stands the pinnacled gable carrying twelve prophets and, in the center, a bishop probably belonging to the early fourteenth century.[7]

On the north side it seems likely that by 1300 the transept façade had been built up to the top with the high vaults and clerestory windows in place, but with a provisional wooden wall closing in the upper part of the façade. The existing screen of tracery and glass, including the triforium (fig. 5.1), has been inserted (with some dislocation) into already existing framing buttresses, and the forms of the stones of the triforium display multiple signs of hesitation and changes of intention on the part of the builders.[8] The tracery forms of the triforium arcade bear some similarity with the eastern nave chapels from the early fourteenth century. The upper gallery and rose are somewhat later. The five-pointed star pattern bears some resemblance to the north transept rose of Saint-Ouen in Rouen.[9] The little exterior buttresses inside the window supporting the upper rim have clearly been inserted later (the masonry is not integrated with the window tracery), and the upper rim of the window rebuilt, bearing testimony to fears about the stability of the window. The builders have not dared to install a stone gable above.

Seen from the inside, the two transept façades present opposite solutions (figs. 5.1–2). On the south side, the composition is sculptural with pockets of space enclosed between the framing arch of the rose and the last transverse arch; on the north side it is entirely flat.[10]

b) Chapter House and Cemetery: Matters of Life and Death

By the end of the thirteenth century members of the clergy had realized their long-cherished dream: a custom-designed choir to facilitate their splendid liturgical life. Still missing, however, were appropriate spaces to accommodate their *institutional* life as a corporate body, and to provide a visual expression of their hopes of eternal life after death—in other words, a properly appointed chapter house and cemetery. Regular meetings of the chapter were essential to orchestrate the liturgical life of the choir, to regulate the lives of the canons, and to address issues relating to their property and income, as well as the fabric of the cathedral.[11] During the period of major construction in the thirteenth century, such meetings must have taken place in a provisional space in the unfinished cathedral or in some nearby house in the cloister. Then, there was a need for more burial space to accommodate members of the chapter and others. In order to create a special place for the dead, the clergy wanted an architectural frame to signal the link between consecrated exterior burial ground and the choir where the relics of the saints were preserved and where the dead were commemorated in daily masses. This linkage was achieved by means of an arcaded passageway known as the cloister (*cloître*), ringing the area directly to the east of the choir where members of the clergy were buried (fig. 5.3).[12]

The two projects, chapter house and cloister, had been linked in a charter issued by Bishop Geoffroy d'Eu in 1232 when the bishop had ceded land for this purpose on the north side of the cathedral, between the bishop's palace and the old hospital of Saint John.[13] However, immediate realization of the construction project was delayed until the years around 1300—probably on account of the massive expenses involved in the construction of the cathedral itself.[14]

The cemetery cloister no longer exists—deemed in very poor condition in the early nineteenth century, it was demolished. Viollet-le-Duc reconstructed several bays (still existing) at its southern end (fig. 5.4).

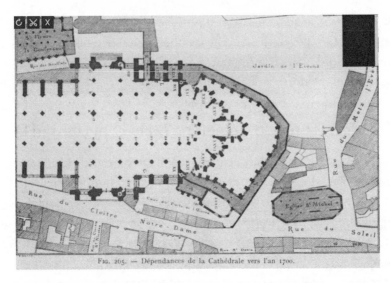

FIG. 205. — Dépendances de la Cathédrale vers l'an 1700.

FIGURE 5.3 Cathedral precinct (Georges Durand, *Monographie*)

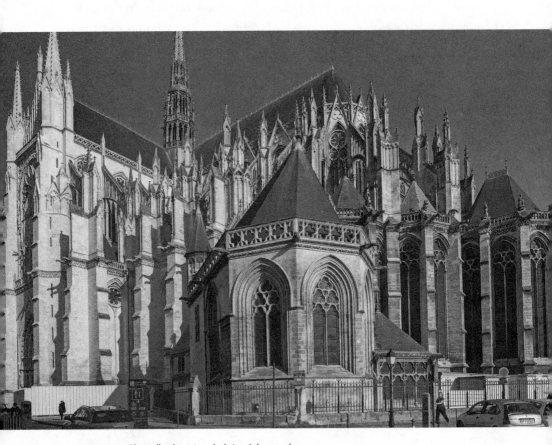

FIGURE 5.4 Chapelle des Macchabées/chapter house

Written and graphic sources indicate that it was an arcaded gallery covered with a wooden barrel vault opening inward through a tracery-filled arcade to the burial area for the canons.[15] It became known as the Cloître des Macchabées on account of a painted representation of the *danse macabre* thought to belong to the fifteenth century.[16] Access to the gallery was provided by fourteenth-century decorated doorways inserted into the chapels of Saint Quentin and Saint Eloi at the base of the hemicycle. The passage might have served the clergy as an area of solitary contemplation or for ceremonial burial processions. Perhaps it also incorporated a charnel house for storing disinterred bones. It assumed major importance in the stational liturgy of All Saints' Day.[17] Two solemn processions were undertaken in commemoration of the dead. The first one, already documented in 1291, passed out through the main portal and ringed the cathedral to the north before heading south to the cemetery of Saint Denis at the southeastern side of the city.[18] The eighteenth-century *Cérémonial* confirms that this procession was still undertaken at that time, that a station was made at the chapel founded by Dean Adrien de Hénencourt at the priory of Saint-Denis to the southeast of the cathedral, and that on reentry into the cathedral a station was made at the two bronze episcopal tombs in the nave that were aspersed with holy water.[19] Villeman also describes a second procession that actually passed through the cemetery gallery, exiting the cathedral through the northern doorway in the chapel of Saint Quentin and reentering the cathedral by the matching doorway on the south.[20]

The construction of the chapter house to the southeast of the choir also belongs to the fourteenth century (figs. 1.24 and 5.4).[21] Because this structure, which still survives, was linked with the cemetery gallery, it became misleadingly known as the Chapelle des Macchabées. Roofed with a wooden barrel vault, the simple, thick-walled structure has a rectangular body and a trapezoidal eastern termination. The window tracery with its stacked trefoils mimics the radiating chapels of the choir, completed half a century earlier. The fourteenth-century date is revealed in the moldings of the window frames, some of which have no capitals and combine rounded and prismatic forms. At the western end a wooden gallery linked the chapter house to the cathedral archive (demolished)—a three-bay, rib-vaulted, first-story structure.[22] A stone staircase led from the archive into the masons' yard. Close clerical supervision of the building enterprise, and the compiling of

the annual fabric accounts kept in the archive, would have provided a powerful link between the lives of the artisans and clergy. The little courtyard, known as the Cour du Puits de l'Oeuvre, was the logistical nerve center of cathedral construction and maintenance.[23]

c) Lateral Chapels in the Nave[24]

Another major construction operation overlapped in time with work on the upper transept façades and chapter house: in the ninety-year period between the 1290s and approximately 1380, six lateral chapels were built on each side of the nave butting up against the transept arms to the east and terminating at the western frontispiece (figs 1.16–18, 1.20, and 1.28–30).[25] This was a time of extreme economic and military distress that had begun during the period of the Franco-Flemish War (1297–1305); it is quite probable that construction was interrupted by the disastrous defeats at Crécy (1346) and Poitiers (1356), the subsequent 1356 imprisonment of King John II (known as Jean le Bon, or John the Good), and the incursion into the city of the forces of King Charles II of Navarre (known as Charles le Mauvais, or Charles the Bad).

While work on the upper transept arms was driven by the pressing need to complete the existing fabric under difficult circumstances, including incipient structural failure, the addition of the chapels resulted from the desire on the part of individuals and groups to create and occupy discrete spaces in the cathedral for purposes of burial, private devotional practice, and as an expression of personal and corporate identity.[26] Commemoration of the dead, already embedded in the common daily offices said in the choir and the cemetery cloister, signaled the presence of the corporate dead; the new chantry chapels allowed commemorative masses to be said for individuals by chaplains in multiple spaces that could be personalized in relation to the occupants.[27] In a time of fiscal distress, the clergy would welcome the gifts of lands and revenues to establish the endowments from which to pay the chaplains. Cemetery cloister and chapels both provide powerful testimony to the growing importance of the cult of the dead in the fourteenth-century cathedral.

With the addition of chapels to an already-existent nave, we should not underestimate the power of the prototype: the prestige of Notre-Dame of Paris, where lateral chapels had been inserted between the outer tips of the deeply projecting buttresses of the nave in the 1220s–1250s and around the

choir in the decades on either side of 1300.[28] In the Parisian choir it was necessary to extend the buttresses in order to provide adequate space for each chapel—this situation also applied at Amiens, where the great buttresses of the nave were extended to create the dividing walls (figs. 1.19–20).

A very different situation prevailed on each of the two flanks of the nave at Amiens. To the north was the secluded space bounded by the bishop's palace and the collegiate church of Saint-Firmin the Confessor. On this side the land falls away down to the river, and some concern had developed over the settlement of the northwestern tower of the cathedral. But the southern side offered both attractions and problems. The rue du cloître Notre-Dame ran hard along the south flank of the cathedral, and the right of full access along this important thoroughfare to the city gate was fiercely guarded by the municipality. It is likely that parasite structures had been established between the deeply projecting buttresses—*logettes* serving as lodging for artisans and boutiques for vendors of pilgrimage mementos.[29] Yet at the same time, this flank of the cathedral offered a wonderful public space for the display of devotional statuary and spectacular new architectural forms.

How can we recount the story of construction? Historians have slipped into the habit of dating a particular chapel by the year of its *foundation*. But of course, in this context the word has nothing to do with the material foundations necessary to build the space, but rather the endowment necessary to pay the chaplains—such arrangements could obviously be made in anticipation of construction or afterward. The story can only be reconstructed through the correlation of the material forms of the chapels themselves. There are three main elements to consider: the new enclosing walls; the vaults overhead; and, the most spectacular feature of the new work, the fenestration. The dedication of each chapel and the changing forms of the windows are hard to retain in the memory: see the composite rendering of all twelve windows and vaults with their identifications (fig. 5.5).

The establishment of a new outer wall was probably the first concern of the builders. It would demand deep foundations and would be more easily built in an extended stretch rather than chapel by chapel. The regularity of the coursing of the masonry suggests that the lower wall of the four eastern chapels on each side was established in a single operation. The foundation dates of the first (eastern) chapels suggest that this operation was begun around 1290 and continued into the early 1300s. The lower courses of masonry

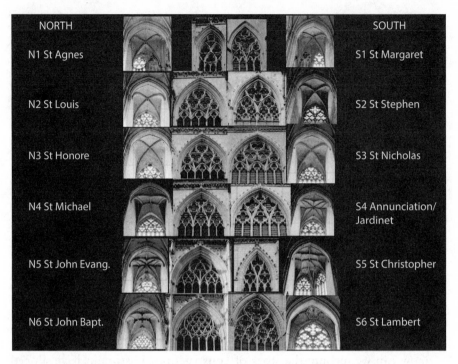

NORTH		SOUTH
N1 St Agnes		S1 St Margaret
N2 St Louis		S2 St Stephen
N3 St Honore		S3 St Nicholas
N4 St Michael		S4 Annunciation/ Jardinet
N5 St John Evang.		S5 St Christopher
N6 St John Bapt.		S6 St Lambert

FIGURE 5.5 Mapping the nave chapel windows and vaults. See also color plate.

above grade are composed of hard grey impervious limestone capped by a chamfered edge;[30] above this, the chalk masonry is laid in regular horizontal courses. The two western chapels on each side posed special problems: on the north side, additional buttressing was necessary to support the northwestern tower.[31] The written evidence provides an approximate terminus of 1380 for the two western chapels on the north. And at the west end of the south side, space was limited because of the proximity of the road (fig. 1.30).

From the form of the lower wall and the fenestration, it is easy to deduce that the first chapel constructed was that of Saint Margaret at the east end of the southern chapels, founded before 1292 by Bishop Guillaume de Mâcon (1278–1308) who wanted a special place for his burial—a highly desirable "corner office" space, as it were—in the angle between the south transept and nave (figs. 1.28 and 5.6).[32] We have already seen that prior to the tenure of Guillaume de Mâcon, the "building bishops" of the cathedral had been happy to lie in the shared space of the nave and choir: perhaps it was easier for an "outsider" to demolish the work of the legendary Master Robert de

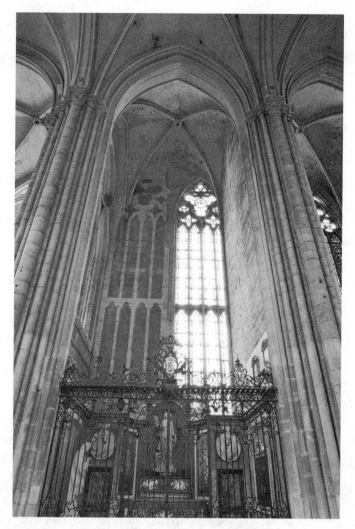

FIGURE 5.6 South nave chapel of Saint Margaret, interior

Luzarches in order to create an elite semiprivate burial space. This is the only chapel where the western edge of the exterior wall is defined by a buttress: square-set at the bottom, but continuing upward into a diagonally-turned square, providing a precarious niche for the statue of the founding bishop (figs. 1.28 and 3.6). Also, this is the only window with a severe, undecorated exterior frame.[33] The simple quadripartite form of the vault and the fat, rounded profile of the ribs also sustain the notion of an early date.

An inspection of the rib profiles in the nave chapels reveals the coexistence of two broad types: rounded and prismatic, the former with a central flat-nosed rounded fillet and the latter with simple angular front surfaces. In principle, the rounded form is older and we find such a rounded rib profile in the Saint Margaret chapel and in the adjacent chapel of Saint Stephen, suggesting that the two were built in quick succession, both with simple quadripartite vaults.[34] However, the Saint Stephen window is quite different with an exterior frame strewn with foliage and gathered into a tightly pointed tip or *ogee* at the top (fig. 1.28). The tracery forms of the first two chapels lie well within the tradition of Master Renaud de Cormont, but with the addition of a novel feature—a horizontal bar or *transom*—suggesting links with architectural practice in England and the Low Countries.

The two matching chapels on the north side came very soon after the Saint Margaret chapel (fig. 1.17). The first (easternmost) chapel, dedicated to Saint Agnes, was founded in 1296 by Drieu Malherbe, mayor of Amiens in 1292, and his wife Marie; and the second, dedicated to Saint Louis, by Bishop Guillaume de Mâcon, soon after the canonization of the king in 1297.[35] Chaplaincies were established there in 1302 and 1305. Both chapels have simple quadripartite vaults, now with prismatic profiles and windows where the leaf-strewn enclosing arch is capped with an ogee.

The window tracery of the Saint Louis chapel introduces an important new design principle (figs. 1.17 and 5.5). In all the previous windows in the cathedral, the decorative tracery had been organized around geometric units (pointed arches, roundels, quatrefoils, trefoils, etc.) that were enclosed by, but geometrically independent of the enclosing arch of the window frame. With the new approach, elements of the tracery picked up the same geometry as the frame: thus, we see three pairs of lancets, with the side units defined by arches formed by the same curve as the window frame.[36] The upper oculus becomes much smaller than in older windows. The design must have been considered a smashing success since it was reproduced in the adjacent chapel dedicated to Saint Honoré on the north side, and in the matching chapel on the south dedicated to Saint Nicholas—this is the only tracery pattern repeated three times in the nave chapels (fig. 5.5).[37] Both chapels (Honoré and Nicholas) have quadripartite vaults and prismatic rib profiles, and were constructed at the same time at a date in the early fourteenth century.

The tracery/frame unifying principle was brought a step further in the next chapels (Saint Michael on the north, and the Annunciation on the south) where six lancets are grouped into three double units by enclosing arches that echo the geometry of the frame.[38] These chapels are covered by different types of *lierne* vault—the Annunciation, probably the earlier, has a "classic" interpretation; but its partner to the north, Saint Michael, has omitted the main ribs (fig. 5.7).[39] The earlier unit reverts to rounded-profile ribs; the latter has prismatic tiercerons and rounded liernes.[40]

FIGURE 5.7 South nave chapel of the Annunciation, interior

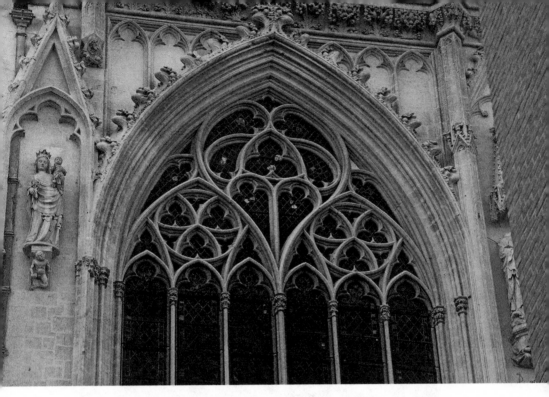

FIGURE 5.8 North nave chapel of Saint John the Evangelist, exterior

A lapse of time ensued before the completion of the last chapels, two on each side. The last two chapels on the north—together with the elaborately decorated Beau Pilier that helped consolidate the north tower—were commissioned by Jean de la Grange, bishop of Amiens (1373 to 1375) and then cardinal (d.1402) (figs. 1.18, 5.8, and 5.9). The eastern chapel was dedicated to Saint John the Evangelist, and the western one to John the Baptist. The foundation of the chaplaincies took place soon before 1375. The window frame in each chapel is still strewn with leaves, but above it we find vertical paneling in the English "Perpendicular" manner. The window tracery of the eastern chapel is crowned by a composition formed of double-curved tracery. The heart-shaped motif[41] shares the same frame as the two panels below; at the center is a spherical triangle enclosed by six interlocking paisley-shaped motifs or *mouchettes*. This window provides the first coherent expression at Amiens of the double-curved forms of *Flamboyant*.[42] After this bold statement we find something of a retrenchment: in the last chapel on the north side, the designers revert to a geometrically organized hierarchical composition: a

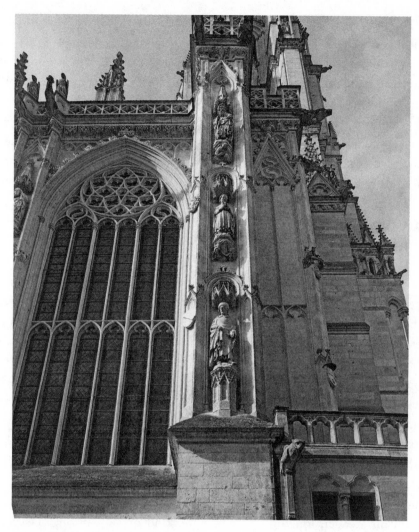

FIGURE 5.9 North nave chapel of Saint John the Baptist and the *Beau Pilier*

great upper oculus filled with a dense composition of spherical triangles and squares (figs. 5.5 and 5.9) Double-curved motifs (*mouchettes*) are present but muted. Both chapels have variations on the lierne vault with very conservative rounded moldings. The window tracery also features conservative rounded moldings and generously sized bases.[43]

The last two chapels on the south side do not fit into a simple story of east-to-west construction and progressive modernization. A sharp break

in the masonry of the lower wall suggests a delay before work started on the next chapel, dedicated to Saint Christopher. A requiem mass was founded in 1390 by a citizen of Amiens, Enguerran d'Eudin: an image of him featured in the glass of the chapel indicates his presence (fig. 1.30).[44] The window tracery of this chapel brings an interesting variant on the "Y" mullion type and a novel kind of gabled transom. The aggressively prismatic moldings of the window frame and mullions are the most advanced of any of the chapels. The unusual coffered vault was improvised to fit the irregular shape; the rib profile is prismatic. The western wall of the chapel, which carries a colossal statue of Saint Christopher, is canted inward and brings the outer wall to the same level as the original nave buttresses.[45]

The last chapel, dedicated to Saint Lambert (Fig. 1.30), is raised aloft above a porch protecting the exquisite little portal into the western bay of the southern nave aisle. There is no written evidence to indicate a date.[46] The façade of the porch with its gable and flanking pinnacles bears a strong resemblance to the tomb of Bishop Simon de Gonçans (d.1325) in the axial chapel.[47] It is probable that the porch was begun in the first decades of the fourteenth century at a time close to start of work on the chapels. The design of the tracery pattern of the upper window must have been made early, since it closely resembles that of the second southern chapel of Saint Stephen. But that the actual manufacture and installation were delayed is indicated by the streamlined forms (limited use of capitals) of the window frame and mullions. The very unusual coffered vault is rendered with a complex angular rib profile.[48]

But my reader, longing to reach some kind of conclusion, may grow weary of my story laden with architectural description—what is the "big picture" here? It is tempting to associate the start of work with the lower wall of four chapels laid out on either side with the tenure of Bishop Guillaume de Mâcon and the relative peace of the years before Crécy, Poitiers, and the Treaty of Bretigny; and the last two chapels on either side with the period thereafter.[49] The middle chapels of Saint Michael and the Annunciation, with their lierne vaults and matching windows, were probably begun (lower exterior wall) in the first period but finished (vault and window) in the second.

Notre-Dame of Paris, while it might have initially inspired the addition of chapels, did not provide the architectural model for the vaults and windows—this is most obvious in the complete absence of gables in the exterior walls of the Amiens chapels where the foliate window frames point to an internal model—the arcade of the cathedral jubé.[50] The use of the transom; lierne vaults; the geometric unification of window frame and tracery; and double-curved forms, on the other hand, all point to parallels in the North—both England and the Low Countries. Well-established trade and commercial links associated with the textile trade may have been more powerful than the attraction of the architectural forms of the churches of the French capital.[51]

The Amiens nave chapel architecture is full of contradictions. The project was essentially destructive, yet care was taken to preserve a key element of the old order: the dado that had run along the old outer wall of the aisle was modified and reinstalled at the base of each of the new chapels. The work on the windows is highly refined, yet the clumsy dividing walls crash into the old buttresses with little attempt to improvise a proper liaison. This, coupled with the possibility of inadequate foundations, has caused some of the new chapels to pull away from the old buttresses, leaving ugly cracks.[52]

The project had an essentially elitist character, providing semiprivate space for favored individuals—Bishop Guillaume de Mâcon, Mayor Drieu, Cardinal Lagrange—yet it also provided communal space for the woad merchants (Saint Nicholas) and the bakers (Saint Honoré).

Georges Durand thought he saw progressive modernization in architectural forms as work advanced steadily from east to west. The careful student may be surprised to find the reappearance of rounded rib profiles in the last chapels founded by Cardinal Lagrange where the articulation of the elements of fenestration (mullions and bases) also looks old-fashioned. The geometric tracery of the window of the chapel of Saint Lambert mimics a window that was at least half a century older. But the most surprising chapel is that of Saint Christopher where the constraint created by the need to pull the line of the southern chapels inward led to the odd shape with the angled wall. Yet the result was a uniquely beautiful interior space, while the angled exterior wall bearing the great statue of the saint provides one of the most memorable features of the cathedral (fig. 1.30).

d) Upper Western Frontispiece and Towers[53]

Initial work between the 1220s and 1240s had brought the west façade to the level above the rose window, including the lower belfries, but had left the triforium and kings' gallery unfinished: these elements were added to in the years toward 1300 (fig. 1.32). The arcade of the kings' gallery completed at this time was capped with little gables, whereas the original intention, embodied in the panels of the gallery attached to the four great buttresses, involved a trefoiled foliate frame. Viollet-le-Duc felt free to remove the old gabled arcade and "restore" the "original" type of foliate arcade.[54]

The upper level of the two western towers was not yet in place. Work already under way on the towers was suffering from an acute lack of funds when in 1366 Bishop Jean de Cherchemont promised half the income that he had been receiving from taxes (*tailles*) derived from episcopal estates to provide funds for the construction of towers.[55] The south (lower) tower was the first constructed—it was probably finished by the time of Bishop Jean de Cherchemont's death in 1373. The taller northern tower came next, during the episcopate of Jean de la Grange and Jean de Boissy.

e) Grave Danger: Crisis in the Plot

We have seen that deformation had begun to occur in the crossing area of the cathedral even as the original work of construction was still under way in the 1250s.[56] By the fifteenth century the alarming symptoms of potential imminent collapse could no longer be ignored: gaping cracks in the masonry of the arcade wall resulted from the buckling of the crossing piers at arcade level.

In March 1497 two crucially important meetings took place, providing a vital key to understanding both the human structure of the fabric and the physical structure of the cathedral itself. *On the fourteenth day of the month of March, 1497, on the orders of my lords, the dean and chapter of the church of Notre-Dame of Amiens, a visit was made to the said church by Master Colart de Haudrechies [master mason], Master Pierre Tarisel [master mason of the king, the city and the cathedral of Amiens], and Master Pierre Blancregnier [master carpenter of the cathedral] in the presence of my lord the dean of the said church [Adrien de Hénencourt], my lord*

Vualequin [canon and cellarer], Master Pierre Dumas [canon and master of the fabric], and several others of the said chapter.[57]

What was the problem? The inspection revealed that *the four principal pillars of the crossing of the church on one side and the other are bent and bowed through the thrust of the first [i.e. aisle] vaults, and even the bays of the [arcade] walls contiguous with the said pillars are broken and gaping because of the said thrusts [bouttures]; and similarly the said bays of the walls are broken on the side toward the great portals of the nave and in the said transept of the church at a similar height. For this reason, it seems to the people named above that it is necessary for the welfare and security of the church, so that the masonry cannot open up or deteriorate further than it is at present, that the said pillars should be tied [literally: anchored] at the height of the pavement of the passageway of the covered passages [i.e. the triforium] of the said church, and that the said ties should be of Spanish iron of a good thickness and tensioned in such a way that they can resist and hold together without allowing the said masonry to stretch; and for this it is necessary to pierce the pillars with holes to install the said ties everywhere appropriately.*

The roots of the problem defined here should be traced back to the initial vision of the cathedral articulated by Master Robert de Luzarches in a similar meeting of the fabric committee nearly three hundred years before. Robert's plan envisaged a relatively thick arcade wall supported atop slender, widely spaced piers. This would not necessarily cause a problem in a continuous line of arches where the thrust of each arch was met by the equal thrust of the adjacent one. But at the intersection of the transept, two such arches joined at a ninety-degree angle at the crossing piers and were met by no counter force. In addition to this, the arcade arch adjacent to the crossing was wider than the others: the bigger arch would generate a greater thrust. The mass of the crossing piers, which also supported the central steeple, was not adequate to sustain such a load: the diagonal movement of the piers inward had allowed the adjacent arches to open and great cracks to form: this is particularly evident on the southeast side (fig. 1.57).

In other words, the very planning strategy devised by Master Robert de Luzarches that produced the dramatic spatial configuration of the center of the church, the heart of lay participation in the liturgy, was also the cause of structural crisis and near disaster.

From our written sources we have learned that the members of the fabric committee were perfectly aware of the dynamic behavior of Gothic structure, and that they had the vocabulary to define and to discuss it.[58] Particularly interesting is the use of the word *boutture* to designate force that we call *thrust*.[59] Our text also provides confirmation of the essentially democratic nature of the Gothic building business. Members of the fabric committee must have been dismayed at the complexity and expense of the task. It would be necessary to drill a hole in each of the piers at the level of the triforium sill (including the massive crossing piers) to allow eight chains to pass through and be extended on each side of the nave, the choir, and the transept arms. In such a context, disagreements might occur: at Amiens the artisans felt that in order to avoid expense the retaining ties might be made of great oak beams linked together by iron plates attached to each end.

A second meeting took place soon afterward in the choir on March 25, 1497, summoned by Dean Adrien de Hénencourt, with an even wider representation of interested parties. The meeting was attended by the master of the fabric, Pierre Dumas; a leading member of the chapter, Robert de Cocquerel; the royal provost; several aldermen (including one from the nearby city of Abbeville); a number of artisans, including the master mason, Pierre Tarisel; the carpenters Pierre Blancregnier, Jean Messier, and Jean le Carton; and two ironworkers. *Having seen and considered the cracks in the four principal pillars and in the [arcade] walls contiguous to the said pillars that support the crossing of the said church, [they] were of the opinion for the benefit and maintenance of the entire church that the said four pillars should be tied with good Spanish iron: no other kind of iron, nor wood. That is to say, [the ties should extend] from each of the said pillars to the outside of the church on all sides of the said pillars.*

In the years immediately following, eight chains (total length of about 300 meters) were installed. Each was composed of long bars of iron (average length 4 meters; average thickness of about 0.04 by 0.08 meters) forming a band that ran the length of the triforium of the nave, choir, and transept arms (fig. 1.58).[60] The lengths of iron were probably forged with a hydraulic hammer, perhaps driven by the waters of the Somme in one of the mills in the northern part of the city. The ends of the chains were tied by means of crosspieces anchored in the crossing piers and in each of the extremities of nave, transept, and choir.[61] Once the full length of the chain was extended and fixed at both ends (work proceeded from the crossing outward to the

extremities of the building), iron wedges were driven in at each link to ensure tension and the chain was pegged to the floor of the triforium, just as defined in the text. Recent testing of the iron has revealed that although the experts had recommended the use of "Spanish" iron (meaning iron of the highest quality), the chain is actually forged of standard locally produced iron. The chain seems to have ensured the stability of the edifice, although there are currently some concerns about the stability of the south transept arm.[62]

In 1503, only six years after the meetings that determined the installation of the chain, further problems were diagnosed as a result of the work of Robert's two successors, Thomas and Renaud de Cormont. Once again, we have a most informative text: *Visitation made on April 26, 1503 to the church of Notre-Dame of Amiens on the orders of my lords the dean and chapter of the said church by the master artisans of the said church—that is, Master Pierre Tarisel, master mason of the said church; Jehan le Pruvost, master mason of the church of Corbie; Nicolas Lesveillié, master mason of the works of Saint-Riquier; Pierre Blancregnier, Jehan le Messier and Jehan Carton, carpenters—present for this and deputized by my said lords and masters Jehan Dumas [master of the fabric], and Jean Fabus and Robert de Coquerel, canons. And first, the said masters and artisans say that it is appropriate and necessary to repair the two pillars in the choir on the left [north] side of the said church next to the pillar that has been repaired beside these two pillars. That is to say, the transverse arches and ribs inside the said choir, for the support of the vaults and outside it is necessary to make at each of these pillars a flying buttress of the same fashion and form as has been done for the said pillar that has been repaired; and for this it is necessary to raise up and install the great crane in order to repair the said pillars and for the support of the said vaults . . ."[63]*

Thus, our text has documented problems with certain pillars on the north (left) side of the choir: interior work is to be to be done on transverse arches and ribs, and exterior work on the flying buttresses at the same pillars. The text heralds the major campaign of repair and reconstruction conducted on the flying buttresses of the choir in the first decade of the sixteenth century.[64] The openwork flyers installed around the choir by Renaud de Cormont around 1260 were too light in weight and placed too high to meet the thrust of the high vaults: the upper piers were bulging outward at a point below the level of the head of the flyer.[65] No written text survives to document the completion of the new flyers around the choir, but we can reconstruct the procedure

from the form of the rebuilt flyers (fig. 1.66). In each bay a substantial lower flying buttress was inserted just below the original openwork flyer—the new unit would meet the outward thrust of the high vaults. It was then possible to demolish the openwork unit, one flyer at a time, without danger to the stability of the upper choir. The tracery panels of the old flyers must have been damaged by the sheering caused by their settlement: once demolished, the old flyers were reworked through the insertion of new elements and the refurbishing of old elements, and then reinstalled using the lower flyer as centering. This explains why we see both geometric and double-curved tracery side by side—the former reused from the original work of Renaud de Cormont, and the latter representing the new work of Pierre Tarisel.[66]

In addition to his supervision of the installation of the great iron chain and the rebuilding of the choir flyers, three other most important works can be attributed to Master Pierre Tarisel. The massive uprights (culées) of the flying buttress on each side of the nave have clearly been rebuilt at a date in the late fifteenth or early sixteenth century (fig. 1.61). The new diagonally-set pinnacles differ sharply from the original units capped by a square pinnacle atop a square-set paneled base as seen in the surviving units in the angles of the transept arms and nave on north and south sides. The rebuilt buttresses lend the jagged look of Late Gothic to the exterior of the nave. But beyond this aesthetic objective there may have been structural concerns reflected in another passage of the same 1503 document quoted above: *Item, the artisans say that it is necessary to demolish certain tops of the pinnacles or spines (espis) of the pillars of the cleresvoies together with certain columns placed on the exterior of the towers of the said church and several other places above the said church in order to avoid the problems that could occur if the said columns or pinnacles buckle or collapse.* While this text is ambiguous, the reference to the towers suggests that the work was in the nave: the only clear evidence of rebuilding is in the pinnacles of the nave culées as described above.

Two more major features of Amiens Cathedral were probably the work of Pierre Tarisel: the Flamboyant rose windows of the south transept and the western frontispiece. The visiting experts whose recommendations were recorded in the deliberations of the chapter on April 28, 1503 had noticed cracks in the south transept close to the great rose window, which was subsequently repaired (figs. 3.27 and 5.2). The design can be related to a series of

contemporary rose windows, especially the north transept rose of Limoges Cathedral, the north transept of Auxerre Cathedral, and the west rose of the nearby church of Abbeville. In each case the petals of the rose are formed of leaf-shaped units or *soufflets* radiating from the center, enclosed between two paisley-shaped units or mouchettes that nod together. The Amiens south rose has six such units, which are quite narrow and sharply pointed: the similar roses designed by the greatest architect of French Late Gothic, Martin Chambiges (Sens Cathedral, south transept, c. 1500; Troyes Cathedral, c. 1530; Beauvais Cathedral, c. 1530), are much more rounded.[67] The web of tracery in the Amiens south transept is denser than its immediate prototype, the Sens Cathedral south transept rose (c. 1500), offering more resistance to wind buffeting and deformation. Tarisel also reworked the interior masonry framing the rose (with the deep concave molding studded with schematized roses) and rebuilt the last (southernmost) transverse arch of the high vaults.

The four-petal west rose is a little more open in its composition: the arms of Canon Robert de Coquerel (d. 1521) are set in the sculptured shield set at the center of the rose and in stained glass panels (fig. 3.28).[68] It seems appropriate that this great rose, which speaks the common language of Late Gothic and whose stained glass celebrates the union of the city of Amiens and the kingdom of France, should constitute one of the principal markers of the end of the life of the Gothic cathedral.

f) Refurbishing and Embellishing the Choir and Transept, c. 1490–c. 1530

As the work on the consolidation of the crossing piers and upper choir was under way, the clergy began a vast new project—the refurbishing of the furniture and liturgical equipment of the choir and sanctuary. It is an astonishing testimony to the confidence and abundant resources of the clergy: while redressing these pressing structural problems, and under the threat of damage from falling stones and debris, they simultaneously began work on the installation of sumptuous furnishings directly below—the sculptured screens that enclosed the sides of the choir (*clôtures*) and the wooden stalls of the clergy. What was the driving force? Certainly, it was the dean, Adrien de Hénencourt, motivated not only by the need to save and embellish his beloved cathedral, but also to redeem his family name.

i) Lateral Choir Screens or *Clôture*, c. 1489–c. 1531 (Figs. 5.10–13)[69]

At a date close to 1489, Dean Adrien de Hénencourt initiated a project to enclose the north and south sides of the liturgical choir with new stone screens lavishly adorned with "virtual reality": three-dimensional narratives telling the stories of Saint Firmin (south side) and John the Baptist (north side). The new screen was intended to serve multiple purposes. At the most practical level, it masked the back of the wooden choir stalls that accommodated the clergy during the Divine Office. Although the original choir stalls must have been established around 1260–1270 when the choir was first occupied by the clergy, by 1500 they were considered inadequate and old fashioned, and the clergy began to plan a new installation. Second, the

FIGURE 5.10A Lateral screen of the choir, south side, arrival of Saint Firmin; preaching. See also color plate.

sculptural cycles set into the screens were intended to reinforce and extend stories of the saints already recounted in the northwest portal, pulling visitors and pilgrims forward toward the east in their quest for closer contact with the relics of John the Baptist and local saints—indeed, the cult of Saint Firmin the Martyr was more popular than ever. But perhaps most pressing was the dean's desire for an appropriate burial place for himself and his uncle Bishop Ferry de Beauvoir (figs. 3.8–9), who, it will be remembered, had been disgraced because of his association with the Burgundian cause.

The story of Saint Firmin's arrival in Amiens, and his subsequent ministry and martyrdom, unfolds in a series of four deep niches each framed by delicate supports painted to look like marble with pointed arches capped by characteristic Late Gothic curved gables (fig. 5.10). The composition is

FIGURE 5.10B Lateral screen of the choir, south side, Saint Firmin baptizes; he is arrested and executed. See also color plate.

crowned by lacy vertical openwork panels through which the tips of the gables and the upper parts of the supports penetrate in a series of triumphant flourishes. Occupying the niches are *tableaux vivants* where lively, vividly painted sculptured figures carved in stone occupy a narrow stage in front of illusionistic city spaces created by a painted background.[70] Underneath each scene is painted a two-line verse that equips the visitor to recount the story of Saint Firmin lying at the root of the life of the cathedral in the city. Intoned by an interlocutor, the tale might be performed for an audience of pilgrims: the equivalent of liturgical drama. On the saint's commemorative feast days candles were lit in the choir aisle to illuminate the sculpture.

In the westernmost bay above the tomb of Bishop Ferry de Beauvoir, Saint Firmin makes his first entry into the city of Amiens where he is welcomed by Senator Faustinian and a crowd of local people (fig. 10a). The mode of representation is hyperrealistic: the twin-towered city gate projects from the illusionistic space of the niche into the real space of the viewer. The saint wears the garb of a fifteenth-century bishop: a golden-red cope, a white alb, and gold miter. His gloved hand grasps his bishop's staff or crozier. He is greeted by the courtly senator who is accompanied by a crowd that includes all kinds of individuals, some looking quite rustic (but caution: many of the heads were replaced in the nineteenth century). Most important, the scene is set in fifteenth-century Amiens: in the painted background we recognize our city walls to the southwest where the Porte de Beauvais was located. Affixed to the gate are the fleurs-de-lys of France celebrating the recent reunion of city and kingdom. We can also see city houses, the church of Saint-Nicolas, and the *chemin de ronde* of the surrounding wall, beyond which is a great, unfinished church that has been identified as the monastery of Saint-Jean. Beside the city gate, projecting into our space, the donor, Adrien de Hénencourt (head replaced), identified by his insignia, kneels in prayer. His motto winds around the supporting column. It would be hard for even the unlettered visitor to miss the link between Saint Firmin, bishop and patron of cathedral and city, and Bishop Ferry de Beauvoir, once disgraced but now rehabilitated through this visual association with the founding bishop. And that link was facilitated and realized through the patronage of the bishop's ever-industrious and resourceful nephew, Adrien de Hénencourt. Time is collapsed and the liturgical celebration that

took place each year on October 10 is animated through the simple but most effective strategy of locating a story of third-century happenings in a fifteenth-century city.

The central role of the bishop is further developed in subsequent scenes as the story unfolds. The job of a bishop is to convert the people, to preach, and to baptize. This is exactly what we see here with Firmin in an elevated silk-draped pulpit, while in front is a mixed assembly: men, women, and children respond in different ways—some listen intently, some seem astonished, while others debate his message. Once again, the painted background shows us contemporary Amiens, now looking to the west, including the church of Saint-Firmin-à-la-Porte, the western gate of La Hotoie, and the great tower (le Beffroi) expressing the authority of the commune.

Bishops baptize: this is emphatically shown in the next panel (fig. 10b) where Firmin baptizes the noble lady Attilla, wife of Agrippinus. Others gather around and begin to remove their clothes in preparation for baptism. The rustic types characteristic of the first panel (the Arrival) have disappeared. Our view over the city swings northward, revealing the church of Saint-Sulpice and, beyond the city walls and gates, the landscape (with windmill) to the north of the city.

Savage faces reappear in the next scene showing the arrest of Saint Firmin at the behest of the Roman officers Longulus and Sebastianus. The most remarkable feature of this scene is the view to the east—we have climbed a tower in the western part of the city (possibly the church of Saint-Germain) and are looking over the rooftops to the western frontispiece of the cathedral. We see the new west rose, replaced in Flamboyant style soon after 1500. To the right (south) of the cathedral, the churches of Saint-Nicolas-au-Cloître and Saint-Martin-aux-Jumeaux are readily recognizable. The execution of the saint is thrust forward into our space in front of a tower, surely intended to represent the Beffroi where the city dungeon was located.

We are now in the second bay of the choir where Dean Adrien de Hénencourt chose to locate his tomb and effigy directly underneath the story of the miraculous discovery (invention) of the lost body of Saint Firmin (fig. 11a). Having been led to the cathedral in virtual reality, we are now allowed to enter and see Bishop Sauve and his people in prayer in church space, as they beg for guidance in their quest for the lost body of Saint Firmin. Whereas the church space of the bishop's prayer is generic, the

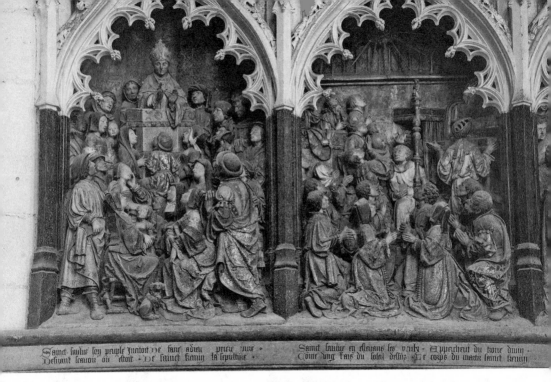

Saint sauueur soy peuple inuitoit de faire adou prier nue ·
Destrant leauou ou choir · De sainct firmin la sepulture ·

Sainct sauueur en elleuans ses yeulx · Apparebent du cione diuin ·
Come vng rais du solel deslus · Le corps du maint sainct firmin ·

FIGURE 5.11A Lateral screen of the choir, south side, Bishop Sauve prays for revelation of location of the body of Saint Firmin; the location is revealed. See also color plate.

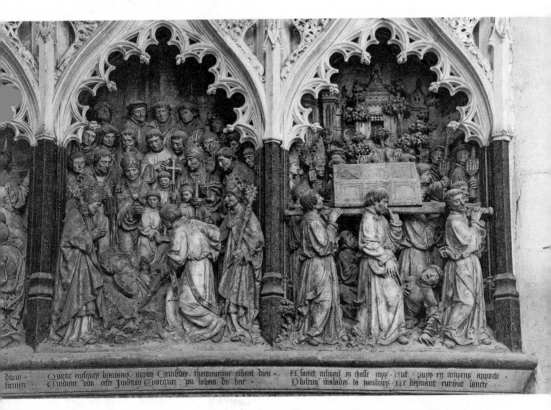

diuin · fumin ·

Quelle richesse beaulnis ncroy Cambray thresmeune aidant dieu ·
Tindient dou ceste Inuiehon Euocquez pu louua du bar ·

El sainct nchoril en chalse mys · Hut / puys en ampens apporte ·
Plusieu malades la saulups · De depriant curou saute ·

FIGURE 5.11B Lateral screen of the choir, south side, discovery (*Invention*) of the body of Saint Firmin; the *châsse* containing the relics is carried back into the city (*Translation*). See also color plate.

revelation of the location of the lost tomb is specifically placed in front of the principal altar—we have entered the sanctuary. The main altar of Amiens Cathedral was, indeed, surrounded by columns and veiled with a curtain, just as depicted in our scene. Bishop Sauve is directly in front of the altar: looking up, he sees radiant light. The burst of light (once brilliantly gilded) is placed in front of a generic Flamboyant window. Dean Adrien de Hénencourt, depicted in the tomb effigy below, participates forever in the miraculous illumination (fig. 3.9).

The opening of Saint Firmin's tomb is also placed in church space—here we are in the church of Saint-Acheul to the east of Amiens where the saint had been buried (fig. 5.11b). The episcopal theme, recurrent throughout the story, here reaches its climax with no less than four bishops, all robed, participating in the exhumation of a fifth bishop: Saint Firmin.

Finally, in the most forward-moving scene of all, six acolytes bear the gilded châsse containing the body of Saint Firmin forward toward the city gate, while all around trees come into leaf and infirm people, seen below, are healed. The pilgrim, having already seen the image of the châsse, by taking several steps forward could look through the lateral door of the choir to see the real thing glittering at the center of the relic gallery above the main altar.[71]

This story has done four things. First, it has confirmed the essential role of the bishop as one who preaches, converts, baptizes, and prays, and it has emphasized the continuing presence of the bishop (and the good dean) in the cathedral. Second, it has projected essential milestones of the liturgical year and its celebrations beyond the confines of the choir for the consumption of laypeople. October 10, the day of Firmin's entry, and January 13, the day of the discovery of his relics, remain the principal feasts in the calendar of Amiens Cathedral, together with the September 25 date of the saint's death. The vividly hyperrealistic images echo the dramatic liturgical recreations of the miraculous events of the past. The treatment of urban space is systematic as our view shifts from southwest, to the west, to the north, and finally to the east. We exit the city to the east and find ourselves in the church of Saint-Acheul; we then reenter Amiens by the eastern gate, the Porte de l'Arquet—location of the miracle of Saint Martin and the beggar. And, finally, in addition to rehabilitating a disgraced bishop, the screen has provided an appropriate resting spot for our dean.

Returning to our notion of "bookends" for the life of Gothic cathedral, the sculpture of the screen has introduced dynamic movement and life into the story as already told in the somewhat stilted images of the tympanum of the north portal of the west façade. While the founding dean, Jean d'Abbeville, had expressed his devotion through the foundation of the chapel of the Conversion of Saint Paul (behind us on the east side of the south transept)—an event that was, of course, mediated by a vision of blinding light—the last great dean of the Gothic cathedral will forever witness the guiding light of the Saint-Firmin miracle.

Work on the southern screen was still not complete in 1527 when Dean Adrien de Hénencourt made his last will and testament, specifying that he was to be buried below the scene of the Invention of the relics of Saint Firmin. The Saint Firmin narrative was probably complete in 1531, one year after the dean's death. The dean's tomb effigy (*gisant*) was done by Antoine Anquier, a local man, who probably also worked on the Saint Firmin narrative in the panels above. Cartoons for the sculptured images were made by the painter Guillaume Laignier, the polychromy applied (appropriately) by Pierre Palette, and the ironwork of the protective grill by Jean Parent, locksmith (*serrurier*).

THE SAINT JOHN THE BAPTIST STORY (FIGS. 5.12–13)

While on the south side the patronage of our dean is certain, for the northern screen we are less well informed—the antiquarians of Amiens tell us that individual canons from local wealthy families (the Louvaincourt and Cocquerel, for example) provided the funds. The story of Saint John the Baptist depicted in the eight niches was derived from the *Aurea legenda* (*Golden Legend*) compiled by Jacobus de Voragine, from the *Postilla* of Nicolas of Lyra, and perhaps also from mystery plays. Compositions are simpler and less dynamic than in the earlier Saint Firmin scenes, generally dominated by a pair of balanced figures or a single central one. In the westernmost bay on the north side, corresponding to the scenes of the arrival and public mission of Saint Firmin on the south, we find four scenes of the public life of John: preaching, baptizing Christ, being questioned as to his identity, and announcing the identity of Christ (figs. 5.12a–b). In all four scenes there is a powerful central figure, and the last scene matches the first. Whereas local viewers of the Saint Firmin scenes could locate themselves in

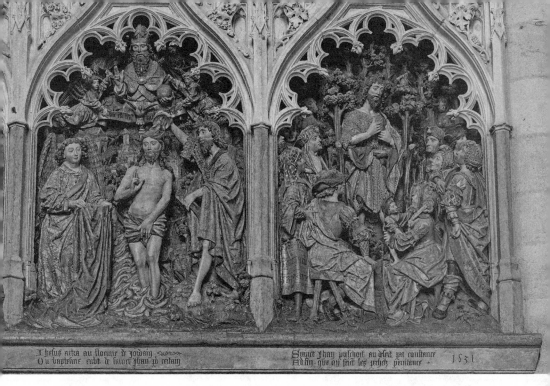

Ihelus entra au flonnie de jordain
Ou baptefine eubt de lainct Jhan jo retain

Sainct Jhan prelchoit au delert zat conltance
Adfin que on fien les gethech penitance — 1531

FIGURE 5.12A Lateral screen of the choir, north side, John the Baptist preaching; John baptizes Christ. See also color plate

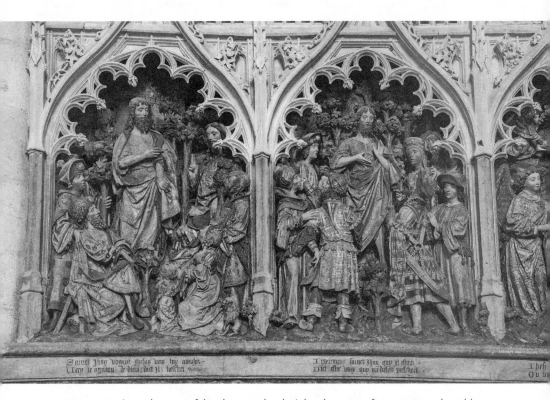

Sainct Jhan voyrut Ihelus vers luy maxche
Clery le agneau de dieu (dict il) lurechet

Interrogue lainct Jhan quy il eltoit
Dict eltre voix quy au delert prelchoit

Ihelu
Ou ti

FIGURE 5.12B Lateral screen of the choir, north side, John, the voice of one crying in the wilderness; he reveals the identity of Christ. See also color plate.

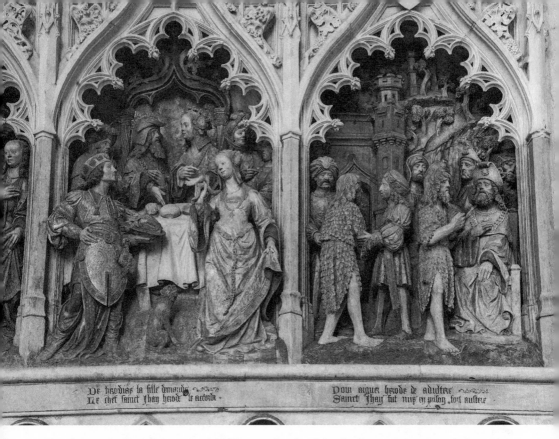

DE herodias la fille demande
Le chef sainct Jhan herode le accorde ·

Dom aigues herode de adultere
Sainct Jhan fut mis en prison fort austere

FIGURE 5.13A Lateral screen of the choir, north side, John is thrown into prison; Herod's feast. See also color plate.

their own beloved city of Amiens, here with Saint John the Baptist we are in a frightening faraway place, thickly forested and inhabited by beasts. Exotic costumes provide an "oriental" flavor.

In the second sequence of four scenes depicting the imprisonment and decapitation of John, pictorial structures are a little more complex but some level of symmetry continues (figs. 5.13a–b). The first scene (imprisonment) rhymes with the third (decapitation)—both have an architectural background intended to convey the space of the prison. And the second scene (Salome's dance) matches the last (the Baptist's head placed upon the table and stabbed). As with the Saint Firmin sequence on the south side, here, on the north, medieval visitors or pilgrims could hardly miss the point. Just as the decapitation of Saint Firmin takes place in our space on the southern screen, so the headless body of the Baptist lurches alarmingly out, almost toppling out of the frame on top of us. And when we reach the

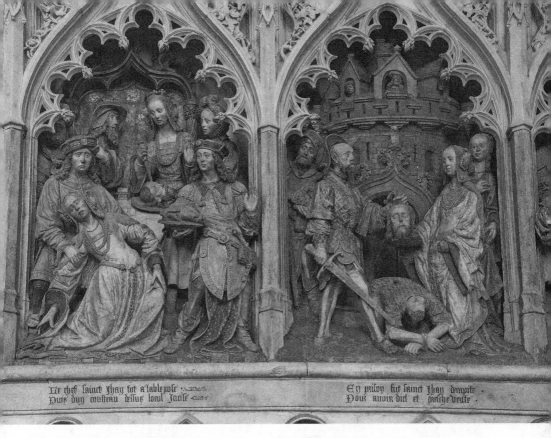

FIGURE 5.13B Lateral screen of the choir, north side, execution of John; the head of John is stabbed with a knife. See also color plate.

dreadful scene of the stabbing of the head we are right opposite the door—reworked in the fifteenth century—opening to the staircase of the upper chapel where the precious relic was kept. And the veracity of the relic has been "proven" by the story of the stabbing of the head: the Amiens head has just such a puncture wound over the left eye.

ii) Embellishment of the Transept

The monument conceived for the tombs of Ferry de Beauvoir and Adrien de Hénencourt, which also carried the story of Saint Firmin, must have been considered a great success since very similar projects were soon undertaken on the west side of each transept arm.

The transept screens, like the choir clôtures, were partly intended to mask an uncomfortable transition (figs. 5.14–15). With the fourteenth-

century addition of the nave chapels, the glass of the west-facing window of each transept arm had been knocked out, leaving in place the bare tracery of the old window. Also left in place was the old dado of the lower wall forming the base of two new monuments, each of which, like the screens of the choir aisles, was formed of four *tableaux vivants* set in niches framed by Flamboyant tracery.

Whereas the creators of the lateral screens of the choir (completed over a period of around forty years) were obliged to continue, bay by bay, the original architectural scheme in order to retain continuity and coherence, here, in the south transept, the architectural forms are more adventurous (fig. 5.14). The enclosing arch of each panel nods forward toward us, and in the two outermost panels a central *baldachin*, or canopy, projects beyond the frame. Most interesting is the new form of cusping in the two central panels: the emphatic vertical lines that form the panels of the upper screen project through the enclosing arch as vertical pendant cusps. This motif was the signature of France's most prolific master mason of Late Gothic, Martin Chambiges, who had worked closely with the amiénois master, Pierre Tarisel.[72]

The story of Saint James told in the screen has been taken from the pages of the *Golden Legend*. We first see James as he is preaching (echoes of Saint Firmin and John the Baptist) and countered by the sorcerer Hermogenes, who sends his disciple, Philetus, to oppose the Apostle. Philetus, converted by James, is struck down by his former master (panel two), but cured by contact with the Apostle's kerchief. Hermogenes sends demons to bring James and Philetus to him (panel three). But the demons, like Philetus, are won over by the power of the Apostle and return to seize their former master Hermogenes (panel four). Returning good for evil, James liberates Hermogenes, who is converted.

Like the southern lateral choir screen, this was a funerary monument. The patron was the wealthy canon, Guillaume aux Cousteaux (d. 1511),

FIGURE 5.14 *(top, opposite page)* South transept, west side, funerary monument for Canon Guillaume aux Cousteaux depicting the story of Saint James. Below, black marble tablets with names of the masters of the Puy Notre-Dame

FIGURE 5.15 *(bottom, opposite page)* North transept, west side, funerary monument for Canon Jean Wytz depicting the Temple

who was buried in the pavement directly in front. Guillaume, the son of Jacques (James) aux Cousteaux, had developed a special relationship with Saint James for family reasons; this saint's relics were preserved in the nearby altar under the southern end of the western jubé. In a wider sense, the story of Saint James as recounted in the scenes above provided a visual representation of the power of the relics of this saint, located in Amiens Cathedral, at a time when the veneration of relics was being challenged. Amiens was on the pilgrimage route to the shrine of Saint James at the cathedral of Santiago de Compostela, in northwestern Spain, and pilgrims were served by a hostel in the city.

If we may see the south transept screen as a statement in defense of the cult of saints and the miracle-bearing potential of their relics, the matching screen in the north transept, a funerary monument for Canon Jean Wytz (d. 1522), may be understood as an apologia for the material fabric of the church with its progressively more sacred spaces, culminating in the choir and the sanctuary, the exclusive domain of the clergy (fig. 5.15). Solomon's Temple provides an allegory for the Church. The sequence of images brings us from the outer chamber of the Temple, the *Atrium*, forward into the *Tabernaculum* and on to the *Sancta* and the *Sanctorum*. Each of the four spaces is so labeled and the viewer is led forward in the same kind of passage or *ductus* that brought us through the cathedral from portal to nave, to central crossing, to choir, and finally to the sanctuary.

In the Atrium Christ cleanses the temple of buyers and sellers. Christ, seen on the right, is clad in a golden robe and rendered eloquent by the text written on his banderole: "Take these things hence: make not my Father's house an house of merchandise," *Auferte ista hi(n)c. nolite face domu(m) patris mei domu(m) n(egotiationis)* (John 2:16). Just in front of Christ, a bird seller has dropped his money on the table. Behind him a money changer throws sack of gold over his shoulder and clutches a little chest. On the extreme left a merchant has a dead calf on his back. Right in the foreground a richly clad merchant is checking a goat's teeth—hearing Christ's admonition, his head jerks toward Christ parallel with the goat's.

In the second space, the *Tabernaculum*, the gold-robed Christ stands in front of an enclosure richly decorated with Italianate motifs. Behind him inside the enclosure, two robed priests preside over the burnt offering—a

premonition of the Eucharist. In the left foreground a lame man looks up attentively, expecting to be healed, and thus projecting the notion of the power of Amiens Cathedral as a locus of healing: "And the blind and the lame came to him in the temple and he healed them" (Matthew 21:14).

We now enter the *Sancta* where a robed priest, attended by an acolyte, censes an altar. The scene is reminiscent of the Eucharist, an association reinforced by the heaps of showbread in the foreground. And passing into the *Sanctorum* we find Aaron in full priestly attire (Exodus 39) with an incense burner, venerating the Ark of the Covenant. Two seraphim stand atop the Ark, holding its lid. The Ark is set inside an enclosure with rich curtains, here drawn back. Behind Aaron is a piscina, much as one would expect with a Christian altar. The figure of Aaron, set in this most holy place reserved for priests, is an allusion to the bishop in the Christian sanctuary: the notion of the Temple as a precedent for the Church had been frequently explored by Christian commentators.

This powerfully forward-moving sequence of images of the spaces of the Temple; their anticipation of the Church; and the sharp division between the Sancta Sanctorum, reserved for priests, and the spaces available for laypeople were obviously highly relevant in relation to the events of the 1520s. In 1520 Martin Luther published his *De captivitate Babylonica ecclesiae praeludium* (On the Babylonian Captivity of the Church) in which he dismissed the doctrine of Transubstantiation, criticizing the sharp division between clergy and layfolk and propagating his ideas of the priesthood of all believers. The established Church moved rapidly to respond, excommunicating Luther on January 3, 1521; it took another two months for the Church to issue its final *Determinatio* condemning Luther's teaching.

iii) Choir Stalls c. 1508–c. 1522[73]

In the three-hundred-year "Life" of the Gothic cathedral, both beginning and end were marked by an intense phase of image production. The west portals (1220s–1240s), intended principally for consumption by laypeople, are dominated by monumental stone figures carved by sculptors who had come to Amiens from elsewhere. The new choir stalls, on the other hand, intended for the use of the clergy, embody hundreds of miniature wooden sculptures

carved by local men. The portals are rich in allegorical and tropological levels of meaning; the choir stalls, on the other hand, dominated by storytelling and images of contemporary life, have a distinctly demotic flavor.

As prosperity returned to Amiens in the last decades of the fifteenth century, the clergy must have looked with envy at the sumptuous stalls recently created in the nearby cities of Rouen, Beauvais, and Saint-Riquier. The original Amiens choir stalls, constructed in haste and with a limited budget in the 1260s, must have appeared old-fashioned and humble.[74] The new stalls, exquisitely wrought of oak, invite us to enter into a world where more than one hundred members of the clergy—canons, chaplains, vicars, choirboys, and visitors—interacted daily in the Divine Office and in the performance of the sacraments and other rites (fig. 5.16). The daily choreography, performed in sumptuous attire, included music, processional movements, gesture, prayer, song, illumination, incense, and dramatic reenactments, appealing to all the senses. The stage set was provided by one of the most extensively embellished sets of choir stalls ever created. The elaborate canopies projecting over the heads of the clergy provided a resonant sounding box for their voices. The wood has been polished to a high sheen by the daily movement of the robed bodies of members of the clergy though and around the stalls, as well as the touch of their hands: a poignant physical testimony to the presence of the clergy.

Arranged in double rank facing each other across the fifty-foot central space of the choir, members of the clergy would find their attention drawn forcibly toward the east. Here, the main altar with its silver retable stood surmounted by an arcaded stone tribune bearing the glittering châsses containing the bones of the saints who had first established Christianity on Picard soil. And beyond that, the piers of the eastern hemicycle and the multifaceted, brilliantly colored windows of the crown of radiating chapels provided a sumptuous backdrop like a jeweled crown. The ranks of clergy, standing in their stalls, might bear some resemblance to the column figures lining the west portals (figs. 2.28–30)—appropriately enough, since the clergy were the successors of the prophets, the apostles, and the saints. The images of the apostles in the choir triforium windows serve to reinforce this point (fig. 3.24). But whereas in the west portals each of the column figures triumphs over a crouching antifigure placed in the pedestal, our clergy had as their supports the *misericords:* little brackets or "mercy seats" projecting

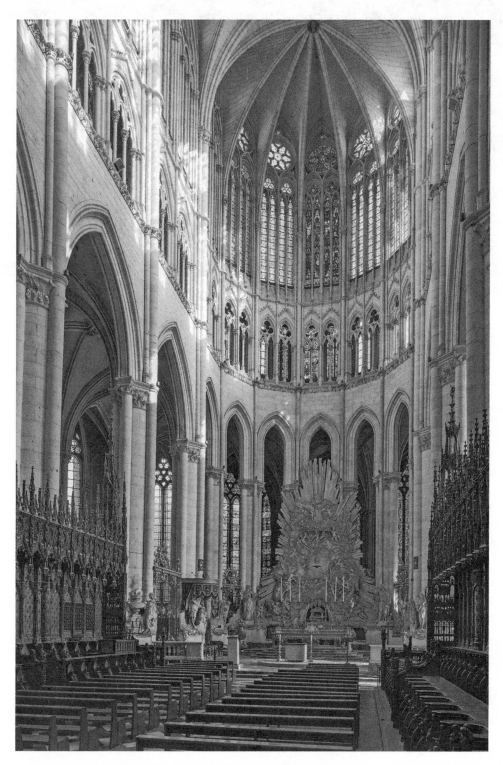

FIGURE 5.16 The choir and sanctuary, looking east. See also color plate.

FIGURE 5.17 The choir stalls, misericord depicting Noah's Ark in the dean's stall

from the reverse side of their upturned folding seats, providing support during the long hours of the Divine Office (fig. 5.17). As we shall see, these carved misericords provided a fabulous vehicle for storytelling, as the dramatic events of the early books of the Old Testament unfold.

Seated or standing in his stall, our canon must have felt safely enclosed inside this complex, fictive wooden architecture. The lower stalls accommodated vicars, chaplains, choirboys, musicians, and visiting clergy. The cathedral canons seated in the upper stalls would enjoy the expression of their superior status with seniority indicated by seating toward the west, along with the dignitaries or officers of the chapter in the seats that formed the L-shaped western arms of the enclosure and flanked the main western doorway into the choir through the choir screen. These western seats, of course, held the privileged view: facing directly east, the occupants did not need to turn their heads to see the altar. On the south side, next to the principal entrance gate, sat the dean; on the north side sat the king during his visits to the city, or his representative when he was absent. These two stalls of honor (*stalles d'honneur*) are elaborately decorated and crowned by great pinnacles that mimic, in a general sense, the central spire (fig. 5.18). The bishop's throne was located to the south of the main altar.[75] Each of the stalls forms a kind of niche enclosed by rounded arms embellished with

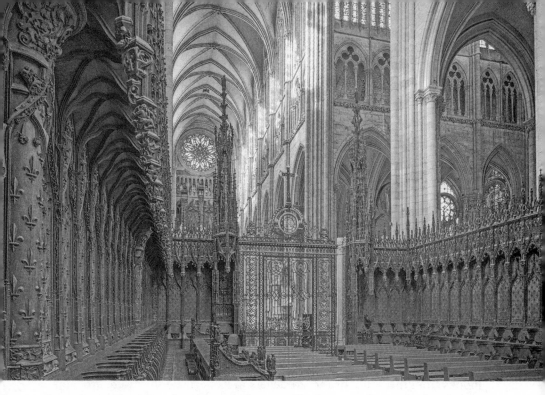

FIGURE 5.18 The choir stalls, south side looking west. The dean sits in the grand stall on the left, the king on the right

exquisitely carved—sometimes quite provocative—handrests. And those sitting in the upper stalls were further framed by the wooden panels strewn with fleurs-de-lys and sheltered by canopies with little wooden quadripartite vaults mimicking the great stone vaults of the choir. The niche spaces expressed the individual status of each canon—occupants of the upper stalls were provided little storage boxes for their possessions. But the *unity* of the chapter was emphasized by the continuous screen of arches that forms the vaulted canopy sheltering the stalls. The front arcade of the canopy is without visible support—hanging pendants celebrate this triumph of carpentry work, leaving the viewer wondering how on earth the structure holds up. This arcade is formed of traditional pointed arches, elaborately cusped; the gables surmounting the arches, on the other hand, have concave curved sides creating a tightly pointed apex. Moldings are deeply hollowed and richly strewn with foliage. At the top is a screen of delicate diaphanous tracery composed of interlocking ogee arches rising to an emphatic upper rail that is punctuated with pinnacles and tracery elements. The viewer looking up

might compare and contrast the delicacy and deceptiveness of this fictive dark wooden architecture with the massive forms of both the main arcade of the choir and the brilliantly lit towering stone superstructure above.

The creative process underlying the production of this extraordinarily rich sculptural program must have involved close collaboration between representatives of the clergy and the artisans themselves. The clergy's job was to provide the funds, supervise logistics, procure materials, and orchestrate the production of narratives. A team of four canons was appointed to oversee production—Jean Dumas, Jean Fabus, Jean Lenglacié, and Pierre Waille, as well as the chapter lawyer, Robert Langlez. It is probable that their work was principally administrative: when a similar committee presented the accounts at the end of work, the total cost was reckoned at 11,230 livres 5 sous.[76] This was money derived from the revenues of the chapter, mostly from *marances* or amends paid by delinquent canons. Some gifts were also received—Dean Adrien de Hénencourt gave 100 pounds; canon Jean de Clerk, 120. The 1510 account (now lost) recorded 20 sous paid to two monks from the house of the Cordeliers in Abbeville—they were probably theological consultants. The logistics committee found a source of appropriate oak in the forest of La Neuville-en-Hez near Beauvais.

As they contemplated the production of the dense image cycles of the choir stalls, it would have been hard for the clergy to escape from the power of the sculptural program of the western portals created almost three hundred years earlier, and probably under restoration (repainting) in the years around 1500. In both the choir stalls and the west portals, interwoven Old and New Testament narratives have a distinct starting point. In the earlier program, that starting point is found in the southwest portal where the new story of the Incarnation of Christ and the redemptive agency of the Virgin Mary is elucidated allegorically with references to the creation of Adam and Eve, the Original Sin, and Mary as the New Eve, as well as the Ark of the Covenant, Moses, and Aaron. We have seen in the west portals that the minor prophets carry the story from right to left and prepare the visitor for entrance into the church. In the stalls the starting point of interwoven Old and New stories is provided by the magnificently embellished stall of the dean at the southwestern end (figs. 5.18–20). The terminal wall of the dean's seat is formed of openwork lattice, creating an immediate and direct relationship between inside and outside. On the outside the image of God

FIGURE 5.19A Dean's stall,
Creation of Adam and Eve

the Creator crowns the panel, the creation of Adam and Eve is in the mid-
dle, and an allegorical image of the purity of the Virgin is placed below
(fig. 5.19). The figures in the lattice on the *inside* of the screen are hard to
see, since they are sharply backlit. Once the eyes accommodate to the fil-
tered light, the shadowy figures can be perceived, perhaps with some aston-
ishment, as erotically charged images of Eve and Adam flanking the Tree of
the Knowledge of Good and Evil (fig. 5.20). The serpent is coiled around
the tree and Adam eats the pernicious fruit handed to him by Eve, clutching
his throat as he chokes, just as in the similar sculpture of the southwestern
portal (fig. 2.12). The Virgin Mary, with her promise of redemption, towers
over the serpent who had perpetrated the betrayal.

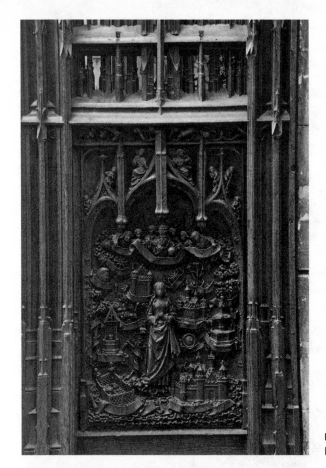

FIGURE 5.19B Dean's stall, Purity of the Virgin Mary

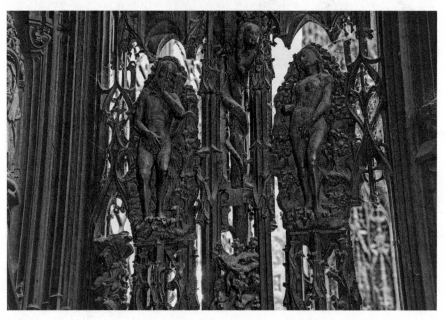

FIGURE 5.20 Inside the dean's stall, Adam and Eve and the Original Sin

The theme of sin is reiterated in the scene of Cain slaying Abel at the back of the dean's seat. Yet redemption is promised by both Testaments: the Virgin Mary appears above the tree to counter the action of the serpent, and Noah and his family are saved from the Flood aboard the Ark. The unforgettable image of the Ark floating safe in roiling waters filled with debris of lost cities and dead bodies (both animal and human) is located on the misericord that would be hidden under the dean's backside (fig. 5.17).

Dean Adrien de Hénencourt had presided over the cathedral chapter during a period of grave danger for the cathedral in the aftermath of the flight of his uncle, Bishop Ferry de Beauvoir, who had sided with the Burgundian occupiers. The dean had also seen the near-collapse of the cathedral and had organized an appropriate solution. To be borne up by the Ark of Salvation must have been a great comfort to him.[77] Indeed, it is tempting to think that the dean was the key player in the invention of the narrative cycles of the stalls; that he was able to hold the program as a mnemonic map in his head, envisaging even the parts that were hidden behind the bodies of his fellow canons or concealed in the staircase ramps. It is from the dean's seat is that the waters of Old Testament stories flow eastward through the southern ranks of the high stalls, then turning back westward along the southern low stalls to continue on the northern side where they follow a similar route before finding a grand finale in the northeastern terminal wall (figs. 5.21–22). Having gained this overview of the plot, together with maps of the New Testament and Old Testament narratives, let us continue with a look at the five vehicles for narrative imagery in the stalls: the misericords, the little figures atop the stair rails, the relief panels, the hand rests, and the pendants.[78]

Beginning with the Flood, the Ark, and the sacrifice of Noah, the Old Testament sequence of misericords continues to the dean's right (south), leading us to the story of God's promise to Abraham that he would be father of many nations. But then, as the story turns to run along the southern high stalls toward the east, we almost lose Abraham's son, Isaac, as he narrowly escapes from being the victim of the sacrifice demanded by God. Isaac then sets out to find a wife—no fewer than eight scenes mark the passage of Isaac with his camel caravan until he encounters his future wife, Rebecca. They have twin sons: Esau was born minutes before Jacob. What will determine which son will carry forward God's promise? Trickery— it should have been the elder son, Esau, his father's favorite, but Rebecca

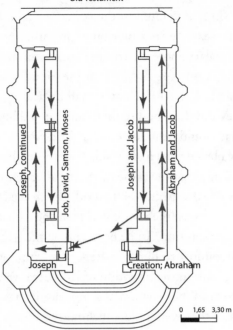

Notre-Dame of Amiens: Narratives of the Misericords
Old Testament

Joseph, continued

Job, David, Samson, Moses

Joseph and Jacob

Abraham and Jacob

Joseph

Creation; Abraham

0 1,65 3,30 m

FIGURE 5.21 The choir stalls, plan of Old Testament imagery (rendered by Emogene Cataldo after Lemé-Hébuterne)

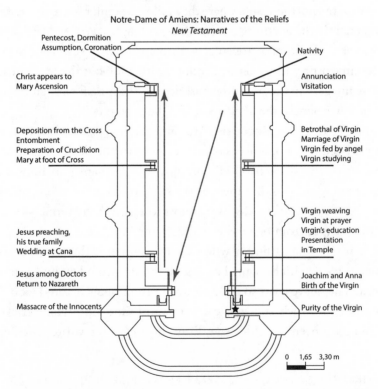

Notre-Dame of Amiens: Narratives of the Reliefs
New Testament

Pentecost, Dormition
Assumption, Coronation

Nativity

Christ appears to
Mary Ascension

Annunciation
Visitation

Deposition from the Cross
Entombment
Preparation of Crucifixion
Mary at foot of Cross

Betrothal of Virgin
Marriage of Virgin
Virgin fed by angel
Virgin studying

Virgin weaving
Virgin at prayer
Virgin's education
Presentation
in Temple

Jesus preaching,
his true family
Wedding at Cana

Jesus among Doctors
Return to Nazareth

Joachim and Anna
Birth of the Virgin

Massacre of the Innocents

Purity of the Virgin

0 1,65 3,30 m

FIGURE 5.22 The choir stalls, plan of New Testament imagery (rendered by Emogene Cataldo after Lemé-Hébuterne)

persuades Joseph to trick Isaac, now blind, into thinking that he is Esau. The younger brother thus gets the blessing, which was the birthright of the older, who, enraged, forces Jacob to flee. The fulfillment of God's initial promise to Abraham now seems in real doubt as we reach the east end of the upper stalls on the south side. But as Jacob flees Esau's wrath, he has a vision of angels ascending and descending a heavenly ladder: he anoints the stone that formed his pillow in the night—the cut stone is a sign of the future role of Christian altars and churches constructed of cut stones. This brings us to the eastern termination where the figures atop the staircase rail form a crescendo, with Jacob welcomed by his uncle Laban.[79]

As the narrative borne by the misericords turns back toward the west in the lower stalls on the south side, Jacob is visited by three angels and wrestles with a fourth. Esau's impending attack does not materialize, and the two brothers are reconciled. The story continues westward with the presumptuous young Joseph dreaming of the wheat sheaves and the sun and moon bowing down to him. The dramatic scenes depicting the jealousy of his older brothers and their attempt to get rid of him ascend to take their place atop the middle staircase. More trickery ensues as Jacob is told that his favorite son, Joseph, had been devoured by a wild beast, when in fact he had been shoved into a well. The passage of wealthy Egyptian merchants leads Joseph's brothers to realize that he could be sold at a considerable price, so he is carried off to Egypt where he enters the service of Potiphar, captain of Pharaoh's guard. Joseph's refusal to yield to the advances of Potiphar's wife leads to prison where he is able to interpret the dreams of two of Potiphar's servants who had fallen out of favor. The butler, released from prison, tells his master of Joseph's ability to interpret dreams; meanwhile, Pharaoh has had a couple of dreams of his own: dried up wheat sheaves and fat and thin cattle. Joseph interprets the dreams as signs of an impending famine and is appointed governor of Egypt to avert the disaster through careful husbandry. Thus, the last phase of the cycle, as it approaches the dean's seat, is one of triumph. Under the eyes of the dean, atop the westernmost staircase, we find Pharaoh dreaming of the wheat sheaves and the fat and thin cattle (fig. 5.23). Although small, the image of Pharaoh assumes truly monumental force. Like Egypt, Amiens had come through some thin years at the close of the Hundred Years War and the period of Burgundian control. The cathedral had endured a period of structural crisis and

FIGURE 5.23 The choir stalls, south side, westernmost stair rail, Pharaoh's dream

had been saved thanks to the intervention of the good dean and his master mason, Pierre Tarisel. Through all these difficulties, the dean might have considered himself to have been borne up by Noah's Ark, and then rewarded with ensuing decades of peace and prosperity around 1500, allowing him to commission the sumptuous choir stalls. Yet at the same time, he might also have been reminded of the fickleness of fortune by the story of the drunkenness of Noah, placed directly in his line of vision.

With the story of the triumph of Joseph, the Old Testament narrative leaps across the central space of the choir to the king's stall at the west end of

FIGURE 5.24 The choir stalls, north side, westernmost stair rail, granaries of Egypt

the northern stalls. The king is flanked by images of good governance—the full granaries of Egypt (fig. 5.24). The Old Testament cycle then turns east along the northern high stalls, with the story of the famine in Canaan and Jacob's sons sent to Egypt to buy grain. This phase of the story seems unnecessarily extended with multiple scenes of Joseph's deception of his brothers as he conceals his identity and has precious objects placed in the sacks of grain purchased by the brothers so they may later be arrested. The touching scene where Joseph finally reveals his identity to his brothers reminds us of the matching scene of the reconciliation of Jacob and Esau on the south side. Jacob's old age, his blessing of Joseph, and his death comes at the extreme east end of the northern stalls and is celebrated in the freestanding figures in the eastern staircase rail. Then the cycle turns back toward the west in the front stalls on the north side with the story of Moses (celebrated in the middle staircase) and Samson (in the western staircase). The Old Testament sequence ends with the very brief appearance of David. The story, as told on the south side, had reached a climax with the triumph of Joseph, but of

course, the Israelites were in the wrong place, namely Egypt. Here on the north the story climaxes with promises of a better future: the establishment of the Law, with Moses; the prefiguration of the Church, with the Ark of the Covenant; the origin of kings, with David; and the anticipation of the Promised Land—the right place—as spies bring back grapes. More enigmatic, placed in the king's line of vision are images of the blinding of Samson and, just under his nose, the sufferings of Job. Job's story was sometimes understood as an invitation to penitence, and Job himself as the suffering Church.

Our Old Testament narrative is inextricably intertwined with Mariological and New Testament images—the architecture of the stalls provides an interactive armature allowing the viewer to search for and create typological linkages. The dean's seat provides the starting point for everything. We have seen that the Creation of Man is placed on the exterior surface of his stall; directly beneath is placed an allegorical image of the Virgin (the New Eve) where the central figure is surrounded by emblems of her purity (fig. 5.19). Thus, the choir stall program extends the ordering principle of the Virgin that dominates the south flank of the cathedral: from the portal of the Mère Dieu on the south side of the western frontispiece, to the Vierge Dorée of the south transept portal, to the chapel of Puy Notre-Dame in the south transept. The presence of the redemptive Virgin inside the dean's stall unleashes the Apocryphal story of her conception: scenes of Joachim and Anna are set into the back of the same stall and in front, the Nativity of the Virgin is depicted. The Mariological cycle, drawn from Apocryphal sources, continues from west to east on the side panels of the three staircases (fig. 5.25). The westernmost staircase features the education of Mary, her presentation in the Temple, and Mary depicted at prayer and weaving. In the middle staircase, Mary is depicted at her studies, being fed by angels, and betrothed to Joseph. And finally, in the easternmost staircase we see the Annunciation and Visitation. On the panel that marks the eastern termination of the south rank of stalls, we find four scenes: the resolution of Joseph's doubts about the purity of the Virgin; the Nativity; the Epiphany; and the Presentation of Christ in the Temple.

The New Testament story then takes a diagonal leap back across the space of the choir to the west end of the north bank of stalls—the king's seat—where, corresponding to the panel with the Purity of the Virgin, we find the image of the Massacre of the Innocents—an astonishingly frank

FIGURE 5.25 The choir stalls, south side, westernmost staircase, relief sculpture of the Virgin weaving and the Virgin at prayer in front of the Ark of the Covenant

commentary on the effects of bad kingship, countering the signs of good government conveyed by the scenes of plenty in Egypt. Then, as on the other side, the cycle advances from west to east with Christological scenes (fig. 5.26). In the first staircase are images of the Miracle at Cana and Jesus with his mother and brothers; in the second (middle) staircase, the Crucifixion with Mary at the Cross and the Deposition and Entombment. Finally, in the eastern staircase are the post-Resurrection appearance of Christ to his mother and his Ascension. On the terminal wall to the east are Pentecost (fig. 5.27), the Dormition and Assumption of Mary, and her reception and coronation in heaven—a scene that brings us to the Second Coming of Christ and the end of time.

FIGURE 5.26 The choir stalls, north side, middle staircase, relief sculpture of the Man of Sorrows and the Crucifixion of Christ

The Old Testament and Mariological/Christological cycles are driven forward by strong teleological mechanisms. There is a third vehicle for figurative images that is entirely lacking such a mechanism: the exquisitely sculptured handrests adorning the divisions between the stalls. Whereas the misericords remained half hidden and the panels flanking the staircases can only be seen obliquely, the handrests—like the freestanding sculpture atop the staircase rails—remained in full view as the canons sat or stood in their stalls. Although it is impossible to determine the extent to which members of the clergy controlled the choice of subject matter, they effectively allowed (whether actively or passively) these figures to represent the three worlds of the cathedral. The world of the clergy is represented in only about 5 percent of the images (fig. 5.28); that of the layfolk in the city and surrounding

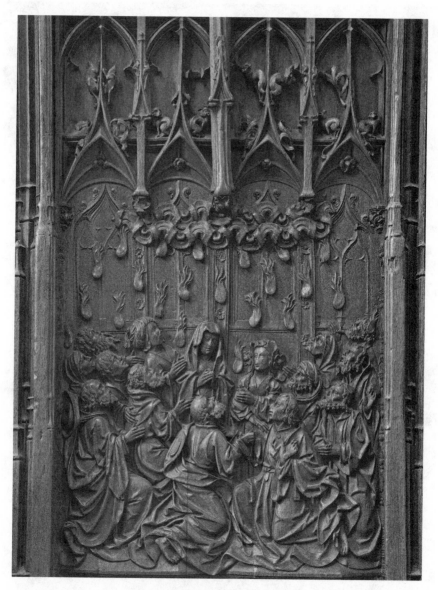

FIGURE 5.27 The choir stalls, north side, eastern terminal, Pentecost

area, more than 50 percent (fig. 5.29); and that of the artisans, 4 percent (figs. 5.30–31). There is, in addition, a significant fourth dimension, which we might term the Other: the grotesque, the enigmatic, the marginal (including fools, drunkards, and beggars), and the erotic: these figures

FIGURE5.28 The choir stalls, handrest, two clerks sing from a great choir book

FIGURE 5.29 The choir stalls, handrest, washerwoman

FIGURE 5.30 The choir stalls, handrest, Master Jean Trupin carves a small wooden figurine

comprise 25 percent of the figures (fig. 5.32). In addition to these four cat-
egories there are a few musicians (4 percent) and biblical/mythological fig-
ures (7 percent).

A final vehicle for figurative sculpture is provided by the pendants. Fig-
urative compositions, often featuring three principal characters, alternate

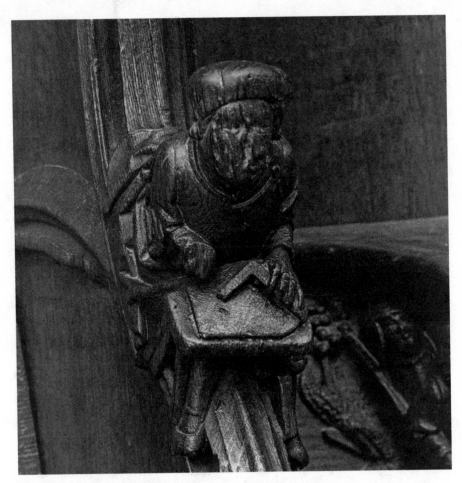

FIGURE 5.31 The choir stalls, handrest, master carpenter?

with deeply undercut foliage. The themes of the figurative units mostly pertain to the category we have termed "Other."

While the stalls of Amiens bear a generic similarity with existing prototypes, they are unique in their figurative cycles. The creative process behind the production of these vibrant scenes remains something of a mystery: the search for prototypes has led to the discovery of only one image clearly directly dependent upon an existing model: the image of the Purity of the Virgin (fig 5.19).[80]

The absence of direct models for the Old Testament cycle suggests that the images were worked out through close collaboration between members

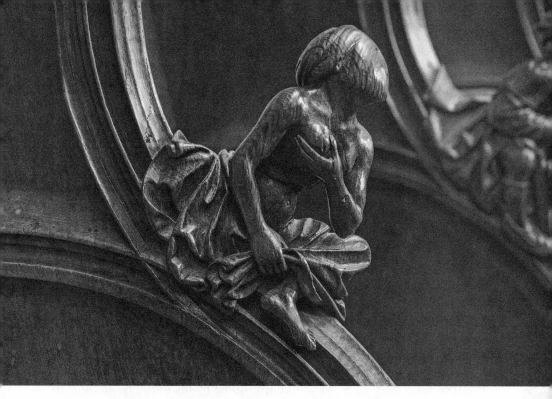

FIGURE 5.32 The choir stalls, handrest *la baigneuse*

of the clergy and the wood carvers or *tailleurs d'images*. It seems possible
that this conversation was accompanied by the preparation of sketches or
cartoons. Whether the carvers were able themselves to read the Old Testa-
ment texts remains open to question: they may have had access to Bible pic-
ture books with running captions or poetic paraphrases.[81] The northeastern
region of France had been a center for biblical translation from at least the
twelfth century. The climax of the translation movement was reached with
Guyart des Moulins's translation (1291–1295) of Peter Comestor's *Historia
scholastica*, also known as the *Bible historiale*.[82] Guyart was a canon of St
Peter's church in Aire-sur-la-Lys, near Saint-Omer, to the north of Amiens;
he had been dean there from 1297 to around 1312. He may have translated
the full Bible into Picard French. This work inspired many subsequent cop-
ies and adaptations, including the *Bible historiée* (Great Bible) edited by
Jean de Rély (born 1430 in Arras; died 1499), the confessor of King Charles
VIII. It is fascinating to find that the growing desire on the part of lay read-
ers for access to a complete French translation of the Bible comes to fruition

in the 1520s, just as our stalls were being completed. There is much evidence to suggest that by the beginning of the sixteenth century an increasing number of residents of Amiens (including artisans) were in possession of biblical texts, the *Golden Legend*, or books of hours.[83]

The misericords in our choir stalls bear witness to the desire to follow the drama of the early books of the Old Testament in a historical, rather than allegorical, sense. Each scene is set in a background almost like a painting: city settings are predominant. The buildings, furniture, and attire correspond to current taste in late medieval Amiens—little attempt has been made to archaize the scenes. It is if the drama of the historical books of the Old Testament was unfolding in contemporary time and space—just as we saw in the narratives of the lateral choir screens. Equally striking is the desire on the part of the storyteller(s) to illustrate the accidental aspects of the unfolding of God's promise to Abraham, particularly when it comes to family relationships. Noah's drunkenness causes him to curse Ham, allowing the Promise to be carried forward by his other sons. Jacob's role was the result of his trickery. Joseph was almost killed by his brothers and imprisoned by Potiphar. Joseph repeatedly deceived his brothers, concealing his identity and planting precious objects in their grain sack so that he might rearrest them. Moses is almost drowned, and God's contract with the Israelites (expressed through the Ark of the Covenant and the Tablets of the Law) almost rescinded as a result of continuing idolatry. And the cycle ends with the colossal enigma of Job, the pious man who is nevertheless allowed to suffer. In this way we catch a glimpse of the early historical books of the Old Testament making way for the Psalms, which, in the form of the Divine Office, occupied the space of the choir.

Let us conclude with some thoughts about the artisans responsible for the work: unlike the carvers of the sculpture of the western portals, these were local men, often with well-established businesses. Dominant among these were the *huchiers*: carpenters or joiners who might work upon the interior furnishings of houses in Amiens. Then, we have the *menuisiers*: artisans producing finely carved interior woodwork, including sculptural embellishments; and the *tailleurs d'images*, carving figurative images. By the fifteenth century a sizeable community of such artisans resided in Amiens, especially around the Place des Huchers in the parish of Saint-Leu to the northwest of the cathedral.[84] The market for high-quality sculpture in Amiens—whether

in wood or stone—was limited by the lack of princely patrons or great monasteries in the city or surrounds, though the town houses of elite bourgeois were, no doubt, sumptuously embellished with ornate woodwork. The market was thus dominated by clerical patrons, mainly the cathedral clergy. In addition, nearly all the parish churches of the city were entirely or partially rebuilt and redecorated at this time.[85]

We have the names of some of the artisans who worked on the choir stalls from about 1508 to about 1521 under the direction of a committee of five canons appointed to inspect and direct the work. In May 1509 a first contract was signed with a huchier by the name of Arnoul Boulin, who was engaged at seven sous a day plus twelve écus (288 sous) a year. Boulin would have to pay his apprentice from his seven-sous daily wage, probably leaving him four sous. A second contract with similar terms was issued in September of the same year with Alexandre Huet, another local huchier who had partnered with Boulin on other projects. It has been suggested that Boulin was responsible for the double range of stalls to the north, and Huet the stalls to the south. Both were residents of Amiens. Each of the two masters was assisted by apprentices who earned three sous a day: Linard le Clerc, Guillaume Quentin, and Pierre Meurisse. The huchiers were responsible for the structural framework of the stalls: the sculptural details of the misericords, panels, ramps and pendents were carved by menuisiers and tailleurs d'images.[86] One of these carvers, Jean Trupin, left us an image of himself in the handrest attached to 85–6 (fig. 5.30; see also the website). Trupin was paid only 3 sous a day. It is thought that Antoine Anquier was responsible for most of the figurative sculpture of the southern ranks of stalls while another local artist, Jean Warin dit Hac did the northern side.[87]

The written sources provide a fascinating glimpse into the creative process with the visit made in 1509 by Arnoul Boulin to Beauvais—the cathedral or abbey church of Saint-Lucien—to study the choir stalls there. Boulin also visited the choir stalls of Saint-Riquier where Huet had worked. And again, in 1511 Boulin and Huet went to Rouen Cathedral to inspect the recently completed stalls. We can imagine the clergy ordering that the new stalls at Amiens should resemble such prototypes, but with certain carefully specified improvements including the extraordinary cycles of figurative images.

We know something of the lives and practice of the artisans who resided in Amiens, many of them in the northern parish of Saint-Leu. Anquier lived

and worked in a large house across from that church, and other artisans lived quite close by: sculptors Jean Granthomme and Nicolas Pezé; the painters Bon Hénot and Jean Raboche; and the illuminator Nicole Obry. Anquier also had a house in the western part of the city close to the Beffroi, in the rue au Lin close to the sculptor Jean Warin dit Hac, as well as a community of menuisiers. The artisans of Amiens were a closely interlocked community dominated by a limited number of extended families and protected from outside competition by local ordinances. In executing the extended and complicated work on the choir stalls they probably made arrangements and contracts between themselves: they were entrepreneurs as well as carpenters.

We may conclude that despite the extraordinary visual dynamism inherent in the lively sculptured narratives of the Amiens choir, certain social, economic, and religious factors were at play that would ultimately contribute to the demise of such image production.[88] It has been suggested that few of the sculptors would be able to make a comfortable living entirely from their artistic production: many were forced to supplement their income through real estate speculation or through the purveyance of raw materials (wood, stone, pigments, etc).[89] Their interests and experience were local, extending to neighboring cities (especially Abbeville, Beauvais, and Thérouanne) as well as to churches in nearby prosperous villages and small towns.

The character of this last burst of image production can best be described as "hyper-realistic demotic"—ideally suited to storytelling and rapid consumption on the part of the audience.[90] The same mode was employed for the cycles of images intended for lay audiences on the lateral screens of the choir and the cycles of images intended for the clergy in the stalls. Unusual about the Amiens situation was the sheer scale of the enterprise and the systematic organization of highly controlled narratives involving hundreds of scenes set in an architectural framework. Such production came to an end in the first decades of the sixteenth century—another manifestation of the end of the "Life" of the Gothic cathedral. Study of economic and social conditions has suggested that the demise of this mode of image production came partly from within, resulting both from excessive control over the profession by a very limited number of families, and from restrictions imposed upon outsiders leading to boring repetition of well-tried formulae.

New masters were required to present a master work to their seniors: this might help perpetuate conservative taste.[91]

But let us also recall also the sixteenth-century shift of taste away from the humble to the heroic that opened the way for artists working in Italianate modes.[92] And, of course, the Reformation brought new skepticism about the cult of saints and the authority of the established Church.

g) The Golden Steeple (Figs. 5.33–35)

Forming a slender central pivot around which the sun revolved in its daily cycle, the central steeple flashed with gold in the shifting light. Rising at midpoint directly over the liturgical heart of the cathedral, it expressed the will to defy structural limitations and reach dizzying heights: the tip, about one hundred and twelve meters about pavement level, is visible for miles around, across the flat expanse of the Picard plain. Inhabitants of nearby villages and hamlets might interrupt their daily work to raise their eyes to make visual contact with the saints whose relics were incorporated in the tip, responding to the ringing of bells housed in the steeple whose pealing marked critical points in the Divine Office.

Our Dean Adrien de Hénencourt, now close to the end of his life and largely confined to his home, the House of the White Hound (*la maison du Blanc Lévrier*) must have thought his work was complete, with the structural integrity of the choir restored and sumptuous new liturgical furniture and embellishments in place. We can imagine him as an old man perched securely atop his Ark of Noah in the choir stalls, dreaming during the long Offices: did his ancient predecessor Dean Jean d'Abbeville ever appear to him in his dreams to share his experiences of cathedral construction and embellishment? Yet, Dean Adrien was jolted out of his reverie into one last effort by a disastrous lightning strike that destroyed the central steeple on July 15, 1528 at 10:00 p.m.[93] The dean was one of the major contributors to the project to rebuild the steeple with a donation of four hundred pounds, while the bishop François de Halluin gave six hundred. Louise de Savoie, duchesse of Angoulême and the mother of François I, offered one hundred écus; the king himself offered oaks cut from the royal forest of La Neuville-en-Hez. The seigneur of Liancourt, master of the waters and forests of Clermont, went to designate the trees to be cut down, accompanied by a

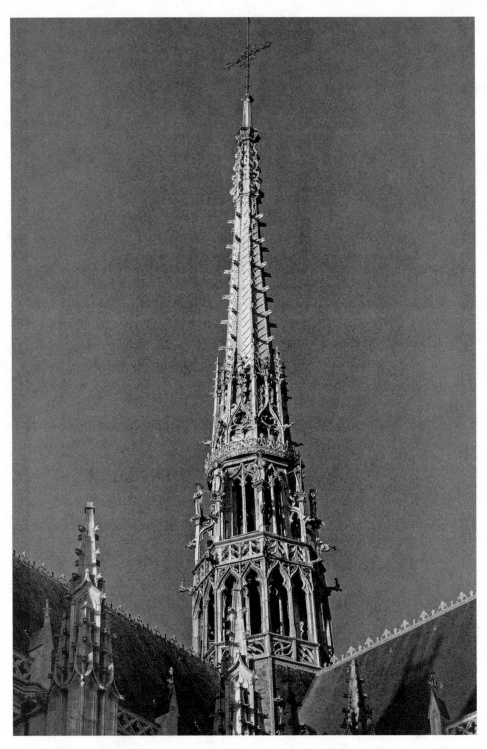

FIGURE 5.33 The central steeple seen from the southwest. See also color plate.

FIGURE 5.34 Interior of the base of the central steeple: *La forêt*

delegation of canons. The monastery of Saint-Martin-aux-Jumeaux provided space for a drawing office for the new steeple.

The fire must have presented an awesome spectacle—how can we ever forget those terrible images of the final buckling and calamitous crash of the fiery steeple of Notre-Dame of Paris (April 15, 2019)? Fearing for the safety of the entire church, the Amiens clergy had the precious châsses removed to the church of Saint-Firmin-à-la-Porte. The inhabitants of the area around the cathedral (including, we are told, the *filles de joie*) formed a human chain to pass buckets of water, but there was no reaching the top of the steeple. The fire was finally extinguished and the main roof saved thanks to the intervention of a torrential rainstorm. The survival of the main roof of the cathedral must have seemed like a miracle.

Decisions relating to the planning and construction of the new spire were assigned to a commission of two canons, the *penitencier* and one of the archdeacons. Simon Taneau, carpenter of Beauvais, was summoned to direct work at a very substantial daily salary of ten sous and a large loaf of bread—he was provided a room to facilitate the drafting of a plan. But the commission was not satisfied with the proposed design, fearing that the

FIGURE 5.35 The central steeple, section (after Viollet-le-Duc and Durand; rendered by Gabriel Rodriguez)

new steeple, taller and heavier than the old one, would impose too much weight upon the crossing piers—which indeed, as we have seen, had almost failed thirty years earlier. Local antiquarians tell the story of the almost-miraculous appearance of a carpenter, Louis Cordon (or Cardon) from the nearby village of Cottenchy, who proposed a scheme employing relieving devices (*clefs de décharge*) that would carry the weight directly to the crossing piers, not the main arches: *In the year 1529 Bishop François de Halluin*

and the chapter, conferred with several architects and contractors of the city of Amiens and even from further afield but none of them could formulate an opinion or provide a plan suitable for the construction of the new steeple. In the cathedral happened to be a poor unknown and apparently uneducated man called Louis Cordon from the village of Cottenchy, two leagues from Amiens. He freely said to M. Delameth that we can only succeed if we avoid charging the vaults and arches that will certainly break under such a great weight, and that this could be achieved by means of relieving braces and "tétaroles" [meaning unclear], *which he showed to the canon by means of a little drawing that he sketched for him and immediately erased. Louis Cordon's advice drew attention and he was brought to the chapter, where, in the presence of the entire assembly he drew out his design for a second time and explained the execution so clearly that everyone, by common accord, entrusted to him this great enterprise, which he completed without problem in a period of two years.*[94]

Louis Cardon was hired to work with Taneau on the construction of the steeple, which was finally sheathed in lead imported from England and purchased in Dieppe. Bells were cast in September 1528, and in February 1531 a contract was made with Jean Cornaille of Gisors for making the iron cross crowning the steeple. Finally, the work was embellished with gold leaf and on May 22, 1533 Bishop François de Halluin had relics sealed in a gilded silver box and mounted at the tip of the steeple: included were fragments of: the True Cross, the Holy Sepulcher, the table of the Last Supper, Saint Honoré, Saint Thomas, Saint Acheul, and the dalmatic worn by Thomas of Canterbury. Eight statues made of lead-covered oak were placed on the angles around the viewing chamber. To the west is Christ holding the globe, flanked by Paul on his right and Peter on his left. Facing east, the crowned Virgin Mary is flanked by John the Baptist and John the Evangelist. Saint James, dressed as a pilgrim, looks out over the south transept; a bishop, probably intended to represent Firmin the Martyr, looks out to the north. The ensemble makes a compact statement about the identity of the cathedral, echoing the placement of key statues and chapels below. To raise the effigies of the saints and the collection of relics high above the Picard plain was a gesture of defiance in the face of the preaching of Martin Luther. The finished steeple was blessed by Bishop François Halluin on May 22, 1533, three years after the death of our good dean, Adrien de Hénencourt.

The story of the persuasiveness of the plan presented by the village carpenter in words and images has a powerful romantic appeal—one is led to expect a high level of elegant simplicity in the design of the steeple. Yet confronted with the dense forest of lumber in the base of the construction, one's first response is one of baffled disappointment (fig. 5.34)—Viollet-le-Duc himself thought that the design was unreasonable and cumbersome.[95] The great theoretician and restorer of cathedrals had given his careful attention to the design of the Amiens steeple in order to learn lessons for his own work on the new steeple at Notre-Dame of Paris. All subsequent descriptions of the work have drawn upon Viollet-le-Duc's exposition in words and images.

Let us try and capture the essential principles of the design that was conceived in relation to two pressing needs: to resist the pressure of the wind (like rigging for a ship's mast), and to distribute weight to the four corners of the crossing where it could be received directly atop the crossing piers without overloading the already-weakened transverse arches of the crossing. There are three basic elements. First is the steeple itself, composed in its lower levels of a double octagon where the inner and outer frames are diagonally braced (fig. 5.35). As the steeple rises above the level of the main roof of the cathedral the vertical beams of the outer octagon terminate as pinnacles and miniature flyers, and the inner octagon, still firmly braced with diagonals, ascends to the tip of the steeple. Two spectacular openwork chambers mark this point of transition: the lower one housed a peal of bells that were rung at critical points in the Mass and the upper one, a *mirador*, provides exhilarating vistas over the city and Picard plain beyond.[96] At the center of the steeple, extending from base to tip, is an elegant octagonal kingpost (*poinçon*). The second element in the ensemble is the square platform, composed of nine massive beams running north-south, atop which the base of the steeple sits. This platform has been braced in order to make it rigid so that the enormous load it bears will be delivered to the four corners of the crossing square and the great piers that support it. The third element, which has the task of communicating the weight to the corners, are the four great diagonally placed trussed brackets, or *fermes*, which delivered their load securely to the crossing piers. It was necessary to create a kind of bridge mechanism for the sides of the platform in order to render it entirely rigid and capable of delivering its weight mainly on the four corners. This was done by means of triangular assemblies, or *fermes*, mounted atop each

of the four sides: the massive sides of the triangle were linked to the base with vertical stirrups to prevent it from sagging in the middle.[97]

It is difficult to give the exact height of the steeple since it has been modified several times: Georges Durand recorded 57 meters, or 112 meters (367.5 feet) from the ground.[98] The steeple has been struck by lightning many times (a lightning conductor was finally installed in 1834), and has been repeatedly propped up and repaired. For a while it was supported by a great wooden brace sitting atop the north transept. It is a miracle that it still stands, the last trumpet blast of the Gothic made at the threshold of the new world of the Reformation.[99]

Liturgical Performance | 6

Angels in the Architecture

THE MODERN STUDENT may assume that liturgical practice and Gothic architecture were seamlessly linked, as if in some kind of symbiotic relationship.[1] Yet it has proved difficult to fix any kind of causal relationship: to what extent did the development of Gothic architecture result from a response to liturgical needs? It is worth remembering that while liturgical theory and practice tended to change slowly, architectural forms and spaces were transformed remarkably rapidly in the "Gothic" revolution of the later twelfth to early thirteenth centuries. Was this transformation driven by liturgical needs?

Whereas the theories lying behind liturgical practice are defined in multiple written sources and the practices themselves are relatively well documented, no comparable contemporary explanatory exposition—and little documentation—can be found for the conception of the architecture we call Gothic. But it is surely true that we can learn much about the significance of the architectural envelope and the desires of the makers and users through an understanding of the liturgy it contained.

Paradoxically, the most informative source documenting liturgical theory and practice in Amiens Cathedral was written less than half a century before the French Revolution that terminated the life of the chapter. Canon François Villeman of Amiens, in his *Essay de Cérémonial*, laid out a clear justification for liturgical practice, suggesting that although worship that is purely spiritual without visible forms of expression might be claimed by heretics, it was actually only possible for the saints who reside in heaven: ordinary people cannot aspire to such heights, needing outward and visible

signs like the sacraments instituted by Jesus Christ. *The Church, animated by the same spirit, sustains the piety of the faithful by means of exterior rites linked with interior adoration. . . .*[2] Villeman's semiotic explanation of liturgy echoed that of Bishop William Durand, in his *Rationale divinorum officiorum*, written almost five hundred years earlier: "Whatever belongs to the liturgical offices, objects, and furnishings of the Church is full of signs of the divine and the sacred mysteries, and each of them overflows with a celestial sweetness when it is encountered by a diligent observer who can extract *honey from rock and oil from the stoniest ground* [Deut. 32:13]."[3] For Durand, such a system was necessitated by the fact that human beings could not comprehend the heavenly without visual prompts or signs: "we rightly receive the sacraments as signs or figures, since figures are not themselves the virtues but signs of the virtues, just as men are instructed through writing. Moreover, some signs are natural while others are posited by men. . . . Priests . . . must understand these sacraments and shine with the virtues they represent so that through their light, others may similarly be illumined."

Returning to our eighteenth-century canon of Amiens, François Ville-man, we find a most succinct definition of the sense of liturgical practice, *Therefore the Divine Office with all its texts and ceremonies was instituted by the Church to provide God a cult that is agreeable to him, to preserve the majesty of the Christian religion, to elevate spirits to the contemplation of the Mysteries and to excite in us the fervor of holy devotion. We should take especial care with its joyful observation and with the precision demanded by the great Apostle . . . It is thus that animated by the same spirit we will glorify God the Father and Our Lord Jesus Christ with the same heart and the same mouth; we will give a new brilliance to the Mother Church of this diocese, rendering it like the Celestial Jerusalem where the happy render their devotion to God with profound respect, united in an admirable order; we will augment the religion of the people and we will draw down upon us an abundance of grace and the blessings of heaven.*[4]

Canon Villeman then goes on to describe the organization of the daily service of God around the hours of the day, days of the week, and weeks of the year, with the latter marked out in an endlessly repeating cycle of feasts celebrating the principal events in the life and mission of Christ, the Virgin Mary (to whom the cathedral was dedicated) and the saints.[5] His account

of the practices includes many details not to be found in the great *Ordinaire* compiled in 1291 by Raoul Rouvray at the orders of Bishop Guillaume de Mâcon soon after the inauguration of the new Gothic choir with its sumptuous choir screen (*pulpitum*).[6]

In their daily routine, members of the chapter would rise before dawn each morning, walk the short distance from their houses in the cloister on the south side of the cathedral, and pass through the south transept portal where they would be greeted by the Golden Virgin on the central trumeau of the portal and by images of the miracles associated with the sainted bishop Honoré in the tympanum (fig. 2.40). They would then pass around the ambulatory to the sacristy located in the two-story edifice—also housing the head of John the Baptist—adjoining the north choir aisle (figs. 1.23, 3.10, and 4.21).[7] Having put on their clerical robes, they would take their place in the upper ranks of the choir stalls, with the principal officers and senior members of the chapter to the west and the others arranged according to years in office (fig. 5.18).

This operation would be completed nine times or more in the course of the day: with the eight offices and one or more celebration(s) of Mass. The nocturnal and morning services of Matins and Lauds were followed by the six liturgical hours, with Prime taking place after dawn, Terce at midmorning, Sext around midday, None in the afternoon, Vespers at dusk, and Compline after dark. High mass normally followed Terce in the latter part of the morning.

At each of the daily offices a member of the chapter would lead his colleagues in the chanting of the Psalm: a practice that was believed to have originated in the early Church in the east.[8] Extraordinary continuity in liturgical practice is indicated by the fact that François Villeman confirms that the distribution of the Psalms between individual canons who would lead the singing had remained unchanged since the in the early 1200s when it had been reorganized by Dean Jean d'Abbeville.[9] We may assume that the assigned canon would lead off with the opening verse of the Psalm and that the verses were then chanted antiphonally, alternating between the left and right side of the choir—it required little musical skill.[10] However, the Psalms were embellished by other musical performances requiring more ability: these might be performed by choristers and choirboys, sometimes grouped around the eagle lectern in the center of the choir.[11] The content of this material would respond to the various feast days.

Amiens Cathedral had been an important center of musical performance and production since the early Middle Ages.[12] The presence of vicars (*vicarii*) to help the canons in their singing is documented in the eleventh century: the arrangement may have started in Carolingian times. A charter of Bishop Gervin (1091–1102) mentions the presence of three choir boys and a principal singer (*cantor*). There is much evidence to suggest that the years just before the construction of the Gothic cathedral of Amiens saw renewed interest in improving the quality of the singing—this is reflected in the creation of the office of *precentor* in 1218. Just as the material production of the cathedral was organized by the fabric (*fabrique*), musical production was directed by the *maîtrise*, defined in a charter of 1324. It was the task of the *maître du choeur* to recruit the choir boys, numbering between six and ten, and to prepare them—as well as vicars, chaplains, and others—to perform the musical repertoire of the cathedral. The written sources surveyed by Frédéric Billiet in his study of the *maîtrise* of Amiens Cathedral document the presence of a number of well-known masters and composers (most notably Guillaume de Machaut and Jean Mouton), and inventories make mention of numerous choir books. In addition to choral performances, cathedral space would also be filled with the sound of the mighty organ: an instrument existed already by the mid-fourteenth century (it was repaired in 1354), and in 1420 a magnificent new organ with 2,500 pipes—donated by Alphonse le Mire, *recevreur des aides*, and his wife Massine de Hainault—was installed above the west portal.[13]

Whereas the Hours of the Divine Office were a corporate affair involving the entire chapter with two choirs, one seated on each side, the celebration of Mass, the "principal act of worship in the Roman Catholic Church," was a priestly act centered upon the *one* who officiated at the main altar in the sanctuary.[14] The celebrant might be the bishop himself on major feast days, but was generally the dean or some other member of the chapter, assisted by a deacon, subdeacon, and attendants. After a carefully orchestrated sequence of chants and readings, the climax arrives with the Eucharistic prayer of consecration delivered by the celebrant and accompanied by the elevation of the bread and wine, which, through the words and gestures of the celebrant, *become* the body and blood of Christ—a moment depicted in the tympanum of the Saint Honoré portal (fig. 2.43). The dramatically transformative nature of the sacrament is best described in the words of

Miri Rubin, "At the centre of the whole religious system of the later Middle Ages lay a ritual which turned bread into flesh—a fragile, small wheaten disc into God."[15] It will be remembered that the principal altar of Amiens Cathedral was placed exactly at the center of the great circle defining the east end of the chevet—architectural form and sacramental ritual are here perfectly coordinated with Christ at the center.[16]

The repetitive daily sequence of the Divine Office and Mass was relieved by performances relating to the festive cycle of the year. Events associated with the birth and Passion of Christ were part of the "Temporale." Some of these feasts were fixed by the movements of the sun: the coming (Advent) and birth (Nativity) of Christ belong to the season of the winter solstice and fall on the same calendar date each year. The events associated with the Passion and Crucifixion of Christ, on the other hand, responded to the movements of the moon: Easter Day is the first Sunday after the first full moon after March 21. The calendar date for these feasts varies from year to year, but the days of Easter Week are always the same (Palm Sunday, Maundy Thursday, Good Friday, Holy Saturday). Ascension and Pentecost are also moveable feasts, forty and fifty days after Easter.

The other great feast cycle was the "Sanctorale," which included events associated with the life of the Virgin Mary (Purification: February 2; Annunciation: March 25; Assumption: August 15; Nativity: September 8), as well as the saints. The cathedral calendar includes both saints recognized universally, as well as saints of more local interest: at Amiens these local saints include Saint Firmin the Martyr (Invention: January 13; Death: September 25; Entry into Amiens: October 10); Saint Ulphe, Saints Ache and Acheul, and Saint Honoré (May 16); Saint Firmin the Confessor (September 1); Saint Sauve (October 29); and Saints Fuscien, Victoric, and Gentien (December 11). John the Baptist could be considered universal and local at the same time, since the cathedral possessed (and still possesses) his head: his birth was celebrated on June 24, his beheading on August 29, and the reception of his relic on December 17. Particularly important was the feast of All Saints on November 1. Feast days with a fixed date might obviously sometimes fall on a Sunday or upon one of the moveable feasts—liturgical books like the *Ordinary* and the *Ceremonial* were intended partly to resolve such conflicts.

Feast days were classified in a hierarchy with great double feasts at the top, then semi-doubles and, finally, small. At the *magnum duplum cum eo*,

the bishop himself would celebrate mass.[17] At such feasts canons had their beards and the crowns of their heads shaved, lighting was at its highest level with a full complement of candles, nine lessons (the maximum number) were chanted at Matins, the precious relic châsses and silver retable were uncovered, and bells were rung in the central steeple.[18] The celebration of the most important feasts began during Vespers of the previous day and might be carried over into the entire following week (*Octave*).

The relative importance of the feast might also be marked with special representations—*tableaux vivants*—of the event or personage commemorated. Thus, at the Vespers before Christmas, two deacons representing angels would sing at the central eagle lectern in the choir. On the feast of the Purification of the Virgin Mary on February 2, during the mass of the confraternity of Puy Notre-Dame, a beautiful young woman in queenly attire was enthroned upon a podium in the nave, from which she descended to enter the choir and be greeted at the altar by a member of the clergy representing the aged Simeon.[19] On Easter Sunday there was a representation of the women coming to the empty tomb, in the form of the principal altar.[20] At Pentecost lighted wicks and flowers were dropped from the high vaults to represent the descent of the Holy Spirit as tongues of flame (fig. 5.27).[21]

Such representational practices, increasingly considered vulgar and inappropriate for the consumption of the clergy, were mostly suppressed in the early eighteenth century. The same is true for aspects of the fascinating paraliturgical practices projecting the cult beyond the confines of the choir into the spaces of the nave, the cloister, and the city.

Some processions were entirely for the clergy: we have already touched upon the favorite loop around the ambulatory with a station in the axial chapel, the Petite Paroisse. Such stational liturgy could involve exiting the choir in procession and stopping at any of the altars in the cathedral where prayers and responses might be said and sung. In other cases, there was a clear intention to engage the laity: such occasions often involved the crossing space directly to the west of the choir screen, *in medio ecclesiae*. Thus, for example, at the feast of Saint Ulphe her châsse, having been placed upon the high altar the night before, was brought out and placed *in medio ecclesiae*, available for the veneration of the laity.[22] Bells were sounded and incense wafted to sanctify the event. The châsse was then carried out of the cathedral through the south transept portal in a procession around the

cloister, with stations at the churches of Saint-Martin-aux-Jumeaux and Saint-Nicolas-au-Cloître. At Sext it was brought back into the choir and placed upon the altar. Processions through the cloister with stations at these two churches were common; sometimes Saint Firmin the Confessor, to the north of the nave, was also visited.

Let us consider three of the most spectacular paraliturgical events as outlined in the *Ordinaire* from 1291 and in Canon François Villeman's *Cérémonial* from four and a half centuries later.

When the *Ordinaire* was compiled, Epiphany and the feast of the Invention of Saint Firmin were celebrated together between January 6 and January 13 as a first-class feast in the presence of the bishop: *magnum duplum cum eo*. The two feasts were separated soon thereafter. For Vespers on the night before Epiphany the canons had their heads and beards shaved and put on their white robes; the altar was also draped.[23] Two bells were sounded and the candles were kindled. In order to represent the miracle of the Invention, where sweet odors emanated from the tomb and winter's day turned into spring with flowers and leaves, incense was wafted from the space between the principal altar and the little altar to the east. Ivy fronds were strewn through the choir to represent the prolific foliage. At Terce a procession passed through the cloister.

Villeman adds many more details of the celebration as it was elaborated in the later Middle Ages and beyond.[24] We are told that Epiphany used to be celebrated with great solemnity as a great double feast in the presence of the bishop. The clergy put on golden copes and the full complement of candles was lit. The feast was known as the feast of the kings (*la fête des Rois*) and a special epistle known as an *epître farci* was chanted with French mingled with Latin.

At the feast of the Invention and Translation of Saint Firmin (January 13), candles are lit at Vespers to illuminate the story of the saint told in the lateral choir screen in the south aisle. Dignitaries and older canons go behind the altar to dress in white copes to assist the celebrant in the blessing of the incense representing the sweet odor from the tomb. During the chant of the anthem, *Cum aperiretur*, sung by two choirs, one on each side, the sacristan uncovers the châsse of Saint Firmin in front of which seven candles are kindled. A hymn is sung with voices alternating with organ. The chapter is joined in their stalls by canons from Saint-Firmin the Confessor and

Saint-Nicolas on the right and left sides. At Prime the following day there is a procession through the cloister and a station in the nave. Soon before Villeman wrote his *Cérémonial*, a traditional practice that lay at the heart of the paraliturgical performances of the Amiens clergy had been abolished: the appearance of the Green Man (*l'homme vert*). Villeman notes that this action was taken *in order to prevent the irreverence that would happen in the church . . . at the arrival of the man dressed in green who would come into the choir to present floral crowns to my lords* This green man, representing the miracle of the flowers and leaves at the discovery of the body of Saint Firmin, was played by the beadle of the church of Saint-Firmin-en-Castillon. The practice was finally dismissed as a gratuitous *divertissement au petit peuple* (amusement for the common folk)—such playful reenactments did not appeal to the seriousness of the canons of the mid-eighteenth century who set about dismantling the more popular paraliturgical manifestations, just as they demolished medieval tombs and shrines— including the choir screen that had provided such a vital staging point from which to reach out to the laity.[25]

Now let us turn to our second illustration from Palm Sunday liturgy. We learn from the *Ordinary* that prior to Vespers the night before Palm Sunday the canons were shaved—beards as well as the crowns of their heads.[26] The châsse of Saint Domice was placed upon the altar ready for the procession next day. At Prime the clergy, robed in red, are led by the precentor. Standing atop the choir screen (*pulpitum*) the bishop, wearing a black cope with a white miter, blesses the palms to be distributed to the people. In the procession that follows, the clergy wear white albs: the left and right sides of the choir follow different routes—the right side led by the precentor and the left by the chanter, both wearing red. The right side carries the châsse of Saint Domice as well as the venerable processional cross known as *Baiart*. The two choirs took two different processional paths. The right one went through the main western portal and headed downtown and through the corn market, passing through what was the old Roman gate, then heading east toward the Priory of Saint-Denis. The left-hand choir followed the shorter route, going through the south transept portal across the cloister to the same location. There they listened to a Gospel reading from Matthew 21 recounting the Triumphal Entry of Christ into Jerusalem. The two processions returned as one back through what was once the eastern gate of

the Roman city, known in the Middle Ages as the Porte de l'Arquet—the Arched Gate or the Jerusalem Gate— where they sang *Gloria laus*, the magnificent Easter hymn composed in the ninth century by Theodulph of Orléans (c. 750–821).[27] On reentry into the cathedral a station was made *in medio ecclesiae*. Canon Villeman confirms that the form of the celebration remained remarkably unchanged. He adds that the bishop, after reentering the cathedral and making the final station in front of the great crucifix on the choir screen, strikes the choir door three times for reentry.[28] The ritual of the procession has thus transformed city and cathedral into Jerusalem, and has linked the reception of Christ with the reception of the body of Saint Firmin celebrated on January 13.

Ascension Day was marked by the most spectacular procession of all—one that provided a highly visible testimony to the close bonds between the clergy and townsfolk.[29] Representatives of the different professional and trade groups participated, carrying their processional *mais*—festive expressions (like carnival floats) of their corporate identity. The renewal of the term of city authorities, mayor and aldermen took place at this time. An extraordinary feature of the procession was the deployment of great serpents known as *papoires* with articulated jaws that could snap. The châsse of Saint Firmin the Martyr was carried out of the cathedral by a group of nobles and then across the city by a group of bourgeois. It was the occasion for the display of fine clothes and hats embellished with flowers. The procession passed out through the main west portal of the cathedral and headed to the church of Saint-Firmin-à-la-Porte on the western side of town. Here there was a great stone known as the *Pierre Saint Firmin*. Resembling an altar, this stone was thought to mark the location of a miracle that took place in 1137 when the châsse, intended for a relic quest in the surrounding area, refused to leave town.

The *Ordinary* specifies that to honor the day the canons had their beards and heads shaved and they put on white copes. There is express mention of the serpents—*duo capita admodum serpentum*. After the return to the cathedral there is a station *in medio ecclesiae*.

Villeman provides more narrative detail.[30] After Lauds, eight canons of matching height gather up the châsse of Saint Firmin the Martyr from the altar and carry it into the nave singing *Laudamus*. There follows a procession with choirboys carrying torches and a chaplain carrying Saint Firmin's

arm reliquary—this and the châsse are deposited in the nave. Prime at 7:30 a.m.—two vicars in green copes go down to the chapel of Saint John the Evangelist at the west end of the north nave aisle, and are joined by three canons from the abbey of Saint-Martin-aux-Jumeaux: they process back up into the choir. The great procession leaves the church at 8:00 a.m. to make the station at the Pierre Saint Firmin, returning by a different route. At the head of the procession are representatives of the different profession and trade groups (*corps de métier*) wearing floral crowns and carrying torches with their insignia attached. Then come the "Pilgrims of Saint James" with their hoods and staffs, each carrying a candle. Next are the members of the different religious orders of the city: Capuchins, Minims, Cordeliers, Jacobins, and Augustinians, each with their cross. The secular clergy of all the parishes of the city then process with their crosses, followed by the four banners, the crosses, and the candlebearers of the cathedral. The châsse of Saint Firmin is carried by two aldermen and six bourgeois. At the rear is the bishop and his officers, and then the officers of the municipality. The procession returns to the cathedral with the great organ playing. Finally, the châsse is redeposited in the nave. Villeman adds some interesting notes on the papoires: *formerly they used to carry dragons or serpents, which in Amiens were called papoires, and which during the march of the procession were carried at the end of a pole through which it was possible to make the teeth clack against each other through the manipulation of a cord making a loud noise to scare the children. These monstrous heads represented, so they said, the images of extraordinary flies [mooches] that used to infest the air from which came great contagions.* Villeman notes the parallels with the *Garguille* of Rouen, the *Mere-folie* at Dijon, the *Tarasque* at Tarascon, the *Duc d'Urbin* at Avignon and the *Prince d'Amour* at Aix-en-Provence. He suggested that they might also signify the copper gargoyles guarding the city gate in Richard de Fournival's *Roman d'Abladane*. He concludes that a few years earlier the chapter had "wisely" abolished the custom of carrying the dragons.

Let us conclude this survey of paraliturgical practices with a glimpse of a most unexpected event with unique power to bind together makers and users. We have seen that the labyrinth in the nave pavement (fig. 1.40) provides the most powerful expression of the identity of the masons, presented as the inheritors of the artifice of Daedalus—but how did it serve the

interests of the clergy and layfolk? Craig Wright has documented the role of the labyrinths of Auxerre, Chartres, and Sens Cathedrals in the joyous celebration of Easter Day, the central feast of the Christian year.[31] On Easter Sunday before Vespers, members of the Auxerre Cathedral clergy would perform a kind of ring dance in and around the labyrinth, which was set in tiles in the nave pavement. As they danced, the clergy would sing the Easter sequence "Praises to the Easter Victim," *Victimae paschali laudes.* With the dean standing at the center, canons and chaplains joined hands and danced in and around the loops of the maze, passing from hand to hand what appears to have been a leather ball (*pilota*)—perhaps a reference to the ball of twine that had provided salvation for Theseus. Members of the upper levels of the urban community witnessed the celebration and participated in the feast that accompanied it. The words of the hymn celebrated the triumph of Christ over death: *The Innocent Christ has redeemed the sinners to the Father. Life and Death have been joined in a wonderful battle. The leader of life rules, living though dead.*[32] More fragmentary evidence suggests that the same celebration took place around the labyrinths at Sens and Chartres Cathedrals.[33]

The palpable delight and the spiraling gyrations of modern visitors on encountering the Amiens maze provide some compensation for the loss of this wonderful, joyous practice.[34]

And so, the offices, sacraments, ceremonies, and festivities rolled on apparently endlessly, driven by the turning hours of the day and seasons of the year—in other words, by shifting *light*. The Gothic cathedral of Amiens, with its enormous windows, provides an ideal receptacle for the effects of the daily cycle of the sun. The first rays shine through the glass of the axial chapel, where the infancy of Christ and the Tree of Jesse (fig. 3.21) were depicted in the stained glass; and through the axial window of the choir clerestory, where the Virgin Mary is presented in a window by Bishop Bernard d'Abbeville (fig. 3.23) and the Annunciation is depicted below in the triforium. Through the glowing colors of its enormous windows, the edifice changed a natural phenomenon—light—into something miraculous. Particularly striking was the effect of the morning rays of the sun coming through the eastern window of the chapel of the Conversion of Saint Paul, known as the Chapel of the Dawn, or *Chapelle de l'Aurore* (fig. 1.48). The midday sun would blaze upon the gilding of the Golden

Virgin (fig. 2.44), set in the south transept portal, and would animate the brightly colored angels dancing in the south transept rose (fig. 3.27). The setting sun would illuminate images of the end of time in the Last Judgment tympanum of the west façade and would penetrate the glass of the western rose, which probably originally contained images of the Apocalypse; the present rose replaced the original one around 1520 (fig. 3.28). The steeple, placed exactly at the center of the cathedral and glittering in gold leaf, is like the finger of a sundial, marking the daily solar trajectory.[35]

The deployment of *artificial* light was also turned to serve the purpose of conveying affect and meaning. The morning and evening offices took place before sunrise and after sunset when, on feast days, the choir would be ablaze with candles: twelve candelabras placed on the choir screen, twelve more on the "Glory Beam" in front of the sanctuary, and additional candles on and in front of the main altar. The lighting and extinguishing of these candles were used to great effect. On a particular saint's feast day, candles would be lit just as the glittering châsse containing the bones of that saint was uncovered. Candlelight would also flash upon the silver retable behind the main altar. The reverse effect was achieved in the evening office on Ash Wednesday, when the blackness associated with the Crucifixion of Christ was achieved through the extinguishing of one candle after each Psalm and lesson so that at the end of the service the clergy sat in complete darkness.[36] An intense awareness of shifting light conditions is conveyed in the 1291 *Ordinaire* that records the number of hours of light and darkness each month, as well as equinoxes and solstices.[37]

Cathedral spaces were animated not only with light but also with sound. Some historians have suggested that the users of the Gothic cathedral deliberately baffled interior spaces with hangings in order to deaden the acoustics. However, at Amiens an eighteenth-century source commented that a lively acoustic ambience was actually desired—copper vessels had been inserted in the pierced keystones in order to augment the repercussion of voices, *making the Echo*.[38] In our own age we have become so used to the cracked and distorted noises issuing from the loudspeakers of the public address system that we may have lost awareness of the natural role of cathedral spaces in the broadcasting and transformation of sound. On September 18, 2018, thanks to the tireless and inspired work of Susan Boynton, Benjamin Bagby, and Frédéric Billiet, we assembled a small group of singers in the choir.

We remained in the cathedral for seven hours in the gathering darkness as they sang. Three microphones were placed: in the choir, the crossing space, and at the west end of the north nave aisle. The music can be heard on the website, www.learn.columbia.edu/amiens, "The Choral Experience." What we demonstrated was that far from being excluded from the performance of the Offices, lay people entering through the west portal during the Offices would experience the spaces of the entire cathedral singing along with the singers. Sounds are diffused and mysterious, but very audible—the source of the heavenly music is not at first clear, since voices are picked up and bounced back by multiple vaulted surfaces. Sound seems to be coming from everywhere. In the middle of the cathedral, on the other hand, choir singing is heard to perfection.[39] The expanse of the transept arms seems to take the individual voices of the singers and blend them beautifully. This blending is lost in the choir itself, where the music seems to be the result of a combination of individual voices rather than a totality.

So what, finally, was the relationship between the Gothic architecture of the cathedral and liturgical practice? Canon Villeman reminds us emphatically of the upward-lifting (anagogical) force possessed by the ceremonies of the church: *Indeed, the ceremonies, if they are well done, inspire piety, excite virtue, instruct and form the spirit, elevating and touching the heart; exciting the soul and detaching it from the earth to carry it up to heaven, attaching it to God. . . .*[40] The notion of the upward-lifting force of the church with its liturgy can be documented throughout the life the Gothic Cathedral: we learn from the writer of the *Ordinaire* compiled around 1200 that such performance resulted from *the necessity that the Church Militant should imitate, albeit from afar, the praises to God offered by the heavenly hosts.*[41] And we have seen that the crossing space, *in medio ecclesiae,* was in every sense at the heart of liturgical performance. As if to enhance this notion of the cathedral singers as the heavenly hosts in their praise of God, angels emphatically make their presence felt here in the middle of the church.[42] Magnificent sculptured images of angels adorn the interior frontispiece of the south transept portal, while the south transept rose is entirely populated with brightly colored angels who soar and plunge into cathedral space (fig. 3.27). And there, in the distance, we can experience the bevy of angels who attend the donation of the axial clerestory window (fig. 3.23). Angels in the architecture, animated by light and sound. . . .

Epilogue

L ET US FINALLY RETURN to the question I posed at the beginning: How best to represent a monument of overwhelming scale and beauty that is very much part of our own time and space, yet one that simultaneously beckons us to enter into ineffable worlds beyond our own?

In our age of digital miracles, we can provide compelling visual and aural representations of the cathedral online—I have repeatedly exhorted the reader to open the attendant website (www.learn.columbia.edu/amiens) where high-resolution, zoomable images, together with animations and liturgical music, provide dimensions impossible to achieve on the printed page.

In the book itself I have pursued three avenues of access. First, I am convinced that we cannot treat the cathedral entirely as if it were an object detached from ourselves, a specimen to be analyzed. We must insert ourselves by approaching, entering, and moving through. By "approaching" I mean conceptually and historically, as well as visually and physically. Does this necessitate the intervention of a guide or interlocutor: one who points and talks, telling us what we can see and what remains invisible? I have made the case for the "humble" interlocutor—one who recognizes that he or she has no contract with the cathedral, yet hopes to prompt the audience to see things that they might otherwise miss, and is also able to supply vital information about the vanished past. I have also invoked the notion of *ductus*—the almost involuntary forward movement induced by the cathedral visit. As we enter and move through cathedral spaces we experience various kinds of *transformation*, and even the skeptical modern visitor may be moved to consider the miraculous. The lifelike sculpture

of the western portals, once brightly painted—a kind of medieval virtual reality—provides a direct invitation to turn this sense of the miraculous into the stories of the saints whose salvific relics were enshrined in the sanctuary; into the veneration of the Virgin Mary, Sainte Marie d'Amiens; and into the hope of the resurrection of the body.

In the second avenue of approach the role of the interlocutor becomes more pressing, invoking the lost presences of the medieval clergy, the artisans, and the laypeople who frequented the cathedral. It is easiest to talk about the role of the clergy: their presence is palpable in the magnificent choir stalls where the oak is polished to a high sheen by the swish of vestments and the touch of many hands. That sense of clerical presence is enhanced by the experience of the episcopal tombs, leading us to recognize the role of the building bishops.

The presence of the masons is enshrined not just in the central plaque of the labyrinth recording the names of the master masons, but also in the characteristic forms of the cathedral itself, which reveal quite clearly the roles of each master. We have also attempted to tease out some understanding of the role of the sculptors and glaziers, who, it must be admitted, remain tantalizingly elusive.

Even more elusive are the medieval lay users of the cathedral. Yet, we have documented their gifts of windows and chaplaincies, and have found physical testimony of the life of the once-powerful confraternity of the Puy Notre-Dame with their altar in the south transept. And who can forget the images of the woad vendors who "made" the chapel of Saint Nicholas with their contributions (fig. 3.19)?

The linear sequence imposed by the pages of a book lends itself best to storytelling—this is our third avenue of approach. I believe that the story of Amiens Cathedral has sometimes been misrepresented through too much emphasis on the fifty years of initial construction work—the cathedral was *not* "complete" by "1269." By extending the "life" of the Gothic cathedral to the late Middle Ages (a chapter of three hundred years), I anchor it more securely in the glorious eight-hundred-year lifespan, 1220–2020, that we celebrate in this anniversary year. And I have energized my story of cathedral construction by focusing upon the *desire* of the builders for a spectacular new space to showcase the reforms associated with the Fourth Lateran Council of 1215. Seen in this way, the 1218 fire might

even have been considered a godsend, allowing the clergy to deploy their very substantial resources to the creation of a custom-designed space to meet their expanded needs. In order to achieve the object of their desire the clergy were led into a kind of plot: this was a *spatial* phenomenon, where the vision of the cathedral began as ropes stretched out and staked to the ground; and it continued as a *social* phenomenon, leading to an almost symbiotic relationship with the master builders and a wider set of collaborations with lay people in order to accomplish the great enterprise. Understood in this way, the first part of our story reaches a first crescendo in the 1270s when the clergy were finally able to take their seats in the grand new choir to the accompaniment of magnificent liturgical celebrations, like the 1279 transfer of the relics of Saint Ulphe. The crowning achievement of the great roof followed quite soon afterward, accompanied quite probably by a central crossing spire.

But all was not well. The upper façades of the transept arms and western frontispiece had been left unfinished and the inner structural forces in the Gothic edifice were working themselves out in the progressive deformation of the bays on each side of the crossing. Facilities vital to the life of the chapter were still not available (cemetery and chapter house), and the users of the cathedral felt the growing need for more space to accommodate the privileged dead (chantry chapels). Finding the necessary funds for major construction work was increasingly difficult, given the extended war with the English (Amiens was on the front line) and recurrent pestilence. Our story reaches a second crescendo with the near-collapse of the central crossing and the heroic installation of the great iron chains in order to arrest further movement. The choir is richly refurbished and the old steeple, destroyed by a lightning bolt in 1528, is replaced by one even more beautiful.

I have anchored this great story with matching bookends—a start soon after the critical battle fought close to Amiens at Bouvines, where the defeat of Plantagenet and imperial forces ensured the future of France within geographical bounds that began to resemble those of the modern nation. And an ending where the renewed unity of the city of Amiens with the Crown is expressed in the mingled fleurs-de-lys and the ivy (the insignia of Amiens) in the stained glass of the great west rose. Seen in terms of the unity and power of the Catholic church, the resonance of start and finish was less propitious: it started with the triumph of Catholicism marked by

the great Church Council of 1215 and the defeat of heresy, and ended with the increasing power of Martin Luther's ideas in the sixteenth century.

I have sometimes imagined our last great building dean, Adrien de Hénencourt, as an old man propped up on his perch representing Noah's Ark in his magnificent stall in the choir. Directly in his line of vision are images of the drunkenness of Noah and the two dreams of Pharaoh (fig. 5.23). Did our dean have his own dream? We can imagine him nodding off during the long hours of the Office and his great predecessor appearing to him. Dean Jean d'Abbeville shares his reminiscences of the glorious building project launched in his time over three hundred years earlier. Perhaps the founding master mason, Robert de Luzarches, adds more insights on the architectural plot underlying cathedral forms and spaces. And our late Gothic Master Pierre Tarisel joins in to scold him a little for failing to anticipate the problem of the buckled crossing piers and leaving his successors a major problem to fix. Any thoughts of a secure and easy conclusion for the long odyssey were jolted by the lightning bolt that destroyed the central spire, leading the builders to face one last great challenge. The result was the magnificent steeple we still see today, where Christ, the Virgin Mary, and the saints still witness the daily circling of the sun and watch over the city at their feet (fig. 1.7).

Glossary

AEDICULA: from Latin *aedes* or house: a small space-enclosing shrinelike feature. In gothic an aedicula is often framed by colonnettes and capped by gables.

ALB: a long, flowing, sleeved white linen tunic, symbol of purity, worn with a girdle; the common clerical garment of a priest celebrating Eucharist.

AMBULATORY: the curving passageway surrounding the hemicycle and sanctuary of a church.

AMICE: a collar, perhaps derived from a hood, worn around the neck.

ANTIPHONAL: a liturgical book containing the chants for the Divine Office

ANTIQUE REVIVAL: the conscious reference to the forms of antiquity associated in architecture with the use of columns and in the figurative arts with contrapposto stance and crinkled, or damp-fold drapery.

APSE: see HEMICYCLE.

ARCADE: a line of arches.

ARTIFEX: an artist. Medieval thought conflated human with divine creativity: thus God might be depicted holding a compass like a master mason

AXIAL CHAPEL: the central chapel, often opening from an ambulatory.

BALDACHIN: a canopy, sometimes with ceremonial functions.

BANDEROLE: a strip of text used to allow a figurative work of art to speak.

BAR TRACERY: see *TRACERY*.

BASILICA: a longitududinal structure—as opposed to centralized.

BAY: a vertical slice of space, square or rectangular, rising from four corner supports at ground level to a ceiling or vault.

BEFFROI: a tower, generally containing bells.

CANON: member of the regular clergy of a cathedral or collegiate church; he receives a *prebend* (income in cash and kind) from the estates of that church.

CATHEDRAL: seat (*cathedra*) of a bishop.

CEPHALOPHORE: a decapitated person, generally a saint, who miraculously carries his or her own head.

CHAPEL: discrete space with an altar for the celebration of Mass and other offices; commonly occurring architectural forms include radiating (from the ambulatory), axial and lateral.

CHASUBLE: a sleeveless outermost sacramental garment worn by priests and bishops during the Eucharist.

CHÂSSE: container for relics, often made of wood sheathed in richly decorated silver and gold.

CHEMIN DE ROND: a passageway running atop the wall of a castle or fortification.

CHEVET: the "head" of the church extending east of the crossing space and transept.

CHOIR: the area where the clergy sit, often accommodated in sumptuous stalls.

CLERESTORY: the uppermost level of a multistory church, generally pierced with great windows.

CLOISTER: in monastic architecture, a galleried passage forming a square linking the church with the dormitory and refectory.

CLÔTURE: screen, often enclosing the lateral edge of the choir.

COLLEGIATE CHURCH: the seat of a body of regular clergy or canons, headed by a dean, not a bishop.

COLONNETTE: a thin, cylindrical shaft attached to a vertical element in order to express support for arches and ribs.

CONFRATERNITY: group of laypeople engaged in spiritual and social activities in support of the church.

COPE: a ceremonial cape, often richly embroidered, opening at the front and reaching to the ankles.

CORPS DE MÉTIER: group of professionals, artisans or tradespeople (butchers, bakers, candlestick makers etc.).

CROSSING PIER: an oversized pier marking the intersection of the main vessel of the church with the transept.

CROZIER: see STAFF.

CRUCIFORM: cross-shaped.

CULÉE: the massive upright supporting the arch of a flying buttress.

CUSPED ARCH: an arch with decorative internal lobes formed from circular segments.

DADO: a blind arcade at the base of a wall, often below the aisle windows.

DALMATIC: the long, sleeved outer garment of deacons, often richly decorated.

DANSE MACABRE: the dance of death; a common image in 14th-century painting.

DOUBLE SQUARE: can have two meanings: a square inside another or a rectangle made of two contiguous squares.

DUCTUS: from Latin *ducere*, to lead: the almost-involuntary passage through a work of art or architecture.

EMBRASURE: the splayed walls flanking an opening such as a portal or window.

EUCHARIST: the central sacrament of the Catholic church celebrating the sacrifice of Jesus where bread and wine become the body and blood of Christ.

FABRIC: the material envelope of the church or the institution (*fabrica*) established for its construction and maintenance.

FERME: a triangular carpentry structure lending rigidity, especially to a roof.

FILLET: a decorative molding applied to an arch or a support, often almond-shaped, sometimes with a flattened front edge.

FLAMBOYANT TRACERY: the decorative stone elements supporting the glass of a window where the patterns embody curvilinear or double-curved shapes.

FLEUR-DE-LYS: stylized lily having three leaves or petals; the insignia of France.

FLYING BUTTRESS: exposed segment of an arch supporting the wall (generally upper) of a church.

GALLERY: an upstairs space generally occupying the entire width over the aisle, with a floor and windows in the outer wall.

GEOMETRIC TRACERY: the decorative stone elements supporting the glass of a window where the patterns embody shapes formed around circles and segments of circles.

GISANT: tomb effigy.

GLACIS: see WEATHER MOLDING.

GRISAILLE GLASS: colorless, translucent glass, popular in the later thirteenth and fourteenth centuries.

HEMICYCLE: the half-rounded or polygonal space often forming the eastern termination of a church. A hemicycle may have a surrounding passage or *ambulatory;* an apse does not.

HODEGETRIA: depiction of the Virgin Mary as "god bearer" (theotokos) holding the infant christ at her side.

INVENTION: the discovery (*Inventio*) of a relic of a saint.

JUBÉ: (from the invocation, *Jubé, Domine, benedicere*) a screen marking the division between space designated for the use of the clergy and the space for laypeople. Also known as a *pulpitum,* the screen often supports a gallery for sermons and readings.

KEYSTONE: stone celebrating the center point of an arch or vault.

LABYRINTH: in Gothic, a decorative floor panel (octagonal or circular) marked with a complex looped pattern reminiscent of the legendary labyrinth built by Daedalus on the island of Crete.

LANCET: a vertical panel topped by a pointed arch: generally found in window tracery, but also used to articulate wall surfaces.

LIERNE: a linking element in a complex rib vault.

LINTEL: the horizontal top of a window or door frame.

MANIPLE: a liturgical handkerchief bound around the wrist.

MISERICORD: "mercy seat": a projecting bracket attached to the underside of a hinged seat providing support for the occupant while standing.

MITER: double-pointed cap worn by bishops.

MONTÉE: elevation.

MOUCHETTE: an asymmetrical double-curved element of flamboyant tracery shaped like a tadpole.

MOULE: a template or mold.

MULLION: vertical support, generally in a window.

NAVE: from latin *navis,* boat; can be applied to the entire central vessel of a church, but more correctly to the area to the west used by lay people.

OCULUS: a circular element, generally forming the upper part of a window.

OGÉE: an arch where the crown is pinched into a tightly pointed tip.

PARVIS: the square in front of the main portals of a church.

PENDANS: literally "hangers"—the small stones making up the web of a vault.

PENDANT: a suspended architectural element, often embellished.

PERPENDICULAR STYLE: applies to late medieval architecture in England where articulation is dominated by vertical paneling.

PILIER CANTONNÉ: a support formed of a central cylindrical core flanked by four small shafts or colonnettes placed on the axes of the core.

PISCINA: a basin set in the wall of a church or chapel for ritual ablution.

PLATE TRACERY: see *TRACERY.*

PORTAL: large ceremonial doorway.

PRISMATIC MOLDING: applied to arches or supports where the shapes are dominated by polygonal rather than rounded forms.

PULPIT: elevated podium to facilitate the delivery of sermons (preaching).

PULPITUM: see *JUBÉ.*

QUADRATURE: the practice of inscribing a diagonally turned square inside a larger square. The area of the smaller square will be half that of the larger.

RELIC: a fragment of a holy person: generally part of the body, but can also be a garment.

RINCEAUX: stylized foliate frond, often curled like a scroll.

ROSE: a circular window.

SACRISTY: a space attached to the flank of the choir to accommodate clergy as they robe and disrobe and for the storage of liturgical garments and equipment.

SCOTIA: a deeply grooved element in a complex molding profile.

SEDES SAPIENTIAE: throne of wisdom. the term is applied to images of the infant Christ on the lap of the Virgin. The image expressed the Christian belief that the incarnation of Christ extended and transformed the Old Testament order associated with the wisdom of Solomon.

SEVERY: the segment or web of a vault stretched between the arches and ribs.

SOCLE: the lowest part of a wall or support, often with a projecting ledge or plinth.

SOFFIT: inner surface of an arch.

SOUFFLET: a symmetrical double-curved element of flamboyant tracery shaped like bellows, or a leaf.

STAFF (CROZIER): shaped like a shepherd's crook; the essential sign of episcopal office.

STALLS: see CHOIR.

STASIS: state of inactivity of equilibrium.

STATIONAL LITURGY: where the clergy leave their choir, generally in procession, to conduct a ceremonial visit and pray at other sacred locations.

STOLE: a long narrow strip of decorated cloth, often fringed, draped around the neck: sign of clerical ordination.

TABLEAU VIVANT: a "living picture" generated when a static group of people recreate a scene in a story or theatrical play.

THEOPHANY: the visible intervention of the divine in human affairs.

THRUST: the outward force generated by the action of gravity upon arched masonry.

TIERCERON: a rib that does not reach the central keystone in a complex vault pattern.

TORUS: a fully rounded molding.

TRACERY: stone armature in an opening, generally a window; plate tracery is formed of thin slabs of stone cut to form openings; bar tracery is formed of sticks of stone.

TRANSI: effigy of a cadaver sometimes incorporated in a late-medieval tomb.

TRANSOM: horizontal bar of tracery; associated with English late Gothic "perpendicular" architecture.

TRANSVERSE: running across the axis of a longitudinal structure.

TREE OF JESSE: symbolic tree with Old Testament figures embodying the genealogy of Christ.

TRIFORIUM: the middle level of the elevation occupying the space between the top of the arcade and the point where the lean-to roof over the aisle butts against the main vessel. Often articulated with a band of arches and a passageway in the wall thickness.

TRUMEAU: central support in a portal.

TYMPANUM: the area, often richly decorated, between the lintel of a doorway or window and an enclosing arch, round or pointed.

VAULT: a masonry canopy; in Gothic architecture generally articulated with crisscross projecting ribs.

VOUSSOIR: a stone, generally wedge-shaped, forming part of an arch.

WEATHER MOLDING (glacis): projecting rim applied to a buttress or wall to throw off rain-water.

Notes

Prologue

1. David Goldblatt, *Art and Ventriloquism*, x–xii.
2. You may also do a quick Internet search for the project's home page using "Life of a Cathedral: Notre-Dame of Amiens."
3. John Ruskin, *The Bible of Amiens*.
4. John Ruskin, *The Bible of Amiens*, 91.
5. Mary Carruthers, "The Concept of *ductus*, or Journeying Through a Work of Art." How can the writer attempting to describe Amiens Cathedral forget the words of its most famous chancellor, Richard de Fournival?

 > All men naturally desire knowledge. . . . Wherefore God, who so loves man that He wants to provide for his every need, has given him a particular faculty of mind called Memory. This Memory has two doors: Sight and Hearing. And to each of these two doors a pathway leads, namely Depiction and Description. Depiction serves the eye and Description serves the ear. . . . Memory . . . renders the past as if it were present.

 See Richard de Fournival's *Bestiary of Love and Response*, 1.
6. Stephen Murray, *A Gothic Sermon*.
7. This date is not found in the primary written sources, but is repeated by the antiquarians of Amiens.
8. This celebration was anticipated in the 2012 publication of Mgr. Jean Bouilleret's sumptuous edited volume *Amiens: la grâce d'une cathédrale*. The volume offers studies bearing upon the entire life of the cathedral down to the present.

1. Visiting the Cathedral

1. Villard de Honnecourt (active 1230s) provides an excellent example of a medieval layman who was clearly driven to articulate verbal responses to the architectural forms of the Gothic, displaying remarkable understanding of form and command of nomenclature. See Stephen Murray, *Plotting Gothic*, 17–46.
2. Conrad Rudolph, "The Tour Guide in the Middle Ages."

3. Louis Douchet, *Manuscrits de Pagès*, 5: "Description de la cathédrale d'Amiens." For other such early modern visits to the cathedral, see Pierre Janelle, "Le voyage de Martin Bucer et Paul Fagius de Strasbourg en Angleterre en 1549," and Alex Eeckman, "Un voyage en Flandre, Artois et Picardie en 1714." For a modern visit conceived in the spirit of John Ruskin, see Thomas Perkins, *The Cathedral Church of Amiens*.

4. Louis Douchet, *Manuscrits de Pagès* 5: 76–77. Notably, it was not just the rich who gave money—Pagès tells us that *a praiseworthy and holy desire to do the same animated the citizens of Amiens at that time to donate their wealth for the construction and decoration of the cathedral*. Pagès documented the role of the professional corps and communities of merchants in the windows "*in which were represented in lively colors the different instruments and tools they used in their professions.*" All italicized texts in the notes are my own translations into English of the French or Latin originals.

5. Louis Douchet, *Manuscrits de Pagès* 5: 69: *the centers of these rib vaults are formed by two matching curved lines forming diagonal arcs, intersecting at the summit where the keystones are pierced through.* . . .

6. Louis Douchet, *Manuscrits de Pagès* 5: 62.

7. Louis Douchet, *Manuscrits de Pagès* 5: 439, where the author remarks that the somber obscurity of churches was thought to inspire *la sainte horreur dans l'âme* (holy terror in the soul) and more respect for the sacred ministry—the faithful can participate without having their eyes penetrate the barriers screening off the choir.

8. Louis Douchet, Manuscrits de Pagès 5: 451–52: *Yes, indeed, I will repeat it once again: the citizens of Amiens are fortunate every day to be able to hear this great host of canons, clergy, chaplains, chanters, and choirboys mingling their voices in worship of their sovereign Lord with such devotion: singing the sacred psalms composed by the prophets, filled with the spirit of God.*

9. "Where are the snows of yesteryear?" François Villon, 1461.

10. Christine Bonneton (ed.) *Amiens* 11–19.

11. On Amiens in the Roman period, see Didier Bayard and Jean-Luc Massy, *Amiens romain*; see also *La marque de Rome: Samarobriva (Amiens) et les villes du nord de la Gaule*; and Ronald Hubscher, *Histoire d'Amiens*, 14–46.

12. A Celtic *oppidum*, La Chaussée-Tirancourt, existed just downstream from Amiens—this may have been where Caesar summoned the council of the Gauls. See Didier Bayard and Jean-Luc Massy, *Amiens romain*, 28–35.

13. Didier Bayard and Jean-Luc Massy suggest that the foot unit employed at this time was the *pes drusianus* of 0.332 or 0.333 meters; see their *Amiens romain*, 50.

14. Didier Bayard and Jean-Luc Massy have also proposed that in the new grid, the foot unit was the *pes monetalis* of 0.296 meters. This was the foot unit used in medieval Amiens, including during the construction of the cathedral.

15. Brian J. Campbell, *The Writings of the Roman Land Surveyors*. More recently, Laure Miolo, "Science des nombres, science des forms," 161–164, has shown that writings on the practical geometry of the *agrimensores*, as well as more modern adaptations of Arabic geometry, were present in the library of Richard de Fournival, chancellor of Amiens Cathedral in the mid-thirteenth century.

16. John Ott, *Bishops, Authority and Community*, 237; Pascal Montaubin, "Le clergé de la cathédrale," 311. The story of the life (*Vita*) of Saint Firmin the Martyr was not written down until the tenth century; Saints Victoric and Fuscien of Amiens appear already in the sixth-century list of saints known as the *Martyrologe hiéronymien*; see Élie Griffe, *La Gaule chrétienne* 3: 163.

17. The story is told in the *Vita* of Saint Sauve (Lat.: Salvius). A church dedicated to the Virgin Mary was built on the site.

18. According to apocryphal sources from the eighth and ninth centuries this second Firmin was the son of the senator converted by Firmin the Martyr.

19. *Acta Sanctorum, Septembris VII,* 30F (my translation): *On the discovery (invention) of the body of Saint Firmin the martyr, under January 11 in the Life of Saint Sauve, we read the following: Since people did not know where the body of Christ's holy martyr lay, thanks to the instructions of the Holy Spirit he [Sauve] came to the place where Christ's martyr lay; and, raising his eyes to heaven, with indescribable terror he saw lit up, as if by a ray of light coming from a lofty throne, the place where Saint Firmin lay. Grateful for this great sign of divine mercy, he began quickly and very reverently to dig and to open the tomb of the holy martyr. The odor that emanated was so sweet and alluring that it was if all kinds of colors and scents were crushed together and the countryside was alive with the beauty of various flowers. He [Sauve] raised him [Firmin] up from the tomb and set out for the city [of Amiens], the people bearing the holy martyr. Crowds of people rushed up along the way, throwing their clothes on the road and crying in a loud voice: "Hosanna in the highest; blessed is he who comes in the name of the Lord." The most blessed Bishop Sauve placed [the body] in the eastern crypt of the splendid church that he had ordered to be constructed in honor of the said martyr, and buried him with dignity and honor, embellishing the tomb with gold and gems. Everyone there thought that white lilies and live roses, and other green plants and flowers, were beautifully sprouting from inside the tomb; and the more people that came to the holy miracle the greater became the odor; and it flowed over the entire diocese of Amiens widely spreading its pleasant stream to the other cities of the diocese. And the entire populations of the cities of Thérouanne, Cambrai, Noyon, and Beauvais, satiated at that time by the sweetness and delicacy of that wonderful odor, thought that they had come to the delights of paradise. . . . And all the priests and clergy and population of both sexes from the aforementioned cities rose up with candles and with palms, singing hymns and psalms with rapid step on their way to Amiens; thus they doubtlessly came to the martyr Firmin as if each one had his own teacher and guide. Approaching the city of Amiens they saw such miracles as had not been seen before or after, nor spoken of in the entire world. Soon, as the venerable Bishop Sauve and the religious, priests of God, raised Firmin from his tomb, the substance of all the elements was changed, and such a boiling heat came into the world that all the people present, stupified and in a state of ecstasy, were amazed.*

20. Élie Griffe, *La Gaule chrétienne* 3: 214. On the ninth-century translation of relics from funerary shrines outside the walls to churches inside the city of Rome, see Caroline J. Goodson, *The Rome of Paschal I,* 197, "The popular, erratic celebration of the saints that took place on different days throughout the calendar year came under the roof of Papal churches within the city."

21. A number of such sarcophagi still survive in the crypt of the church at Saint-Acheul.

22. Didier Bayard and Jean-Luc Massy, *Amiens romain,* 269–70.

23. Peter Brown, *The Cult of the Saints,* 3–4.

24. In the quatrefoil images of virtues in the central portal, *Charity* is depicted dividing a cloak. But none of the column figures represents Saint Martin. For a translation of the *Life of Saint Martin,* see Thomas F. X. Noble and Thomas Head eds., *Soldiers of Christ: Saints and Saints' Lives,* 1–29.

25. Thomas F. X. Noble and Thomas Head, eds., *Soldiers of Christ: Saints and Saints' Lives*, 7. For a very useful summary of what we know about Saint Martin at Amiens, see Didier Bayard and Jean-Luc Massy, *Amiens romain*, 250.

26. See François-Xavier Mantel, "L'abbaye de Saint-Martin-aux-Jumeaux"; see also Jacques Foucart, "À propos de la controverse sur la localisation de la porte martinienne d'Amiens," 283–304. Gregory of Tours tells us of an oratory founded on the site of the miracle; in 1073 Bishop Guy de Ponthieu rebuilt the church and established a chapter of canons that later adopted the Augustinian rule. Control of that church passed from the hands of the counts to the bishops of Amiens; see John Ott, *Bishops, Authority and Community*, 249ff. The relic of Saint Martin's cape was only acquired in 1277, and was later (1478) housed in a magnificent reliquary given by King Louis XI. The silver-gilt container was formed as a city gate with images of Martin and the beggar.

27. The idea of a fabulous lost past was expressed in an extraordinary book by a clerical writer who may have been a disciple of Richard de Fournival in Amiens in the later thirteenth century: *Le Roman d'Abladane*, ed. and trans. Giovanni Palumbo. The author tells the story of a city, Abladane, that was once the jewel of Europe and the envy of Rome, and protected by a range of magical devices created by its resident sorcerer.

28. Robert Fossier, *La terre et les hommes en Picardie*; see also Georges Duby, *Early Growth of the European Economy*, esp. 263–70 where Duby identifies the most dynamic period of economic change as occurring around 1180.

29. Amiens was a late-Roman manufacturing center for arms.

30. Eleanor Mary Carus-Wilson, "La guède française en Angleterre, 89–105."

31. "Feudal" servitude had already disappeared in the area of Amiens and Beauvais by around the turn of the first millennium; see Edouard Maugis, *Recherches sur les transformations du régime politique et social de la ville d'Amiens*. See also Pierre Desportes, "Le mouvement communal," 108.

32. Stephen Murray, *A Gothic Sermon*, 23–24.

33. Stephen Murray, *Building Troyes Cathedral*, 25.

34. John H. Munro, *Textiles, Towns and Trade*, 15–16.

35. John H. Munro, *Textiles, Towns and Trade*, 28.

36. Dieter Kimpel, "Le développement de la taille en série."

37. Pierre Desportes, "Le mouvement communal;" John Ott, *Bishops, Authority and Community*, 222–26; and Louis-François Daire, *Histoire de la Ville d'Amiens*1: 59, where it is affirmed that Louis VI established the Amiens commune in 1113 but the original charter had been lost.

38. Roland Hubscher, *Histoire d'Amiens*, 57–58.

39. Bishop Geoffroy was, in this respect, quite unlike many other bishops who opposed the communal movement.

40. Count Enguerrand's son was elected bishop and supported the commune; for more on this, see Roland Hubscher, *Histoire d'Amiens*, 59.

41. Jean Massiet du Biest, *La carte et le plan*, 3, discusses the process by which the commune assumed rights previously held by the count: the process, for which there is no documentation, must have happened by the last decades of the twelfth and first decades of the thirteenth century.

42. Roland Hubscher, *Histoire d'Amiens*, 69.

43. Jean Massiet du Biest, *La carte et le plan*, 3.

44. Thérèse de Hemptinne, "Aspects des relations de Philippe Auguste avec la Flandre au temps de Philippe d'Alsace," 257.

45. Yves Renouard, "1212–1216: Comment les traits durables de l'Europe occidentale moderne se sont définis au début du XIIIe siècle."
46. Jacques Boussard, "Philippe Auguste et les Plantagenêts."
47. Leslie C. Brook, "A [sic] translation de la relique de Saint Jean-Baptiste à la cathédrale d'Amiens: récits latin et français."
48. Georges Duby, *Le dimanche de Bouvines*.
49. Gérard Sivéry, *Louis VIII, le lion*, 154.
50. Dieter Kimpel and Robert Suckale, *Die gotische Architektur in Frankreich*, 67. Kimpel and Suckale compare the spread of Gothic churches over the map with the control of England sought by William the Conqueror, and argue that William's desire for control was made visible through the construction of castles and churches.
51. See Johann Georg, Prinz von Hohenzollern, *Die Königsgalerie der französischen Kathedrale*.
52. Robert Lopez, "Économie et architecture médiévales: cela aurait-il tué ceci?" See also Barbara Abou-el-Haj, "Artistic Integration Inside the Cathedral Precinct: Social Consensus Outside?"; and Jane Welch Williams, *Bread, Wine and Money*.
53. André Mussat, "Les cathédrales dans leurs cités."
54. Prescott Stephens, *The Waldensian Story*.
55. A transcription of the 1226 document can be found in Stephen Murray, *Notre-Dame, Cathedral of Amiens*, 132. The tax constituted recognition of the role of Saint Firmin in the establishment of the commune and the commutation of the toll known as *tonlieu* paid by the townsfolk to the count. See also Henri Bouvier, *Histoire religieuse*, 300–302, who suggested that the total annual sum collected by the cathedral treasury amounted to 180 pounds per year.
56. Stephen Murray, *Notre-Dame, Cathedral of Amiens*, 26 and 132.
57. Let me provide here already a brief overview of construction. Work began in 1220 to replace the mid-twelfth century cathedral dedicated to Saint Firmin and Notre Dame. The Gothic cathedral at Amiens—among French cathedrals, second only to Beauvais in height—is constructed of hard chalk drawn mostly from a subterranean quarry located under a pre-Roman *oppidum* at La Chaussée-Tirancourt, about ten miles downstream from Amiens. After laying a vast foundation raft, the builders rapidly constructed the lowest part of the outer wall up to the aisle window sill (not including the polygonal east end). Aisle windows, interior supports, and aisle vaults were begun in the south transept and eastern bays of the south nave aisle. The nave was built from east to west with the south flank going up before the north. The aisle walls and supports of the choir (down to the hemicycle) were begun at the same time. The upper nave dates to the 1230s, the lower walls of the radiating chapels to the 1240s, and the upper choir to the 1250s. The date of "completion," 1269, is provided by the inscription in the axial window of the choir clerestory donated by Bishop Bernard d'Abbeville. However, at this date the roof had still not been built. Work continued through the later Middle Ages, with the lateral nave chapels added in the late thirteenth to fourteenth centuries, the west towers in the late fourteenth century, and major repairs and consolation in the late fifteenth century. The original central steeple burned in 1528, and was replaced by the present Late Gothic unit.
58. The vibration between macro and micro is an essential part of the power of the cathedral.
59. The lateral spread of the transept is almost exactly one-half of the total length of the cathedral.

60. Jacques Thiébaut, "Beffrois, halles et hôtels de ville," 51–57.

61. The rose itself probably belongs to the mid-fourteenth century. The little buttresses are not integrated with the tracery of the rose, suggesting that they were added later.

62. The stones of the circular oculus do not merge with the stones of the enclosing arch. This merging was achieved quite soon afterward.

63. See Marvin Trachtenberg, *Building-in-Time*, 132–43, for a categorization of the different kinds of "change" in a building project such as this.

64. In other words, should form follow function? Should a structural member expressing architectural support incorporate the same forms as a nonsupportive element, such as window tracery? See David Watkin, *Morality and Architecture*.

65. It is a variation on the theme established circa 1240 in a similar position in the interior of the north transept of Notre-Dame of Paris by master mason Jean de Celles.

66. Georges Durand, *Monographie* 2: 613. After the Revolution, the building was used for a while as a chapel for catechisms until it was transformed (1850–1853) into a sacristy by Viollet-le-Duc, who rebuilt part of the old gallery that had been demolished in 1806. The chapter house probably dates from the decades around 1300, when the new Gothic choir was first being put to use.

67. The existing trumeau figure is actually a replica installed in the 1980s. The original Virgin has withdrawn to the shelter of the south transept.

68. The nave south aisle was probably assigned for use by the clergy and parishioners of the church of Saint-Firmin the Confessor, demolished to make way for the cathedral: the little portal provided access while work was still underway on the great west portals.

69. John Ruskin, *The Bible of Amiens*, 7. There are about a dozen entrances into the cathedral, not including those now blocked. The three western portals and two in the transept façades are the most evident, the former used mainly by laypeople and the south transept portal by canons. The little portals into the western bay of the southern nave aisle and on the western sides of the transept arms may have had an important role in the early years of construction while work was under way on the main portals. Artisans might pass directly from the Cour de l'Oeuvre on the south side of the choir through a small doorway in the choir aisle, while the bishop had his own entrance (now blocked) that was accessible via a raised gallery on the opposite side. Two fourteenth-century doorways in the westernmost radiating chapels led to the cemetery gallery that encircled the choir.

70. The original nave aisle windows were about the same size as the clerestory, but look larger because of their proximity to the viewer.

71. The rear wall of the triforium projects beyond the arcade wall and is carried by relieving arches.

72. Georges Durand, *Monographie* 1: 459: the original pavement was made of stone tiles about 37 centimeters square with white stone from Senlis and black "marble" from Belgium. Much of the pavement (especially the choir and south transept) had already been repaired or replaced when it was renovated between 1827 and 1830. The existing pavement (1894–1897) is a replica of the lost original based upon graphic sources.

73. Black and white "marble" pavements with meander patterns are to be found in a number of churches in the Low Countries, including the cathedral of the Saint Savior (Sint-Salvatorskathedraal) in Bruges; the cathedral of Saint Bavo (Sint-Baafskathedraal) in Ghent; and the cathedral of Saint-Rombaut (Sint-Rombautskathedraal) in Malines: see Thomas F. Bumpus, *The Cathedrals and Churches of Belgium*.

74. The hidden symmetry in the pattern was first established by Stephen Murray; see *Notre-Dame, Cathedral of Amiens*, 170–73.

75. The pages of medieval manuscripts contain considerable numbers of images of labyrinths: the essential work of classification was done by Wolfgang Haubrichs, "*Error inextricabilis.*" The type of pattern employed in the octagonal labyrinth at Amiens Cathedral, identical to the circular labyrinth of Chartres, appears to have developed in the late Carolingian period. A useful overview of labyrinths in French cathedrals can be found in Craig Wright, *The Maze and the Warrior*, 37–71. The missing central brass plaque of the Chartres Cathedral did, indeed, contain an image of the Minotaur. Other than Amiens, the lost labyrinth of Reims Cathedral was the only other one to feature the master masons at the center.

76. The power of *enchantment* is explored by Michael T. Saler, *As If*, esp. 3–13. The enchantment exercised by the Gothic cathedral is the principal theme of Paul Binski, *Gothic Wonder*.

77. Mary Carruthers, "The Concept of *Ductus*, or Journeying Through a Work of Art." The notion of a journey has obvious religious connotations as the advance of the Christian toward union with God; see Zachary Hayes, *The Hidden Center*, 213: "the perception of all created things in terms of passage or journey is deeply rooted in the texts of Scripture." The forward passage in the cathedral is best grasped through the sequential images on the website, whose home page can be found at: www.learn .columbia.edu/amiens.

78. Peter Brooks, *Reading for the Plot*, xi–xv; Stephen Murray, *Plotting Gothic*, 197–204.

79. Mary Carruthers, *The Book of Memory*.

80. Arnold van Gennep, *The Rites of Passage*; see also Edith and Victor Turner, *Image and Pilgrimage in Christian Culture*.

81. Is this a reference to the Hexameron (the six days of Creation) and the seventh day when God rested? See Zachary Hayes, *The Hidden Center*, 194–95.

82. Dieter Kimpel and Robert Suckale, *Die gotische Architektur in Frankreich*, 59, interpret this intensification of form or *Steigerung* in light of the liturgical function of the choir.

83. Jacqueline E. Jung, *The Gothic Screen*; Françoise Baron, "Mort et résurrection du jubé de la cathédrale d'Amiens"; Charles Little, "Monumental Gothic Sculpture from Amiens in American Collections."

84. Stephen Murray, *A Gothic Sermon*.

85. This is partly due to an overzealous campaign of cleaning (or scraping) that took place some decades ago.

86. François-Xavier Maillart and Aurélien André, "La confrérie du Puy Notre-Dame."

87. The sculptured elements of the altar, as well as the sculptures over the marble plaques recording the name of the masters, were the work of Nicolas Blasset c. 1627–28, who himself was master of the confraternity; see Christine Debrie, *Nicolas Blasset*, 160–67.

88. A pun playing on *puits* (well) and *puy* (podium).

89. The cusp is created with additional arcs or segments of circles inscribed inside the frame of the pointed arch, creating a trilobed shape. It is used for the first time by Master Pierre de Montreuil at Notre-Dame in Paris and by Thomas de Cormont here in the Amiens chapels.

90. Abbot Suger reflected on the upper chapel at Saint-Denis thus:
"How secluded this place is, how hallowed , how convenient for those celebrating the divine rites has come to be known to those who serve God there as though they were already dwelling, in a degree, in Heaven while they sacrifice."

And in the Pilgrims' Guide, having compared the cathedral of Santiago de Compostela with a royal palace, the author comments:

"For he who visits the galleries, if sad when he ascends, once he has seen the preeminent beauty of this temple, is rejoiced and filled with gladness."

For the texts, see: Erwin Panofsky, *Abbot Suger*, 45; and Caecilia Davis-Weyer, *Early Medieval Art*, 148.

91. Rory O'Neill, "Gothic on the Edge," 239.
92. Dieter Kimpel and Robert Suckale, *Die gotische Architektur in Frankreich*, 59.
93. It is tempting to associate the three different types of foliate band with the tenure of the three master masons: Robert de Luzarches in the nave, Thomas in the transept, and Renaud de Cormont in the choir.
94. The problem of buckled crossing piers is endemic in Gothic architecture; see André Masson, "Le bouclement des piliers de la croisée de Saint-Ouen de Rouen."
95. Eric Fernie, "A Beginner's Guide to the Study of Gothic Architectural Proportions and Systems of Length."
96. At this height the photographer will not need a perspective-correction lens to achieve perfect alignment of verticals.
97. The clue that leads to this hypothesis is the chamfered edge of the enclosing arches of the triforium inner wall on the southern side of the nave. Such a chamfered edge is unusual in a continuous wall and it is noticeable that on the northern side, constructed a little later, the chamfer is missing.

2. The Portals: Unscrambling the Plot

1. On the sculptural program of the west portals of Amiens see: Georges Durand, *Monographie* 1: 299–458; Wolfgang Medding, *Die Westportale der Kathedrale von Amiens und ihre Meister*; Willibald Sauerländer, *Gothic Sculpture in France*; Wilhelm Schlink, *Der Beau Dieu von Amiens*; Paul Williamson, *Gothic Sculpture*, 141–46; Stephen Murray, *Notre-Dame, Cathedral of Amiens*, 103–23; Dany Sandron, *Amiens: la cathédrale*, 106–50; Iliana Kasarska, "Construire un décor sculpté: le portail de la Vierge dorée (Amiens); Iliana Kasarska, "La sculpture des portails"; and Bruno Boerner, "L'iconographie des portails sculptés des cathédrales gothiques."
2. Arnold van Gennep, *The Rites of Passage*. On the power of the portal to induce movement and to persuade, see Paul Binski, *Gothic Sculpture*, 18–49.
3. The design of the deep portals each capped by a gable owes much to Laon Cathedral.
4. Note that because the prophets have been much more exposed to the weather than the other column figures they are badly eroded—in photographs the resolution tends to look soft.
5. Adolph Katzenellenbogen, "The Prophets on the West Façade of Amiens Cathedral."
6. Karl Young, *The Drama of the Medieval Church* 2: 121–71. The *Ordo Prophetarum* was a reenactment designed for performance on Christmas Day or during the Christmas season. In addressing unbelieving Jews and Gentiles the sermon invoked a sequence of messianic prophecies. Most exciting for the Amiens figures is the development of a liturgical performance of the *Ordo* where the prophets would actually appear and testify: the Laon text even provides some specification of how each prophet should look. The Amiens sculptural sequence was not derived directly from the *Ordo* (which included Virgil, Nebuchadnezzar, and the Erythraean Sibyl), and

the prophecies depicted in the Amiens quatrefoils have nothing to do with the *Ordo*. In the Rouen performance of the *Ordo* the prophets would go in procession from the cloister and present their testimony in the nave, after which they would sing from the elevated platform of the jubé. At Notre-Dame of Paris the office was performed between Matins and Mass on Christmas morning; see Craig Wright, *Music and Ceremony at Notre-Dame of Paris*, 112.

7. All the quatrefoils are illustrated and their texts provided on the project website, whose home page is www.learn.columbia.edu/amiens.

8. Most published accounts of the sculpture start their exposition with the central portal, which does indeed provide the point of generation of what we will learn to recognize as God's plot for human salvation.

9. Marcia R. Rickard, "The Iconography of the Virgin Portal at Amiens."

10. Pierre Janelle, "Le voyage de Martin Bucer."

11. The originality of the scheme can be assessed through a comparison with the north portal of Notre-Dame of Paris. Although the Parisian cathedral provided the prototype for the tympanum, it does not embody the drama of the Epiphany and the Annunciation.

12. Stephen Murray, *A Gothic Sermon*, 83.

13. Marie-Louise Thérel, *Le triomphe de la Vierge-Église*. The August 15 feast of the Assumption of the Virgin celebrated the reception of the uncorrupted body of Mary into heaven, borne up by her son, Jesus Christ. First celebrated in fifth-century Jerusalem, the feast then passed into Byzantine liturgical practice. Skepticism in the western Church about such apocryphal accounts of the physical assumption of the Virgin, uncorrupted by death, delayed the acceptance of the practice in the West until the seventh century. Widespread acceptance came only in the eleventh century, helped by Honorius of Autun's commentary on the Song of Songs in which he identified the bride celebrated in the Song with the Virgin Mary, and the Virgin with the Church— the bride of Christ as preached by Bernard of Clairvaux. The great popularity of the image in the twelfth century resulted, above all, from its deployment in the mosaic decoration of the apse of Santa Maria in Trastevere, where rebuilding was initiated by Pope Innocent II (d. 1143). With the vigorous support of Bernard of Clairvaux, Pope Innocent resisted the challenge posed by the antipope Anacletus II, who was supported by Duke William X of Aquitaine and King Roger II of Sicily. In this context the image gained resonance as expressing the Triumph of the Church. In the mosaic the Virgin (the Bride, or *sponsa*) holds a scroll with the text (Canticles 2:6): "His left hand is under my head and his right hand doth embrace me." Christ holds a book with the text from the Golden Legend, : "Come, my chosen one, and I shall put thee on my throne."

14. Revelation 21:2, "And I, John, saw the Holy City, the New Jerusalem, coming down from God out of heaven prepared like a bride adorned for her husband."

15. Explanations of the various items of clerical garb are provided in the glossary.

16. Stephen Murray, *A Gothic Sermon*, 41.

17. These images resonate with concerns of corruption in the priesthood raised by participants during the Fourth Lateran Council of 1215 and also in the preaching of Dean Jean d'Abbeville.

18. The stories of the local saints were gathered together uncritically by Jules Corblet, *Hagiographie du diocèse d'Amiens*.

19. Ulphe was believed to have died in 776.

20. The term "Antique Revival" was coined to describe the intense interest on the part of artists in all media (sumptuous arts, manuscript painting, stained glass, and

monumental sculpture) in forms probably borrowed from surviving fragments of Roman sculpture, particularly contrapposto stances and damp-fold drapery.

21. The well, still visible in the north choir aisle close to the chapel, probably served in the cult.

22. For the text, see chapter 1, note 19.

23. It may have been derived from the enameled images that adorned the châsse of the saint.

24. This portal, like the Virgin Mary portal, was once illuminated by a lantern hanging from the enclosing arch: the hole for the suspensory cable is still visible. The illumination could be understood as the miraculous beam of light that led the way to the lost tomb of the saint.

25. For the text, see chapter 1, note 19.

26. John Ott, *Bishops, Authority and Community*.

27. The placement of Paul on Christ's right was an early Christian tradition found especially in the *Traditio Legis*—in the apse mosaic at Santa Costanza, for example. But more importantly, Paul tells us about the resurrection of the body (depicted above), and was also the patron of Dean Jean d'Abbeville, who probably devised the program.

28. Wilhelm Schlink, *Der Beau Dieu von Amiens*, 52–53, quotes Peter Lombard (1095–1160): "The door is Christ. . . . To enter the door means to enter Christ. Entering through him means copying him (*imitari*), becoming like him." David Bell, *The Image and Likeness*, 111, quotes I John 3:2: "we know that when he shall appear, we shall be like him; for we shall see him as he is." See also Robert Javelet, *Image et resemblance*.

29. Wilhelm Schlink, *Der Beau Dieu von Amiens*, 13, notes that the placing of Christ on the trumeau is new—the immediate precedent was the south transept, center portal at Chartres Cathedral. At Amiens three images of Christ are stacked one atop the other: in addition to that of the trumeau, the tympanum features Christ the Judge in the middle and the Apocalyptic Christ at the tip.

30. Emile Mâle, *Religious Art in France, the Thirteenth Century*, 43–44: the lion was understood as anti-Christ, and the dragon as the devil.

31. Wilhelm Schlink, *Der Beau Dieu von Amiens*, 55. The reading of Matthew is the Gospel for the first Sunday in Lent.

32. Wilhelm Schlink, *Der Beau Dieu von Amiens*, 45, points out that contemplation of this model was especially appropriate during Lent, and suggests that the book held by Christ refers to Matthew 4.4 "It is written, 'Not in bread alone doth man live, but in every word that proceedeth from the mouth of God.'"

33. Matthew 24: 29–31: "Immediately after the tribulation of those days shall the sun be darkened, and the moon shall not give her light, and the stars shall fall from heaven, and the powers of heaven shall be shaken. And then shall appear the sign of the Son of Man in heaven; and then shall all the tribes of the earth mourn, and they shall see the Son of Man coming in the clouds of Heaven with power and great glory. And he shall send his angels with a great sound of trumpet, and they shall gather together his elect from the four winds, from one end of heaven to the other."

34. Peter Brooks, *Reading for the Plot*, xi: the idea is pursued in Stephen Murray, *Plotting Gothic*, 9.

35. Also known as *imagiers* or *ymagiers*. The written sources from the late Middle Ages at Amiens favor the term *tailleurs d'images*.

36. Jean Ribaillier, "Jean d'Abbeville." D'Abbeville's study of Jerome's commentaries on the prophets may also lie behind the unusual choice of the twelve minor prophets to form the frontispiece of the Amiens sculptural program. For a summary of secondary

sources on Jean d'Abbeville, see Stephen Murray, *Notre-Dame, Cathedral of Amiens*, 121, esp. notes 103–113.

37. Beryl Smalley, *The Study of the Bible in the Middle Ages*, 83–105.

38. Conrad Rudolph, *The Mystic Ark: Hugh of Saint Victor*.

39. Song of Solomon 5:4: "My beloved put his hand by the hole of my door and my bowels were moved for him."

40. Bruno Boerner, *Par Caritas par Meritum*, 145–80. The debate involved the mechanism of human salvation. Saint Anselm in *Cur Deus Homo* had emphasized the state of grace through the incarnation and crucifixion of Christ: this is worked by God alone. However, an influential group of theologians in twelfth- and thirteenth-century Paris began to place more emphasis upon the consequences of the actions of the individual in choosing virtue and avoiding vice.

41. Bibliothèque nationale de France, Collection de Picardie, 158, fol. 131–138; Stephen Murray, *A Gothic Sermon*.

42. Larissa Taylor, *Soldiers of Christ: Preaching in Late Medieval and Reformation France*, 86.

43. This combination was first used in the western portals of the abbey church of Saint-Denis c. 1140, assuming that the north portal originally contained a mosaic representation of the Coronation of the Virgin.

44. Pierre Janelle, "Le voyage de Martin Bucer."

45. Christopher Weeks, "The 'Portail de la Mère Dieu' of Amiens Cathedral: Its Polychromy and Conservation," 101–08.

46. Ephesians 2:19–22: "Now therefore, ye are no more strangers and foreigners, but fellow citizens with the saints and of the household of God. And are built on the foundation of the apostles and prophets, Jesus Christ himself being the chief cornerstone; in whom the building fitly framed together groweth into an holy temple in the Lord; in whom ye also are builded together for an habitation of God through the Spirit." Similarly, Paul in 1 Peter 2: 4–5: "To whom coming, as unto a living stone, disallowed, indeed, of men, but chosen of God and precious. Ye also, as living stones, are built up a spiritual house, and holy priesthood."

47. Joachim Poeschke, *Italian Mosaics: 300–1300*.

48. Stephen Kuttner and Antonio Garcia y Garcia, "A New Eyewitness Account of the Fourth Lateral Council."

49. In discussing the loquaciousness of Gothic portals, specifically those of Amiens, Paul Binski invokes Richard de Fournival's image of the two portals to memory—the portal of images (*painture*) and the portal of words (*parole*); see Binski, *Gothic Sculpture*, 35.

50. The tracery pattern was derived from the inner decoration of the north transept at Notre-Dame of Paris.

51. Adolf Katzenellenbogen, "Tympanum and Archivolts on the Portal of St Honoré at Amiens," 1; Dieter Kimpel and Robert Suckale, "Die Skulpturenwerkstatt der Vierge Dorée am Honoratusportal der Kathedrale von Amiens."

52. An interior frame was intended from the start, but installation and completion were delayed: note the presence of an inner trumeau awkwardly placed alongside the outer one.

53. To the east the street might also be closed by a wooden barrier, ensuring the security of the cloister.

54. Elie Berger, *Saint Louis et Innocent IV*, 246. See also William Chester Jordan, *Louis IX and the Challenge of the Crusade*, 20–21; and Gerard Campbell, "The Protest of Saint Louis."

55. The anti-mendicant party was led in the 1250s by Guillaume de Saint-Amour; see Decima L. Douie, *The Conflict between the Seculars and the Mendicants*."

56. In general, imagery of the Virgin Mary is kept to the south, and that of the saints to the north. However, we have seen that while the north transept trumeau carries a bishop, its base has images of the Annunciation and Nativity, which suggests that the Virgin Mary had been intended here.

57. The "archaic" look of the composition is sometimes cited as evidence of the early start of work here. Although I favor the idea of such an early start, I must point out that the composition is carved in shallow slabs and may have resulted from later insertion.

58. Dieter Kimpel and Robert Suckale, "Die Skulpturenwerkstatt der Vierge Dorée," favor a date in the late 1230s; Willibald Sauerländer, *Gothic Sculpture in France*, 175, believed that the work was only done after the 1258 fire.

59. Iliana Kasarska, "Construire un décor sculpté: le portail de la Vierge Dorée," 32–37.

60. Kasarska has documented signs of disjunction between the lintel and tympanum and the framing arch of the voussoirs; see "Construire," 37.

61. Matching the eloquence of our anonymous preacher's panegyric offered to Saint Mary of Amiens, see text on title page.

62. Paul Williamson, *Gothic Sculpture*, 145–55; see also Xavier Dectot and Meredith Cohen, *Paris, ville rayonnante*, 91–93.

3. Clergy, Artisans, and Laypeople: Makers and Users

1. Didier Bayard and Jean-Luc Massy, *Amiens romain*, 264: the authors suggest that Saint Martin's miracle, datable to 334–335, provides clear written evidence of the existence of a Christian community in Amiens, where the saint had probably been baptized.

2. The road had been interrupted by the construction of the city wall.

3. Didier Bayard and Jean-Luc Massy, *Amiens romain*, 270; John Ott, *Bishops, Authority and Community*, 226–28. On the location of churches directly contiguous with city walls, see Élie Griffe, *La Gaule chrétienne* 3: 29. Griffe emphases the importance of the patronage of the Emperor Constantine in both Rome and Trier as setting the stage for the establishment of city churches in the mid-fourth century in Gaul. The Roman precedent of the great episcopal church on the edge of the city and the tomb-shrine of the saint outside the city walls was echoed repeatedly in the north.

4. Pascal Montaubin, "Aux origines du quartier épiscopal," 17.

5. Didier Bayard and Jean-Luc Massy, *Amiens romain*, 264, note that two sarcoph-agi found at Saint-Acheul bear Christian inscriptions of a fourth-century date. For sixth-century inscriptions found close to the cathedral, see Pascal Montaubin, "Aux origines du quartier épiscopal," 18.

6. Charles Munier, ed., *Concilia Galliae*, 27. The Council dealt with the issue of the divinity of Christ, a tenet that had been questioned by Bishop Eufratus of Cologne who was roundly attacked by Eulogius as *falsus doctor*. Scholars have questioned the authenticity of the Cologne record, which may have been copied from an earlier text associated with the Council of Sardique: see Élie Griffe, *La Gaule chrétienne* 1: 180; see also Didier Bayard and Jean-Luc Massy, *Amiens romain*, 256.

7. Pascal Montaubin, "Aux origines du quartier épiscopal," 18.

8. Kathleen Edwards, *The English Secular Cathedrals*, 3–4; Charles Dereine, "Chanoines," 353–405. The *Parvum Decretulum* of Chrodegang of Metz drew extensively upon the

Benedictine rule; it was then codified in the "Rule of Canons (*Institutio Canonicorum Aquisgranensis*) disseminated after the 816 Council of Aachen. Celibacy and obedience were required, and daily liturgical activities were similar to those of a monk. However, while cathedral clergy originally shared a dormitory and refectory, they increasingly resided in their own houses, holding possessions of their own. The designation "canon" (*canonicus*), meaning "regular," was applied already by Chrodegang. Such clergy became known as "secular" in order to distinguish them from their monastic colleagues. As a corporate group they constituted a *chapter*, in reference to the monastic practice of daily reading of a chapter of Saint Benedict's rule or the scriptures. On the legal underpinnings of the cathedral chapter, see Wolfgang Schöller, *Die rechtliche Organisation des Kirchenbaues im Mittelalter*, 86–105.

9. Pascal Montaubin, "Aux origines du quartier épiscopal," 19. Saint Gregory of Tours mentions an oratory on the site of Saint Martin's miraculous encounter with Christ in the guise of a beggar at the city's eastern gate. In 1073 Guy de Ponthieu, bishop of Amiens, installed canons leading a regular life under the rule of Saint Augustine. Subsequently Saint-Martin became an abbey free of dependence upon the cathedral chapter. The abbey was favored by the bishops of Amiens, some of whom were buried there. The monastery was closed in 1634 and eventually demolished. The adjacent "twin" collegiate church of Saint-Nicolas-au-Cloître was established in 1073 by Dreux, bishop of Thérouanne, with the blessing of the bishop of Amiens. A magnificent new church with deep portals and western towers was begun in 1093.

10. Raoul de Rouvroy, *Ordinaire*, xl. Although called a "cloister," the precinct had no surrounding gallery or wall like a monastic cloister. It was bounded by four roads: the rue du Cloître Notre-Dame to the north (alongside the cathedral), the rue du Cloître de la Barge to the south, the rue du Cloître Saint-Nicolas to the east, parallel with the cathedral transept, and the rue du Cloître de l'Horloge to the west, level with the cathedral frontispiece. The rue du Cloître Notre-Dame remained a public thoroughfare, though it might be closed off at each end.

11. Jean Massiet du Biest, *La carte et le plan*, plate III.

12. Pascal Montaubin, "Le clergé de la cathédrale," 339–40. In 1371 the value of an Amiens prebend was estimated at 70 livres, whereas it was 40 at Noyon; 50 at Beauvais and Soissons; 60 at Arras, Laon, Reims, Thérouanne, and Tournai; and 75 at Châlons-sur-Marne. Canons would also receive distributions in cash and in kind at certain offices.

13. On the composition of the chapter, see Pierre Desportes and Hélène Millet, eds., *Fasti Ecclesiae Gallicanae*, 52–53; see also William Mendel Newman, *Le personnel de la cathédrale d'Amiens*. In the thirteenth century many canons were *maîtres*—university graduates, having studied canon law, generally in Paris.

14. Ann K. Warren, "Chapter House," 266–67. The conduct of such meetings in a custom-designed space or chapter house conveyed authority to enactments or statutes. If necessary, however, meetings might take place in the house of the dean or one of the clergy; see Kathleen Edwards, *English Secular Cathedrals*, 29, note 1.

15. François Villeman, *Essay d'un Cérémonial*, Arch. Somme, MS G3031 65v: *Great care has always been taken in churches to conserve the order and the succession of the bishops who governed them, since this provides a proof of the unity of doctrine and ministry which have come down to us uninterrupted from the apostles. Each of them had received [it], from Jesus Christ; and they handed it down to the bishops whom they ordained, and who followed by ordaining others, [thus] making a continuation and perpetuity of religion which will last until the end of time.*

16. Jean-Baptiste Lebigue, "La liturgie médiévale."

17. William Mendel Newman, *Le personnel de la cathédrale d'Amiens*. The principal families came from Heilly, to the east of Amiens; from Abbeville, to the north; and from Boves, to the east. On the dominant role that representatives of local landed families played in cathedral chapters, see also Newman, *Les seigneurs de Nesle en Picardie*.

18. Christopher Lucken, "Parcours et portrait d'un homme de savoir."

19. Richard de Fournival, *Master Richard's Bestiary of Love and Response*.

20. After his death his precious library was bequeathed to the Sorbonne.

21. This situation changed at the end of the thirteenth century, after which time outsiders might be imposed by the king or pope.

22. This status was expressed in the annual payment made each year by each citizen of Amiens. The tax was known as the "Respite" of Saint Firmin because it represented a relief or commutation of the older, more onerous taxes on merchandise. It was reduced from three to two *deniers* a year in 1226; on this, see Stephen Murray, *Notre-Dame, Cathedral of Amiens*, 132. Taxes were also paid to the bishop on marriage and death.

23. The bishop was also assigned a seat in the upper stalls, toward the east end on the north side.

24. The income of the bishop of Amiens was tallied at 2,005 livres in 1371. Within the province of Reims this would put him in the lower echelon: Thérouanne, Laon, Arras, and Noyon were tallied at 3,200; Tournai at 4,000; Beauvais at 5,000; and Reims at 6,000: see Pascal Montaubin, "Le clergé de la cathédrale," 337.

25. The sculptural programs of the cathedral allow us to see the formation of the Apostolic image of the clergy in at least three different ways. First, the image of the clergy was derived from Christ's relationship with the apostles (west façade, center portal column figures). Second, that image was derived from the legendary missionaries, Firmin and his associates, who brought Christianity to Picardy. This is made clear in the sculpture of the north portal of the west façade and in the south transept portal, where stolid local (Picard) clerical types are depicted in the column figures, while the Biblical apostles can be found in the lintel directly above. Finally, in the lintels of the two lateral portals of the west façade we see bishops formed in the image of Old Testament patriarchs.

26. The practice of passing in procession to specific altars in the cathedral for prayers and chants is sometimes called stational liturgy, in reference to the offices said in the various churches of Rome.

27. Abbé Jean-Baptiste Roze, "Nécrologie de l'église cathédrale d'Amiens," 265–503. It has been suggested that the so-called baptismal font in the north transept was, in its original function, a bath for the ritual washing of deceased clergy: see Jacques Foucart-Borville, "Les fonts baptismaux de la cathédrale," 10–12. See also Paul Binski, *Medieval Death: Ritual and Representation*.

28. Jules Corblet, *Les tombes en bronze*; Aurélien André, "Les tombeaux de bronze d'Evrard de Fouilloy et de Geoffroy d'Eu," 28–29. In 1762 the tombs were moved to the side of the main entrance, and in 1867 to their present location.

29. A small hole allows us to assess the thickness. The image was cast using the lost wax method.

30. For an explanation of the elements of clerical attire, see the Glossary.

31. Beginning over the bishop's head:

+QUI POPULUM PAUIT: QUI FUNDAMENTA: LOCAVIT+
HUIUS STRVCTVRE; CVIUS FUIT URBS DATA CURE+

HIC REDOLENS NARDVS; FAMA REQUIESCIT EWARDVS+
UIR PIVS AFFLICTIS VIDVIS: TUTELA RELICTIS+
CVSTOS QVOS POTERAT: RECREABAT MVNERE URBIS+
MITIBUS AGNVS: ERAT: TUMIDIS LEO LIMA SVPERBIS+

> *He who provided for the people, who laid the foundations of this edifice, to whose care the city was entrusted: here lies Evrardus, a man [who was] good to oppressed widows, the guardian and defender of orphans whom he protected, who brought encouragement everywhere through word and deed; to the meek he was a lamb, to the self-important a lion, to the proud a sword."*

Note: the inscription is upside down for those approaching the tomb.

32. Amiens had been a center for armament manufacture in the late Roman period. It is also possible that the artisans responsible for the casting came from elsewhere.
33. Évrard broke with the tradition of his predecessors who had been buried in the nearby monastery of Saint-Martin-aux-Jumeaux; see Louis-François Daire, *Histoire de la ville d'Amiens* 2: 35–37.
34. Louis-François Daire, *Histoire de la ville d'Amiens* 2: 38–39; see also Henri Bouvier, *Histoire religieuse*, 275–98.
35. Henri Bouvier, *Histoire religieuse*, 286.
36. Henry Bouvier, *Histoire religieuse*, 291–92 suggests that Master Robert de Luzarches died soon after in 1223. However, there is no written evidence.
37. Holes gouged in the surface of the bronze suggest that the metal is thicker than in the earlier tomb.
38. The enclosing arch is trilobed, but slightly pointed.
39. The letters are so effaced that I rely here upon the transcription made by Jules Corblet:

ECCE: PREMUNT; HUMILE: GAUFRIDI; MEMBRA CUBILE;
SED: MINUS: AUT: SIMILE NOBIS: PARAT: OMNIBUS: ILLE:
QVEM: LAURUS: GEMINA: DECORAVERAT: +: IN MEDICINA:+
LEGE: QUE: DIVINA+: DECUERUNT: +:CORNVA:+: BINA:+:
CLARE: VIR:+: AUGENSIS: QUO: SEDES: AMBIANENSIS+:
CREVIT:+: IN: INMENSIS:+: IN CELIS:+: AUCTUS:+: AMEN:+: SIS:+

> *See, Geoffrey's body lies upon its humble bed: perhaps he is preparing a lesser or equal one for us all. He who was adorned with the twin laurels of Medicine and Divine Law, the two ornaments that were appropriate for him, the splendid man of Eu, through whom the cathedral of Amiens rises up to the immense heavens.*

40. Louis-François Daire, *Histoire de la ville d'Amiens* 2: 39–40; Henri Bouvier, *Histoire religieuse*, 299–335; Jules Corblet, *Les tombes en bronze*, 14.
41. Odette Pontal, "Le différend entre Louis IX et les évêques de Beauvais."
42. François Villeman, *Essay d'un Cérémonial*, Arch. Somme, MS 4G 3031, 50.
43. Adrian de la Morlière, *Les Antiquitez de la ville d'Amiens*, 201, suggested that Arnoul owed his appointment to Louis IX and specified that the lost gisant was in black marble.
44. Louis-François Daire, *Histoire de la ville d'Amiens* 2: 41.
45. Louis-François Daire, *Histoire de la ville d'Amiens* 2: 40–41; Henri Bouvier, *Histoire religieuse*, 336–59.
46. Henri Bouvier, *Histoire religieuse*, 342.
47. The story is told by many of the historians of Amiens: see, for example, Adrian de la Morlière, *Les Antiquitez de la ville d'Amiens*, 202; Henri Bouvier, *Histoire religieuse*,

352–53; and Albéric de Calonne, *Histoire de la ville d'Amiens* 1: 251. Most recently, see Pascal Montaubin, "Grands événements dans la cathédrale au Moyen Âge," 432.

48. Louis-François Daire, *Histoire de la ville d'Amiens* 2: 41–42; Henri Bouvier, *Histoire religieuse*, 360–367.

49. William Chester Jordan, *Louis IX and the Challenge of the Crusade*.

50. Henri Bouvier, *Histoire religieuse*, 367.

51. Henri Bouvier, *Histoire religieuse*, 368.

52. Mailan Doquang, "The Lateral Chapels of Notre-Dame in Context."

53. Adrian de la Morlière, *Les Antiquitez de la ville d'Amiens*, 209.

54. Louis-François Daire, *Histoire de la ville d'Amiens* 2: 43–45; Henri Bouvier, *Histoire religieuse*, 382.

55. Marianne Cecilia Gaposchkin, *The Making of Saint Louis*, 66–99.

56. Canon of Notre-Dame of Paris and of Beauvais Cathedral; dean of Laon Cathedral.

57. Decima Douie, *The Conflict Between the Seculars and Mendicants*," 28.

58. Henri Bouvier, *Histoire religieuse*, 383–84.

59. The text can be found in Stephen Murray, *Notre-Dame, Cathedral of Amiens*, 143.

60. Evidence for late insertion includes the mingling of different plinth types in the triforium and the use of a gabled arcade in the king's gallery that does not match the forms of the arcade anticipated in the four great buttresses. Viollet-le-Duc removed the gabled arcade and replaced it with trilobed arches matching the original ones in the great buttresses; see Yves Christ, "Comment Viollet-le-Duc défigura la galérie des rois d'Amiens," 12–28.

61. Louis-François Daire, *Histoire de la ville d'Amiens* 2: 47–48; Adrian de la Morlière, *Les Antiquitez de la ville d'Amiens*, 215–16. Bishop Jean de Cherchemont was buried in the north transept close to the altar of Saint Sebastian: his tomb, slightly raised up above the pavement, was clad in sheets of bronze decorated with figures. Jean de Boissy was buried on the north side of the sanctuary next to Jean de la Grange.

62. Louis-François Daire, *Histoire de la ville d'Amiens* 2: 51; Dany Sandron, "La fondation par cardinal Jean de la Grange de deux chapelles à la cathédrale d'Amiens."

63. Dany Sandron, in both "La fondation par cardinal Jean de la Grange de deux chapelles à la cathédrale d'Amiens," and *Amiens: La cathédrale*, 158–161, suggests that the sculptural program constituted a political manifesto of loyalty to the crown, deliberately intended to efface the memory of the disastrous episode (1358) where a considerable number of the urban elite of Amiens shifted their allegiance to the revolt of Étienne Marcel in favor of Charles the Bad, king of Navarre.

64. His tomb in Saint-Martial Avignon, destroyed in the Revolution, was justly famous, rising in multiple levels to a height of 15 meters and with the image of the dead cardinal (*transi*) at the bottom; see *Les fastes du gothique*, 150–51.

65. Louis-François Daire, *Histoire de la ville d'Amiens* 2: 56–58.

66. Jean Ribaillier, "Jean d'Abbeville"; Louis Douchet, *Manuscrits de Pagès* 5: 144.

67. Henri Bouvier, *Histoire religieuse*, 291–92.

68. Philippe Dubois, "Adrien de Hénencourt, le mécène amiénois," 296–344.

69. Detlef Knipping, *Die Chorschranke der Kathedrale von Amiens*, 32, provides Dean Adrien de Hénencourt's Testament: *my body to be buried near the [sculptured] story of Saint Firmin [in the south choir aisle], where I have prepared the place and ordered my executors, hereafter named, to get finished and richly embellished whatever is not done before my death; and to have an iron grille made, like the one of my lord [bishop] of Amiens, my uncle [Ferry de Beauvoir]; and in the lower part to have the*

representation of a dead man, according to the drawing which will be provided, and on the front an epitaph in copper like the one [at the tomb of] my lord [bishop] of Amiens, my uncle, now absolved by God; and above me a copper plaque two or three feet square with my arms embossed in the middle and around the edge my name, title, and the day of my death.

70. Wolfgang Schöller, *Die rechtliche Organisation des Kirchenbaues im Mittelalter*, 124–50.

71. Georges Durand, *Monographie* 1: 104.

72. As, for example, Gervase, sacristan of Canterbury; and Alan of Walsingham of Ely Cathedral. For the range of titles applied to the person in charge of the logistics of construction and the principal architect, see Wolfgang Schöller, *Die rechtliche Organisation des Kirchenbaues im Mittelalter*, 152–65.

73. For authors who have made extensive use of fabric accounts see, for example, Wim H. Vroom, *Financing Cathedral Building in the Middle Ages*; Denis Cailleaux, *La cathédrale en chantier*; and Stephen Murray, *Building Troyes Cathedral*.

74. The 1357–1358 Fabric Account, Archives départementales de la Somme, MS 4G 1157.

NARRATIVE

The account is rendered on a long strip of parchment of mediocre quality made up or two pieces stitched together to form a roll measuring 132 centimeters by 33 centimeters. The good side has been carefully ruled in lead point into two major columns with lines spaced at 5 millimeters. The receipts occupy the left half, and the expenses and arrears the right. Currency is in pounds (abbreviated as *lb.*) with 20 sous (*s.*) to the pound and 12 deniers (*d.*) to the sou. Final sums are given in *strong pounds*, indicating that currency had recently been devalued. We also find a *scutum* (*écu*) of varying value to the pound. At the end, the total expenses (240 lb. 11 s.) are deducted from receipts (430 lb. 18 s. 3 d.) to show a surplus of 190 lb. 11 s. 3 d.

Rendering the account is Jacobus Parvus (Little James), canon and provost of the chapter. He does not receive the title of "master of the works" or *proviseur*. We learn that the final copy of the account is rendered in triplicate—Johannes Daule is paid 30 sous for making the copies. That our account is not the original "working" document where the calculations were made is indicated by the missing entry of a *summa* at the end of the expenses section.

RECEIPTS

There are only four main items of receipt—no regular contribution is made by either bishop or chapter, and there are no substantial donations. The principal source of income (45 percent of total; 195 lb.) is derived from gifts of garments, or "robes," whose value is estimated by an assessor (paid 20 s. for his work). Such garments constituted a major means of holding and transferring wealth in this textile-production city where currency was subject to inflation and devaluation. The second main source of income (30 percent; 129 lb.) is derived from various kinds of collecting box, some fixed in the cathedral and others carried out into the diocese in the form of quests. The list of expenses includes 5 s. 4 d. for copying out the indulgence letters for the quests. Third in value is the sum left unspent from last year's account (19 percent; 85 lb.). And last in value (4 percent; 21 lb.) are the many small legacies made in the testaments of the dead.

Listed in the right side of the account are two kinds of expense. First are the weekly wages of master mason Reginald (*Reginaldus*) and master glazier William (*Guillelmus*), and the other workers of the church. Six weeks of work are completed in the first term (November to December), with Master Reginald paid 2 s. per day and Master William the glazier at 2 s. 4 d. per day. There are three other individuals at comparable salaries but no definition of the nature of their work. In the second term (January to March, 14 weeks), presumably Reginald and William continue their work. In the third term (March to June, 7 weeks), William the glazier continues, now paid 2 s. 6 d., but Reginald has disappeared. In the fourth term (June to October, 17 weeks), Master William is now paid 3 s. per day. And finally, October to November, 8 weeks of roof work with no mention of the master mason or master glazier.

There are then four blocks of mingled expenses, including materials (mostly for roofing: tiles, lathe, etc) and days of work. These four blocks probably correspond to periods of time. A small purchase of building stone from Croissy is recorded. Repairs are made to the big cart and wheelbarrow. But most of the work seems to be devoted to roofing, some of it provisional. The principal roofer was named John Buffart. It is interesting to note that quantities of "old [reused] glass" are purchased. Repairs are made to wooden roofs over the well (probably the *puits de l'oeuvre*) and lean-to structures on the north side of the nave. The last block of expenses includes a payment to Master Reginald for his ceremonial robe trimmed with fur which expressed his status as master mason. Since this was generally an annual payment, we may assume that the value was commuted and paid in cash (5 lb. 4 s.).

CONCLUSION

We are one year after the disastrous battle of Poitiers—it is not surprising to find that major construction work has lapsed. Other than the reference to the location of repairs to wooden roofs (south flank of the nave and masons' lodge), there are no topographical indications. Fire-damaged stones in the lower wall on the north side of the nave suggests that such lean-to structures may have burned at some point. Some masonry work was underway, but most of the recorded work was on roofing and stained glass. This is consistent with the idea that major construction work had paused, with the four eastern nave chapels on each side laid out but the western chapels not yet begun. The roofing work was presumably on the eastern nave chapels— this is confirmed by the fact that these would be shallow terraced roofs made of thin slabs of stone: 60 feet of stone was purchased "to make roofs" (*ad faciendum couverturas*). Stained glass was being installed in the nave chapels, but the principal glass work was probably focused on the upper north transept façade (including the rose window) where reused glass was employed in a non-figurative scheme. Masses of reusable glass must have been retrieved from the old nave aisle windows, recently demolished.

See also Georges Durand, *Monographie* 1: 111.

75. In 1705 it was necessary to resurface the stairs leading up to the chapel of John the Baptist, which had been worn down by the passage of pilgrims; see Louis Douchet, *Manuscrits de Pagès* 5: 400.
76. Stephen Murray, *A Gothic Sermon*.

77. Annates were the first year's income of a newly appointed office holder. At Amiens the annates of the diocese were assigned to the fabric in 1222; see Wolfgang Schöller, *Die rechtliche Organisation des Kirchenbaues im Mittelalter*, 342.

78. François-Xavier Maillart and Aurélien André, "La confrérie du Puy Notre-Dame."

79. Like at nearby Beauvais where the bishop and chapter each conceded one tenth of their income for a period of ten years, see the 1225 charter of Bishop Miles of Nanteuil in Stephen Murray, *Beauvais Cathedral*, 155. At Chartres Cathedral, also, the bishop and chapter committed a substantial sum for the start of work; see Wolfgang Schöller, *Die rechtliche Organisation des Kirchenbaues im Mittelalter*, 224–25. The epitaphs of Bishops Évrard de Fouilloy and Geoffroy d'Eu emphasized the role of each bishop in the construction of the cathedral. Henri Bouvier, *Histoire religieuse*, 289, notes that chapter revenues were increasing rapidly and an *acte capitulaire* of 1220 increased distributions in anticipation of an increase in chapter revenues (*attendu l'acroissement des revenues du chapitre*).

80. In 1240 Gerard de Conchy, then dean, wrote to the abbot of Corbie requesting safe passage for clerks who were carrying the châsse of Saint Honoré in a fundraising quest for the construction of Amiens Cathedral; see Henri Bouvier, *Histoire religieuse*, 341.

81. For the financial involvement of the bourgeois of Strasbourg, see Henry Kraus, *Gold Was the Mortar*, 109–30. At Amiens, episcopal charters of 1236 and 1247 emphasize the support of the bourgeois of Amiens; see Stephen Murray, *Notre-Dame, Cathedral of Amiens*, 136–41.

82. Georges Durand, *Monographie* 2: 632–33.

83. Douglas Knoop and Gwilym P. Jones, *The Medieval Mason*; Pierre du Colombier, *Les chantiers des cathédrales*; Jean Gimpel, *The Cathedral Builders*; John Harvey, *The Medieval Architect*; Louis Francis Salzman, *Building in England*; Nicola Coldstream, *Medieval Craftsmen*; Dieter Kimpel, "Structures et evolution des chantiers médiévaux," 11–52; and Andrew Martindale, *The Rise of the Artist*.

84. The well, providing the water essential for mixing mortar, is still visible today. Another well is located inside the northern choir aisle.

85. René de Lespinasse and François Bonnardot, *Les métiers et corporations de la ville de Paris, XIIIe siècle*.

86. Robert de Luzarches and Renaud de Cormont were designated *maistre de l'oeuvre, and cementarius* respectively. It should be noted that the title *maître de l'oeuvre*, or *maître de l'ouvrage*, might also apply to the member of the clergy in charge of the fabric.

87. I have suggested elsewhere that Master Robert came to Amiens from Laon, and that he had family connections with the cathedral clergy; see Stephen Murray, "Looking for Robert de Luzarches."

88. Georges Durand, *Monographie* 1: 463–64. The existing pavement and labyrinth appear to be accurate replicas of the lost originals.

89. The inscription was recorded in a fourteenth-century martyrology, necrology, and register of the distributions of the chapter of Amiens, Archives départementales de la Somme, MS 4G 2975 fol. 247 ro: *Memore quant l'euvre de l'eglise de cheens fu commenchie et si comme il est escript el moilon de le maison dedalus. En l'an de grace mil IIc & XX fu l'euvre de cheens premierement encommenchie. Adonc yert de cheste evesquie evrart evesques benis et roy de france loys qui fu filz phelippe le sage. Ch'il qui masistre yert de l'oeuvre maistre Robert estoit nommes et de lusarches surnommes. Maistre thomas fu apres luy de cormont et apres ses filz maistre regnault qui mectre fist a chest point chy ceste lectre que l'incarnation valoit XIII ans XII en faloit. The*

passage is written by the same hand as the rest of the text but the entry has been heavily rubbed—the result of many fingers marking the lines.

90. For a useful overview of the presence of labyrinths in church pavements in France, see Craig Wright, *The Maze and the Warrior*, 38–71. The oldest surviving labyrinth appears to be that at Chartres Cathedral where the brass medallion at the center (now lost) carried an image of the Minotaur. The only labyrinth other than Amiens to make specific reference to the master masons was at Reims Cathedral: the images of the four masters with terse descriptive texts have given rise to extended discussions on the role of each in the sequence of construction.

91. See Georges Durand, *Monographie* 1: 24. The 13-meter long inscription was heavily restored in 1823, and has been generally disregarded by historians of the cathedral because of its mutilated state. Before the restoration it read: EN LAN Q L'INCARNATIO VALOIT MCC & XX . . . [5.00 meter lacuna] ORS IFU REMISIT LE PREMIERE PIERE IASIS . . . LE CORS . . . [0.70 meter lacuna] ROBERT [0.90 meter lacuna]. The restored inscription cannot be trusted. Durand, *Monographie* 1: 433, accepts the idea that a foundation stone was laid at the start of work on the south transept and even sees the bishop portrayed in the base of the trumeau as engaged in the stone-laying ceremony. We might recall the inscription at the base of the south transept of Notre-Dame of Paris: *In the year of the Lord 1257 on February 12, this [work] was begun in the honor of the Mother of Christ by Master Jean de Chelles, master in his lifetime*; see Dany Sandron and Andrew Tallon, *Notre-Dame de Paris*, 135.

92. Georges Durand interpreted the object as a spade (*pique*)—in fact, with its very short handle it resembles the rounded kind of trowel sometimes called a Dutch trowel. Some have also found that the motif reminds them of a human heart.

93. Pierre du Colombier, *Les chantiers des cathédrales*, 66–68.

94. Franklin Toker, "Alberti's Ideal Architect: Renaissance—or Gothic?" Toker notes that the distinction between devising and doing, often associated with Alberti, can already be found in Thomas Aquinas: "Take architecture for example: you apply the term "wise" and "master-builder" (sapiens et architectus) to the artist who plans the whole structure and not the artisans who work under him who cut the stones and mix the mortar."

95. Stephen Murray, *Plotting Gothic*, 118.

96. Douglas Knoop and Gwilym P. Jones, *The Genesis of Freemasonry*; Roland Bechmann, "The Saracen's Sepulcher," has suggested that some of the basic practices of freemasonry existed already in the period of the construction of Amiens Cathedral.

97. For example, Jehan Fierabras at Troyes Cathedral; see Stephen Murray, *Building Troyes Cathedral*, 205.

98. On medieval scaffolding and formwork, see John Fitchen, *The Construction of Gothic Cathedrals*.

99. James Ackland, *Medieval Structure: The Gothic Vault*, 82.

100. Without this cushion, stones might crack under compression if they were not perfectly fitted.

101. The fabric accounts of Troyes Cathedral document the use of "masoning earth" (*terre à massoner*) to support the stones of the severies; see Stephen Murray, *Building Troyes Cathedral*, 81. The earth or dirt was heaped atop a high-level terrace. Alternatively, the same function could be served by flexible wooden boards or wickerwork.

102. *Huchier*—or, locally, *hucher*—is difficult to translate: some favor "joiner," some "cabinet maker."

103. Dieter Kimpel, "Le développement de la taille en série."

104. The term "workshop" is often used to designate a centrally organized group of artisans. Since I favor the idea of small semiautonomous groups, I use the word workshop without inverted commas to designate the lodge or space where the sculptors carved, presumably on the south flank of the choir.

105. Such a group might include a master who might be accompanied by a colleague and a couple of apprentices. Laborers were probably local men.

106. Local tradition suggests that the foliate decoration was intended to represent woad. Brightly painted, the effect would, in fact, resemble mosaic or *opus sectile*.

107. There are several points where a single image continues over two stones where the liaison is not perfectly controlled.

108. Because they project out from the flanking walls of the portals and might be damaged in the insertion of formwork and construction of the architectural frame of the portal, the preference may have been for later installation. This is particularly true of the figures of the prophets exposed on the front surfaces of the great buttresses.

109. Wolfgang Medding, *Die Westportale der Kathedrale von Amiens und ihre Meister*.

110. Willibald Sauerländer, "L'art antique et la sculpture autour de 1200."

111. The beautiful female figure identified with Saint Ulphe was probably initially carved as the Virgin of the Annunciation.

112. Perhaps derived from the enameled châsse that contained the saint's relics.

113. The model was possibly brought from Constantinople in 1204.

114. Reference to Italo-Byzantine art in the sculpture of Amiens Cathedral and the tympanum of the north portal of Notre-Dame of Paris was noticed by Willibald Sauerländer, who credited André Michel with the first recognition of the phenomenon; see Sauerländer, "Die Kunstgeschichtliche Stellung der Westportale von Notre-Dame in Paris." Sauerländer suggested that we are dealing with a conscious reaction against the Antique Revival style.

115. Guiseppe Bovini, *Ravenna Mosaics*, plate 26; Joachim Poeschke, *Italian Mosaics*, 53.

116. See Paul Williamson, *Gothic Sculpture*, 145–55; see also Xavier Dectot and Meredith Cohen, *Paris, ville rayonnante*, 52–69.

117. Vincent Brunelle, "Bilan du chantier de restauration des portails de la façade occidentale de la cathédrale d'Amiens." I am particularly grateful to Didier Groux and Christopher Weeks, pioneers, for allowing me access to their work in the early 1990s.

118. Hélène Richard and Jean-Michel Quesne, "Polychromies des portails d'Amiens: couleurs de lumière." The authors describe how they were led, given the limited nature of the discoveries of surviving pigment, to invent a color scheme based upon their studies of manuscript illustrations, wall paintings, and similar material. The intention was less to recreate the original polychromy "as it actually was" but more to excite the emotions of audiences who, they hope, will be led to an interest in history.

119. Françoise Baron, "Mort et résurrection du jubé de la cathédrale d'Amiens"; Charles Little, "Monumental Gothic Sculpture from Amiens in American Collections"; and Aurélien André, "Le jubé."

120. A total of some twenty-six individual statues or groups survives from the exterior of the nave chapels.

121. See Dany Sandron, "La fondation;" Aurélien André, "Le Beau Pilier"; and Claire Richter Sherman, *The Portraits of Charles V of France (1338–1380)*, 58–63. Sherman dates the work on the Amiens sculpture to 1373–1375.

122. Otto Pächt, "Die Gotik der Zeit um 1400 als gesamteuropäische Kunstsprache," 53–65.

123. Diane Daussy, *Sculpter à Amiens en 1500*; Henri Zanettacci, *Les ateliers picards de sculptures à la fin du Moyen Âge*, 81.

124. See two works by Nathalie Frachon-Gielarek: *Amiens: les verrières de la cathédrale*; and "Les vitraux."

125. On the production of medieval stained glass, see Theophilus's *On Divers Arts*, 49–74.

126. Nathalie Frachon-Gielarek, "Les vitraux," 262, finds links between the earliest (nave aisle) glass at Amiens, Chartres, and Auxerre Cathedrals; later (choir chapel) glass at Saint-Quentin and the Laon and Reims Cathedrals; and finally, (choir clerestory) glass at Beauvais and Saint-Urbain, Troyes.

127. Culminating in a fire in the restoration workshop in 1920.

128. Wolfgang Kemp, *The Narratives of Gothic Stained Glass*.

129. The panel showing the carpenters at work is associated with the Genesis narrative but may, of course, have originally come from any of the other windows.

130. Grisaille was much less expensive than colored glass.

131. Replaced by a bishop.

132. The fabric account for 1357–1358 records purchases of "old" (reused) glass and solder.

133. The motto of Amiens was *lillis tenaci vimine jungor*—"I cling to the lilies [of France]."

134. Medieval laypeople would receive mass (normally at Easter, Christmas, and Pentecost) in their parish church, where they would also benefit from the sacraments (including baptism, marriage, confession, and last unction) and listen to sermons. It seems that marriage and mass took place in the Petite Paroisse, but not baptism.

135. See the charters of Bishops Geoffroy d'Eu and Arnoul de la Pierre in Stephen Murray, *Notre-Dame, Cathedral of Amiens*, 135–38.

136. *Since memory of Saint Honoré has always been held in great veneration in the diocese to engage and animate the countrypeople to contribute to great expense of this edifice it was resolved in 1240 by Bishop Arnoul and the chapter to carry the relics out into all the towns, bourgs and villages of the dependent diocese. You can still see the letter which Girard de Conchy, first dean, then bishop of Amiens dated September 15 of that year to Raoul, abbot of Corbie, to ask him to issue orders in places of his jurisdiction that the relics should be honorably received*; from J. J. De Court, *Mémoires cronologiques*, transcribed in Stephen Murray, *Notre-Dame, Cathedral of Amiens*, 138–39.

137. The murder of the clerks by townsfolk in 1244, and the arson fire of 1258, have already been recounted.

138. Professional groups adopting chapels included: the wool carders in the choir chapel of John the Baptist, weavers in Saint Augustine of Canterbury, haberdashers in the chapel of Saint James, painters in the chapel of Saint Eloi, woad merchants in Saint Nicholas, and the bakers in Saint Honoré; on this, see Pascal Montaubin, "Évêques, chapitre et fabrique," 38. On the role of the professional corporations in the production of the lower windows, see Nathalie Frachon-Gielarek, *Amiens, les verrières de la cathédrale*, 5–6.

139. Georges Durand, *Monographie* 2: 632–33; Henry Kraus, *Gold was the Mortar*, 45, note 21.

140. Georges Durand, *Monographie* 2: 632–63.

141. LES BONES GENS DES VILES DENTOUR AMIENS QUI VENDENT WAIDES ONT FAITE CHETE CAPELE DE LEURS OMONNES. *The good folk of the towns near Amiens who sell woad have made this chapel with their gifts.*

142. Georges Durand, *Monographie* 2: 626–32.

143. Maurice Duvanel, Pierre Leroy and Matthieu Pinette, *La confrérie Notre-Dame du Puy d'Amiens*; Maillart and André, "La confrérie du Puy Notre-Dame."

144. Such "puys" were common in the North, including at Rouen, Arras, and Dieppe. In Amiens there was much *double entendre* play around the word *puits*, or well.

145. A *chant royal* was made up of five verses each of eleven lines. Elaborate rhyming patterns were required. The poems were called *Palinods* (English: palinode), which means *refutation*—each year's poem would thus supplant the previous one.

146. For example, in 1461 the Virgin was extolled as *Lampe rendant en ténèbres lumière:* Lamp lightening the shadows;" on this, see Maurice Duvanel et al., *La confrérie Notre-Dame du Puy d'Amiens*, 2. The text would then become the master's motto.

147. Maurice Duvanel et al., *La confrérie Notre-Dame du Puy d'Amiens*, 4–5.

148. Luke 2:23–24.

149. Bibliothèque nationale de France, MS fr. 145. The pages of the manuscript were reproduced in Maurice Duvanel et al., *La Confrérie Notre-Dame du Puy d'Amiens,*.

150. Nicolas Blasset was commissioned to carve the sculptured elements that crown each panel; see Christine Debrie, *Nicolas Blasset: 160–67.*

151. Stephen Murray, *A Gothic Sermon*, 9–12; I suggest here that this was a sermon carefully tuned to the instincts and disposition of members of the congregation.

152. Stephen Murray, *A Gothic Sermon*, 113.

153. Stephen Murray, *A Gothic Sermon*, 133.

154. Louis Douchet, *Manuscrits de Pagès* 5: 251–52.

4. Telling the Story of the Great Enterprise, I, 1220–c. 1300: Incomplete Completion

1. François Villeman, *Essay d'un Cérémonial*, Arch. Somme, MS 4G 3031, 66v–68v.

2. Frédéric Billiet, "La maîtrise de la cathédrale d'Amiens," 351.

3. There are no original written sources recording the fire: the date 1218 remains open to question.

4. Stephen Murray *Plotting Gothic*, 47–72.

5. "French and English artificers were therefore summoned, but even these differed in opinion. . . . amongst the other workmen there had come a certain William of Sens, a man active and ready, and as a workman most skillful in both wood and stone. Him, therefore, they retained on account of his lively genius and good reputation." The text is given in Robert Willis, *The Architectural History of Canterbury Cathedral*, 35 and Theresa Frisch, *Gothic Art*, 17.

6. Remember the images of the neighboring cities in the Saint Firmin tympanum: Cambrai, Noyon, Beauvais, and Thérouanne (fig. 2.26).

7. Stephen Murray, *Plotting Gothic*, 50–53.

8. Stephen Murray, "Looking for Robert de Luzarches."

9. Carl Barnes, *The Portfolio of Villard de Honnecourt.*

10. Villard de Honnecourt, fol. 14v: *vesci les ligement del chavet notre dame sainte marie de cambrai ainsi com il est sur tierre.* . . . The stem of the word *ligement* is *esligier*, to construct: in relation to his drawings of the tower at Laon (fol. 9v), Villard uses the word *esligement* to designate the various levels or stories.

11. I use the word "chevet" to designate the entire "head" of the cathedral east of the transept crossing. Strictly speaking, the term "choir" should specify the three bays of the central vessel where the clergy sat, west of the sanctuary.

12. Stephen Murray, "Looking for Robert de Luzarches."

13. Alain Saint-Denis et al., *Laon: la cathédrale*, 100–55.

14. Alain Erlande-Brandenburg, "Le choeur dans les cathédrales gothiques," 57–66.

15. The idea of a "pilgrimage church" as a recognizable architectural type was popularized by Kenneth Conant, *Carolingian and Romanesque Architecture*, 91–103. See the skeptical remarks of Roger Stalley, *Early Medieval Architecture*, 147–66.

16. Abbot Suger describes the circular procession that marked the consecration of the new choir: "You might have seen—and those present did not see not without great devotion—how so great a chorus of such great pontiffs, decorous in white vestments, splendidly arrayed in pontifical miters and precious orphreys embellished with circular ornaments, held the crosiers in their hand, walked round and round the vessel and invoked the name of God by way of exorcism; how so glorious and admirable men celebrated the wedding of the Eternal Bridegroom so piously that the King and the attending nobility believed themselves to behold a chorus celestial rather than terrestrial, a ceremony divine rather than human." See Erwin Panofsky, ed., *Abbot Suger*, 115.

17. Zachary Hayes, *The Hidden Center*, 192–93. At Amiens a silver vessel containing the Host was suspended directly above the altar.

18. On the power of centralized architectural planning to create community, see Sheila Bonde, Edward Boydon, and Clark Maines, "Centrality and Community: Liturgy and Gothic Chapter House Design at the Augustinian Abbey of Saint-Jean des Vignes in Soissons."

19. Abbot Suger noted the way the radiating chapels at Saint-Denis "would shine with the wonderful and uninterrupted light of most luminous windows, pervading the interior beauty"; quoted in Erwin Panofsky, *Abbot Suger*, 101. The circular planning of the Saint-Denis hemicycle results in the existence of a single point, just in front of the principal altar, where all the chapels can be seen at the same time without interruption.

20. Richard Krautheimer, "Introduction to an 'Iconography of Medieval Architecture,'" 1–33.

21. Arnaud Timbert, " 'Existe-t-il une signification politique de l'architecture gothique au XIIIe. siècle?"

22. Caroline Bruzelius, "Cistercian High Gothic."

23. Alain Saint-Denis et al., *Laon*, 100.

24. Jacqueline Jung, *The Gothic Screen*.

25. Hans Kunze, *Das Fassadenproblem des französischen Früh-und Hochgotik*.

26. Carl Barnes, *Portfolio of Villard de Honnecourt*, plate 65, folio 31v. This is far from a measured drawing: Villard has exaggerated the height of the arcade and triforium at the expense of the clerestory. He has "corrected" Reims to produce the steeply compressive interior actually achieved at Amiens.

27. By definition, a gallery occupies the entire space over the aisle: it often has windows in the exterior wall. A triforium is a passage in the thickness of wall in the area between the top of the arcade and the point where the aisle roofs butt against the main vessel. The old fire-damaged cathedral of Amiens may have had a gallery.

28. Mailan Doquang, *The Lithic Garden*, linked the Amiens foliate band with the vine of Solomon in the Jerusalem Temple. However, it is hard to understand why the carvers who were capable to rendering naturalistic vine leaves chose rather to deploy round-lobed leaves in clusters of three and five, which do not have an immediate source in nature. More than anything, the leaves in the Amiens foliate band resemble the idealized forms found in the contemporary drawings by Villard de Honnecourt—see especially fol. 29r, the image of the terminal wall of a rank of choir stalls. The prolific foliage was probably intended to refer to the miracle that attended the discovery of the body of Saint Firmin, when green plants and flowers *were beautifully sprouting from*

inside the tomb. Similar round-lobed leaves loop around the bronze tomb of Bishop Evrard de Fouilloy. These are miraculous leaves.

29. The Amiens triforium must be considered one of the most brilliant inventions of Robert de Luzarches and Thomas de Cormont. Its form points to distant prototypes like Sens Cathedral and Saint-Germain-des-Prés in Paris.

30. Fig. 4.9 shows the transverse sections of Chartres, Reims, and Amiens Cathedrals each inscribed inside a square, *ad quadratum*. The square at Amiens is defined by the total width of the western frontispiece, 42.20 meters. In fact, the nave vault is slightly higher than this at around 42.30 meters. The only other French cathedral matching this steep proportion is Beauvais Cathedral, begun in 1225 and reaching just beyond 46 meters.

31. Gervase of Canterbury understood the synecdochal role of the vaulted canopy (*ciborium*) with its central keystone or *clavis*: "I write clavis for the whole ciborium because the clavis placed in the middle locks and binds together the parts which converge on it from every side"; see Robert Willis, *The Architectural History of Canterbury Cathedral*, 49. The importance of the vaulted canopy or *ciborium* as the essential spatial building block of the Gothic cathedral was famously developed by Hans Sedlmayr, *Die Entstehung der Kathedrale*.

32. Of course, the system works best in a church with a single aisle on either side. The Amiens choir, like Chartres and Reims, has double aisles, necessitating an intermediary support for the flyers.

33. The deep *culée* was deployed for the first time in Notre-Dame of Paris, begun around 1160. Many of the Amiens clergy, having studied in Paris, would be familiar with the new, lightweight forms of the metropolitan cathedral.

34. Master Robert clearly believed in the connection between forms that we find "beautiful" and the existence of an underlying geometric armature that made sense: this sense can be discovered when we consider the relationship between the Amiens *pilier cantonné* and the massive piers that form the central crossing square (fig. 4.11). The crossing pier has a stepped core with each step corresponding to about one foot, creating a grid of two-foot squares. This allows the pier to express its role in supporting the main arcade, which is four feet thick. The cylindrical body of the *piler cantonné* is more than enough to receive the thickness of the arcade.

35. Carl Barnes, *Portfolio of Villard de Honnecourt*, plate 42, fol. 20r.

36. Vitruvius Pollio, *Ten Books of Architecture*, Book 10, 107.

37. Peter Kidson "Vitruvius." The existence in Amiens of texts from Vitruvius and the *agrimensores* is attested in Chancellor Richard de Fournival's *Biblionomia* (c. 1250), but there is no evidence for the earlier period; see Christopher Lucken, "Parcours et portrait d'un homme de savoir," 34.

38. The process may be described in nine steps, illustrated in figure 4.13.

 1. Mark out a square of 50 feet: this is the crossing space. Swing the diagonal of the half square to create a great double square.

 2. The relationship of outer and inner squares, in the order of the Golden Section, gives the enlarged bays adjacent to the crossing.

 3. Rotate the great central square and migrate it to the west.

 4. This gives the length of the nave.

 5. The length of the choir straight bays is given by half the same rotated square.

 6. The circle describing the hemicycle is struck from center point C located just to the east of the last straight bay of the choir.

7–8. The span of the transept is given by another rotated square constructed around the great central square.

9. Note that the overall footprint of the cathedral is very close to a double square.

39. Vitruvius, *Ten Books*, book 6, chapter 2, emphasizes that once perfect regularity had been achieved in a building through the application of *symmetry*, the gifted architect, guided by flashes of genius, is free to depart from the regularity of the plan in order to achieve desired effects relating to appearance and function.

40. Nancy Y. Wu, "The Hand of the Mind: The Ground Plan of Reims Cathedral as a Case Study" ; see also Michael Davis and Linda Neagley, "Mechanics and Meaning: Plan Design at Saint-Urbain, Troyes and Saint-Ouen, Rouen."

41. Heaven was often depicted as a double square; particularly close to Amiens is the image in the Trinity Apocalypse, Trinity College MS R 16–2 25; on this, see Stephen Murray, *Notre-Dame, Cathedral of Amiens*, plate 47.

42. Dieter Kimpel, "Le développement de la taille en série."

43. Robert W. Hanning, " 'Ut enim faber . . . sic Creator': Divine Creation as Context for Human Creativity in the Twelfth Century," 108, quoting William of Conches: "for as a craftsman wishing to make something first arranges it in his mind and afterward, having procured material, forms it according to his idea [*iuxta mentem suam*], so the Creator, before he was to create anything, had an idea of it in his mind and thereafter performed it by his act."

44. Stephen Murray, *Notre-Dame, Cathedral of Amiens*, 44–86.

45. This is a supposition based upon the fact that there is no discernible point of transition between the work of Masters Robert and Thomas.

46. On the antiquarians of Amiens, see Stephen Murray, *Notre-Dame, Cathedral of Amiens*, 9–12; and André Rostand, *Les descriptions anciennes de la cathédrale d'Amiens*.

47. Stephen Murray, *Notre-Dame, Cathedral of Amiens*, 48–58.

48. It had been believed that a charter issued by Bishop Geoffroy d'Eu in 1236 indicated that the site of the choir had been blocked by the continuing presence of the church of Saint-Firmin the Confessor. I was able to demonstrate that this was not the case; see Stephen Murray, *Notre-Dame, Cathedral of Amiens*, 49–51.

49. The epitaph of Bishop Evrard (d. 1222) states that he *laid out the foundations*.

50. On the foundations, see Sheila Bonde, Clark Maines and Robert Mark, "Archaeology and Engineering: The Foundations of Amiens Cathedral," 348: "by opening up a huge area (presumably the entire surface area of the cathedral) the builders seem to have deliberately distributed the building load." See also Sheila Bonde, Clark Maines, and R. Richards Jr., "Soils and Foundations."

51. Peter the Chanter, *Summa Theologica*, quoted by Theresa Frisch, *Gothic Art*, 32.

52. As specified in the 1236 charter of Bishop Geoffroy d'Eu; see Stephen Murray, *Notre-Dame, Cathedral of Amiens*, 135–136.

53. The design of the oculus seems tentative; it is not properly centered, and its rim is not perfectly round.

54. Antiquarian sources suggest he died soon after Bishop Evrard (d.1222.).

55. This text is the 1243 charter of Bishop Arnoul de la Pierre; it mentions the "tower towards the cloister," referring to the southern belfry of the west façade.

56. Without an excavation it is impossible to establish definitively whether the foundations for the hemicycle had been laid out at the start of work, though I consider it likely.

57. This cusped arch design is also found in the lower chapel of the Sainte-Chapelle, Paris.

58. Stephen Murray, *Notre-Dame, Cathedral of Amiens*, 134.

59. Did the master fully anticipate that these slender supports would have to bear the weight of the intermediary uprights of the flying buttresses?

60. William Chester Jordan, *Louis IX and the Challenge of the Crusade*, 65–104, "War Finance." Jordan calculates that two-thirds of the total cost of the crusade was paid by taxes levied on the Church. Cities like Amiens were also heavily taxed.

61. *The dean and chapter of Amiens [Cathedral] complained that on the night when the cathedral was burned, a certain chest containing the church's seals and privileges placed inside the said church was taken from that place and broken and carried away, and the aforementioned seals and privileges were stealthily removed; begging the lord king to give his counsel on this. Through the royal inquest that was then made the three suspects named below were found, that is: Robert Bisaharz who did much damage to the church that night; Anseau, sergeant of the city of Amiens, gravely suspected of having carried off and broken the said chest; and Enguerrand de Croi, [who] was also found somewhat suspect. The king decided to have the three taken prisoner by the bailiff of Amiens.* See Stephen Murray, *Notre-Dame, Cathedral of Amiens*, 141–42.

62. The charter documents the sale of land to *magistri Renaudi cementarii magister fabrice beate marie ambianensis*; see Stephen Murray, *Notre-Dame, Cathedral of Amiens*, 142.

63. Anne Prache, "Pierre de Montreuil," 26–38.

64. Stephen Murray, *Building Troyes Cathedral*, fig. 33. Similar openwork flyers were used for the same reason at Auxerre Cathedral and Saint-Quentin.

65. It thus seems that settlement on the east side of the south transept arm began almost immediately. In the narrower bays of the hemicycle Master Renaud reverted back to the form of a single big trefoil.

66. Georges Durand, *Monographie* 1: 282.

67. The assigning of space is recorded in a 1236 charter of Bishop Geoffroy d'Eu: *Gallia Christiana* X, col. 342, LXVIII; see Stephen Murray, *Notre-Dame, Cathedral of Amiens*, 135–36. The same charter mentions the bitter grief caused by the loss of the old cathedral.

68. We can also track the progress of this work on the new choir through the placement of episcopal tombs; see chapter 3 of this book.

69. Georges Durand, *Monographie* 2: 607, transcribes a description of the structure which also housed the relic of Saint Ulphe. Similar two-story treasury/sacristy complexes can be found at the cathedrals of Sens, Troyes, and Beauvais: in each case, the complex was built contemporaneously with the body of the cathedral.

70. Françoise Baron, "Mort et résurrection du jubé de la cathédrale d'Amiens"; Charles Little, "Monumental Gothic Sculpture from Amiens in American Collections"; and Jacqueline Jung, *The Gothic Screen*. An extended description of the screen was made by Jean Pagès around 1700; see Louis Douchet, *Manuscrits de Pagès* 5: 426–42.

71. Louis Douchet, *Manuscrits de Pagès*.

72. Pascal Montaubin, "Grands événements dans la cathédrale au Moyen Age," 433.

73. Stephen Murray, *Notre-Dame, Cathedral of Amiens*, 143. King Louis IX had been in Amiens in 1264 to arbitrate in the affair between King Henry III of England and his barons (the Mise of Amiens), but it is not known if the judgment took place in the cathedral.

74. It has been suggested that if we suppose the foot unit employed by the carpenters to be around 0.308 meters, we could understand the thickness of the main ties as exactly one foot, given that the principal space frames of the roof were spaced at 12 feet and

the secondary rafters were spaced at 2 feet; see Andrée Corvol-Dessert, Patrick Hoffsummer, Jannie Meyer, et al., eds., *Les charpentes du XIe au XIXe siècle*, 132.

75. Georges Durand, *Monographie* 1: 510.

76. Although the Beauvais Cathedral roof actually survived the collapse that brought down one transverse arch as well as attendant flyers and vault severies of the upper choir.

77. Corvol-Dessert, Hoffsummer, Meyer, et al., *Les charpentes du XIe au XIXe siècle*, 127.

78. The case for late installation of the Amiens high vaults was made by Anne Prache, "Remarques sur les parties hautes de la cathédrale d'Amiens," 55–62. The question of the priority of vaults or roof is discussed in Corvol-Dessert, Hoffsummer, Meyer, et al., *Les charpentes du XIe au XIXe siècle*, 135.

5. Telling the Story of the Great Enterprise, II, c. 1300–1530

1. See Roland Hubscher, *Histoire d'Amiens*, 81–86; see also Alberic de Calonne, *Histoire de la ville d'Amiens* 2: 250–86. The bishop of Amiens, Jean de Cherchemont, played a role at the Battle of Crécy, helping hustle the defeated French king away to safety. On the role of Amiens as frontier city in the struggles between the French and English, see Jonathan Sumption, *The Hundred Years War*.

2. This was exacerbated by the charge delivered by the intermediary uprights that received flyers from both the choir and the east side of the transept. The same area also failed at Notre-Dame of Paris in the years around 1300.

3. There is a sharp change in the interior of the staircase at the level where the central newel post becomes much more slender. Exterior decoration of the buttress also takes on new forms at this point.

4. Several features indicate that this strip was inserted post facto. First, there are dislocations between the coursing of the strip and the surrounding masonry at triforium level, as well as clear signs of insertion visible inside the staircase turret on the east side of the south transept above the level of the triforium sill where the inserted strip of masonry crashes into the staircase. Second, this inserted strip is no is no longer found in the staircase turret above the level of the clerestory sill, suggesting that the staircase and framing strip around the rose were built integrally. Third, new decorative motifs are applied to the front surface at this level.

5. The outer skin of the triforium and molding profiles are characteristic of the mid- to later thirteenth century when Renaud was in charge, yet the tracery forms do not resemble his work—instead, they are reminiscent of the choir screens of Chartres and Strasbourg Cathedrals, and of small-scale ivories and metalwork; see Xavier Dectot and Meredith Cohen, *Paris, ville rayonnante*, 52–69.

6. The inner surface of the wall and the arch enclosing the rose were reworked at the same time as a deep concave molding set with schematized flowers.

7. This fourteenth-century work was heavily restored by Caudron in the 1840s: see Georges Durand, *Monographie* 1: 495.

8. Some of the mullions of the inner skin of the triforium are grooved as if to receive glass—yet glass could never have been installed here.

9. Peter Seyfried, *Die ehemalige Abteikirche Saint-Ouen in Rouen*, 69–75: the author dates the north transept rose at Saint-Ouen with its Flamboyant tracery elements considerably later than the unit at Amiens, and associates it with the work of Colin de Berneval (d.1479).

10. On the south side the builders had intended to introduce an additional transverse passage at the level of the bottom of the rose; it was never completed.

11. Pascal Montaubin, "Le clergé de la cathédrale," 341. In addition to the weekly meetings, four general chapter meetings were held each year. Unfortunately, the records of chapter deliberations have been lost.

12. At Amiens the word "cloister" (*cloître*) was also applied to the area to the south of the nave where the canons' houses were located. Noyon Cathedral has a fully developed cloister; Laon has an arcaded gallery on the south side of the nave. On the Amiens cemetery cloister, see Georges Durand, *Monographie* 2: 609–12 and *Ordinaire*, xliv, note 1.

13. On the 1232 charter of Bishop Geoffroy d'Eu conceding land on the north side of the cathedral *ad faciendum capitulum suum et claustrum*, see Stephen Murray, *Notre-Dame, Cathedral of Amiens*, 133.

14. Georges Durand, *Monographie* 2: 609–12.

15. The cemetery cloister was represented in a sketch done by the Duthoit brothers and reproduced in the unpublished *Etude historique et archéologique: le chevet*, Direction Régional des Affaires Culturelles, Picardie, Amiens 2003. The tracery forms are comparable with some of the nave chapel windows.

16. *Danse macabre* probably refers to 2 Maccabees which embodies prayers of the dead and the hope of the resurrection of the body. Paintings of the danse macabre were featured on the back wall of the gallery enclosing the cemetery of the Holy Innocents in Paris from 1424–1425. On the macabre in medieval life and thought, see Paul Binski, *Medieval Death: Ritual and Representation* 123–63; and most recently see Kristiane Lemé-Hebuterne, "L'Arlésienne Amiénois ou la danse macabre de la cathédrale d'Amiens."

17. The celebration of All Saints, between October 31 and November 2, was one of the nine great feasts of the year: *magnum duplum cum eo*—celebrated with the bishop presiding. Vestments were in red, changing to black at the most solemn moment.

18. *Ordinaire*, 505.

19. François Villeman, *Essay d'un Cérémonial*, Arch. Somme, MS 4G 3031, 161v.

20. *From there the procession passes into the cloister called the "Machabé,"entering through the chapel of Saint-Quentin. There a third station is done at the place corresponding to the axial chapel where the celebrant says the psalm "Misere mei Deus" together with verses and prayer. A little further a fourth station is done, singing the psalm "De Profundis" and the prayer, after which the celebrant makes another aspersion of holy water in the cemetery. . . .*

21. In France there was no protocol for either the shape or location of the chapter house of a secular cathedral: the Laon Cathedral chapter house is to the south of the nave, at Soissons it is to the north of the western frontispiece, at Notre-Dame of Paris it was located in a multi-purpose building to the north of the choir, and at Chartres is was in the lower space below the chapel of Saint Piat constructed to the east of the choir in the early fourteenth century.

22. Georges Durand, *Monographie* 2: 612–13. Durand thought that he recognized the arms of Pope Martin V (1417–1431) in one of the keystones.

23. Where were the latrines? Georges Durand, *Monographie* 2: 653, locates them at the northern end of the cemetery gallery, adjacent to the sacristy.

24. I would like to express thanks to Nicolas Asseray, who is conducting an intensive study of the chapels based upon archival sources and rigorous archaeological analysis.

25. On the addition of the chapels and the foundation dates, see Georges Durand, *Monographie* 1: 40–47.
26. At Amiens, this is particularly true of both the woad merchants (who paid for the foundation of the chapel of Saint Nicholas on the south side of the nave) and the bakers (who adopted the chapel of Saint Honoré).
27. Simon Roffey, *Chantry Chapels and Medieval Strategies for the Afterlife*, 16–21, defines a chantry as the foundation and endowment, by one or more benefactors, of a mass that is to be celebrated at an altar for the souls of the founders and other specified persons. The institution of the chantry was based upon beliefs in the afterlife, especially the idea of purgatory. Roffey emphasizes the importance of the medieval mass as a means of guaranteeing a shorter stay in purgatory for the deceased and of providing proof of salvation through the resurrection of Christ.
28. Mailan Doquang, "The Lateral Chapels of Notre-Dame in Context"; Michael Davis, "Splendor and Peril: The Cathedral of Paris, 1290–1350"; Henry Kraus, "New Documents for Notre-Dame's Early Chapels."
29. The logettes on the south side of the parvis rented for a much higher price than those on the north; see Louis Douchet, *Manuscrits de Pagès* 5: 22.
30. This chamfered edge is interrupted on each side just beyond the western side of the fourth chapel.
31. Alarming cracks are visible in the interior masonry above the north portal of the western frontispiece (fig. 1.34).
32. The endowment (foundation) of the chapel is dated 1292: construction might have begun soon before or soon afterwards, but was probably complete by the bishop's death. The window bore the inscription *Guillelmus Ambianensis episcopus, natione burgundus, fieri me fecit*, and the bishop was buried here under an enameled copper tomb. The dedication to Saint Margaret referred to Margaret of Provence, wife of Louis IX.
33. The wall framing the window of this chapel is a little thicker than the adjacent chapel to the west.
34. There is no documentary evidence for the initial foundation of the chapel of Saint Stephen. On the exterior, the Transfiguration of Christ is depicted above statues of Adam and Eve, which have been lost.
35. A panel of glass survives showing a secular personage offering a chapel to Saints Agnes and Catherine (fig. 3.25).
36. This principle of tracery design was widespread in England in the second half of the thirteenth century, as, for example, in the west window of Tintern Abbey, c. 1270. See Nicola Coldstream, *The Decorated Style*, 32; Georgina Russell, "The North Window of the Nine Altars Chapel, Durham Cathedral," and Russell, "The Thirteenth-Century West Window of Lincoln Cathedral."
37. Neither chapel has a clear foundation date. Saint Nicholas provided the seat for the community of woad merchants: on the exterior there are sculptured images of the merchants and the inscription (transcribed in chapter 3, note 41). In the chapel of Saint Honoré were four chaplaincies: two founded by Bishop Guillaume de Mâcon and two by a certain Guillaume de la Planque (*Guillelmus de Planca*), dean in 1324—he was buried there in 1325.
38. No documentation survives for the foundation of the chapel of Saint Michael which enshrined numerous tombs including *gisants* thought to have been those of Angilguinus and his wife Rumildis—ninth-century benefactors of cathedral. The chapel of the Annunciation was in use by 1378. The sculptured Annunciation group on the exterior wall is often associated with the famous silver Virgin given to Saint-Denis in 1339 by Jeanne d'Évreux.

39. There are similar parallels with the lierne vault in the main crossing at Amiens, proba-
 bly installed after the completion of the roof, c. 1310.
40. A *tierceron* is a rib that springs from the corner but does not reach the central keystone.
 A *lierne* is a linking rib, not anchored to the corner springing points.
41. For comparisons to the great west window of York Minster donated by Archbishop
 Melton in 1338, see Nicola Coldstream, *The Decorated Style*, 9.
42. The sinuous, flickering forms of Flamboyant tracery correspond to the term *curvilinear*
 in English Gothic.
43. A sign of lavish funding?
44. In 1358, in return for an English prisoner he had handed over to the king, Enguerran
 d'Eudin received a large share of the goods the king had confiscated from a man con-
 victed of treason and beheaded—alderman Jacques de Saint-Fuscien. Perhaps this
 royal bounty was the money used to found and construct the chapel.
45. The figure appears to have been reused—the Antique Revival style of Saint Christopher's
 garment suggests a mid-thirteenth century date.
46. An inscription was recorded by La Morlière: *Ceste chapelle fist faire sire Henris
 Biaxpignié.*
47. The two sculptured figures are generally identified as Saint Lambert, bishop of Maastricht,
 and Pepin, father of Charles Martel. The bishop had denounced Pepin's adulterous rela-
 tionship with the woman Alpaida.
48. The chronological relationship between the two western chapels on the south side and
 their counterparts on the north remains ambiguous.
49. A hiatus in major construction work is indicated by the fabric account for 1357.
50. Gabled forms also predominate in the nave chapels of Rouen and Troyes cathedrals.
51. Jean Bony, *The English Decorated Style*, 11–12, characterized the kind of trac-
 ery design used in the fourth chapel on each side at Amiens (Saint Michael and the
 Annunciation) as the very "symbol" of the English "Decorated" style of Gothic, find-
 ing early examples in the chapel of Saint Etheldreda in London (c. 1280) and the
 north window of the Durham Cathedral Chapel of Nine Altars (c. 1270). However,
 he points out that the design mechanism had appeared at an earlier date in northern
 France (Agnetz and Saint-Germain in Auxerre), as well as Amiens Cathedral itself
 in the interior frontispiece of the south transept portal (c. 1240). Most significantly,
 the type of window also appeared at Troyes Cathedral on the west side of the north
 transept (c. 1300) and in four of the early nave chapels (c. 1309–c. 1326); see Stephen
 Murray, *Building Troyes Cathedral*, 30. Jean de Cherchemont had been bishop of
 Troyes (1324–1326) before becoming bishop of Amiens (1326–1373); it is therefore
 tempting to associate the construction of the chapels of Saint Michael and the Annun-
 ciation with this bishop.
52. Only in the two western chapels on the north was any attempt made to make a proper
 liaison in the masonry courses. It is possible that some of these problems were veiled
 behind textile hangings or pictures.
53. Georges Durand, *Monographie* 1: 48–51, 249–69, and 498–507.
54. Georges Durand, *Monographie* 1: 265–66; Yves Christ, "Comment Viollet-le-Duc
 défigura la galerie des rois d'Amiens."
55. *Persecutiones quas fabrica nostrae Ambianensis ecclesiae nuper passa fuit, et maximas
 miserias quas in opera lathomiae de novo incepto, pro turribus ejusdem aedificandis
 et levandis. . . .* Pursuant to great penury of the works of masonry undertaken by the
 recently activated fabric of our cathedral of Amiens on the construction and elevation
 of the towers of the said church. . . . See Georges Durand *Monographie* 1: 265–66.

56. The proof can be found in the repairs to the triforium on the east side of the south transept.

57. The texts from Amiens Bibliothèque municipale MS 563, 226ro–229ro are transcribed and translated in Stephen Murray, *Notre-Dame, Cathedral of Amiens*, 143–45.

58. This problem was, of course, endemic in vaulted structures intersected by a transept, especially if there is a crossing tower. The solution was either internal bracing, as in the "strainer arch" of Wells Cathedral, or external ties, as in Amiens. See André Masson, "Le bouclement des piliers de la croisée de Saint-Ouen de Rouen."

59. *Bouture* may be defined as "something which pushes"—the term was used to designate growth in the world of plants. On the medieval understanding of dynamic behavior of arched masonry, see James Ackerman, "'Ars Sine Scientia Nihil Est,'" and George Kubler, "A Late Gothic Computation of Rib Vault Thrusts," 135–148.

60. Emeline Lefèbvre, "Le chaînage du triforium de la cathédrale Notre-Dame d'Amiens," 141–48.

61. How the outer ends of the chains on the west side of the transept arms are anchored remains a mystery.

62. At the time of writing (2019), a wire net suspended in the south transept arm protects visitors from the possible danger of falling debris.

63. Amiens Bibliothèque municipale MS 563; transcribed and translated in Stephen Murray, *Notre-Dame, Cathedral of Amiens*, 144–45.

64. The "pillars" might be the upper piers of the choir clerestory and the arches and vaults of the upper choir. However, there is no visible sign of repair work in the high vaults of the choir, whereas the piers and vaults of the westernmost bay of the north choir aisle have clearly been rebuilt in this period. The intermediary choir aisle piers support the flyers mentioned in the text.

65. Stephen Murray, Robert Bork, and Robert Mark, "The Openwork Flying Buttresses of Amiens Cathedral."

66. The situation resembled that at Troyes Cathedral in 1362, when a visiting expert recommended that the openwork flyers of the nave should be demolished and rebuilt "saving the [old] masonry completely throughout"; see Stephen Murray, *Building Troyes Cathedral*, 121.

67. Florian Meunier, *Martin et Pierre Chambiges*, 205–9. The list of similar roses includes Toul, Chaumont-en-Vexin, Gisors, Notre-Dame at Les Andelys, Saint-Wulfran at Abbeville, Meaux, Lieu-Restoré, and the Sainte-Chapelle in Paris. Immediate precedents are Auxerre (the north transept, c. 1497) and Sens (the south transept, c. 1500).

68. Particularly similar to the north transept rose of Limoges Cathedral.

69. Detlef Knipping, *Die Chorschranke der Kathedrale von Amiens*; Diane Daussy, *Sculpter à Amiens en 1500* and "Les clôtures du choeur."

70. Detlef Knipping, *Die Chorschranke der Kathedrale*, 34, aptly refers to the "eloquently hyper-realistic image discourse" (*die sprechende, üppig-realistische Bildrhetorik der Skulpturenzyklen*), associating it with the demotic art (*die vulgärsprachliche Beschriftung*) of late-Gothic Picardy.

71. We should note, however, that the châsses were sometimes draped.

72. On Martin Chambiges, see Florian Meunier, *Martin et Pierre Chambiges*. On Pierre Tarisel, see Georges Durand, *Maître Pierre Tarisel, maître maçon du roi, de la ville et de la cathédrale d'Amiens (1472–1510)*.

73. Kristiane Lemé-Hébuterne, *Les stalles de la cathédrale Notre-Dame d'Amiens*; also "les stalles."

74. Is it possible, moreover, that they were damaged in the repair work on the upper choir?

75. When the bishop celebrated mass, a magnificent throne was erected just to the south of the altar. Otherwise the celebrants would be seated in *des chaires ou formes de menuiserie d'un gout gothique pratiquées contre la muraille*; see Louis Douchet, *Manuscrits de Pagès* 5: 459. The bishop was also allocated a seat toward the west end of the northern high stalls for occasions where he did not preside.

76. This is the sum given in eighteenth-century sources; on this, see "Kristiane Lemé-Hébuterne, Les stalles," 241.

77. Noah's Ark had been interpreted by Hugh of Saint Victor (b. c. 1096—d. 1141) not just as a vehicle of salvation, but also as a means of organizing knowledge. The stalls themselves also provided just such a vehicle: the main vessel was 50 feet wide, and the Ark 50 cubits.

78. I strongly recommend that the reader turn to the website, www.learn.columbia.edu/amiens, in order to explore this rich imagery more fully.

79. Elaine C. Block, "Images de Joseph et ses frères en Picardie," examines the background of the telling of the Joseph story in illustrated bibles and proposes a typological interpretation of some of the scenes in which Joseph appears as a prefiguration of Christ.

80. The relief owes much to a printed frontispiece in *Les heures à l'usage de Rouen* (1503) printed by Thielman Kerver; see Kristiane Lemé-Hébuterne, *Les stalles de la cathédrale Notre-Dame*, 93. The image was adapted in the frontispiece of *Peanes*, a book of poetry written by canon Pierre Bury (d. 1504) and published by Dean Adrien and his colleagues Pierre Dumas and Jean Lenglacié commemorating the five feasts of the Virgin.

81. Geoffrey W. Lampe, *The Cambridge History of the Bible: the West from the Fathers to the Reformation* 2: 436–52.

82. See Rosemarie Potz McGerr, "Guyart Desmoulins, the Vernacular Master of Histories and his *Bible historiale*." Margriet Hoogvliet's study "*Pour faire laies personnes entendre les hystoires des scriptures anciennes:* Theoretical Approaches to a Social History of Religious Reading in the French Vernaculars during the Late Middle Ages," 266: "religious texts in French were in fact accessible for much wider groups of readers, sometimes even including humble craftsmen." Also useful is the work of Sabrina Corbellini and Margriet Hoogvliet, "Artisans and Religious Reading before the Reformation in Italy and northern France (c. 1400–1520)," 521, which identifies Jehan Poisson, goldsmith of Amiens, as the 1441 winner of the Puy Notre-Dame literary competition. Corbellini and Hoggvliet also mention the merchant Pierre de Coyn of Amiens, who kept a copy of the *Vita Christi* in his workshop.

83. Inventories of property at the time of death have provided an extraordinary glimpse into the reading habits of the people of Amiens; on this, see Albert Labarre, *Le livre dans la vie amiénoise du seizième siècle; l'enseignement des inventaires après décès 1503–1576*. Anthoine Ancquier, a *tailleur d'images* who worked on the choir stalls, possessed one book at the time of his death in 1542. See also Mary Jane Chase, "Popular Piety in Sixteenth-Century Picardy."

84. The written sources at Amiens favor the form *hucher*, rather than the more usual *huchier* that when translated might be understood as joiner or fine cabinetmaker.

85. Georges Durand, *Maître Pierre Tarisel*.

86. The term *imagier* is not found in the Amiens documentation.

87. On the division of "hands," see Diane Daussy, *Sculpter à Amiens*, 137–88.

88. But remember the important caveat: "Forms may manifest circumstances but circumstances do not coerce forms." Michael Baxandall, *The Limewood Sculptors of Renaissance Germany*, 164.

89. Diane Daussy, *Sculpter à Amiens*, 191. Very similar conclusions were reached by Raymond Koechlin and Jean-Jacques Marquet de Vasselot, *La sculpture à Troyes*, 50: (my translation) "all those artisans we have met were ordinary people and without pretensions. As masters they received modest salaries that were not much more than than those of the workers under their orders: enough to hold an honorable rank, but not more. Continuing [the work] of the *bons imagiers* of the Middle Ages, they lived in the same neighborhoods as other artisans of the city: fullers, shoemakers, or saddle makers; leading the same life as them; doing their best to carry out their jobs; never considering themselves *artists* as conceived in Italy at that time, and such as Primaticcio and Cellini were propagating in the French Court."

90. In literary terms we might think of a kind of *sermo humilis*—this was an idea profitably explored by Wolfgang Kemp in relation to stained glass production: see *The Narratives of Gothic Stained Glass*, 102–15.

91. The following is my summary of the 1491 statute of the *Tailleurs d'images* of Amiens as presented in Diane Daussy, *Sculpter à Amiens*, 47:

1. Practice of multiple professions is prohibited.

2. Apprenticeship is fixed at 3 years, and entry fees at 8 sous (to be shared by the confraternity of Saint Luke and the masters).

3. Apprentices may not quit their master or practice before 3 years.

4. Foreign masters may work for only 8 days—beyond this they must pay 2 sous for entry and, at the end of a month, 4 sous a month.

5. Apprentices at the end of their term pay 4 pounds entry fee and offer a masterwork.

6. Masters must continue to contribute.

7. Sons of masters entering the profession pay 40 sous and offer a masterwork acceptable to the other masters and *compagnons*.

On the potentially restrictive nature of medieval craft guilds, see Michael Baxandall, *The Limewood Sculptors of Renaissance Germany*, 106–16.

92. At Amiens this shift is powerfully expressed in the prolific work of Nicolas Blasset; on this, see Christine Debrie, *Nicolas Blasset*, 407. Contrasting Blasset's mode of production with that of his medieval predecessors, Debrie concludes that Blasset was "the first Picard artist, in the modern sense of the term."

93. Antiquarian sources suggest that the old steeple, the *parvum campanile*, had first been built around 1240 under Bishop Arnoul de la Pierre, but the recent redating of the roof makes it unlikely that the construction could have been undertaken much before 1310 with the completion of the roof.

94. Georges Durand, *Monographie* 1: 518. The account was said to come from the chapter deliberations as recorded by Achille Machart.

95. Eugène-Emmanuel Viollet-le-Duc, *Dictionnaire raisonné* 5: 426–72, "Flèche." John Ruskin agreed with this negative assessment.

96. We learn about the belfry in Jean-François Daire, *Histoire de la Ville d'Amiens* 2:104: *the steeple is full of little bells which form a most agreeable carillon. They bear different names . . . Jesus Maria to announce extreme unction; Breton sounds at the Benedictus . . . another for the mass of eleven o'clock . . . a fourth one; and one called Jeanne founded in 1672; and a sixth one made in 1697; Adrienne, named after Adrien de Hennencourt who gave money for the bells. . . .* We might think of Jean-François Millet's painting *Angelus* (L'Angélus).

97. Unfortunately, the recent dendrochronological survey does not allow specific dating of the individual parts of the structure, which has been reinforced several times: see, for example, Georges Durand, *Monographie* 1: 520, note 2.

98. Georges Durand, *Monographie* 1: 524.

99. Jean Morand, who had studied in Paris and later became a canon and vicar general of Amiens, was condemned in 1534 for the dangerous ideas in his preaching and his books publicly burned. See Geoffrey Treasure, *The Huguenots*, 68.

6. Liturgical Performance

1. The word "liturgy" is derived from the Greek, *leitourgia*, meaning public service: see John Harper, *The Forms and Orders of Western Liturgy*, 12. The word is generally applied to designate the entire range of worship practices of a corporate Christian community.

2. Canon Villeman undertook his work of recording liturgical theory and practice at Amiens Cathedral in order to make good the 1554 theft of the previously existing *Ceremoniale ecclesiae ambianensis*. Such a book would serve both as instructional guide for recently appointed clergy in the practices at Amiens and as a constantly available reference to help resolve ambiguities that might occur, for example, because of the intersection of Sundays and feast days. I have consulted two drafts by François Villeman: the *Essay d'un Cérémonial pour l'église d'Amiens, 1738*, Arch. Somme, MS 4G 3031 and his *Essay de Cérémonial pour la Sainte Eglise d'Amiens*, Tome I, Arch. Somme, MS DA 8 (formerly MS 14 bis). The extract quoted here is from the opening page of the preface of the latter source. On Villeman, see Frédéric Billiet, "La maîtrise de la cathédrale d'Amiens," 343. Villeman joined the chapter of Amiens Cathedral in December 1729 and died in 1743; he also held a prebend at Saint-Nicolas-au-Cloître in Amiens.

3. See Durand, *The Rationale Divinorum Officiorum of William Durand of Mende*, 2. Guillaume (William) Durand was born in the village of Puimisson, Languedoc in 1230 and was educated in cathedral schools in Provence, leading to a degree in Divine Law from the University of Bologna. Having served in the papal curia, he was appointed bishop of Mende; finally, called back to Rome, he died in that city in 1296. The *Rationale Divinorum Officiorum* found widespread circulation in the Middle Ages in early printed editions.

4. François Villeman, *Essay de Cérémonial*, Arch. Somme, MS DA 8, preface.

5. John Harper, *The Forms and Orders of Western Liturgy*, 45–57, provides a succinct account of these interlocking temporal cycles.

6. Raoul de Rouvroy, *Ordinaire*, i–xv. The Ordinary (or Ordinal) provided a precise script for the daily liturgical activities of the clergy. A copy was be available in the choir for consultation at all times; a 1491 written source mentions one chained behind the main altar. Raoul de Rouvroy's 1291 Ordinary replaced an earlier version that had been compiled around 1200 under Bishop Thibaud de Heilly. Bishop Évrard de Fouilloy and Dean Jean d'Abbeville had reorganized liturgical practice just before the 1220 fire; see Frédéric Billiet, "La maîtrise de la cathédrale d'Amiens," 110.

7. Raoul de Rouvroy, *Ordinaire*, xl.

8. The central role of the psalms is defined clearly in François Villeman's *Essay d'un Cérémonial*, Arch. Somme, MS 4G 3031, 66vo: *Psalms have always been considered one of the principal parts of Scripture—and we cannot doubt that these divine canticles were the work of the Holy Spirit who dictated them in order to instruct us, heal*

us, correct us and form us in virtue and justice. It is like an inexhaustible treasure of all kinds of spiritual richness and a source of life, allowing us to remedy all the ills of our souls. The Psalter, said Saint Basil, amounts to perfect theology. Here we find prophecies touching the incarnation of the Son of God; warnings of judgment, hope of resurrection, fear of punishment, promises of glory, revelation of all the Mysteries: like a treasure containing true wealth. From the time of King David until today the psalms have rightly always been the delight of pious souls and the consolation of penitent hearts. Villeman (fol. 67vo) goes on to discuss the practice of singing the Psalms antiphonally with two choirs, one to the left and one to the right, suggesting that the practice began in Antioch and was brought to the West by Bishop Ambrose of Milan. On the importance of the Psalms generally in medieval liturgy, see John Harper, *The Forms and Orders of Western Liturgy*, 67–72.

9. François Villeman, *Essay d'un Cérémonial*, Arch. Somme, MS 4G 3031, fol. 68vo. *This is why around 1200 Jean d'Abbeville, descended from the family of the Counts of Ponthieu, divided the 150 psalms between all the prebends [i.e., canons] for them to recite verbatim, this according to the extract from an ancient martyrology written before 1280 . . .* We are told that the reform was necessitated by the exhaustion of the clergy through the daily singing of the entire psalter together with the celebration of the offices of the Virgin and of the Dead. The new distribution was intended as a remedy. Each canon was made responsible for about four psalms (the very long Psalm 119 was split in two). John Harper, *The Forms and Orders of Western Liturgy*, 70, suggests that the psalter was completed each week.

10. On antiphonal singing see John Harper, *The Forms and Orders of Western Liturgy*, 78. The practice at Amiens is confirmed in the *Ordinaire*, 185, *debet cantari alternatim de dextro et sinistro choro*. Also see François Villeman, *Essay d'un Cérémonial*, Arch. Somme, MS 4G 3031, 67vo where it is affirmed that the practice of singing with two choirs (left and right sides of the choir) began in the East.

11. Frédéric Billiet, "La maîtrise de la cathédrale d'Amiens," 349.

12. Frédéric Billiet, "La musique à la cathédrale d'Amiens," 105.

13. Frédéric Billiet, "La musique à la cathédrale d'Amiens," 106.

14. John Harper, *The Forms and Orders of Western Liturgy*, 109.

15. Miri Rubin, *Corpus Christi*, 1.

16. Above the altar hung a silver vessel containing the Host: the body of Christ; while the keystone above carried an image of the resurrected Christ.

17. There were eight such occasions in the year: Epiphany, with the Invention of Saint Firmin; Saint Honoré; Birth of John the Baptist; the Assumption of the Virgin; Saint Firmin the Confessor; the Nativity of the Virgin; Saints Fuscien, Victoric, and Gentien; and the Nativity of Christ.

18. The bell ringers were presumably in the crossing space.

19. François Villeman, *Essay de Cérémonial*, Arch. Somme, MS DA 8, 49.

20. François Villeman, *Essay de Cérémonial*, Arch. Somme, MS DA 8, 152.

21. François Villeman, *Essay de Cérémonial*, Arch. Somme, MS DA 8, 188. In addition to burning wicks, down from the vaults came a white pigeon, and wafers (*oublies*). In some churches, Villeman tells us, a bucket of (baptismal) water was also dropped.

22. *Ordinaire*, 239.

23. *Ordinaire*, 108–9.

24. François Villeman, *Essay de Cérémonial*, Arch. Somme, MS DA 8, 26–32.

25. François Villeman, *Essay de Cérémonial*, Arch. Somme, MS DA 8, 38: *Here, briefly, is the story of the Green Man. At first Vespers on the feast of the Invention of Saint*

Firmin there appeared, seated in one of the lower choir stalls at the foot of the bishop's throne, and participating in the Mass, a Green Man, so called because he was dressed in a tunic sown over with ivy leaves, with a floral crown on his head and a candle in his hands. It was said that this was to represent the miracle that ensued at the Translation [of the saint's relics] when the intense cold that reigned during that season suddenly changed into agreeable Spring weather whose warmth caused leaves to grow on the trees and flowers [to bloom]. The appearance of this vernal personage, in reality a beadle from the parish church of Saint-Firmin-en-Castillon, which served as a diversion for the lesser kind of people [petit people] was wisely reformed, and all that was retained from the ceremony was the blessing of the incense, which takes place at First Vespers on that feast day, when two archdeacons in copes at the eagle lectern sing the response: Dum aperiretur Martyris Firmini sepulchrum. [Then the tomb of the Martyr Firmin is laid open]. At which words, there came such an abundance of sweet fragrances as if all types of color were diffused together [underlined words taken from the Latin Vita of Saint Sauve]. The bishop or celebrant accompanied by four dignitaries tosses a quantity of incense into a burner placed in front of the altar from which the smoke rises up to the vault of the church to represent, in some way, the sweet scent that was diffused not only in neighboring dioceses but as far as Beaugency and Orleans where Simon, seigneur of that place was miraculously cured of leprosy at the moment of the Invention.

26. *Ordinaire*, 216.
27. The eastern gate of the old Roman city wall at Beauvais was known as the *Gloria Laus*—presumably the site of a similar celebration; see Stephen Murray, *Beauvais Cathedral*, 9.
28. François Villeman, *Essay de Cérémonial*, Arch. Somme, MS DA 8, 88–93.
29. *Ordinaire*, 307–309.
30. François Villeman, *Essay de Cérémonial*, Arch. Somme, MS DA 8, 170–178.
31. Craig Wright, *The Maze and the Warrior*, 129–58.
32. Craig Wright, *The Maze and the Warrior*, 144.
33. There is no record of ring dancing on the labyrinth at Amiens on Easter day, though at five o'clock in the evening the clergy would process into the nave in order to perform the *Salut* with the singing of *Dicunt nunc Judaei* and *Victimae Paschali*. The great organ would play and the bishop would perform the benediction in the nave.
34. The ring dance at Auxerre and Sens was suppressed in the sixteenth century.
35. At nine o'clock on a summer's evening the chalk of the western frontispiece, gilded by the setting sun, is visible from far across the Picard plain: *ma toute belle au front doré. . . .* (Canon Adrian de la Morlière).
36. François Villeman, *Essay de Cérémonial*, Arch. Somme, MS DA 8, 100.
37. For example, under January it is noted, *NOX HABET HORAS XVI, DIES VIII* (*Ordinaire*, 2). Under June it is noted, *NOX HABET HORAS VI, DIES XVIII* (*Ordinaire*, 9).
38. Louis François Daire, *Histoire de la Ville d'Amiens* 2: 98: *The keystones are pierced through, and the cavity seems to have been filled with vases and vessels of copper to enhance the repercussion of the voice, forming the Echo. The white stones that compose the vault [severies] are called "Pastoureaux" because shepherds used to cut them in the countryside. See also vol. 5, 69, the centers of these rib vaults are formed by two matching curved lines forming diagonal arcs, intersecting at the summit where the keystones are pierced through. In the hole it seems that there were vases and vessels of copper, which augment the repercussion of the voice and form that agreeable echo*

which is heard in this admirable cathedral which is full of resonances which help the voice and amplify its volume as it mounts, leading it directly and clearly to the ears.

39. It is hard to find words to describe the affect. This is what Jean Pagès (c. 1700) had to say: *Sometimes you hear choir boys whose voices, tender, delicate and flexible, supported by continuous bass singing, are able to express the speech of the holy Church which, like the mystic bride, bears witness to her sadness at the suffering of her dear spouse. At another time it is the choir whose strong male voices intone a sweet canticle to witness the joy felt by this same bride who celebrates the triumph of her divine spouse Or again it is the combination: mixing sweetness and force, conjuring God most powerful to send his holy spirit to enflame our hearts with his divine love and to banish all evil that could keep us from his service.* See Louis Douchet, *Manuscrits de Pagès* 5: 453.

40. François Villeman, *Essay de Cérémonial*, Arch. Somme, MS DA 8, preface.

41. Quoted by Frédéric Billiet, "La musique," 110.

42. For the vital role of the angels, see David Keck, *Angels and Angelology in the Middle Ages*; see also Dominique Poirel, "L'ange gothique."

Bibliography

Abou-El-Haj, Barbara. "Artistic Integration Inside the Cathedral Precinct: Social Consensus Outside?" In *Artistic Integration in Gothic Buildings*, ed. Virginia Chieffo Raguin, Kathryn Brush, and Peter Draper, 214–235. Toronto: University of Toronto Press, 1995.

Ackerman, James S. " 'Ars Sine Scientia Nihil Est': Gothic Theory of Architecture at the Cathedral of Milan," *Art Bulletin* 31, no. 2 (1949): 84–111.

Ackland, James H. *Medieval Structure: The Gothic Vault.* Toronto: University of Toronto Press, 1972.

André, Aurélien. "Le Beau Pilier." In Bouilleret et al., *Amiens*, 213–18.

——. "Le jubé." In Bouilleret et al., *Amiens*, 219–24.

——. "Les tombeaux de bronze d'Evrard de Fouilloy et de Geoffroy d'Eu." In Bouilleret et al., *Amiens*, 28–29.

Asseray, Nicolas, "Entre rayonnant et flamboyant: la cathédrale d'Amiens au XIVe. siècle. . . . Les chapelles de la nef. . . ." (PhD diss., Université de Picardie Jules Verne, in progress).

Barnes, Carl. *The Portfolio of Villard de Honnecourt (Paris, Bibliothèque nationale de France, MS Fr 19093): A New Critical Edition and Color Facsimile.* Farnham, UK: Ashgate, 2009.

Baron, Françoise. "Mort et résurrection du jubé de la cathédrale d'Amiens," *Revue de l'art* 87, no. 1 (1990): 29–41.

Bautier, Robert-Henri, ed. *La France de Philippe Auguste: le temps des mutations. Actes du colloque international organisé par le CNRS (Paris, 29 septembre–4 octobre 1980).* Paris: Éditions CNRS, 1982.

Baxandall, Michael. *The Limewood Sculptors of Renaissance Germany.* New Haven, CT: Yale University Press, 1980.

Bayard, Didier, and Noël Mahéo, eds. *La marque de Rome: Samarobriva (Amiens) et les villes du nord de la Gaule, exposition, Musée de Picardie, 14 fév.–29 août 2004.* Amiens: Presses de l'imprimerie OCEP, 2006.

——, and Jean-Luc Massy. *Amiens romain: Samarobriva Ambianorium.* Amiens: Revue archéologique de Picardie, 1983.

Bechmann, Roland. "The Saracen's Sepulcher: An Interpretation of Folio 6r in the Portfolio of Villard de Honnecourt." In *Villard's Legacy: Studies in Medieval Technology, Science and Art in Memory of Jean Gimpel*, ed. Marie-Thérèse Zenner, 121–134. London: Ashgate, 2004.

Bell, David N. *The Image and Likeness: The Augustinian Spirituality of William of Saint Thierry.* Kalamazoo, MI: Cistercian Publications, 1984.

Berger, Élie. *Saint Louis et Innocent IV: étude sur les rapports de la France et du Saint-Siège.* Reprint. Ann Arbor, MI: University of Michigan Press, 2014.

Billiet, Frédéric. "La maîtrise de la cathédrale d'Amiens d'après le projet de cérémonial du chanoine Villeman au XVIIIe siècle." In *Maîtrises et chapelles aux XVIIe et XVIIIe siècles: des institutions musicales au service de Dieu,* ed. Bernard Dompnier, 343–65. Clermont-Ferrand: Presses Universitaires Blaise-Pascal, 2003.

——. "La musique à la cathédrale d'Amiens du XIe au XVIIe siècle." In *La musique en Picardie du XIVe au XVII siècle,* ed. Camilla Cavichi, Marie Alexis Colin, and Philippe Vendrix, 105–15. Turnhout, Belgium: Brepols, 2012.

Binski, Paul. *Gothic Sculpture.* New Haven, CT: Yale University Press, 2019.

——. *Gothic Wonder: Art, Artifice and the Decorated Style, 1290–1350.* New Haven, CT: Yale University Press, 2014.

——. *Medieval Death: Ritual and Representation.* Ithaca, NY: Cornell University Press, 1996.

Block, Elaine C. "Images de Joseph et ses frères en Picardie." In *Autour des stalles de Picardie: tradition iconographique au Moyen-Âge. Actes du colloque de Misericordia International et du 1er colloque de Stalles de Picardie (Amiens, septembre 1999),* ed. Kristiane Lemé-Hébuterne, 115–34. Amiens: Encrage, 2001.

Boerner, Bruno. "L'iconographie des portails sculptés des cathédrales gothiques: les parcours et les fonctions rituels." In *Art médiéval: les voies de l'espace liturgique,* ed. Paolo Piva, 221–61. Paris: Picard, 2010.

——. *Par Caritas par Meritum: Studien zur Theologie des gotischen Weltgerichtsportals in Frankreich—am Beispiel des mittleren Westeingangs von Notre-Dame-de-Paris.* Freiburg, Switzerland: Universitätsverlag, 1998.

Bonde, Sheila, Edward Boyden, and Clark Maines. "Centrality and Community: Liturgy and Gothic Chapter House Design at the Augustinian Abbey of Saint-Jean-des-Vignes, Soissons." *Gesta* 29, no. 2 (1990): 189–213.

——, Clark Maines, and Robert Mark. "Archaeology and Engineering: The Foundations of Amiens Cathedral." *Kunstchronik* 42 (1989): 341–53.

——, Clark Maines, and R. Richards, Jr. "Soils and Foundations." In *Architectural Technology up to the Scientific Revolution: The Art and Structure of Large-Scale Buildings,* ed. Robert Mark, 16–50. Cambridge, MA: MIT Press, 1993.

Bonneton, Christine, ed. *Amiens.* Paris: Tardy, 1989.

Bony, Jean. *The English Decorated Style: Gothic Architecture Transformed, 1250–1350.* Ithaca, NY: Cornell University Press, 1979.

Bouilleret, Jean, Aurélien André, Xavier Boniface, and Jean-Marc Albert, eds. *Amiens: la grâce d'une cathédrale.* Strasbourg: La nuée bleue, 2012.

Boussard, Jacques. "Philippe Auguste et les Plantagenêts." In Bautier, *Philippe Auguste,* 263–87.

Bouvier, Henri. *Histoire religieuse de la ville d'Amiens, des origines au XIVe siècle.* Amiens: Yvert et Tellier, 1921.

Bovini, Guiseppe. *Ravenna Mosaics.* Greenwich, CT: New York Graphic Society, 1965.

Brook, Leslie C. "A [sic] translation de la relique de Saint Jean-Baptiste à la cathédrale d'Amiens: récits latin et français." *Neuphilologische Mitteilungen* 91, no. 1 (1990): 93–106.

Brooks, Peter. *Reading for the Plot: Design and Intention in Narrative.* New York: Vintage, 1984.

Brown, Peter. *The Cult of the Saints: Its Rise and Function in Latin Christianity.* Chicago: University of Chicago Press, 1981.

Brunelle, Vincent. "Bilan du chantier de restauration des portails de la façade occidentale de la cathédrale d'Amiens." In Verret and Steyaert, *La couleur et la pierre*, 223–32.

Bruzelius, Caroline. "Cistercian High Gothic: Longpont and the Architecture of the Cistercians in France in the Early Thirteenth Century." PhD diss., Yale University, 1977.

Bumpus, Thomas Francis. *The Cathedrals and Churches of Belgium.* London: T. W. Laurie, 1909.

Cailleaux, Denis. *La cathédrale en chantier: la construction du transept de Saint-Étienne de Sens d'après les comptes de la fabrique, 1490–1517.* Paris: Comité des travaux historiques et scientifiques, 1999.

Calonne, Albéric de. *Histoire de la ville d'Amiens*, 3 vols. Amiens: Piteux Frères, 1899–1906.

Campbell, Brian J. *The Writings of the Roman Land Surveyors: Introduction, Text, Translation, Commentary.* London: Society for the Promotion of Roman Studies, 2000.

Campbell, Gerard J. "The Protest of Saint Louis." *Traditio* 15 (1959): 405–18.

Carruthers, Mary. *The Book of Memory: A Study of Memory in Medieval Culture.* Cambridge: Cambridge University Press, 1992.

——. "The Concept of *Ductus*, or Journeying through a Work of Art." In *Rhetoric Beyond Words: Delight and Persuasion in the Arts of the Middle Ages*, ed. Mary Carruthers, 190–213. Cambridge: Cambridge University Press, 2010.

——, ed. *Rhetoric Beyond Words: Delight and Persuasion in the Arts of the Middle Ages.* Cambridge: Cambridge University Press, 2010.

Carus-Wilson, Eleanor Mary. "La guède française en Angleterre: un grand commerce du Moyen-Âge. *Revue du Nord* 35 (1953): 89–105.

Chase, Mary Jane. "Popular Piety in Sixteenth-Century Picardy: Amiens and the Rise of Private Devotions, 1500–1540." PhD diss., Columbia University, 1992.

Christ, Yves. "Comment Viollet-le-Duc défigura la galérie des rois d'Amiens." *Les pierres de France* 13 (April–June 1950): 12–28.

Coldstream, Nicola. *The Decorated Style: Architecture and Ornament, 1240–1360.* Toronto: University of Toronto Press, 1994.

——. *Medieval Craftsmen: Masons and Sculptors.* Toronto: University of Toronto Press, 1991.

Colombier, Pierre du. *Les chantiers des cathédrales, les architectes, les maçons, les sculpteurs d'après les textes, les miniatures, les vitraux, les sculptures.* Paris: Picard, 1953.

Conant, Kenneth. *Carolingian and Romanesque Architecture, 800–1200.* Harmondsworth, UK: Penguin Books, 1959.

Corbellini, Sabrina, and Margriet Hoogvliet. "Artisans and Religious Reading before the Reformation in Italy and Northern France (c. 1400–1520)." *Journal of Medieval and Early Modern Studies* 43, no. 3 (2013): 521–44.

Corblet, Jules. *Hagiographie du diocèse d'Amiens.* 5 vols. Paris: J.-B. Dumoulin, 1868–1875.

——. *Les tombes en bronze des deux évêques fondateurs de la cathédrale d'Amiens.* Paris: Donnaud, no date.

Corvol-Dessert, Andrée, Patrick Hoffsummer, Jannie Meyer, et al., eds. *Les charpentes du XIe au XIXe siècle: typologie et évolution en France du Nord et en Belgique.* Cahiers du Patrimoine 62. Paris: Éditions du Patrimoine, 2002.

Daire, Louis-François. *Histoire de la ville d'Amiens depuis ses origines jusqu'à présent.* 2 vols. Paris: Veuve Delaguette, 1757.

Daussy, Stéphanie Diane. "Les clôtures du choeur." In Bouilleret et al., *Amiens*, 225–33.

——. *Sculpter à Amiens en 1500.* Rennes: Presses Universitaires de Rennes, 2013.

Davis, Michael T. "Splendor and Peril: The Cathedral of Paris, 1290–1350." *Art Bulletin* 80, no. 1 (1998): 34–66.

—— and Linda Neagley. "Mechanics and Meaning: Plan Design at Saint-Urbain, Troyes and Saint-Ouen, Rouen." *Gesta* 39, no. 2 (2000): 161–82.

Davis-Weyer, Caecilia. *Early Medieval Art, 300–1150: Sources and Documents*. Medieval Academy Reprints for Teaching 17. Englewood Cliffs, NJ: Prentice Hall, 1971.

Debrie, Christine. *Nicolas Blasset: architecte et sculpteur ordinaire du roi, 1600–1659*. Paris: Nouvelles Éditions Latines, 1985.

Dectot, Xavier and Meredith Cohen, eds. *Paris, ville rayonnante: exposition au Musée national du Moyen Âge, 10 février–24 mai 2010*. Paris: Réunion des musées nationaux, 2010.

Dereine, Charles. "Chanoines (des origines au XIIIe siècle)." In *Dictionnaire d'histoire et de géographie ecclésiastiques*, ed. Roger Aubert, vol. 12, 353–405. Paris: Letouzey et Ané, 1950.

Desportes, Pierre. "Le mouvement communal dans la province de Reims." In *Les chartes et le mouvement communal: colloque régional, octobre 1980, organisé en commémoration du neuvième centenaire de la Commune de Saint-Quentin*, 105–112. Saint-Quentin: Société Academique de Saint-Quentin, 1982.

——, Helen Millet, et al., eds. *Fasti Ecclesiae Gallicanae (FEG): répertoire prosopographique des évêques, dignitaires et chanoines de France de 1200 à 1500*, vol. 1, *Diocèse d'Amiens*, 52–53. Turnhout, Belgium: Brepols, 1996.

Doquang, Mailan. "The Lateral Chapels of Notre-Dame in Context." *Gesta* 50, no. 2 (2011): 137–61.

——. *The Lithic Garden: Nature and the Transformation of the Medieval Church*. New York: Oxford University Press, 2018.

Douchet, Louis, ed., and Jean-Baptiste Pagès. *Manuscrits de Pagès, marchand d'Amiens: écrits à la fin du 17e et au commencement du 18e siècle, sur Amiens et la Picardie; mis en ordre et publiés par Louis Douchet*. 6 vols. Amiens: Alfred Caron, 1856–1864.

Douie, Decima L. *The Conflict between the Seculars and the Mendicants at the University of Paris in the Thirteenth Century: A Paper Read to the Aquinas Society of London on 22nd June, 1949*, vol. 23. London: Blackfriars, 1954.

Dubois, Philippe. "Adrien de Hénencourt, le mécène amiénois." *Bulletin de la Société des antiquaires de Picardie* 4 (1999): 296–344.

Duby, Georges. *Le dimanche de Bouvines: 27 juillet 1214*. Paris: Gallimard, 1973.

——. *Early Growth of the European Economy: Warriors and Peasants from the Seventh to the Twelfth Century*. Trans. Howard B. Clarke. Ithaca, NY: Cornell University Press, 1994.

Ducos, Joëlle, and Christopher Lucken, eds. *Richard de Fournival et les sciences au XIIIe siècle*. Micrologus Library 88. Florence: SISMEL, Edizioni del Galluzzo, 2018.

Durand, Georges. *Maître Pierre Tarisel, maître maçon du roi, de la ville et de la cathédrale d'Amiens (1472–1510): discours de réception prononcé le 12 mars 1897*. Amiens: Yvert et Tellier, 1897.

——. *Monographie de l'église Notre-Dame, cathédrale d'Amiens*. 3 vols. Paris: A. Picard, 1901–1903.

Duvanel, Maurice, Pierre Leroy, and Matthieu Pinette. *La confrérie Notre-Dame du Puy d'Amiens*. Amiens: Imprimerie Yvert, 1997.

Edwards, Kathleen. *The English Secular Cathedrals in the Middle Ages: A Constitutional Study with Special Reference to the Fourteenth Century*. Manchester, UK: Manchester University Press, 1949.

Etude historique et archéologique: le chevet, Direction Régional des Affaires Culturelles, Picardie, Amiens 2003.

Eeckman, Alex, ed. "Un voyage en Flandre, Artois et Picardie en 1714, publié d'après le manuscript du sieur Nomis par Alex Eeckman." *Annales du Comité flamand de France* 22 (1895): 336–72.

Erlande-Brandenburg, Alain. "Le choeur dans les cathédrales gothiques." In *La place du choeur: architecture et liturgie du Moyen Âge aux temps modernes*, actes du colloque de l'EPHE, les 10 et 11 décembre 2007, ed. Sabine Frommel and Laurent Lecomte, 57–66. Paris: Picard, 2012.

Les fastes du gothique: le siècle de Charles V—Galeries nationales du Grand Palais, 9 octobre 1981–1er février 1982. Paris: Réunion des musées nationaux, 1981.

Fernie, Eric. "A Beginner's Guide to the Study of Gothic Architectural Proportions and Systems of Length." In *Medieval Architecture and Its Intellectual Context: Studies in Honour of Peter Kidson*, ed. Eric Fernie and Paul Crossley, 229–37. London: Hambledon, 1990.

Fitchen, John. *The Construction of Gothic Cathedrals: A Study of Medieval Vault Erection*. Oxford: Oxford University Press, 1961.

Fossier, Robert. *La terre et les hommes en Picardie jusqu'à la fin du XIIIe siècle*, 2 vols. Louvain, Belgium: Nauwelaerts, 1968.

Foucart, Jacques. "À propos de la controverse sur la localisation de la porte martinienne d'Amiens. *Bulletin de la Société des antiquaires de Picardie* 61 (1986): 283–304.

Foucart-Borville, Jacques, "Les fonts baptismaux de la cathédrale, ancienne cuve à laver les morts." *Bulletin de l'Association des amis de la cathédrale d'Amiens* 24 (2009): 10–12.

Frachon-Gielarek, Nathalie. *Amiens: les verrières de la cathédrale*. Amiens: AGIR-Pic, 2003.

———. "Les vitraux." In Bouilleret et al., *Amiens*, 253–68.

Frisch, Teresa G. *Gothic Art, 1140–c. 1450: Sources and Documents*. Englewood Cliffs, NJ: Prentice Hall, 1971.

Gaposchkin, Marianne Cecilia. *The Making of Saint Louis: Kingship, Sanctity, and Crusade in the Later Middle Ages*. Ithaca, NY: Cornell University Press, 2008.

Gimpel, Jean. *The Cathedral Builders*. Trans. Teresa Waugh. New York: Grove, 1983.

Goldblatt, David. *Art and Ventriloquism*. London: Routledge, 2006.

Goodson, Caroline J. *The Rome of Paschal I: Papal Power, Urban Renovation, Church Rebuilding and Relic Translation, 817–824*. Cambridge: Cambridge University Press, 2010.

Griffe, Élie. *La Gaule chrétienne à l'époque romane*, 3 vols. Paris: Letouzey et Ané, 1964.

Guillaume Durand. *The Rationale Divinorum Officiorum of William Durand of Mende: A New Translation of the Prologue and Book One*, ed. and trans. Timothy M. Thibodeau, Records of Western Civilization Series. New York: Columbia University Press, 2007.

Hanning, Robert W. " 'Ut enim Faber . . . sic Creator': Divine Creation as Context for Human Creativity in the Twelfth Century." In *Word, Picture and Spectacle*. Ed. Karl P. Wentersdorf and Clifford Davidson. Early Drama, Art and Music Monograph Series 5, 95–149. Kalamazoo: Medieval Institute, 1984.

Harper, John. *The Forms and Orders of Western Liturgy from the Tenth to the Eighteenth Century: A Historical Introduction and Guide for Students and Musicians*. Oxford: Clarendon, 1991.

Harvey, John. *The Medieval Architect*. London: Wayland, 1972.

Haubrichs, Wolfgang. "*Error inextricabilis*: Form und Funktion der Labyrinthabildung in mittelalterlichen Handschriften." In *Text und Bild: Aspekte des Zusammenwirkens zweier Künste in Mittelalter und früher Neuzeit*, ed. Christel Meier and Uwe Ruberg, 63–174. Wiesbaden: Ludwig Reichert, 1980.

Hayes, Zachary. *The Hidden Center: Spirituality and Speculative Christology in St. Bonaventure*. New York: Paulist Press, 1981.

Hemptinne, Thérèse de. "Aspects des relations de Philippe Auguste avec la Flandre au temps de Philippe d'Alsace." In Bautier, *Philippe Auguste*, 255–62.

Hohenzollern, Johann Georg, Prinz von. *Die Königsgalerie der französischen Kathedrale*. Munich: W. Fink, 1965.

Hoogvliet, Margriet, "*Pour faire laies personnes entendre les hystoires des escriptures anciennes:* Theoretical Approaches to a Social History of Religious Reading in the French Vernaculars during the Late Middle Ages." In *Cultures of Religious Reading in the Late Middle Ages: Instructing the Soul, Feeding the Spirit, and Awakening the Passion*, ed. Sabrina Corbellini, 247–74. Turnhout, Belgium: Brepols, 2013.

Hubscher, Ronald. *Histoire d'Amiens*. Toulouse: Privat, 1986.

Janelle, Pierre. "Le voyage de Martin Bucer et Paul Fagius de Strasbourg en Angleterre en 1549." *Revue d'Histoire et de Philosophie religieuses* 8, no. 2 (1928): 162–77.

Javelet, Robert. *Image et ressemblance au XIIe siècle: de Saint Anselme à Alain de Lille*. Paris: Letouzey et Ané, 1967.

Jordan, William Chester. *Louis IX and the Challenge of the Crusade: A Study in Rulership*. Princeton, NJ: Princeton University Press, 1979.

Jung, Jacqueline E. *The Gothic Screen: Space, Sculpture, and Community in the Cathedrals of France and Germany, ca. 1200–1400*. Cambridge: Cambridge University Press, 2012.

Kasarska, Iliana. "Construire un décor sculpté: le portail de la Vierge dorée (Amiens) et la fenêtre des Arts Libéraux (Laon)." In *Mise en oeuvre des portails gothiques: architecture et sculpture—actes du colloque tenu au musée de Picardie Amiens, le 19 janvier 2009*, 29–46. Paris: Picard, 2011.

——. "La sculpture des portails." In Bouilleret et al., *Amiens*, 175–212.

Katzenellenbogen, Adolf. "The Prophets on the West Façade of Amiens Cathedral." *Gazette des Beaux-Arts* 6, no. 40 (1952): 241–60.

——. "Tympanum and Archivolts on the Portal of St Honoré at Amiens." In *De artibus opuscula XL: Essays in Honor of Erwin Panofsky*, ed. Millard Meiss, vol. 1, 280–90. 2 vols. New York: New York University Press, 1961.

Keck, David. *Angels and Angelology in the Middle Ages*. New York: Oxford University Press, 1998.

Kemp, Wolfgang. *The Narratives of Gothic Stained Glass*. Cambridge: Cambridge University Press, 1996.

Kidson, Peter. "Vitruvius." In *The Dictionary of Art*, ed. Jane Turner, vol. 32, 632–42. Oxford: Grove, 1996. 34 vols.

Kimpel, Dieter. "Le développement de la taille en série dans l'architecture médiévale et son rôle dans l'histoire économique." *Bulletin monumental* 135, no. 3 (1977): 195–222.

——. "Structures et évolution des chantiers médiévaux." In *Chantiers médiévaux*, ed. Francesco Aceto et al., Présence de l'art 2, 11–52. Milan: Zodiaque, 1995.

Kimpel, Dieter, Albert Hirmer, and Robert Suckale. *Die gotische Architektur in Frankreich: 1130–1270*. Munich: Hirmer, 1985.

—— and Robert Suckale. "Die Skulpturenwerkstatt der Vierge Dorée am Honoratusportal der Kathedrale von Amiens." *Zeitschrift für Kunstgeschichte* 36, no. 4 (1973): 217–65.

Knipping, Detlef. *Die Chorschranke der Kathedrale von Amiens: Funktion und Krise eines mittelalterlichen Ausstattungstypus*. Munich: Deutscher Kunstverlag, 2001.

Knoop, Douglas. *The Genesis of Freemasonry: An Account of the Rise and Development of Freemasonry in Its Operative, Accepted, and Early Speculative Phases*. Manchester, UK: Manchester University Press, 1947.

———, and Gwilym P. Jones. *The Medieval Mason: An Economic History of English Stone Building in the Later Middle Ages and Early Modern Times.* Manchester, UK: Manchester University Press, 1933.

Koechlin, Raymond, and, Jean-Jacques Marquet de Vasselot. *La sculpture à Troyes et dans la Champagne méridionale au seizième siècle: étude sur la transition de l'art gothique à l'italianisme.* Paris: F. de Nobele, 1966. Reprint.

Kraus, Henry. "New Documents for Notre-Dame's Early Chapels." *Gazette des Beaux-Arts* 6th period, 74 (1969): 121–34.

———. *Gold Was the Mortar: The Economics of Cathedral Building.* London: Kegan Paul, 1979.

Krautheimer, Richard. "Introduction to an 'Iconography of Medieval Architecture.'" *Journal of the Warburg and Courtauld Institutes* 5 (1942): 1–33.

Kubler, George. "A Late Gothic Computation of Rib Vault Thrusts." *Gazette des Beaux-Arts* 6th series 26 (1944): 135–48.

Kunze, Hans. *Das Fassadenproblem des französischen Früh- und Hochgotik.* Leipzig. Germany: Oscar Branstetter, 1912.

Kuttner, Stephen, and Antonio Garcia y Garcia. "A New Eyewitness Account of the Fourth Lateran Council." *Traditio* 20 (1964): 115–78.

Labarre, Albert. *Le livre dans la vie amiénoise du seizième siècle: l'enseignement des inventaires après décès 1503–1576.* Paris: Nauwelaerts, 1971.

La Morlière, Adrian de. *Les Antiquitez de la ville d'Amiens et le Recueil de plusieurs nobles et illustres maisons vivantes et esteintes en l'estenduë du Diocese d'Amiens.* Paris: Sebastien Cramoisy, 1642.

Lampe, Geoffrey W., ed. *The Cambridge History of the Bible, Volume 2: The West from the Fathers to the Reformation.* Cambridge: Cambridge University Press, 1969.

Lebigue, Jean-Baptiste. "La liturgie médiévale." In Bouilleret et al., *Amiens,* 387–407.

Lefèbvre, Emeline. "Le chaînage du triforium de la cathédrale Notre-Dame d'Amiens." In *L'homme et la matière: colloque de Noyon 16–17 novembre 2006,* ed. Arnaud Timbert, 141–48. Paris: Picard, 2009.

Lemé-Hébuterne, Kristiane. "L'Arlésienne amiénoise ou la Danse macabre de la cathédrale d'Amiens," *Bulletin des antiquaires de Picardie* 69, no. 691/692, 3 et 4 trimestres (2009): 487–511.

———, *Les stalles de la cathédrale Notre-Dame d'Amiens: histoire, iconographie.* Paris: Picard, 2007.

Lespinasse, René de, and François Bonnardot. *Les métiers et corporations de la ville de Paris, XIIIe siècle: le livre des métiers d'Étienne Boileau.* Paris: Imprimerie Nationale, 1879.

Little, Charles T. "Monumental Gothic Sculpture from Amiens in American Collections." In *Pierre, lumière, couleur: études d'histoire de l'art du Moyen Âge en l'honneur d'Anne Prache,* ed. Fabienne Joubert and Deny Sandron, 243–53. Cultures et civilisations médiévales 20. Paris: Presses de la Sorbonne, 1999.

Lopez, Robert. "Économie et architecture médiévales: cela aurait-il tué ceci?" *Annales, Économies-Sociétés-Civilisations* 8 (1952): 433–38.

Lucken, Christopher, "Parcours et portrait d'un homme de savoir." In Ducos and Lucken, *Richard de Fournival,* 3–45.

Maillart, François-Xavier, and Aurélien André. "La confrérie du Puy Notre-Dame." In Bouilleret et al., *Amiens,* 407–22.

Mâle, Emile. *Religious Art in France,* Vol. 2, *The Thirteenth Century: A Study of Medieval Iconography and its Sources.* Ed. Harry Bober. Trans. Marthiel Mathews. Princeton: Princeton University Press, 1984.

Mantel, François-Xavier "L'abbaye de Saint-Martin-aux-Jumeaux." *Mémoires de la Société des antiquaires de Picardie* vol. 45 (1934): 1–409.

Martindale, Andrew. *The Rise of the Artist in the Middle Ages and Early Renaissance.* New York: McGraw-Hill, 1972.

Massiet du Biest, Jean. *La carte et le plan considérés comme instruments de recherche historique: études sur les fiefs et censives et sur la condition de tenures urbaines à Amiens, XIe–XVIIe siècle.* Tours: Gibert-Clarey, 1954.

Masson, André. "Le bouclement des piliers de la croisée de Saint-Ouen de Rouen." *Bulletin monumental* 85 (1926): 307–36.

Maugis, Édouard. *Recherches sur les transformations du régime politique et social de la ville d'Amiens: des origines de la commune à la fin du XVIe siècle.* Études d'histoire municipale 2. Paris: Picard, 1906.

McGerr, Rosemarie Potz. "Guyart Desmoulins, the Vernacular Master of Histories, and his *Bible historiale.*" *Viator* 14 (1983): 211–44.

Medding, Wolfgang. *Die Westportale der Kathedrale von Amiens und ihre Meister.* Augsburg, Germany: Filser, 1930.

Meunier, Florian. *Martin et Pierre Chambiges, architectes des cathédrales flamboyantes.* Paris: Picard, 2015.

Meyer, Ann R. *Medieval Allegory and the Building of the New Jerusalem.* Woodbridge, UK: Brewer, 2003.

Miolo, Laure, "Science des nombres, science des formes: arithmétique et géométrie dans les manuscrits de la *Biblionomia* de Richard de Fournival. In Ducos and Lucken, *Richard de Fournival,* 155–78.

Montaubin, Pascal. "Aux origines du quartier épiscopal: IVe–début XIIIe siècle." In Bouilleret et al., *Amiens,* 17–20.

——. "Le clergé de la cathédrale jusqu'en 1500." In Bouilleret et al., *Amiens,* 331–47.

——. "Évêques, chapitre et fabrique: les commanditaires de la cathédrale gothique." In Bouilleret et al., *Amiens,* 23–27.

——. "Grands événements dans la cathédrale au Moyen Âge." In Bouilleret et al., *Amiens,* 431–34.

Munier, Charles, ed. *Concilia Galliae a. 314– a.506.* Corpus Christianorum Series Latina 148. Turnhout, Belgium: Brepols, 1963.

Munro, John H. *Textiles, Towns and Trade: Essays in the Economic History of Late-Medieval England and the Low Countries.* Aldershot, UK: Variorum, 1994.

Murray, Stephen. *Beauvais Cathedral: Architecture of Transcendence.* Princeton: Princeton University Press, 1989.

——. *Building Troyes Cathedral: The Late Gothic Campaigns.* Bloomington: Indiana University Press, 1987.

——. *A Gothic Sermon: Making a Contract with the Mother of God, Saint Mary of Amiens.* Berkeley: University of California Press, 2004.

——. "Looking for Robert de Luzarches: The Early Work at Amiens Cathedral." *Gesta* 29, no. 1 (1990): 111–31.

——. *Notre-Dame, Cathedral of Amiens: The Power of Change in Gothic.* Cambridge: Cambridge University Press, 1996.

——. *Plotting Gothic.* Chicago: University of Chicago Press, 2014.

——, Robert Bork, and Robert Mark. "The Openwork Flying Buttresses of Amiens Cathedral: 'Postmodern Gothic' and the Limits of Structural Rationalism." *Journal of the Society of Architectural Historians* 56 (1997): 478–93.

Mussat, André. "Les cathédrales dans leurs cités." *Revue de l'art* 55 (1982): 9–22.

Newman, William Mendel. *Les seigneurs de Nesle en Picardie (XIIe–XIIIe siècle): leurs chartes et leur histoire.* 2 vols. Philadelphia: American Philosophical Society, 1971.

———. *Le personnel de la cathédrale d'Amiens, 1066–1306, avec une note sur la famille des seigneurs de Heilly.* Paris: Picard, 1972.

Noble, Thomas F. X., and Thomas Head, eds. *Soldiers of Christ: Saints and Saints' Lives from Late Antiquity and the Early Middle Ages.* University Park, PA: Pennsylvania State University Press, 1995.

O'Neill, Rory. "Gothic on the Edge: Light, Levitation and Seismic Culture in the Evolution of Medieval Religious Architecture of the Eastern Mediterranean." PhD diss., Columbia University, 2015.

Ott, John. *Bishops, Authority and Community in Northwestern Europe, c. 1050–1150.* Cambridge Studies in Medieval Life and Thought: Fourth Series. Cambridge, MA: Cambridge University Press, 2015.

Pächt, Otto. "Die Gotik der Zeit um 1400 als gesamteuropäische Kunstsprache." In *Europäische Kunst um 1400: Achte Ausstellung unter den Auspizien des Europarates,* ed. Vinzenz Oberhammer et al., 53–65. Vienna: Kunsthistorisches Museum, 1962.

Palumbo, Giovanni, ed. and trans. *Le Roman d'Abladane,* Classiques français du Moyen Âge 164. Paris: Champion, 2011.

Panofsky, Erwin, ed. and trans. *Abbot Suger on the Abbey Church of St-Denis and Its Art Treasures.* Princeton, NJ: Princeton University Press, 1979.

Perkins, Thomas. *The Cathedral Church of Amiens.* London: G. Bell and Sons, 1902.

Poeschke, Joachim. *Italian Mosaics: 300–1300.* New York: Abbeville Press, 2010.

Poirel, Dominique. "L'ange gothique." In *L'architecture gothique au service de la liturgie: Actes du colloque organisé à la Fondation Singer-Polignac (Paris) le jeudi 24 octobre 2002,* ed. Agnès Bos and Xavier Dectot, 130–37. Turnhout, Belgium: Brepols, 2003.

Pontal, Odette. "Le différend entre Louis IX et les évêques de Beauvais et ses incidences sur les Conciles (1232-1248)." *Bibliothèque de l'École des Chartes* 123, no. 1 (1965): 5–34.

Prache, Anne. "Un architecte du XIIIe siècle et son oeuvre: Pierre de Montreuil." *Dossiers d'histoire et archéologie* 47 (1980): 26–38.

———. "Remarques sur les parties hautes de la cathédrale d'Amiens." *Gazette des Beaux-Arts* 127 (1996): 55–62.

Raoul de Rouvroy. *Ordinaire de l'église Notre-Dame, Cathédrale d'Amiens, par Raoul de Rouvroy (1291), publié d'après le manuscrit original par Georges Durand.* Ed. Georges Durand. Mémoires de la Société des antiquaires de Picardie: documents inédits concernant la province, vol. 22. Amiens: Société des antiquaires de Picardie, 1934.

Renouard, Yves. "1212–1216: Comment les traits durables de l'Europe occidentale moderne se sont définis au début du XIIIe siècle." In *Études d'histoire médiévale,* 77–91. Paris: SEVPEN, 1968.

Ribaillier, Jean. "Jean d'Abbeville." *Dictionnaire de spiritualité: ascétique et mystique, doctrine et histoire,* vol. 8, 250–55. Paris: Beauchesne, 1974.

Richard, Hélène and Quesne, Jean-Michel. "Polychromies des portails d'Amiens: couleurs de lumière." In Verret and Steyaert, *La couleur et la pierre,* 255–58.

Richard de Fournival. *Master Richard's Bestiary of Love and Response.* Ed. and trans. Jeanette Beer, illustr. Barry Moser. Berkeley: University of California Press, 1986.

Rickard, Marcia R. "The Iconography of the Virgin Portal at Amiens." *Gesta* 22 (1983): 147–57.

Roffey, Simon. *Chantry Chapels and Medieval Strategies for the Afterlife.* Stroud, UK: Tempus, 2008.

Rostand, André. *Les descriptions anciennes de la cathédrale d'Amiens*. Conférences des Rosati Picards 47. Cayeux-sur-Mer, France: 1910.

Roze, Abbé Jean-Baptiste. "Nécrologie de l'église cathédrale d'Amiens, suivi des distributions aux fêtes." *Mémoires de la Société des antiquaires de Picardie* 28 (1855): 265–503.

Rubin, Miri. *Corpus Christi: The Eucharist in Late Medieval Culture*. Cambridge: Cambridge University Press, 1991.

Rudolph, Conrad. *The Mystic Ark: Hugh of Saint Victor, Art, and Thought in the Twelfth Century*. New York: Cambridge University Press, 2014.

——. "The Tour Guide in the Middle Ages: Guide Culture and the Mediation of Public Art." *The Art Bulletin* 100, no. 1 (2018): 36–67.

Ruskin, John. *The Bible of Amiens*. In *"Our Fathers Have Told Us": Sketches of the History of Christendom for Boys and Girls Who Have Been Held at Its Fonts, Part I*. Orpington, UK: George Allen, 1884.

Russell, Georgina. "The North Window of the Nine Altars Chapel, Durham Cathedral." In *Medieval Art and Architecture at Durham Cathedral, British Archaeological Association Conference Transactions for the Year 1977*, ed. Nicola Coldstream and Peter Draper, 87–90. London: British Archaeological Association, 1980.

——. "The Thirteenth-Century West Window of Lincoln Cathedral," In *Medieval Art and Architecture at Lincoln Cathedral, British Archaeological Association Conference Transactions for the Year 1982*, ed. Thomas A. Heslop and Veronica A. Sekules, 83–89. London: British Archaeological Association, 1986.

Saint-Denis, Alain, Martine Plouvier, and Cécile Souchon, eds. *Laon: la cathédrale*. Paris: Zodiaque, 2002.

Saler, Michael T. *As If: Modern Enchantment and the Literary Prehistory of Virtual Reality*. New York: Oxford University Press, 2012.

Salzman, Louis Francis. *Building in England down to 1540: A Documentary History*. Oxford: Clarendon, 1992.

Sandron, Dany. *Amiens: la cathédrale*. Photog. Christian Lemzaouda. Paris: Zodiaque, 2004.

——. "La fondation par cardinal Jean de la Grange de deux chapelles à la cathédrale d'Amiens: une tradition épiscopale devenue manifeste politique à la gloire du roi Charles V." In *L'artiste et le clerc: commandes artistiques des grands ecclésiastiques à la fin du Moyen Âge (XIVe–XVIe siècles)*, ed. Fabienne Joubert, 155–70. Paris: Presses de l'Université Paris-Sorbonne, 2006.

——, and Andrew Tallon. *Notre-Dame de Paris, neuf siècles d'histoire*. Paris: Parigramme, 2013.

Sauerländer, Willibald. "L'art antique et la sculpture autour de 1200." *Art de France* 1 (1961): 47–56.

——. "Gothic: the Dream of an Un-classical Style." In *Gothic Art and Thought in the Later Medieval Period: Essays in Honor of Willibald Sauerländer* [Conference on the Gothic . . . in Princeton . . . on March 19th and 20th, 2009], ed. Colum Hourihane, 7–12. Princeton, NJ: Index of Christian Art, University Park, in association with Pennsylvania State University Press, 2011.

——. *Gothic Sculpture in France, 1140–1270*. London: Thames and Hudson, 1972.

——. "Die kunstgeschichtliche Stellung der Westportale von Notre-Dame in Paris: Ein Beitrag zur Genesis des hochgotischen Stiles in der französische Skulptur." *Marburger Jahrbuch für Kunstwissenschaft* 17 (1959): 1–56.

Schlink, Wilhelm. *Der Beau Dieu von Amiens: Das Christusbild der gotischen Kathedrale*. Frankfurt am Main: Insel Verlag, 1991.

Schöller, Wolfgang. *Die rechtliche Organisation des Kirchenbaues im Mittelalter vornehmlich des Kathedralesbaues.* Cologne: Böhlau Verlag, 1989.

Sedlmayr, Hans. *Die Entstehung der Kathedrale,* new edition, ed. Bernhard Rupprecht. Graz, Austria: Akademische Druck-u. Verlagsanstalt, 1988.

Seyfried, Peter. *Die ehemalige Abteikirche Saint-Ouen in Rouen.* Weimar: VDG, 2002.

Sherman, Claire Richter. *The Portraits of Charles V of France (1338–1380).* New York: New York University Press, 1969.

Sivéry, Gérard. *Louis VIII, le lion.* Paris: Fayard, 1995.

Smalley, Beryl. *The Study of the Bible in the Middle Ages.* Notre Dame: University of Notre Dame Press, 1970.

Stalley, Roger. *Early Medieval Architecture.* Oxford: Oxford University Press, 1999.

Stephens, Prescott. *The Waldensian Story. A Study in Faith, Intolerance and Survival.* Lewes, UK: The Book Guild, 1998.

Stookey, Laurence Hull. "The Gothic Cathedral as the Heavenly Jerusalem: Liturgical and Theological Sources." *Gesta* 8 (1969): 35–41.

Sumption, Jonathan. *The Hundred Years War,* 4 vols. London: Faber and Faber, 1990.

Taylor, Larissa. *Soldiers of Christ. Preaching in Late Medieval and Reformation France.* New York: Oxford University Press, 1992.

Theophilus. *On Divers Arts: The Treatise of Theophilus.* Ed. and trans. John G. Hawthorne and Cyril Stanley Smith. Chicago: University of Chicago Press, 1963.

Thérel, Marie-Louise. *À l'origine du décor du portail occidental de Notre-Dame de Senlis: le triomphe de la Vierge-Eglise, sources historiques, littéraires et iconographiques.* Paris: Éditions CNRS, 1984.

Thiébaut, Jacques. "Beffrois, halles et hôtels de ville dans le nord de la France et l'actuelle Belgique." In *Les chartes et le mouvement communal: colloque régional, octobre 1980 organisé en commémoration du neuvième centenaire de la commune de Saint-Quentin,* 51–57. Saint-Quentin, France: Société académique de Saint-Quentin, 1982.

Timbert, Arnaud. "Existe-t-il une signification politique de l'architecture gothique au XIIe siècle: l'exemple des chevets de Saint-Denis et de Saint-Germain-des-Prés." *Cahiers d'histoire de l'art* 4 (2007): 15–27.

Toker, Franklin. "Alberti's Ideal Architect: Renaissance—or Gothic?" In *Renaissance Studies in Honor of Craig Hugh Smyth,* ed. Andrew Morrogh, vol. 2, 667–74. Florence: Giunti Barbèra, 1985.

Trachtenberg, Marvin. *Building-in-Time: From Giotto to Alberti and Modern Oblivion.* New Haven, CT: Yale University Press, 2010.

Treasure, Geoffrey. *The Huguenots.* New Haven, CT: Yale University Press, 2013.

Turner, Victor, and Edith Turner. *Image and Pilgrimage in Christian Culture: Anthropological Perspectives.* New York: Columbia University Press, 1978.

Van Gennep, Arnold. *The Rites of Passage.* Trans. Monika A. Vizedom and Gabrielle L. Caffee. Chicago: University of Chicago Press, 1960.

Verret, Denis, and Delphine Steyaert, eds. *La couleur et la pierre: polychromie des portails gothiques, actes du colloque, Amiens, 12–14 octobre 2000.* Paris: Picard, 2002.

Viollet-le-Duc, Eugène-Emmanuel. *Dictionnaire raisonné de l'architecture française du XVe au XVIe siècle.* 10 vols, Paris: B. Bance, A. Morel, 1854–68.

Vitruvius Pollio. *Ten Books of Architecture.* Ed. Ingrid D. Rowland and Michael Dewar; illus. Thomas Noble Howe. Cambridge: Cambridge University Press, 1999.

Vroom, Wim H. *Financing Cathedral Building in the Middle Ages: The Generosity of the Faithful.* Trans. Elizabeth Manton. Amsterdam: Amsterdam University Press, 2010.

Warren, Ann K. " Chapter House." In *Dictionary of the Middle Ages*, ed. Joseph R. Strayer, vol. 3, 266–67. New York: Scribners, 1983.

Watkin, David. *Morality and Architecture: The Development of a Theme in Architectural History and Theory from the Gothic Revival to the Modern Movement*. Oxford: Clarendon, 1977.

Weeks, Christopher. "The 'Portail de la Mère Dieu' of Amiens Cathedral: Its Polychromy and Conservation." *Studies in Conservation* 43, no. 2 (1998): 101–08.

Williams, Jane Welch. *Bread, Wine and Money: The Windows of the Trades at Chartres Cathedral*. Chicago: University of Chicago Press, 1993.

Williamson, Paul. *Gothic Sculpture, 1140–1300*. New Haven, CT: Yale University Press, 1995.

Willis, Robert. *The Architectural History of Canterbury Cathedral*. London: Longman, 1845.

Wright, Craig. *The Maze and the Warrior: Symbols in Architecture, Theology, and Music*. Cambridge, MA: Harvard University Press, 2001.

——. *Music and Ceremony at Notre-Dame of Paris, 500–1550*. Cambridge: Cambridge University Press, 1989.

Wu, Nancy Y. "The Hand of the Mind: The Ground Plan of Reims Cathedral as a Case Study." In *Ad Quadratum: The Practical Application of Geometry in Medieval Architecture*, ed. Nancy Y. Wu, 149–68. Aldershot, UK: Ashgate, 2002.

Young, Karl. *The Drama of the Medieval Church*, 2 vols. Oxford: Clarendon, 1933.

Zanettacci, Henri. *Les ateliers picards de sculptures à la fin du Moyen Âge*. Paris: Compagnie française des arts graphiques, 1954.

Manuscript Sources

Archives départementales de la Somme (Arch. Somme), MS G 2975, Martyrology and Register of the distributions of the chapter of the cathedral of Notre-Dame, Amiens.

——, MS 4G 1157, Amiens Cathedral Fabric Account for 1357–8.

——, MS 4G 3031: François Villeman, *Essay d'un Cérémonial pour l'eglise d'Amiens*, 1738.

——, MS DA 8 (formerly 14bis): François Villeman, *Essay de Cérémonial pour la Sainte Eglise d'Amiens*.

Index

Page numbers in *italics* indicate illustrations.

Amiens Cathedral (*continued*)
place and tourism at, 13; early names
for, 160; 18th century engraving, 47;
Gothic era end for, 13; royal patronage
and relations with, 29–30, 162, 167–68,
169, 173, 175, 182, 199, 228, 368n63;
1727 drawing of, *vi–vii*; 1780 views
compared with modern day, 4; Socratic
method in study of, 1–2; spatial envelope
of, 6–7; 2020 anniversary for, 13; views
in 1780 compared with modern day, 4.
See also specific topics
Amos (prophet), *104*
Annunciation: chapel, *52*, 196, *197*, 211,
274, 277, 277, 280, 382n38, 383n51;
confraternity, 211–12; feast day, 212;
Portal of the Virgin Mary, 111, *111*;
sculptural figures, 111, *111*, 123,
146, 196, *197*, 203, 314, 342, 364n56,
373n111, 382n38
Anquier, Antoine, 294, 323–24
anticlerical events. *See* violence and
anticlerical events
antiphonal chanting, 21, 228, 334, 388n10
Antique Revival style, 122, 131, 151,
191–92, 383n45, 361n20, 373n114
arches. *See* flying buttresses; vaults and
arches
architectural forms, 9–10, 357n58;
acoustics and, 343–44; change of
Gothic, factors behind, 86–87; *ductus*
concept in approach to, 3, 102, 300,
345–46; forces and movements behind
Gothic, 30–31; geometry and Vitruvius
teachings of, 236, 238, 377n37, 378n39;
light role in, 342–43, 389n35; liturgical
practice relation to, 70, 224–25,
332–33, 335–36, 344–45; pilgrimages
considered with, 225–26, 228, 376n16;
sameness of, 65–66; transformation
experience through, 20, 117, 140,
142, 144, 164, 332, 346–47; Villard de
Honnecourt understanding of, 235,
240, 354n1. *See also* construction;
specific forms
Arnoul de la Pierre (bishop), 122, 378n55;
background, 169, 367n43; construction

under, 169, 209, 386n93; fundraising
by, 374n136; tomb, *168*, 168–69, 174;
violent incident under, 169
artisans, 367n32, 372n94; Antique Revival
style and, 122, 131, 191–92,
361n20, 373n114; apprenticeship for,
183, 323, 386n91; choir stalls, about,
322–24; choir stalls imagery of, 317,
319, 320; clergy relationship with, 8–9,
187, 193, 271–72, 306, 321; community
in Amiens, 323–24, 373nn104–5,
386n89; entrances for, 358n69; income,
183, 185, 187, 324, 386n89, 386n91;
role and responsibilities of, 9–10, 215;
wood carvers, 321, 322–23. *See also*
carpenters; glaziers; master masons;
sculptors
Ascension Day procession, 336, 340
Augustine (saint), 133, 201, 257, 365n9,
374n138
Auxerre Cathedral, 374n126; influences
from, 287; labyrinth function in,
342, 389n34; openwork flyers at, 98,
379n64
axial chapel (*Petite Paroisse*), 280;
construction, 256, *256*; depth of,
48; functions of and ceremonies in,
209, 256, 337, 374n134; stained glass
windows of, 201, 202, 203, 342

bakers, 281, 374n138, 382n26
bays: ambulatory, 77–78; collapse threat
and reinforcements for central, 11–12;
nave easternmost oversized, 10, 62, 66,
68, 89–90, 172–73; flyers of western,
95; upper views of, 88–90; vaults, 65;
windows, 203
Beau Dieu. See Portal of the Triumphant
Christ
Beau Pilier, 174, 175, 196, 199, 278, 279,
373n121
Beauvais Cathedral, 169, 371n79,
379n69; choir collapse, 262, 380n76;
height, 357n57; prebend at, 365n12;
proportions, 377n30; sacristy/treasury
complex at, 47
Beffroi. See Belfry

Belfry (*Beffroi*), 386n96; in Firmin the
Martyr choir screen sculptural narrative,
291; power symbolism with, 229;
vantage point from, 33–34, *35*
Bernard d' Abbeville, 171, 203, 204, 342,
357n57
Bible of Amiens, The (Ruskin), 2–3, 358n69
Bible translations, 321–22
bishops: appointment/election of, 163,
175; burial space choices, 274–75;
choir stalls seats for, 366n23, 385n75;
commune's relations with, 31,
356nn39–40; construction funding role
of, 163, 181, 210, 371n79; Firmin the
Martyr sculptural narratives depicting
role of, 117, *119*, 291, 293; housing for,
160–61; income, 366n22, 366n24; key, in
Amiens Cathedral early history, 164–76;
order and succession of, 365n15; role
and responsibilities of, 160, 163, 291,
293; Saint-Martin-aux-Jumeaux church
for tombs of, 367n33
bishop's palace, 273; choir access originally
from, 45; entrances to, 80, 146, 169;
exterior views of, *36*, *45*; survival of, 34
bishop's throne (*cathedra*), 9, 163, 259, 304
Blasset, Nicolas, 213, 215, 359n87, 375n150,
386n92
Byzantine artistic forms, 116, 193, 373n114

Caesar, Julius, 16–17, 354n12
canons, 161–64, 306, 365n8, 365nn12–13
Canterbury Cathedral, 187, 218, 220, 255,
375n5, 377n31
Cardon, Louis, 328–29
carpenters, 320, 324, 379n74; choir stalls,
322; Golden Steeple rebuilding by,
327–30; income for, 187; role and
responsibilities of, 9, 187–88; roof
construction by, 259–62; stained glass
window imagery of, 188–89, *189*, 201,
374n129; wooden formwork of, 188–90,
189, 240
cathedra (bishop's throne), 9, 163, 259, 304
Catholic Church: Amiens Cathedral
role in unification of, 30–31; Council
of Cologne, 160, 364n6; Fourth

Lateran Council of 1215 and reforms
in, 99, 113, 138, 145, 166, 217, 220,
346, 361n17; France formation and,
28–29; history, overview, 12, 349–50;
Protestant Reformation and, 12, 210,
325; reform movement of 11th century
and, 160; revenue sources, 181, 209–10;
Transubstantiation doctrine and, 138,
301; views and groups opposing, 29–30;
virtue and vice role in salvation debate
in, 142, 363n40
celebrations. *See* feast days; processions
cemetery, 49, 164, 358n69; cloister, 269, 271,
272, 381n15; construction around, 269,
271; processions through, 271
central space/crossing (*in medio ecclesiae*),
69; bays enlarged around, 10, 62, 66,
68, 89–90, 172–73; conception and
construction of cathedral around, 10;
geometry in piers supporting, 237,
377n34; iron chains intervention for
integrity of, 12, 87, *87*, 179, 284–85,
349, 384n61; Laon Cathedral, 224, *225*;
Last Judgment imagery in, 68; laypeople
and clergy linked within, 10, 15, 70; in
liturgical practices, significance of, 10,
15, 70, 337, 340, 344; spatial envelope
of, 6–7; spatial transformations with,
11, 66–67, 70; structural problems and
interventions with, 282–87, 349, 386n58;
view from south transept triforium, *83*;
visitor experience of, 66, 68, 70
cephalophores, 123
*Ceremonial. See Essay d'un Cérémonial
pour l'église d'Amiens*
Chapelle des Macchabées. See chapter
house
Chapel of the Conversion of Saint Paul
(Chapel of the Dawn), 74, 81, 153,
249; construction of, 255–56, *256*;
establishment of, 73–74, 140, 177, 294;
windows and light in, 73–74, 177, 342
chapels: Saint Agnes, 40, 205, *205*, 274, 276;
ambulatory, 78, *78*–79; Annunciation,
52, 196, *197*, 211, 274, 277, *277*, 280,
382n38, 383n51; Saint Augustine, 201,
256, 257, 374n138; chantry, 211, 272,

70, 286; triforium window, *204*; upper, construction of, 11, 38, 252, 253; upper, exterior views of, 37–38, *38*; upper, interior views of, 88–89, *89*; views looking down, *162*, *227*; views looking east toward sanctuary, *227*, *303*; views looking west, *162*

choir boys, 216, 335, 390n39

choir screens (*jubé* and *clôture*), 71; construction, 257–58, 360n93; destruction in 1755, 66, 257; Firmin the Martyr sculptured narrative in, 76–77, 80, 288, *288*–91, *289*, *292*, *293*–94; John the Baptist sculptural narrative in, 80, 288, 294, *295*, *296*, *296*–97, *297*; Last Judgment imagery in, 258; lateral, refurbishing and embellishing, 287–97; lateral, tombs at, 76, 83, 175–76, *176*, 177, *289*, *290*; purpose of, 258, 354n7; at Saint-Firmin the Confessor church, 155; sculptors/ sculptural program for, 68, 76–77, 80, *195*, *196*, 258, 288, *288*–97, *289*, *292*, *295*, *297*, *298*, *299*–301; spatial drama of crossing space and, 66

choir stalls, 8, *83*; artisans, about, 322–24; artisans imagery in, *317*, *319*, *320*; bishop seats in, 366n23, 385n75; canons overseeing sculptural program of, 306; carpenters work on, 322; clergy life represented in, 9, 316; clergy positions and seats in, 9, 161, *162*, 302, 304, *305*, 334, 366n23, 385n75; Dean's stall, *307*, *308*; Egyptian imagery, 311–13, *312*, *313*; function of, 9, 302, 304–6; funding for embellishment of, 306; handrest figures, 305, 316–17, *318*, 319, *319*, *320*, 321; laypeople imagery in, 316–17, *318*; misericords, 302, 304, *304*, 309, 311, 316, 322, 323; Noah's Ark imagery in, *304*, 309, 312, 325; north side, *304*, 312–13, *313*, 316, *317*, 323; Old and New Testament narratives interwoven in, 306–7, *307*, *308*, 309, *310*, 311–16, *312*, *315*, 316, *317*, 320–21, 322; pendants, 319–20; prototypes and influences behind sculpture of, 320–22,

323; Ruskin on, 3; sculptural program and embellishments, 301–25, *307*, *308*, *315*; south side, *304*, *305*, 311–14, *312*, *315*, 324; staircases and stair rails, 309, 311, *312*, *313*, 313–16, *315*, *316*; Virgin Mary sculptural narratives in, 306, *307*, *308*, 309, 314–16, *315*, 320

Christmas liturgy and performance, 103, 106, 117, 212, 360n6

Christopher (saint): chapel, 52, 53, *53*, 211, 215, 274, 280, 281, 383n44; pilgrimages for, *53*, 215; portals of, 54; statue, *53*, 215, 280, 383n45

Chrodegang of Metz (bishop), 160, 364n8

Clairvaux, Bernard of, 116, 141, 142, 361n13

clerestory: choir, 46–47, 70, 171, 203, 204, 210, 342, 357n57; exterior views from, 92–94; glaziers work on nave, 203; nave, 39, 41–42, 61, *61*, 89–90, 92–96, 203; passage, views from, 92–96

clergy: Apostolic image of, 368n25; artisans' relationship with, 8–9, 187, 193, 271–72, 306, 321; Benedictine rule and, 160, 364n8; burial of, 164; canons' role as, 161–64, 306, 364n8, 365nn12–13; central space/crossing linking laypeople and, 10, 15, 70; choir moved into by, 257–58, 349; choir stalls representation of life of, 9, 316; choir stalls/seats and positions of, 9, 161, *162*, 302, 304, *305*, 334, 366n23, 385n75; community in Amiens, about, 26, 128, 159–64; construction displacement of, 254–55; construction failures and, 11–12; construction funding from, 143, 163, 181, 209–10, 371n79, 374n136; construction plans consideration of, 219–20; construction role of, 11–12, 70, 163, 165–66, 169, 172, 173, 179–80, 219–20, 371n79, 381n11; education behind high-level, 162–63; fabric administration role of, 180, 181, 210, 218, 371n77, 371n86; at Fourth Lateran Council of 1215, 99, 113, 138, 145, 166, 217, 220, 346, 361n17; fundraising sermons, 143; income, 365n12, 366n22,

37–38; north transept, 34, 37, 93–96, 94, 95, 96; of north transept east side, 96, 96; of north transept west side, 94, 95; Notre-Dame of Paris failure of, 380n2; openwork, 96, 96, 97, 98, 253, 285–86, 379n64, 384n66; of polygonal chapels, 48; Portal of the Triumphant Christ, 102–3; Renaud de Cormont design for, 12, 252–53, 285–86; Tarisel work on, 98, 296; upper chevet, 97; at west portals, 102–3

France: Bible translations in, 321–22; England medieval conflicts with, 29, 357n50, 380n2; England treaty and ceremony in 1279 with, 173, 258–59; formation of, 28–30; geographical definition of, 12, 349; Revolution, 13

Franco-Flemish War, 263–64, 272

funding: from clergy, 143, 163, 181, 209–10, 371n79, 374n136; from communes, 181–82, 354n4; from laypeople, 181–82, 209–11, 354n4; from taxation, 282; violence and anticlerical events around, 210

gallery: definition, 376n27; of kings, 30, 54, 173, 368n60

Gallic Wars (Caesar), 16–17

Geoffroy d'Eu (bishop), 269, 378n48, 379n67, 381n13; background and church career for, 167–68; commune relations and, 31, 356n39; construction role and support of, 371n79; tomb, 167, 167, 366n28, 367n39

geometry and proportions, 354n15, 378n41; in construction plotting, 235–37, 237, 238–39, 240, 377n38; of hemicycle, radiating, 13, 238, 240; master masons' use of, 92, 187, 235–36, 243, 377n34; nave, 62, 90, 92, 357n59; of other cathedrals compared with Amiens, 234, 377n30; of portals, 103; quadrature and, 92; Reims Cathedral, 234, 240, 377n30; Robert de Luzarches's understanding and use of, 235–36, 243, 377n34; transept, 357n59; of vaults and arches, 240; Villard de

Honnecourt use of, 235, 237, 240; Vitruvius architectural teachings and, 236, 238, 377n37, 378n39

Gérard de Conchy (bishop), 80, 169–71, 170, 371n80

Gervase of Canterbury, 186–87, 218, 220, 255, 377n31

glaziers and glass production, 207, 208, 374n126, 374n132; fabric committee overseeing, 200; grisaille glass use of, 70, 203, 205–7, 374n130; nave clerestory work of, 203; north transept triforium, 96, 96, 206, 206, 268; role of, 9, 199–200, 346

Golden Steeple. *See* steeple, golden

Guillaume aux Cousteaux, 298, 299–300

Guillaume de Mâcon (bishop), 172–73, 274, 276, 334, 382n37

Habakkuk (prophet), 104

Haggai (prophet), 104, 105, 105, 117, 120, 121–22

hemicycle: chevet, exterior view of, 97; foundation construction, 379n65; geometry of, 13, 238, 240; pilgrimages and design of, 226, 228; prototypes for design of, 228, 376n19; staircases at base of, 80

Herod (king), 106, 108, 296

Honoré (saint): bakers' adoption of, 281, 374n138, 382n26; chapel, 40, 41, 274, 276, 382n26, 382n37; feast day, 123; fundraising around relics of, 374n136; north transept portal trumeau and, 43, 45, 146–47, 147, 364n56; at Portal of Saint Firmin, 120, 123; south transept portal of, 45, 49–50, 123, 125, 148, 150, 154, 154–55, 155, 193, 194, 335

Honorius of Autun, 133, 361n13

Hosea (prophet), 103, 104

Hundred Years War, 199, 207, 263–64, 311

industry and professional groups: bakers, 281, 374n138, 382n26; chapels adopted by specific, 374n138; clergy wealth from and control of, 30, 161; funding from, 354n4; in medieval Amiens, 23–26, 161;

industry and professional groups (*continued*)
textiles, 23–24, 27, 374n138. *See also* woad merchants

in medio ecclesiae. See central space/crossing

interlocutor, role of, 2–3, 14–15, 345–46

Isaiah (prophet), 128, *130*, 131, 142, 192

James (saint), 341; chapel, 256, *256*, 257, 258, 374n138; haberdashers adoption of, 374n138; pilgrimages for, 215, 300; south transept choir screen sculptured narrative of, 298, *299–300*

Jean Avantage (bishop), 175

Jean d' Abbeville (dean), 171, 361n17; background and church career for, 139–40, 142, 177, 221; Chapel of the Conversion of Saint Paul established by, 73–74, 140, 177, 294; construction role of, 70, 176–77, 190, 218, 350; liturgical practice reorganized under, 387n6; mendicant support from, 142–43; portals sculptural program role of, 116, 139–40, 141–42, 146, 362n36; psalms chanting ritual organized under, 217, 334, 388n9

Jean de Boissy (bishop), 173, 282, 368n61

Jean de Chelles, 252, 265, 372n91

Jean de Cherchemont (bishop), 173, 282, 368n61, 380n1, 383n51

Jean de Gaucourt (bishop), 176

Jean de la Grange (bishop and cardinal), 282; chapels established by, 175, 199, 278; statue, 174, *175*, 199; tomb, 168, 174–75, 368n61, 368n64

Jean Wytz, 298, 300

Jeremiah (prophet), 128, *130*, 131

Jerusalem Tower, 20–21

Joel (prophet), *104*

John II (king), 264, 272

John the Baptist (saint), 243; on *Beau Pilier*, 199; chapel, 41, 47, 175, *198*, 256, 257, 274, 278, 279, 370n75; choir screen sculptural narrative of, 80, 288, 294, 295, 296, 296–97, *297*; decapitation of, 123, 296–97, *297*; fabric revenue from cult of, 181; head relic, 29, 80, 122, 215,

256, 297; wool carders' adoption of, 374n138

John the Evangelist (saint), 138–39, 329, 341; chapel, establishment of, 175, 278; chapel windows, *41*, 175, 274, 278

Jonah (prophet), *104*

jubé. *See* choir screens

labyrinth, 63, 64; Auxerre Cathedral, 342, 389n34; central plaque of, 183–84, *184*, 346, 371n89; Chartres Cathedral, 342, 359n75, 372n90; Daedalus myth relation to, 9, 64–65, 341; Easter celebration and, 342; feast days function of, 341–42; influences for, 359n75; master masons identified in, 9, 183–84, 218, 371n89; modern visitors experience of, 64–65; Reims Cathedral, 359n75, 372n90; Sens Cathedral, 342, 389n34

Lambert (saint), *53*, 53–54, 274, 280, 281, 383n47

land surveyors (*agrimensores*), 19, 236, 238, 354n15, 377n37

Laon Cathedral, 103; chapter house location, 381n21; design of, 10, 224–25, *225*, 228, 381n12; prebend at, 365n12; prototypes and influences from, 10, 62, 99, 190, 200, 220, 224, 360n3

Last Judgment, 144, 194; choir screen imagery of, 258; crossing space imagery of, 68; Portal of the Triumphant Christ imagery of, 135, *136*, 137, 143; west portal figurative sculpture of, 8–9, 10, 343

latrines, 381n23

laypeople: agrarian population of, 24; Biblical narratives access for, 321–22; central space/crossing linking clergy and, 10, 15, 70; chapels established by, 211–12; choir stalls imagery of, 316–17, *318*; clergy conflicts with, 10–11; clergy relations with, 10–11, 15, 31, 70, 72–73, 149–50, 162, 212–13, 216, 341–42; confraternities membership for, about, 10; construction funding/donations from, 181–82, 209–11, 354n4; construction plans

consideration of, 219–20; engagement with and role in Amiens Cathedral, 10–11, 72–73, 209–16, 354nn7–8, 374n134; figurative sculpture messages aimed at, 8–9; labyrinth function for, 341–42; saints relics role of, 22; window donations from, 210–11. *See also* communes; confraternities; pilgrimages; Puy Notre-Dame confraternity

Libergier, Hugues, 185, *186*

lierne, 277, 383nn39–40

lion imagery and symbolism, 133, 165, 175, 363n30

liturgical practices and performances: acoustics for, 389–90nn38–39; All Saints' Day, 168, 212, 271, 336, 381n17; antiphonal chanting, 21, 228, 334, 387n8, 388n10; architectural forms relation to, 70, 224–25, 332–33, 335–36, 344–45; central space/crossing significance in, 10, 15, 70, 337, 340, 344; *Ceremonial* on, 12–13, 271, 332–33, 336, 338–39, 341, 387n2; choir boys and, 216, 335, 390n39; Christmas, 103, 106, 117, 212, 360n6; clergy physical appearance of, 339, 340; daily routines of, 334–36; definition and function of, 333–34; Divine Office, 9, 164, 304, 335, 336; documentary sources, 332–33; Easter, 57, 133, 336, 337, 340, 342, 389n33; Eucharist, 86, 164, 257, 335–36; Firmin the Martyr, 117, 290, 293, 338–39, 340–41, 388n25; labyrinths and, 342, 389n34; light role in, natural and artificial, 342–43; "liturgy" meaning in, 387n1; musical production and, 217–18, 334–35, 343–44; *Ordinaire* on, 12, 334, 336, 338–40, 343–44, 365n10, 387n6; *Ordo Prophetarum*, 103, 106, 360n6; Palm Sunday, 21, 25, 133, 339–40; paraliturgical events and, 70, 336, 337, 338–42; Pentecost, 336, 337, 388n21; Portal of the Virgin Mary imagery of, 106, 111; psalms chanting ritual origins and role in, 217, 334–35, 387–88nn8–9; reorganization of, 387n6; sources for

investigation into, 12–13; stational, 219, 226, 271, 337, 366n26; suppression of, 13, 213, 337, 389n34. *See also* feast days; processions

Louis (saint) chapel, 40, 173, 211, 274, 276

Louis IX (king), 162, 228, 367n43, 379n73; crusade of 1249, taxation for, 170–71, 263, 379n60; defeat and capture of, 171; Geoffroy d'Eu loyalty to, 168; Guillaume de Mâcon background with, 173; Saint Margaret as wife of, 172, 382n32

Louis VI (king), 25, 356n37

Louis VIII (king), 29, 182, 228

Louis XI (king), 176, 178, 356n26

Luther, Martin, 12, 301, 329, 350

Malachi (prophet), 103, *104*, 120, 122

Malherbe, Drieu, 181, 205, *205*, 210, 211, 276

Margaret (saint): chapel, 52, 172, *172*–73, 274, *274*–76, *275*, 382n32; Louis IX wife as, 172, 382n32

Martin (saint), 22–23, 355n24, 356n26, 364n1, 365n9. *See also* Saint-Martin-aux-Jumeaux church

master masons, 372n94, 372n96; clergy relationship with, 187, 271–72; community structure, 183, 187; construction building role of, 10, 61–62, 86, 241–54; construction by, hands-on, 186–87; construction plotting role of, 218–22, 240; elevated status of, 185–87; geometry understanding and use by, 92, 187, 235–36, 240, 377n34; Gothic architectural changes and, 86; labyrinth inscriptions identifying primary, 9, 183–84, 218, 371n89; Libergier tomb effigy and, 185, *186*; Montreuil work as, 185, 252, 265, 359n89; at Notre-Dame of Paris, 185, 252, 358n65; role and responsibilities of, 9–10, 218–22, 346; salaries, 183, 185; sculptors' relationship with, 190; stone production serialization by, 189–90, 240; techniques, 372nn100–101; trowel image at south transept portal, 184–85, *185*, 245,

master masons (*continued*)
372n92; yard and well, *182, 182–83*,
271–72, 371n84. *See also* Renaud de
Cormont; Robert de Luzarches; Thomas
de Cormont

Matthew, Gospel of, *133, 135, 137, 339*,
362nn31–33

medieval period: demographic recovery
during, 23–24; formation of France
during, 28–30; industries of, 23–26, 161;
urban identity and space development
in, 25–28

mendicants, 175, 177; Arnoul de la Pierre
support of, 169; Jean d'Abbeville
sympathy to, 142–43; revenue sources
from sermons of, 181; secular clergy
tensions with, 149–50, 364n55; south
transept portal reference to practice of,
153–54

Mère Dieu. *See* Portal of the Virgin Mary

Micah (prophet), *104*, 105, *105*

Michael (saint): chapel, *40, 41*, 205, 274,
277, 280, 382n38, 383n51; at south
transept portal, 149

Montreuil, Pierre de, 185, 252, 265, 359n89

Morand, Jean, 387n99

Nahum (prophet), *104*, 105

nave, 360n93; central crossing spatial
transformations from, 11, 66–67,
70; chapels, construction delays for,
280–81; chapels, contradictions in,
281; chapels, sculptural program of,
196, *197, 198, 199*; chapels, surviving
statues from exterior of, 373n120;
chapels construction, lateral, 272–81,
383n52; clerestory, 39, 41–42, 61, *61*,
89–90, 92–96, 203; colonnettes in, 59,
61; construction of upper, 11, 38, 247;
construction plotting drawings of, 221,
238–39; dado, original and rebuilt, 242,
242–43, 243; elevation, 61, *61*, 88, *89*,
90, 230–35, 234; exterior view of upper,
91; flyers, 37–38, 42, *58*, *91*, 93, *95*, 96,
102–3; flyers, exterior north side, *91*,
93; flyers, stained glass in, *58*; flyers
contrasted with choir, 37–38; geometry

and proportions, 62, 90, 92, 357n59;
iron chains installation for integrity of,
12, 87, *87*, 179, 284–85, 349, 384n61;
north, aisle construction, 245–46;
north, aisle looking east, *56*; north, aisle
looking northeast, *58*; north, interior
view of portal, *57*; northern view of
upper, 37, *37*; north flank of, 39, *40*, *41*;
plan/grid of, 62–63, *63*; proportions,
62, 90, 357n59; south, aisle, 59, *60*, *61*,
358n68; south, aisle construction, 10,
45, 245; triforium, 59, 61–62, 82; upper,
essential elements of, 91–92; vaults,
62, *62*, *63*, 273, 274, 275–77, 279–81;
view down length of, *5*, *67*; windows of
original, aisles, 200–201, 358n70. *See
also specific areas*

Nicaise (saint) chapel, 201, *202*, 256, *257*

Nicholas (saint) chapel: exterior view of,
52, 53; window and vault, 274, *276*;
Woad merchants' adoption of, *53*, 198,
281, 346, 374n138, 382n26, 382n37

Noah's Ark, 304, 309, *312*, 325, 350, 385n77

north portal. *See* north transept portal;
Portal of Saint Firmin

north transept, 39, *40*; baptismal font,
366n27; flyers, 34, *37*, 93–96, *94, 95, 96*;
rose window, 34, 37, 42, 206, *206*, 268,
358n61, 380n9; sculptural narratives in
screen of, 298, 300–301; tracery of, *41*;
triforium, glass work of, *96*, 96, 206,
206, 268

north transept façade, 34, *37*, 45;
construction, 268–69; inner, view of, *82*,
267; south transept façade contrasted
with, 269

north transept portal, 45; austerity of, 42,
146; central trumeau figure of Saint
Honoré, 43, 45, 146–47, *147*, 364n56;
construction of, 45, 146–47, 149–50;
location, factors and meaning behind,
146; tracery of, 147, 363n50; tympanum
installation, 45, 146–47; west portals
contrasted with, 146

Notre-Dame du Puy chapel, 72, *73*, 179, 211

Notre-Dame of Amiens. *See* Amiens
Cathedral; *specific topics*

Portal of the Virgin Mary (south portal), *107*, 150–51, 156, *157*, 334; Annunciation, Visitation, and Presentation of Christ, 111, *111*; apostles at central portal contrasted with, 131–32; Ark of the Covenant, 113, *114*, *115*; Byzantine influence on sculpture of, 116, 193; central trumeau, 106, *109*, *110*, 113, 143, 144, 358n67; column figures, 106, *108*; Coronation of the Virgin, 106, *115*, 116; Dormition and Assumption, *115*, 116, 141, 192; left side sculptural imagery, *108*, 111–12; levitation visually represented at, 141; Magi story and imagery at, 106, *108*, 111; Old and New Testament references and relation in, 113, 116, 141; *Ordo Prophetarum* and, 106; paintwork evidence, 195; quatrefoils, *108*, 111, *112*; right side sculptural imagery, *111*, *112*, 116, 141; salvation path represented with, 144; sculptors/sculptural program for, 106, *108*, *109*, *110*, *111*, 111–13, *112*, 116, 141, 143, 144, 192, 193, 195, 358n67; Song of Songs and, 106, 116, 141–42; tympanum, 113, *114*, 116; visitors' experience historically of, 106, 116, 144

portals, 364n56; Apostolic image of clergy in, 366n25; central and lateral, contrasted, 128, 131; construction sequence of, 245–46; human figures and horizontal elements of, 54, 102, 103, 105; less known, 358n69; memory and, 363n49; north nave interior view of, *57*; paintwork discoveries in 1992, 194–95; proportions and geometry of, 103; prototypes and influences behind, 99, 116, 145, 193, 360n3; of Saint Christopher, 54; salvation paths relation to, 144; sculptural program, factors and meanings behind, 8–9, 102, 140–46; sculptural program, Jean d' Abbeville role in, 116, 139–40, 141–42, 146, 362n36; tympanum and trumeau construction for, 153, 361n11. *See also* west portals; *specific portals*

Presentation of Christ in the Temple, 111, *111*, 213, 314

processions: Ascension Day, 336, 340; cloister role for, 271, 337–38; Firmin the Martyr, 20–21, 340–41; Palm Sunday, 21, 339–40; *papoires* role in, 10, 340, 341; routes and stations, 13, 271, 338–41, 381n20; stational liturgy in, 219, 226, 271, 337, 366n26; suppression of, 13, 213, 337, 389n34; for Saint Ulphe, 337–38

professional groups. *See* industry and professional groups

proportions. *See* geometry and proportions

Protestant Reformation, 12, 210, 325

prototypes and influences: from Auxerre Cathedral, 287; from Byzantine artistic forms, 116, 193, 373n114; from Chartres Cathedral, 58, 59, 190, 200, 224, 230–31, 374n126; in choir stalls figurative sculpture, 320–22, 323; for elevation, 230; for hemicycle plan, 228, 376n19; for labyrinth, 359n75; from Laon Cathedral, 10, 62, 99, 190, 200, 220, 224, 360n3; for lateral chapels, 172, 272–73; from Notre-Dame of Paris, 30, 62, 113, 132, 172, 190, 193, 200, 224, 228, 230, 252, 265, 272–73, 281, 330, 358n65, 361n11, 363n50, 373n114, 377n33; from Noyon Cathedral, 62, 99, 190, 220, 229, 365n12, 381n12; for portals, 99, 116, 145, 193, 360n3; from Reims Cathedral, 41, 99, 145, 200, 230–31, 240; for rose windows, 268, 287, 384nn67–68; from Sens Cathedral, 62, 287, 377n29; from Soissons Cathedral, 10, 200, 220, 229, 230; for triforium, 62, 230, 377n29; for windows, 41, 58, 200, 268, 287, 374n126, 383n51, 384nn67–68

Puy Notre-Dame confraternity, 208; Adrien de Hénencourt as master of, 179; art displays sponsored by, 212, 213, *214*, 215; chapel for, 73, *73*, 179, 211; clergy and laypeople engagement through, 10, 72–73, 212–13; establishment of, 211; poetry

competition held by, 211–12, 375n145, 385n82; power and presence of, 212, 215; representational practices in mass of, 337; revenue from, 181; south transept dedication to, 215, 298, 299, 346; suppression of, 213; Virgin Mary dedication to, 158, 211–12, 213

Quentin (saint) chapel, 169, 256, 256, 257, 271, 374n126, 379n64

Raoul de Rouvroy, 12, 334, 338, 343, 344, 387n6
Reginald (master mason), 185, 369n74
Reims Cathedral, 234; elevation design for, 230–31, 231; foundation at, 244; geometry and proportions, 234, 240, 377n30; labyrinth, 359n75, 372n90; portal sculptural program influence from, 145; prebend at, 365n12; prototypes and influences from, 41, 99, 145, 200, 230–31, 240
Renaud de Cormont, 207, 241; background and training, 252; choir screen construction under, 257–58, 360n93; construction phases attributed to, 11, 38, 51, 51, 247, 251–53, 257–58, 360n93; construction problems role of, 252, 253, 254, 285, 379n65; flyers design of, 12, 252–53, 285–86; inscriptions identifying masonry role of, 9, 183–84; as master mason after fire of 1258, 251–52, 254; south transept façade work of, 51, 51, 265, 268; tracery style of, 276; triforium work of, 61–62, 86, 253–54, 380n5
Richard de Fournival (chancellor), 354n15, 363n49; education and physician career, 162–63; written works of, 163, 341, 353n5, 377n37
Robert de Cocquerel, 208, 284, 287
Robert de Luzarches: age and death records, 246–47; cathedral construction background for, 10, 220–21, 224; clergy relation to construction work of, 70, 165; construction phases attributed to, 51, 51, 243–46, 245, 249, 252, 254,

274–75, 283, 360n93, 378n45; construction plotting role of, 220–21, 229–30, 234, 235, 283; construction problems role of, 252, 254, 283; foundation construction by, 11, 243, 244, 254; as founding master mason, 9, 218, 220–21, 223, 241, 350; geometry understanding and use of, 235–36, 243, 377n34; inscriptions identifying masonry role of, 9, 183–84, 218; lower walls construction by, 245, 246–47; sculptors' role with, 190; south transept façade work of, 51, 51; Thomas de Cormont style contrasted with, 248–49; transept portals construction role of, 149; triforium design of, 61–62, 377n29
Romans, ancient: Abladane city history of, 356n27; Amiens city history and, 16–17, 18, 19–20, 159–60, 258n29, 354n12, 364n3, 367n32
roofs, 380n76; aisle, 92–93; chapels, 91; choir, 70; construction, 259–62, 260, 261, 349; early provisional, 262; interior view of, 260
rose windows: north transept, 34, 37, 42, 206, 206, 268, 358n61, 380n9; prototypes and influences for, 268, 287, 384nn67–68; south transept, 39, 195, 205–6, 207, 268, 286–87, 343, 384nn67–68, 390n44; west, 34, 54, 207–8, 208, 230, 268, 287, 291, 343, 349; west contrasted with south transept, 287
Ruskin, John, 2–3, 31, 33, 34, 49, 56

Sacerdoce de la Vierge, Le, 214
sacristy/treasury complex, 49, 334; current, establishment of, 358n66; demolition of original, 257; entrances to original, 80; Saint John the Baptist's head in, 215; original, evidence of, 47; at other cathedrals, 47, 379n69
Saint-Acheul necropolis ("Abladana"), 19, 355n21; archaeological discoveries at, 16, 22, 127, 364n5; Firmin the Martyr tomb at, 20, 22, 124, 160, 293; Virgin Mary shrine church at, 124, 160

Thomas de Cormont (*continued*)
246, 247, 248–49, 360n93, 378n45;
construction problems role of, 252,
254, 285; inscriptions identifying
masonry role of, 9, 183–84; Robert de
Luzarches style contrasted with, 248–49;
south transept façade work of, 51, *51*;
triforium design of, 61–62, 86, 377n29;
upper nave construction by, 11, 38
tierceron, 277, 383n40
Tour Perret, 31–33, *32–33*, 34
tours and visits: ambulatory function
for, 77–79, 225–26; anticipation
of yet to be seen in, 65; ascending
desire and means in, 80–98; central
space/crossing experience in, 66,
68, 70; during construction, 14–15;
exterior perambulation, 39–54;
interior ground level views and
details in, 56–80; interlocutor role
in experiencing, 2–3, 14–15, 345–46;
of labyrinth, modern experience
of, 64–65; media technology role in
virtual, 2, 345; 19th and 20th century
contrasts for, 33–34; Portal of the
Virgin Mary experienced historically
in, 106, 116, 144; portals experience
historically with, 102, 103, 105; 16th
century versions of, 14–15, 31; west
portals for, 3, 39, 56–57. *See also*
pilgrimages; vantage points
towers: transept arms lack of, 32; west
façade, construction, 173, 229–30, 282.
See also Belfry; Jerusalem Tower
tracery: cemetery cloister, 381n15; changes,
factors behind, 86–87; choir clerestory,
46–47, 70, 286; English history of,
382n36; Flamboyant, 42, 175, 207,
278, 286–87, 291, 293, 299, 380n9,
383n42; investigations of, 37–38; Saint
John the Evangelist chapel example
of Flamboyant, 175; nave clerestory,
39, 41–42, 89–90, 203; of nave lateral
chapels, 276–81, 383n51; of north
transept portal, 147, 363n50; of
northwestern chapels, 199; prototypes
and influences for, 41, 287; of south

transept portal, 147, 149; triforium
trefoils, 83, 86
transept arms, 360n93; embellishment of,
297–301; iron chains installation for
integrity of, 12, 87, 87, 179, 284–85, 349,
384n61; proportions, 357n59; screens,
function of, 297, 299; towers, lack of, 32.
See also north transept; south transept
transept façades: construction, 265, 268–69;
original intention for, 265. *See also*
north transept façade; south transept
façade
Transubstantiation doctrine, 138, 301
triforium, 358n71, 360n97; choir, window,
204; construction, 61–62, 86, 90,
253–54, 268, 380nn4–5, 380n8; defining,
376n27; elevation design role of, 61,
232–34; fire of 1258 impact on, 90–91,
251, 254; interior passage, 83, 87, 87,
90–91; iron chains, installation for
integrity of, 12, 87, 87, 179, 284–85,
349, 384n61; master masons involved in
design of, 61–62, 86, 377n29; nave, 59,
61–62, 82; north transept, 96, 96, 268;
Noyon Cathedral, 230; prototypes and
influences for, 62, 230, 377n29; south
transept, 82–83, 83, 90, 254, 384n56;
south transept, views from, 82–83;
structural concerns, 87–88; tracery,
trefoils, 83, 86
Troyes Cathedral, 383n50; fabric
administration at, 24, 372n101;
openwork flyers at, 98, 253, 384n66;
sacristy/treasury complex at, 47,
379n69; windows influences from,
374n126, 383n51

Ulphe/Ulphia (saint), 131, 169, 173,
373n111, 379n69; chapel for, 122;
death of, 122, 361n19; Saint Domice
relationship with, 124; feast day,
121, 337–38; gender roles and status
considerations with, 123; life story, 122;
Portal of Saint Firmin representations
of, *120*, 121–23, 124; relics transfer
ceremony, 173, 258–59, 349; west portal
sculpture of, 192, *192*

windows (*continued*)

70, 203, 205–7, 374n130; of Saint John the Evangelist chapel, 41, 175, 274, 278; laypeople donations of, 210–11; light role in liturgical practices and, 342–43; nave chapels, lateral, 273, 274, 275, 276–81, 383n51; nave chapels vaults and, map of, 274; nave clerestory, 39, 41–42, 61, 61, 89–90, 92–96, 203; of nave original aisles, 200–201, 358n70; oculus forms and, 41, 46–47, 50, 200, 235, 248, 276, 279, 358n62, 378n53; prototypes and influences for, 41, 58, 200, 268, 287, 374n126, 383n51, 384nn67–68; south transept, 39, 205–6, 207, 235, 236, 245, 342–43; Tree of Jesse, 201, 202, 203, 342; of upper nave contrasted with chapels, 42. *See also* glaziers; rose windows; tracery

winter chapel, 46, 47–48

woad merchants, 182, 196, 210; Amiens as center for, 23–24, 26; construction funding and, 211; foliate decoration and, 373n106; Saint Nicholas chapel adoption by, 53, 198, 281, 346, 374n138, 382n26, 382n37; taxation of, 264

wood carvers, 321, 322–23

World War I and II, 34

Zechariah (prophet), 104

Zephaniah (prophet), 104, 105, 117